ART TODAY

Edward Lucie-Smith

ART TODAY

FROM ABSTRACT EXPRESSIONISM TO SUPERREALISM

PHAIDON
Oxford

Text
EDWARD LUCIE-SMITH

Brief Biographies
LARA VINCA MASINI

Introduction
GILLO DORFLES

Editors
MARIELLA DE BATTISTI
MARISA MELIS

Graphic Production
ENRICO SEGRÉ

Phaidon Press Limited
Littlegate House, St Ebbe's Street, Oxford
First published in Great Britain 1977

Second, enlarged edition 1983

British Library Cataloguing in Publication Data

Lucie-Smith, Edward
 Art to-day.—2nd ed.
 1. Art, Modern—20th century—History
 I. Title II. Arte oggi. *English*
 709'.04 N6490

 ISBN 0–7148–2325–2

English language edition copyright © 1977 by Arnoldo Mondadori Editore, Milano

Originally published in Italian in 1976 by Arnoldo Mondadori Editore, Milano
under the title ARTE OGGI: DALL'ESPRESSIONISMO ASTRATTO ALL'IPERREALISMO
Copyright © 1976 by Mondadori-Kodansha
Illustrations copyright © 1971, 1972 by Kodansha Ltd., Tokyo
Text copyright © 1976 by Mondadori-Kodansha

The illustrative material in this present volume was derived from
a series of 12 books, entitled *Art Now*, originally published by
Kodansha Ltd., Tokyo, in 1971–1972.

The illustrations on pages 10–11, 12, 15, 16, 17, 18–19, 20, 21, 22,
23, 30–31, 31, 32, 33, 34, 37, 38, 39, 45, 46, 50, 51, 52, 53, 54–55, 96–97,
103, 104, 105, 110, 111, 112, 113, 114, 115, 116, 119, 123, 124, 125,
126, 127, 128, 129, 130, 131, 134, 164, 165, 166, 185, 280, 281, 292,
293, 296, 297, 323, 350, 353, 354, 355, 359, copyright © 1976 by
Spadem and Adagp, Paris.

Printed in Italy by Arnoldo Mondadori Editore — Verona

Contents

Introduction by Gillo Dorfles

Up to what point is it possible or indeed valid to trace a history of contemporary art? And where should one begin? From which artist or group of artists? From which movement?

This book provides a clear and decisive answer to such questions, since movements and artists are treated with exemplary impartiality and with a sense of history often lacking in the militant critic. The period is taken to begin with the Fauves' official debut in Paris (1905) and the German Expressionists in the early years of the century, when the world of art was still dominated by Matisse, Gauguin, and Van Gogh.

Certainly one could see modern art, if not specifically "contemporary" art, as beginning earlier, in the middle of the last century, with the first Symbolists and the great Impressionists (especially Monet, Manet, Pissarro); or even earlier still, at the beginning of that century with Turner, the precursor of Impressionism.

On the other hand, as is often the case, it could be seen as beginning somewhat later, with the first abstract painting: when Kandinsky, seeing one of his pictures upside down, realized that the combination of lines and colours, though not at all representational, was in its expressive force already complete.

Or again Malevich and Mondrian could be considered the true "discoverers" of pure abstract art, the non-objective, non-figurative art that was later described as "Concrete" by Kandinsky and Van Doesburg.

So perhaps the real beginning of contemporary art was the abandoning of representational art after hundreds of years of triumph. With Kandinsky and the Dutch De Stijl group, with Russian Constructivism, with Malevich's Suprematism, the Prounism of El Lissitzky, and the Neo-Plasticism of Van Doesburg and Mondrian, we can see that Concrete art was the beginning of a development in which other concrete, or rather non-figurative, movements were to succeed one another as separate but yet overlapping stages; movements which, being non-figurative, are not to be related to Futurism and Cubism, which despite everything remained figurative, such as the Swiss Concrete art (Max Bill, Lohse, Graeser, Glarner). Such as, also, Concrete art's links in the United States (Glarner himself, Bolotowsky) and in Argentina (Hlito, Girola, Jommy, Maldonado, Prati); its adherents in Italy (the Milione group: Reggiani, Bogliardi, Ghiringhelli; and the Como group: Rho, Radice, Badiali); and its post-war continuation in the Milanese MAC (Munari, Veronesi, Soldati, Monnet), in England (Kenneth Martin, Victor Pasmore), in Germany (Vordemberge-Gildewart).

The same Concrete-Constructivist source gave rise after the war to the many trends of object art, the creators of "object paintings" in Italy and of "shaped canvases" in England; for example, the Lombard group in Milan (Manzoni, Castellani, Bonalumi, Scheggi), the Forma I group in Rome (Dorazio, Perilli, Accardi, Consagra), the Zero group in Holland and Germany (Mack, Piene, Uecker), until the explosion of Minimal Art in the United States, superbly described in Chapter IX, propounded by such artists as Tony Smith, Stella, Judd, Morris, LeWitt.

But it would be a mistake to limit oneself to abstract and non-figurative movements and ignore the figurative—but for this no less vital—art of other currents such as Surrealism and Dadaism. The author rightly emphasizes the importance of Marcel Duchamp, who deserves the credit for having overthrown a number of once axiomatic aesthetic principles by denying that artifacts had value in themselves and by shifting the concept of art from the object made to the object "discovered", with his famous *objets trouvés*.

6

Thus a history of art in our time cannot leave out such figures as Marcel Duchamp, Max Ernst, Francis Picabia, Man Ray, and Hans Richter, the founders of Surrealism and Dadaism and the great rebels against Western artistic tradition. Indeed, a history must trace back to these figures the theoretical development of contemporary art. It was especially Duchamp, with Tristan Tzara, Picabia, Jean Arp, and others, who realized the importance of an intellectual element, and not solely a representational one, as the basis of visual art. They understood that it was too easy to limit their own *Kunstanschauung* to the mere juxtaposition of lines and colours on canvas. Artists such as Paul Klee or Wassily Kandinsky had struggled for a "spirituality" in works of art that revealed itself in the play of lines and colours, responding to the appeal of Goethe's maxim *"aus der Farbe heraus"*, painting which evolves "outside colour". But on the other side of the artistic barricade the Dadaists and the Surrealists were struggling for a sense of conceptual factors, even though altered and adulterated, inherent in the figurative play rather than in the search for formal and chromatic elements.

Besides, art in the past had always preserved and exalted its own cognitive and not merely ornamental function. It had established the basis of a world view, whether theocentric or anthropocentric, in which art was the link between object and concept, between sensory and mental data. With Duchamp the exasperation of this cognitive, even magical, tendency found powerful expression. Thereafter those who followed in the footsteps of Duchamp and of primitive Dadaism transplanted to the United States produced those seemingly paradoxical artistic manifestations which flowered in the Fluxus concerts (1962) (Maciunas, Brecht, Cage, Paik, La Monte Young, etc.) and developed into the most recent theoretical initiatives (Kosuth, Beuys, Art-Language, and so on).

Among these latest trends the book rightly includes Body Art, Earth Art, Concept Art; that is, those which used the artist's own body and the land on which man lives as their special medium. Here, too, besides the many American and English artists mentioned, we must not forget that most European countries in the last few years have produced similar movements, often unknown to one another, as if by spontaneous growth. In this context we should remember important artists such as Gina Pane from France; the Italians Vettor Pisani, Gino De Dominicis, Luca Patella, Franco

Vaccari; the Yugoslavian OHO group, the Argentine groups The Thirteen and *Arte de Sistemas*, besides numerous groups from Poland, Hungary, and other countries. Nor must we underestimate the importance, in the development of Body Art, of individual dancers or actresses who were able to combine some aspects of theatrical art or rhythmical dancing with Body Art, for example Trisha Brown, Joan Jonas, Meredith Monk, Simone Forti, and Robert Wilson himself.

Also in the field of sculpture, in the widest sense of visual, dimensional, and spatial art, the last fifty years have been particularly exciting. The old divisions between "paintings" and "statues" have been completely broken down, following the intermingling of the two expressive forms. On one side there has been the appearance of "three-dimensional" paintings (such as the "shaped canvases" mentioned earlier) and on the other the appearance of sculptures and plastics that were painted or even without bodily substance, having been reduced to gaping cavities, or to a mass of rubbish and wreckage. It is not enough to go back to the now legendary figures of Brancusi, Moore, or Arp, the fathers of abstract or rather anti-naturalistic sculpture, nor is it enough to cite the many artists using scraps of metal, fragments of apparatus and machinery (David Smith, Chamberlain, César; or the Italians Ettore Colla, Franchina; the Spaniards Chillida and Cirino; the Yugoslavians Dzamonja, Trsar, and so on). We must not overlook the fact that dynamic kinetic art (of which the author mentions a few examples) has notably developed in many countries. In Italy, for example, artists such as the members of the Paduan N group (Biasi, Costa, Massironi) or the Milanese T group (Boriani, De Vecchi, Colombo, Varisco) and individuals such as Alviani, Mari, Dada Majno enjoyed considerable recognition in the Sixties; while some of them, like Gianni Colombo, were able to extend their work into other areas: the environment, bariestesic and batiestesic study, vibrating surfaces and elastic spaces.

If these forms of optical-kinetic art can be considered the extreme of a certain kind of sculpture, other extremely different but still three-dimensional forms show the importance that the creative handling of volumes still has outside traditional plastic limits. I refer to the so-called poor art (Germano Celant's term), which originated in Italy and found many adherents in other parts of the world. Among the major repre-

sentatives of this art form were the Turin group made up of Merz, Anselmo, Paolini, Penone, and Boetti, as well as the Genoese Prini, the Bolognese Calzolari, and the Milanese Fabro, with whom we can also partly associate the Romans Pascali, Marotta, and Kounellis. All these artists produced works that rely not on the beauty of the materials, on chromatic harmony, etc., but on particular effects that sensitize perceptions, focusing the onlooker's attention on contrasts of weight, of texture, of chemical combinations. Works such as those of Merz, Anselmo, and Boetti found an immediate response among German, Yugoslavian, and English artists and proved an important link between the pure Conceptual movements, Minimal ones, and those of the so-called Concrete poetry, which in Italy developed in the works of artists such as Isgro, Pignotti, Carrega, Miccini, Ori, and Bentivoglio, mingling verbal and representational elements.

Poor art, Concrete poetry, and, even more, the experiments on one's body, on the land, on the detritus of one's past (in the case of narrative art), showed by the ephemeral quality of some of their productions how art can now dispense with the traditional features on which the very identification of "art" was based. The artist can create works apparently gratuitous and transient but no less capable of exciting emotions and ideas new to the onlooker.

In this brief introduction it is not possible for me to sum up the development and in-terconnections of the struggles and achievements of the visual arts in the last fifty years, much less to draw even tentative conclusions about so complex a period as ours. The following pages will give the reader a very clear picture of the most important artistic movements and their best-known representatives.

However, one thing at least still seems to me to need saying by way of conclusion. If the first half of this century saw a great burst of creative energy in the visual arts (documented as we have seen in the now familiar categories of Futurism, Cubism, Surrealism, Constructivism, Expressionism), the years after the Second World War have been no less productive. Movements such as Pop Art, Op art, *tachisme* (or Abstract Expressionism), Minimal Art, and finally Body Art, narrative art, and Concept Art are proof that man's creativity is far from exhausted, as some claim, even if at times it risks extinguishing itself by its desire to be innovatory at all costs, by its fear of not being competitive, and—the real danger in the present situation—by its fear of not keeping pace with the market, often sacrificing what should be its true goals and submitting to the inducements and the exigencies of the consumer society.

But art, however one defines it, must still mirror, favourably or with hostility, the development of the society to which it belongs. Inevitably, contemporary art, too, reflects the complex and divisive social, political, and ethical state of our civilization.

Gillo Dorfles

The Birth of Modernism

Modern art was born into a world very different from the one we know today. If we date the birth of Modernism from the first public appearance of the Fauves, in the Paris Salon d'Automne of 1905, we are looking back to a society which was in many respects very different from our own. In the first decade of the twentieth century, technology, it is true, was making very rapid advances, but these advances had not yet had anything like their full impact upon the daily lives of the majority of Europeans. The internal combustion engine, to cite one example, had already established itself as something a great deal more than a toy. In Paris one-third of the wheeled traffic in the streets in the year 1905 was propelled by that engine rather than by horses. Yet the full possibilities of the invention were far from being realized, and the new motor car still bore a strong resemblance to the horse-drawn conveyances which it was starting to replace. In most minor details the manner in which people lived was far closer to the mode of existence that had prevailed during the nineteenth century than to anything that exists now. The Franco-Prussian War of 1870–71 was a relatively recent memory; the American Civil War still had many living eyewitnesses. The terrible social conditions that had shocked leading nineteenth-century writers such as Dickens and Zola were still largely unremedied, and the gulf between the different classes of society remained very wide in all the European nations. In the United States, with the rise of a new plutocracy—Astors, Vanderbilts, Guggenheims, Goulds—it even seemed to be growing wider still as the immense wealth of America increasingly made its way into the hands of a privileged few.

It was universally assumed that art was, and would remain, the business of a group which, in comparison to the rest of the social mass, was indeed very small: it consisted of the aristocracy, the plutocracy, and (its largest component) the prosperous and cultivated middle class. Such attempts as there were to bring art to a larger public—the Victoria and Albert Museum and the Whitechapel Art Gallery, though both in London, are well-contrasted examples—owed their existence to philanthropic impulses as characteristic of the nineteenth century in one way as its social injustices were in another. Typically, the management of these enterprises remained in middle-class hands. If the Fauves of 1905 were truly "wild beasts", as the critics of the day jokingly dubbed them, then they threatened the tranquillity of a few people only.

The intimate, even cloistered nature of their rebellion can be judged from the subject matter of some of the paintings they produced. Henri Matisse's *Dessert, Harmony in Red* (Plate 1), which dates from 1908, makes use of visual materials which were commonplaces for the artists of the time, whatever aesthetic persuasion they followed, and which had indeed been part of the European stock-in-trade since the Dutch genre painters of the seventeenth century. A maid with a starched collar and cuffs, and wearing a white apron, is seen arranging fruit on a tazza. Another tazza stands ready upon the table, accompanied by two decanters of wine. What gives this domestic scene its originality is the treatment of colour and form. The colour is, as the title claims, harmonious, but it is also unnaturally powerful. This and the drastic simplification of the drawing alike pay little attention to the way in which the eye perceives things in real life.

The use of colour in this way was not something entirely unheard of in painting, though Matisse was pushing his experiments to new extremes. James McNeill Whistler had already put forward the idea that colour could be treated in musical terms, and used for its own sake, though the hues

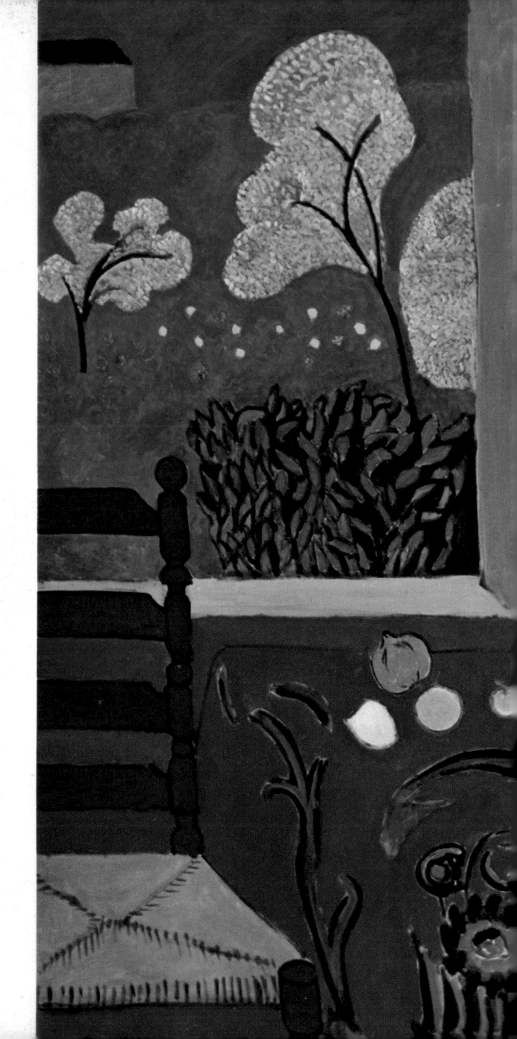

1.
Henri Matisse
La Desserte, harmonie en rouge
1908; 180 × 220 cm. (70 × 86 in.)
Leningrad, The Hermitage

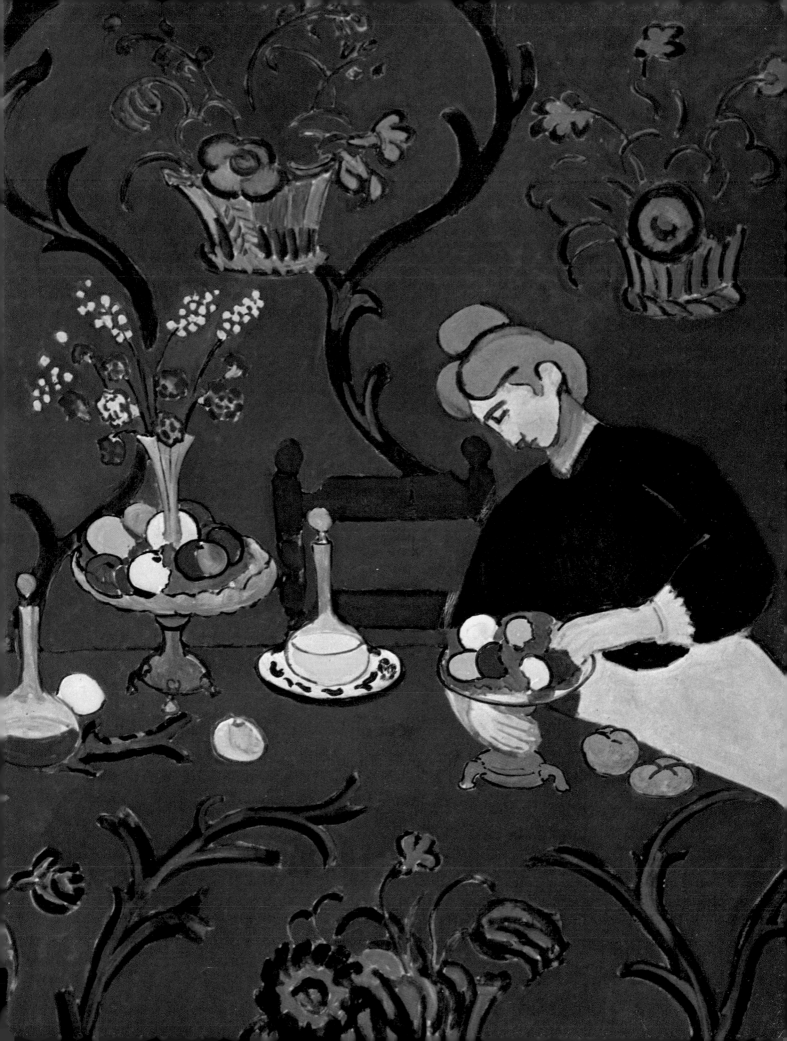

2.
Henri Matisse
La Danse (The Dance)
1910; 260 × 391 cm. (101 × 152 in.)
Leningrad, The Hermitage

3. Opposite
Ernst Ludwig Kirchner
Funf Frauen auf der Strasse (Five Women in the Street)
1913; 120 × 91 cm. (47 × 35 in.)
Cologne, Wallraf-Richartz Museum

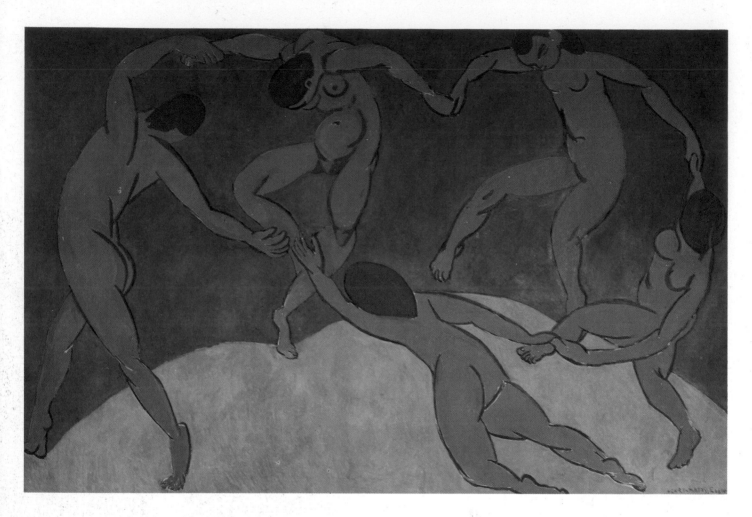

he favoured were subdued. The Symbolist painters in France, pursuing a slightly different line, had begun to accept that colour was something that could be used to express not the look of things as the physical eye perceived it, but the subjective mood they evoked.

Matisse's predecessors in the use of bold and violent hues had been the two great Post-Impressionist masters, Paul Gauguin and Vincent van Gogh. Van Gogh's use of colour was liberating because its violence was so obviously connected to the violence of the painter's own emotions, and for the first time artists were presented with a new kind of rhetoric—a rhetoric of anguish and suffering which went a long way beyond anything the Romantic movement had achieved. The Expressionist strain in European art, which began in the late nineteenth century but

has prolonged itself into the twentieth, is in many respects the main link between Romantic and Modernist painting, and therefore the most conspicuously "traditional" element within Modernism itself.

In Germany, in the years just preceding the First World War, Expressionism achieved the status of a school, and German Expressionism of this type is typified by Ernst Ludwig Kirchner's *Five Women in the Street* (1913), which is illustrated here (Plate 3). But there are many important modern painters who can be classified as Expressionists even though they are independent of any school or movement. One of the most typical of these is the Russian-born Jewish artist Chaim Soutine, who later emigrated from Russia and came to live in Paris. Soutine always worked in isolation, and what he produced was entirely personal to himself

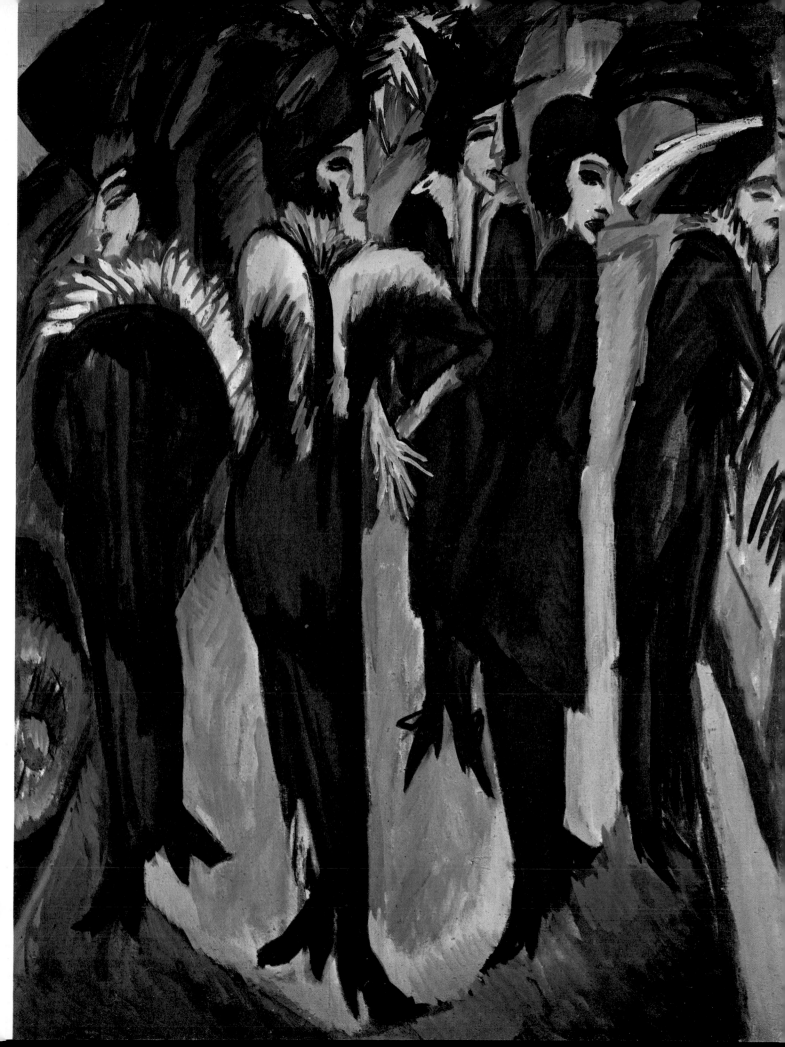

(Plate 4). His chosen images are obsessively repeated; he frequently painted the same motif again and again. But the precise significance of his choice often remains obscure, just as it does here in the artist's portrait of a young page boy. What we are chiefly aware of when we look at the painting is not the boy's character, but the artist's use of paint as a vehicle for his own anguish. We have here a revival of the Romantic assertion that the movements of the individual soul are of paramount interest, and that furthermore the artist unjustly limits himself, and tends to destroy his own potentiality, if he sets any bounds to his own ego. The claim of the artist to be an exceptional man in an increasingly egalitarian environment was to have, as we shall see, important consequences for the visual arts in the post-1945 period.

If we compare Soutine's *Page Boy* to the interior by Matisse, we note a significant difference. This is that, though both are apparently violent in colour, the Matisse lacks the feeling of emotional stress which emanates so powerfully from the work by Soutine. Though he was dubbed the leader of the "wild beasts" by the critics, Matisse was in fact essentially calm and luxurious in temperament. This mood is evoked very powerfully in what is nevertheless one of the most radical of his early works, *The Dance* (Plate 2), painted in 1910. This is one of the decorative compositions in which Matisse most obviously paid homage to Gauguin.

Gauguin may not have been a greater painter than Van Gogh, but he was an artist whose work had perhaps a wider import for the subsequent development of the visual arts. Unlike Van Gogh, Gauguin was regarded as a leader in his own day, even though this leadership was accorded to him by a very restricted coterie of other artists and writers. Not only did he seem to them to find new ways of developing ideas that were already implicit in Symbolism, but his decision to leave France altogether and to go and live and work in the South Seas had an enormous moral impact. What Gauguin celebrated was the primacy of instinct. "Our modern intelligence," he remarked, "lost as it is in the details of analysis, cannot perceive what is too simple or too visible." In this he too paid tribute to Romanticism, which had always made a cult of the simple life. But Gauguin was prepared to go further. He looked among a primitive people, still with the vestiges of their pre-Christian tribal culture, for the qualities that he thought were missing from contemporary European society. And in this sense he was one of the founders of the cult of barbarism which swept through advanced circles on the eve of the First World War.

The Dance is affected both by Gauguin's own vision and, in a more general sense, by the feeling that Matisse shared with many of his contemporaries that the society they lived in was stiflingly elaborate as well as stiflingly conventional, that it was necessary to destroy much before art could be rebuilt from its foundations. The war itself, which was to destroy so much and to transform the structure of its society, seemed to many people in its first moments the great ecstatic release of destructive energy which so many artists had longed for.

A painting which reflects this negative and destructive spirit far more obviously than anything produced by Matisse is Pablo Picasso's early masterpiece, *Les Demoiselles d'Avignon* (Plates 5 and 6). Painted three years before *The Dance*, this is a much more radical statement of disaffection. Indeed, everything leads us to suppose that it was a large part of Picasso's intention to produce a picture which any middle-class spectator would find unacceptably hideous. This suspicion is confirmed by the title, originally given to the work by the poet André Salmon. "Young ladies of Avignon" is an ironic description indeed—these are the whores who plied their trade in the Calle d'Avignon of Picasso's native Barcelona.

Academic historians of Modernism have often claimed that the most significant thing about *Les Demoiselles d'Avignon* is not this element of hostility towards the public, but the fact that the painting ushers in Picasso's so-called Negro Period, which leads in turn to the birth of Cubism. If we look at the five female figures, we note a distinct progression from left to right. The head of the nude on the extreme left is a tribute to the Polynesian faces characteristic of Gauguin's late

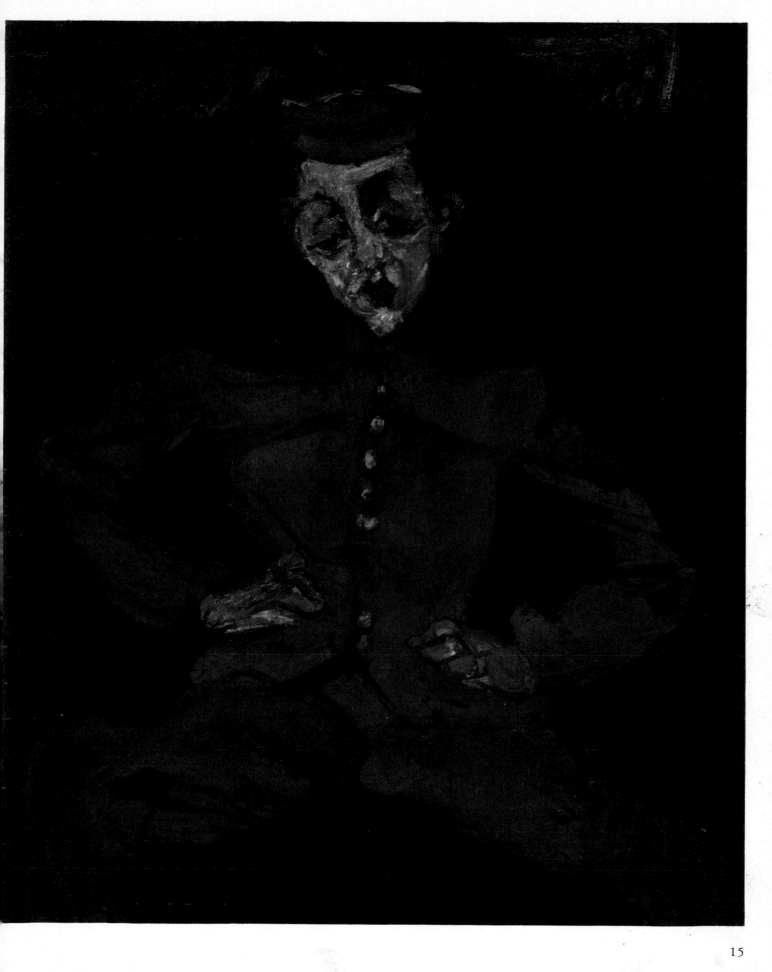

5 and 6.
Pablo Picasso
Les Demoiselles d'Avignon
1907; 243 × 234 cm. (95 × 91 in.)
New York, Museum of Modern Art
Opposite, detail

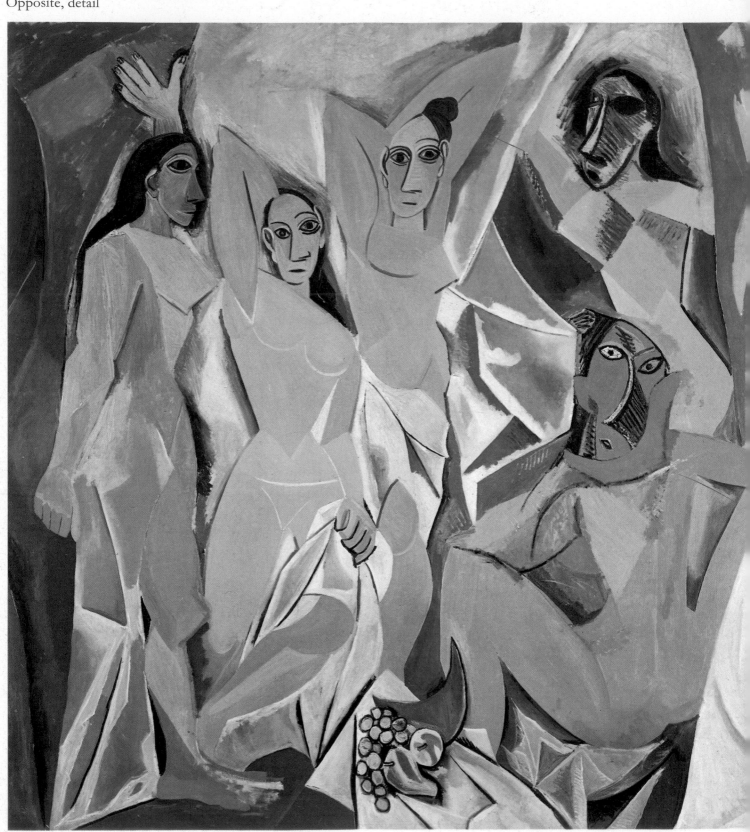

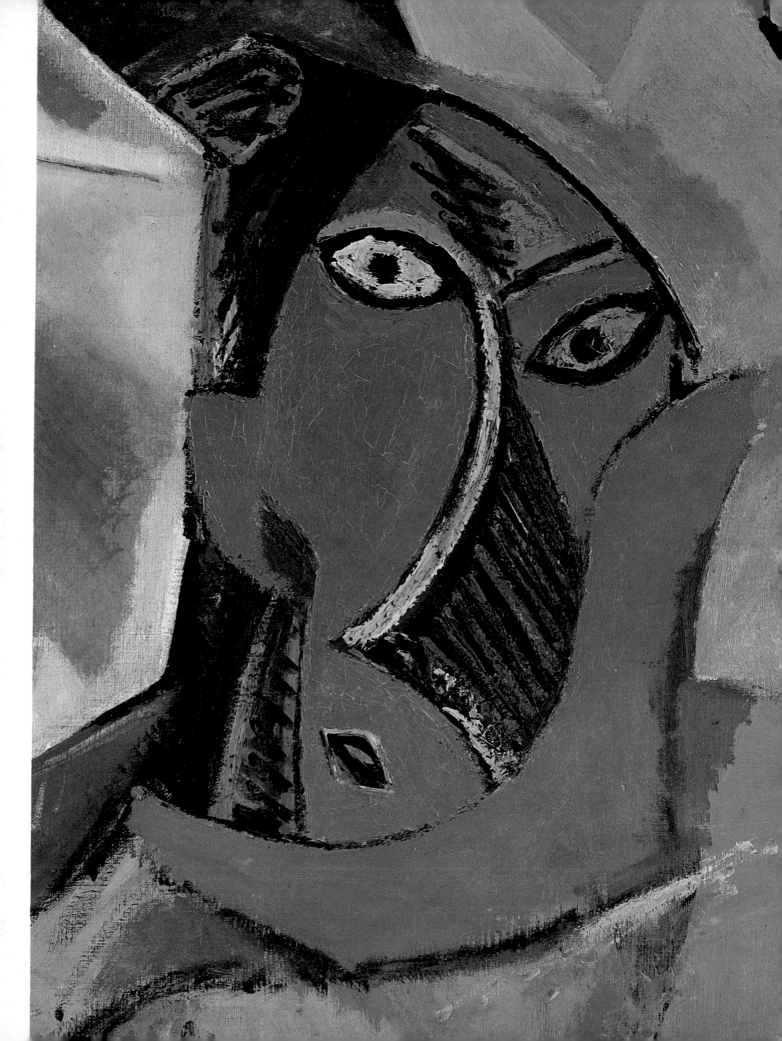

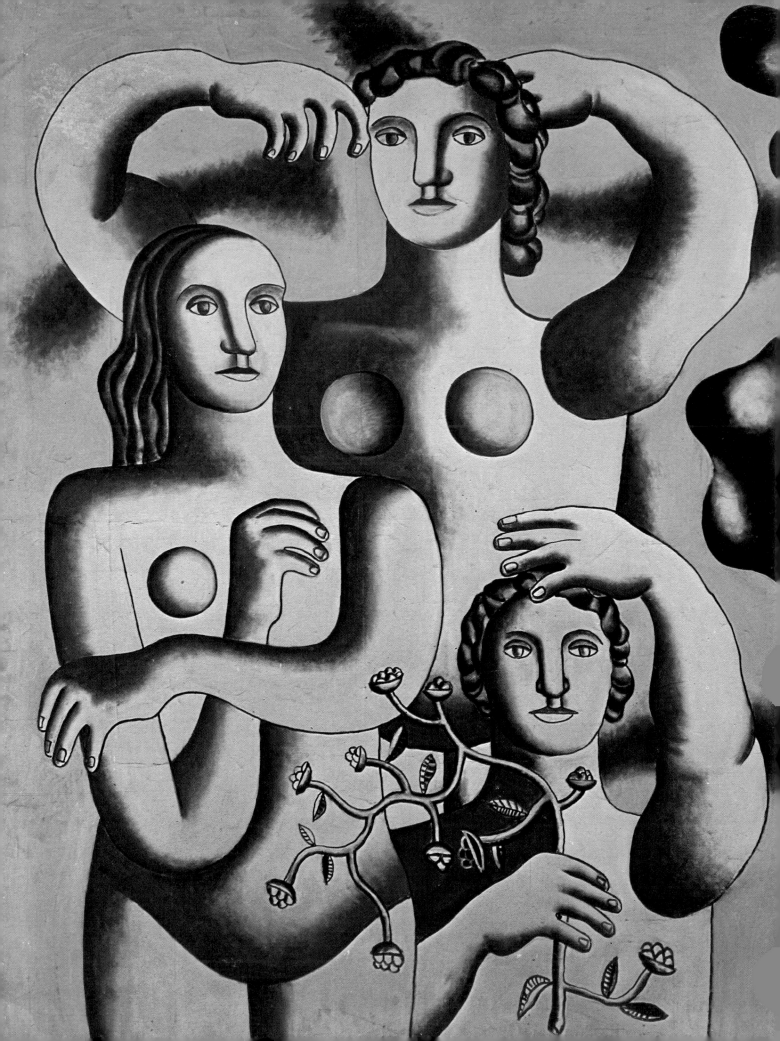

7.
Fernand Léger
*Composition aux trois figures
(Three Women)*
1932; 182 × 282 cm. (72 × 111 in.)
Paris, Musée National
d'Art Moderne

19

8.
Georges Braque
La femme à la guitare (Woman with Guitar)
1912; 130 × 74 cm. (51 × 29 in.)
Paris, Museé National d'Art Moderne

9. Opposite
Pablo Picasso
Portrait of Ambroise Vollard
1909–10; 92 × 66 cm. (36 × 26 in.)
Moscow, Pushkin Museum

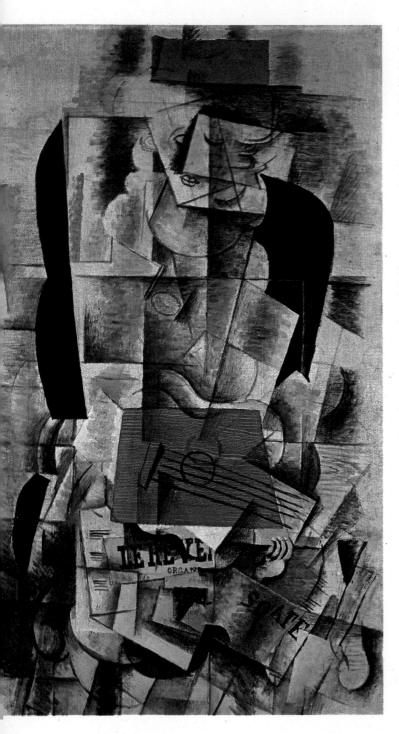

work. The two heads on the extreme right are very different. They are evidently based on the African masks which were just starting to attract the interest and enthusiasm of avant-garde artists. The intention to be "barbarous" in this sense is therefore unequivocally stated.

It is one of the curiosities of the early history of Modernism that this harsh and uncomfortable painting should lead directly to the most sophisticated of early Modernist styles—Analytic Cubism. Georges Braque's *Woman with Guitar* of 1912 (Plate 8) is in all respects typical of the work that both he and Picasso were producing at this time.

Until recently the claim that Cubism was the fountainhead of all subsequent Modernist art passed almost unchallenged. Yet there is a good case for claiming that it is a by-way, or perhaps even a cul-de-sac. Negro art was part of Analytic Cubism's parentage because the primitive artists of Africa had the habit of using faceted forms, in which the planes of the carving are distinguished from one another by a firm and visible boundary. A more important ancestor was Paul Cézanne. Cézanne, too, developed the habit of breaking up the forms he was using into facets, but in his case these were displayed on a flat surface.

During their Analytic Cubist period—it was very brief—Picasso and Braque were determined to see how far Cézanne's researches could be taken. They were fascinated by the problem of representing three-dimensional objects in two dimensions, without betraying their three-dimensionality, yet at the same time without allowing the spectator to forget for a moment that the surface itself was flat. What they did was to discard conventional perspective—and therefore any pretense at illusion—and show what they were painting from multiple points of view. Cubist paintings have often loosely been described as "abstract", whereas in fact they are the very opposite. They strive for the uttermost concreteness, the most precise and refined description of form.

Though contemporary artists have continued to be interested in a notion which Cubism introduced—that painting is in fact a kind of language, which can be used to translate one

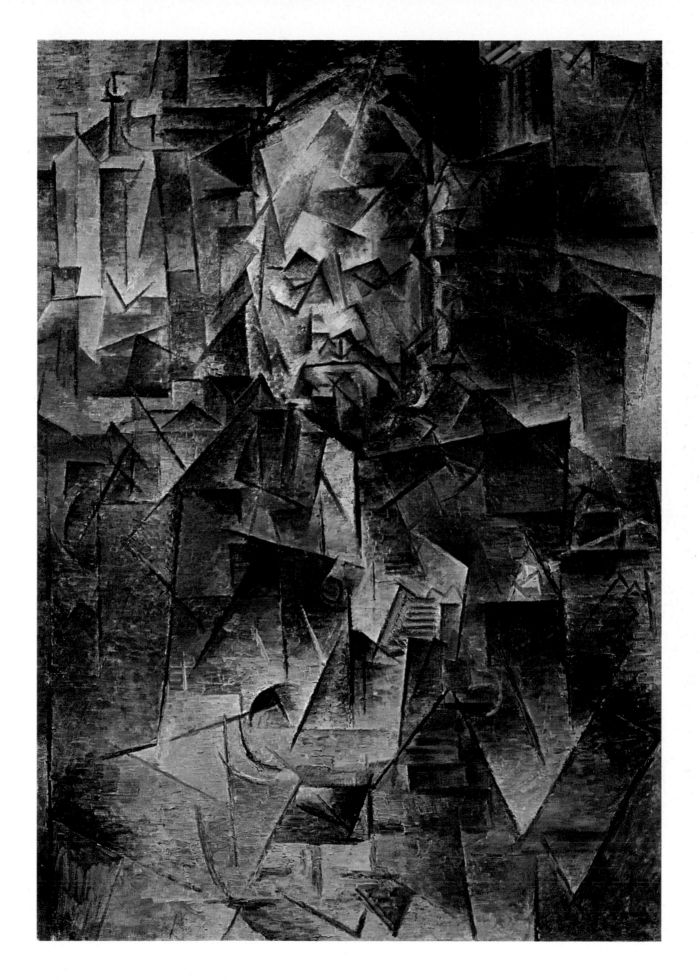

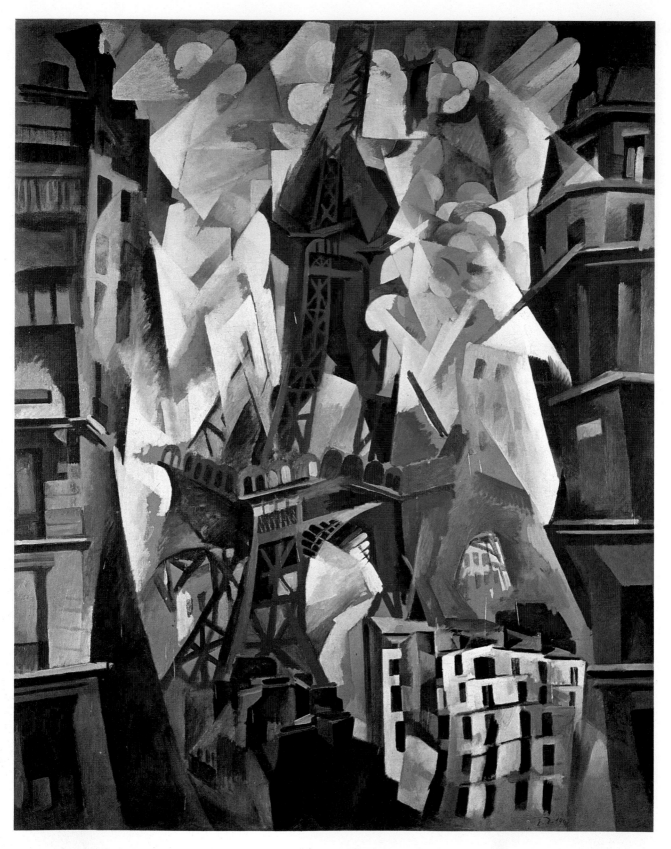

10.
Robert Delaunay
Champs de Mars, La Tour Rouge
1911; 162.6 × 130.9 cm. (63 × 51 in.)
Chicago, Art Institute of Chicago

11. Opposite
Gino Severini
Geroglifico dinamico del Bal Tabarin
1912; 161 × 156 cm. (63 × 61 in.)
New York, by courtesy of the Museum of Modern Art

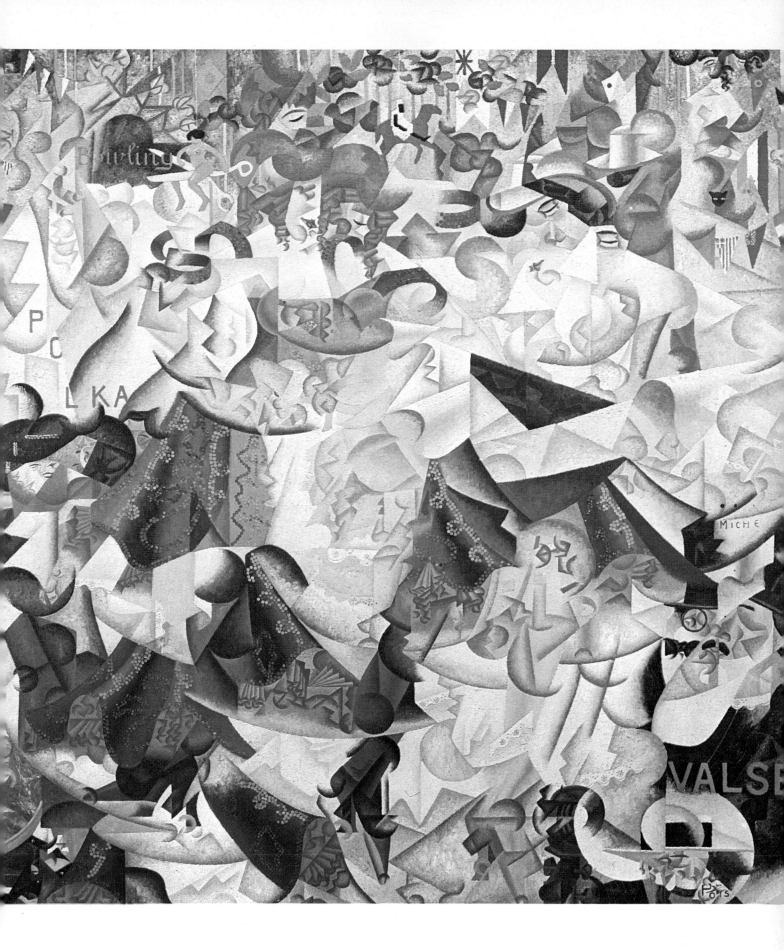

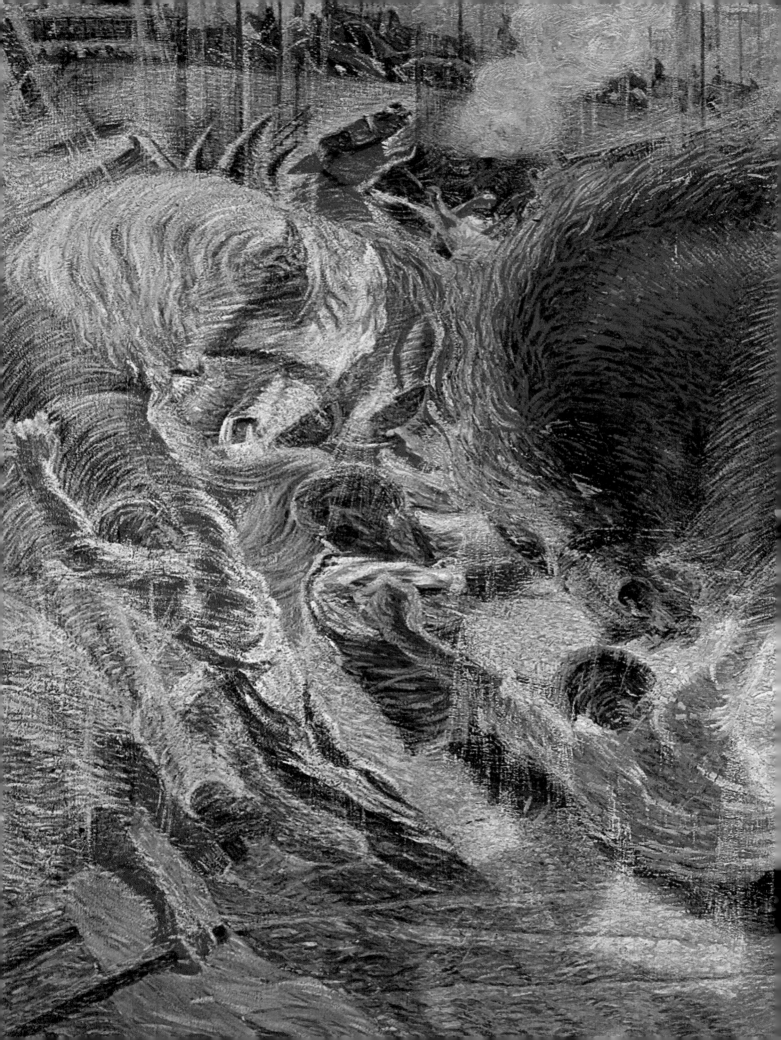

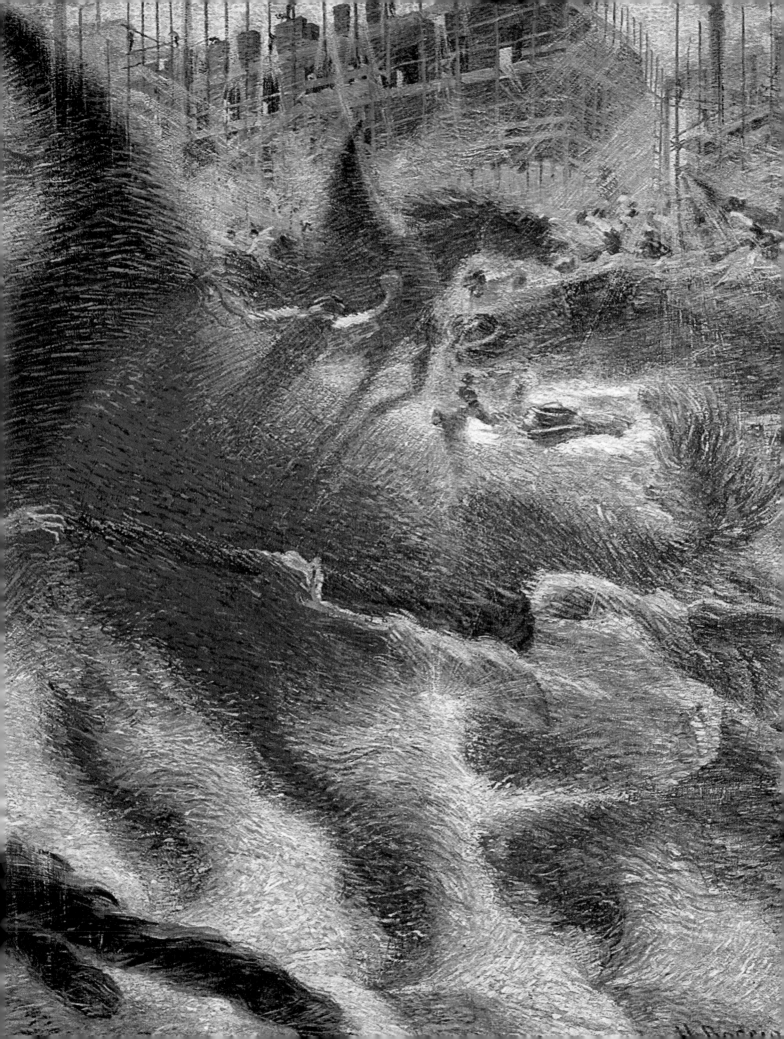

12. Overleaf
Umberto Boccioni
La città che sale (The City Rises)
1910; 199 × 302 cm. (78 × 118 in.)
New York, Museum of Modern Art

13. Opposite
Kasimir Malevich
Suprematist Compositions: Red Square and Black Square
1914 or 1915; 71 × 45 cm. (28 × 18 in.)
New York, Museum of Modern Art

reality into the very different terms of another—they have ceased to regard appearances themselves as paramount. Analytic Cubism can be thought of, paradoxically, as the last manifestation of the Naturalist spirit which affected so much of the art of the late nineteenth century, and even as the logical culmination of academic Salon painting.

After the traumatic shock of the First World War, painters and sculptors in France were half-inclined to abandon the experimental attitudes they had favoured a decade earlier. Cubism had already moved from a stringent analysis of what was seen to a laxer synthesis of decorative elements. The overlapping planes which had once been used to render the three-dimensionality of the object were now employed in a purely conventional way.

In the period between the two wars there was even an inclination, among those who had been associated with Cubism, to revert to the long-established French classical tradition—that of Nicolas Poussin in the seventeenth century and Jean-Auguste-Dominique Ingres in the nineteenth. The influence of Poussin, for example, is visible in Fernand Léger's monumental *Three Women* (Plate 7), painted in 1932. We see in this a tendency, which can also be found in Poussin, to turn details such as eyes, hands, and breasts into purely conventional symbols, with no element of first-hand observation. There seem to be two reasons for this. One is that Léger, as a kind of classicist, believed that a blandly generalized artistic language was likely to be more effective in conveying general ideas—about order and tranquillity, for example. But we also get the feeling that the artist (who was a Communist) was haunted by the suspicion that Modernism had already gone too far, and had put itself out of touch with the masses whom it was destined to serve. The difficulty in reconciling political and artistic radicalism is something that has bedeviled Modernism throughout its career.

Without attempting to deny the quality of the best Cubist work, it must nevertheless be said that the main line of development seems to run in another direction. Cubism did have an offshoot, in the form of the Orphism of Robert Delaunay,

which was enthusiastically supported by the poet and publicist Guillaume Apollinaire, but Delaunay failed to persist in his more radical explorations. He began with a derivation of Cubism which stressed the value of colour and movement (Plate 10), in place of the rather static composition favoured by Braque and Picasso at this point, and progressed from this to one of the earliest varieties of pure abstraction, with paintings showing areas of pure colour that seemed to interpenetrate and revolve around one another. In these, too, as in his figurative work, a sense of dynamic movement was paramount.

Delaunay's interest in rendering movement had already been anticipated by the work of the Italian Futurists. The importance of this group to the early history of Modernism is still somewhat underestimated, though the justice has to some extent been rectified by retrospective exhibitions in Turin and elsewhere. One of the peculiarities of Futurism was the fact that the leader of the movement was not himself a painter. F. T. Marinetti, who published the first Futurist Manifesto in a Paris newspaper in February, 1909, was an Italian poet long resident in France. His manifesto, however, dealt entirely with the Italian situation—it was a blast directed at the cultural apathy into which Italy had fallen and the deadweight of the past. Its most famous sentences run as follows: "We maintain that the splendours of the world have been enriched by a new beauty: the beauty of speed. A racing automobile is more beautiful than the *Victory of Samothrace*." The manifesto also declared that "Beauty exists only in struggle. A work that is not aggressive cannot be a masterpiece. Art must be conceived as a violent assault against the forces of the unknown, designed to subject them to man."

Futurism is of great interest to the student of Modernism for at least three reasons. The first is that it perfectly sums up the aggressive spirit that typified the international avant-garde in the years immediately preceding the First World War. Marinetti was a nationalist, a super-patriot, and he glorified the idea of armed conflict. He looked forward eagerly to war, as something which would let a great gust of fresh air into the musty

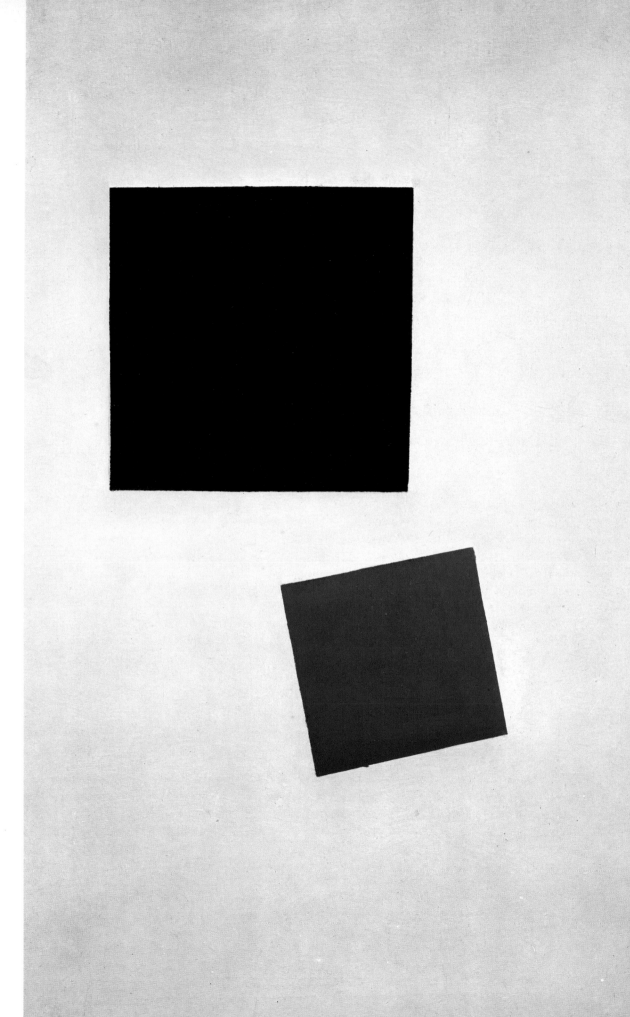

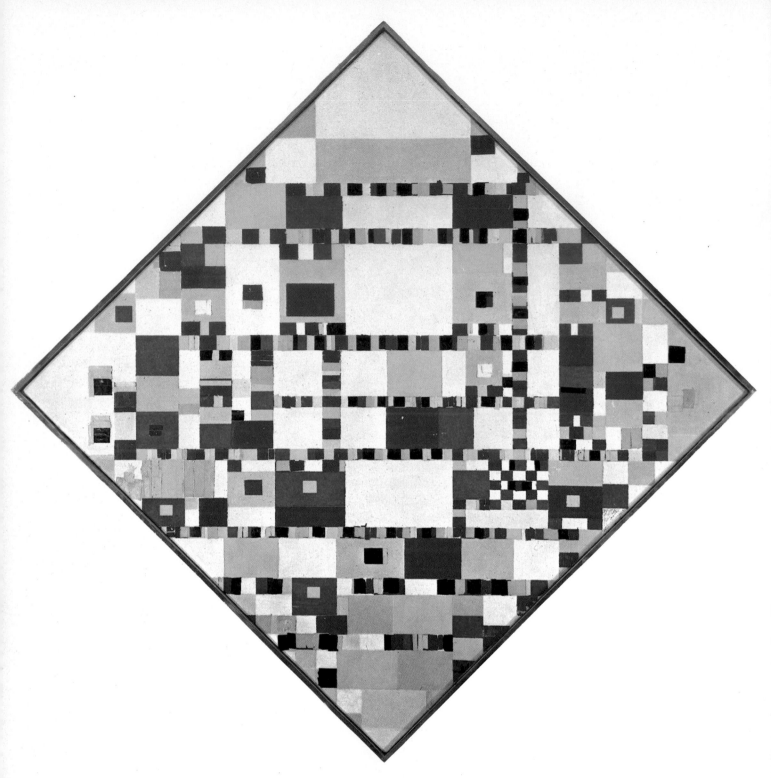

attics of the past. This love of violence was shared by poets and artists elsewhere. We find it loudly expressed by the English Vorticists and by some of the Russian Futurists. The more extreme members of the avant-garde were at this moment only too eager to bring the whole social structure of Europe down upon their own heads. Marinetti himself, however, was not a man of the left but of the radical right. After a brief period during which he treated Mussolini as a political rival rather than

as an ally, he ended his life as a faithful Fascist.

The second important aspect of Futurism is that it was the earliest of the organized, self-conscious avant-garde movements, eager to invent and publicize an identity, rather than leave this task to the critics. Publicity, indeed, was Marinetti's strong suit. He held Futurist demonstrations throughout Italy; and, from 1912 onwards, throughout Europe. The success of these gatherings was measured in the manuals of the

14. Opposite
Piet Mondrian
Victory Boogie-Woogie
1943–44; 127 × 127 cm. (50 × 50 in.)
Connecticut, coll. Mr. and Mrs. Burton Tremaine

15.
Piet Mondrian
Broadway Boogie-Woogie
1942–43; 127 × 127 cm. (50 × 50 in.)
New York, Museum of Modern Art

organizers, by the riots they provoked.

But Futurism is also interesting for a third reason; the talent of the artists whom Marinetti succeeded in attracting to his banner, and the direction their work took under his influence. The most prominent of the Futurists—Giacomo Balla, Umberto Boccioni, Gino Severini (all of them signatories of the Technical Manifesto of Futurist Painting, which was issued in 1910)—plunged themselves into the task of representing and

29

16. Below
László Moholy-Nagy
Composition A-XX
1924; 135 × 115 cm. (53 × 45 in.)
Paris, Musée National d'Art Moderne

17. Right
Wassily Kandinsky
Panel (3)
1914; 162 × 94 cm. (63 × 37 in.)
New York, Museum of Modern Art

18. Opposite
Wassily Kandinsky
Panel (4)
1914; 162 × 80 cm. (63 × 31 in.)
New York, Museum of Modern Art

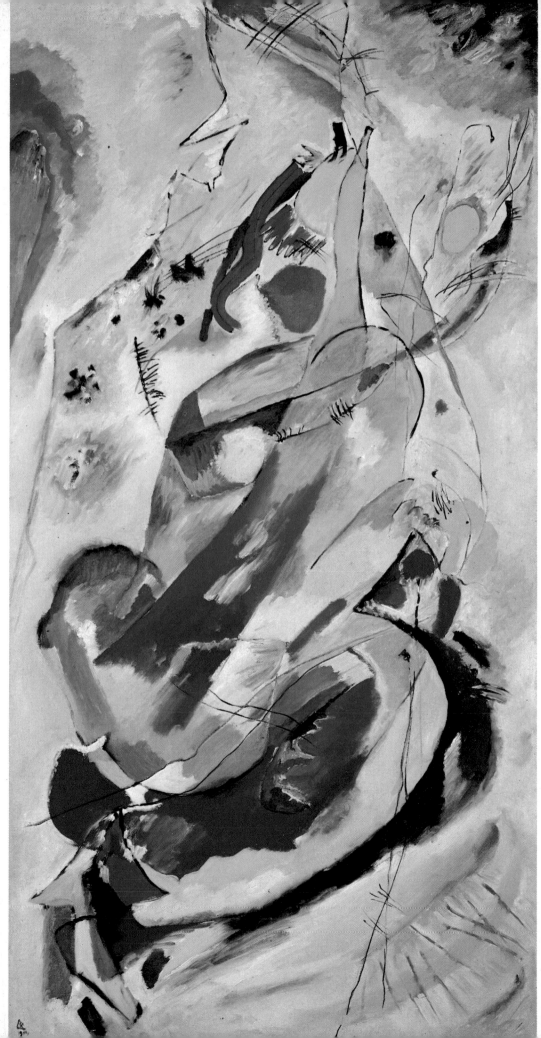

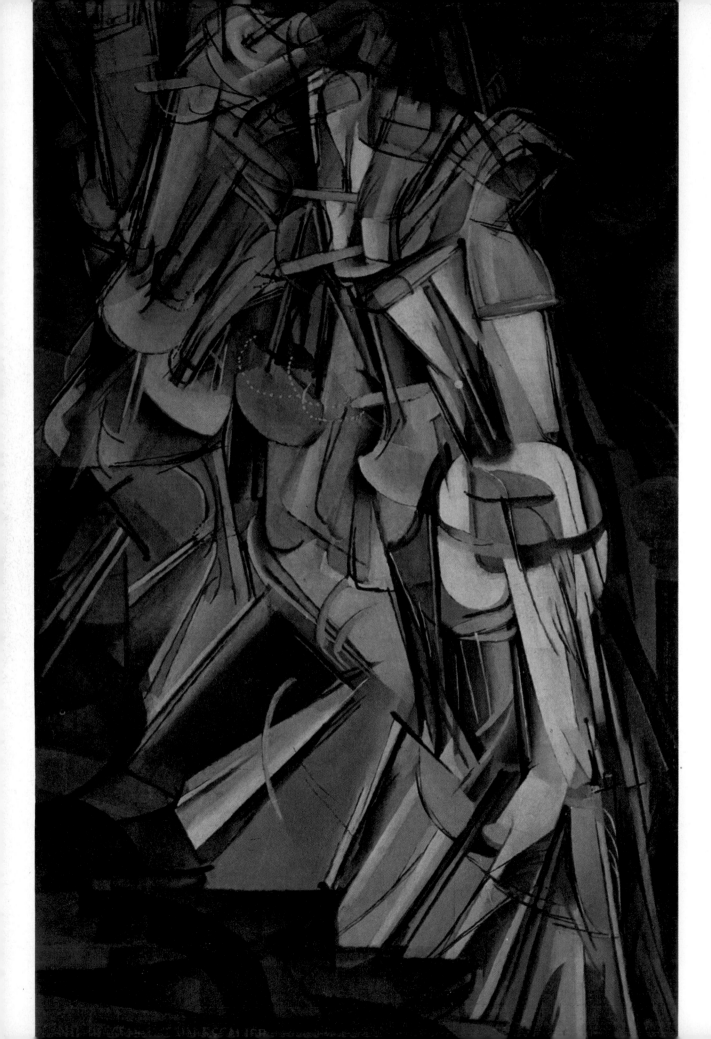

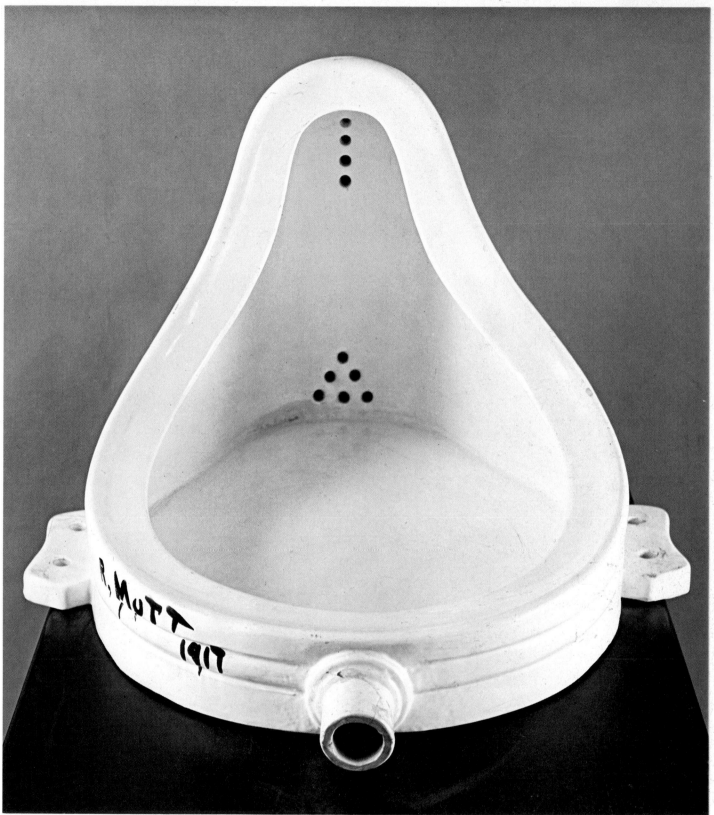

19. Opposite
Marcel Duchamp
Nu descendant un escalier No. 2 (Nude Descending a Staircase No. 2)
1912; 147 × 89 cm. (57 × 35 in.)
Philadelphia, Philadelphia Museum of Art

20.
Marcel Duchamp
Fountain
1964 (replica of 1917 original); 63 × 46 × 36 cm. (25 × 18 × 14 in.)
Milan, Galleria Schwarz

21. Below left
Marcel Duchamp
Roue de bicyclette
1964 (replica of 1913 original); 126 cm. (49 in.)
Milan, Galleria Schwarz

22. Below right
Marcel Duchamp
Porte-bouteille
1964 (replica of 1914 original); 66 cm. (26 in.)
Milan, Galleria Schwarz

reflecting modern life, which they saw as being characterized by frantic speed and dynamism. Boccioni's *The City Rises*, 1910 (Plate 12), is in these respects typical of their work. Interest in movement led the Futurist painters to consider the problem of simultaneity: several phases of movement were represented on the same canvas, in a manner which was probably suggested by the experiments with chronophotography made some decades earlier by E. J. Marey. The Cubist concern to represent a given object in successively unfolding views was taken a stage further, since a temporal element was now introduced. For the first time since the birth of perspective Western art comprehended the ideas of a temporal lapse within the boundaries of the canvas, and the artist no

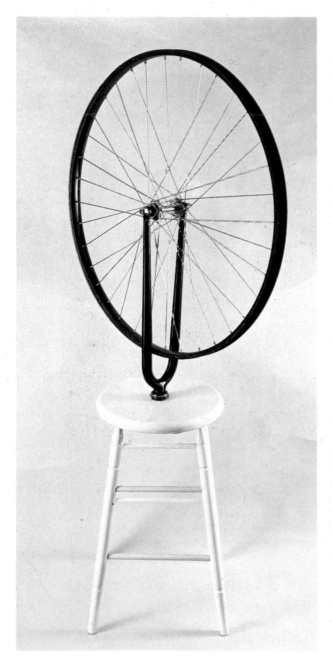

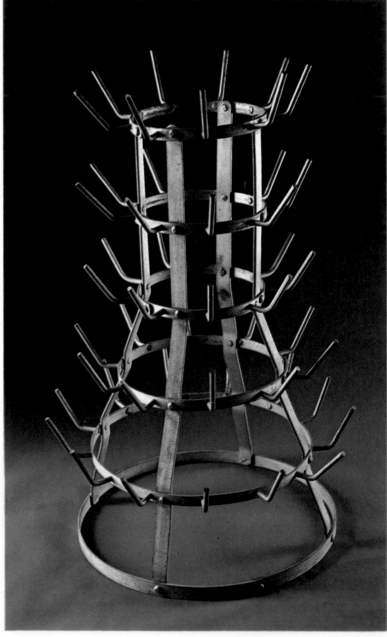

23.
Giorgio de Chirico
L'incertezza del poeta
1913; 106 × 94 cm. (41 × 37 in.)
London, coll. Sir Roland Penrose

longer confined himself to the representation of a single, frozen moment. This was to be full of consequences for the future.

The avant-garde movement elsewhere which most closely resembled Italian Futurism and which was most closely allied to it in ideas and methods was the Futurism that soon afterwards appeared in Russia, basing itself chiefly in Moscow. The Russian avant-garde differed from its Italian equivalent in being far more eclectic, and

in undergoing a more complex development. The leading Russian artists, for example, often went through a phase of neo-primitivism which related their work to that of the Fauves. This development is visible in the work of Kasimir Malevich as well as in that of Mikhail Larionov and Natalia Goncharova. They also felt the attraction of Cubism. One of the most striking things about Russian Futurism, however, was the early appearance of pure abstraction, and the extreme lengths to which it was taken. Malevich's *Suprematist Compositions* (Plate 13), painted early in the war, were at least as extreme as anything produced by any member of the avant-garde during the next thirty years.

Many of the problems that have continued to preoccupy modern artists were first formulated in Russia during the years just before and just after the Revolution of 1917. In the immediately post-Revolutionary period, the Russian avant-garde, led by Malevich's great rival Vladimir Tatlin, moved towards a total abolition of art under the banner of a new movement, Constructivism. They insisted that the artist must become a technician in a technological society, using the tools and materials of modern production for the benefit of all. "Our Constructivism," declared Alexei Gan, in an important text written in 1920, "has declared unconditional war on art, for the means and qualities of art are not able to systematize the feelings of a revolutionary environment."

Constructivism was one of the direct ancestors of the hard-edge geometric abstraction which is still practised by many contemporary artists. But the roots of this are also to be found in Holland and in Germany. In Holland, Constructivism had its counterpart in the group which dubbed itself De Stijl, founded at the height of the war in 1917. The greatest artist connected with this group was Piet Mondrian. After Symbolist beginnings, Mondrian was influenced by Analytical Cubism during a stay in Paris from 1910–14. Cut off in Holland by the outbreak of hostilities, he started to evolve a purely geometrical style, stripped of all references to the figure or to landscape. At last he reached the point where the formal elements in his paintings had been simplified to the uttermost.

Narrow black bands divided the surface into compartments of black, white, grey, and the three primary colours. Towards the end of his life, exiled in America, Mondrian was to demonstrate that this minimal style had an unexpected capacity for development in the work which he produced in the United States. The late masterpiece *Broadway Boogie-Woogie* (Plate 15) anticipates some of the inventions of post-war kinetic art.

The artists associated with the Bauhaus, founded in Weimar in 1919, had close connections with those who belonged to the De Stijl group in Holland. Their aim, like that of the Constructivists, was to produce a rational art, in harmony with the modern technological environment. And like the Constructivists, they increasingly came to think of the fine arts as little more than experimental forms of industrial design. This tendency is clearly discernible in the work produced in the early Twenties by one of the most typical of the Bauhaus masters, László Moholy-Nagy (Plate 16).

Even in the Bauhaus, however, not all abstract art tended towards functionalism. This is particularly true of the work of Wassily Kandinsky, who was at one period closely associated with the school. Kandinsky is a key figure because he, if

24. Opposite
Max Ernst
Deux enfants sont menacé par un rossignol (Two Children Are Menaced by a Nightingale)
1924; 46 × 33 cm. (18 × 13 in.)
New York, Museum of Modern Art

25. Overleaf left
Kurt Schwitters
Merzbild 25 A. Das Sternenbild
1920; 104 × 79 cm. (41 × 31 in.)
Düsseldorf, Kunstsammlung Nordrhein-Westfalen

26. Overleaf right
Kurt Schwitters
Bild mit Heller Mitte
1919; 84 × 65.7 cm. (33 × 26 in.)
New York, Museum of Modern Art

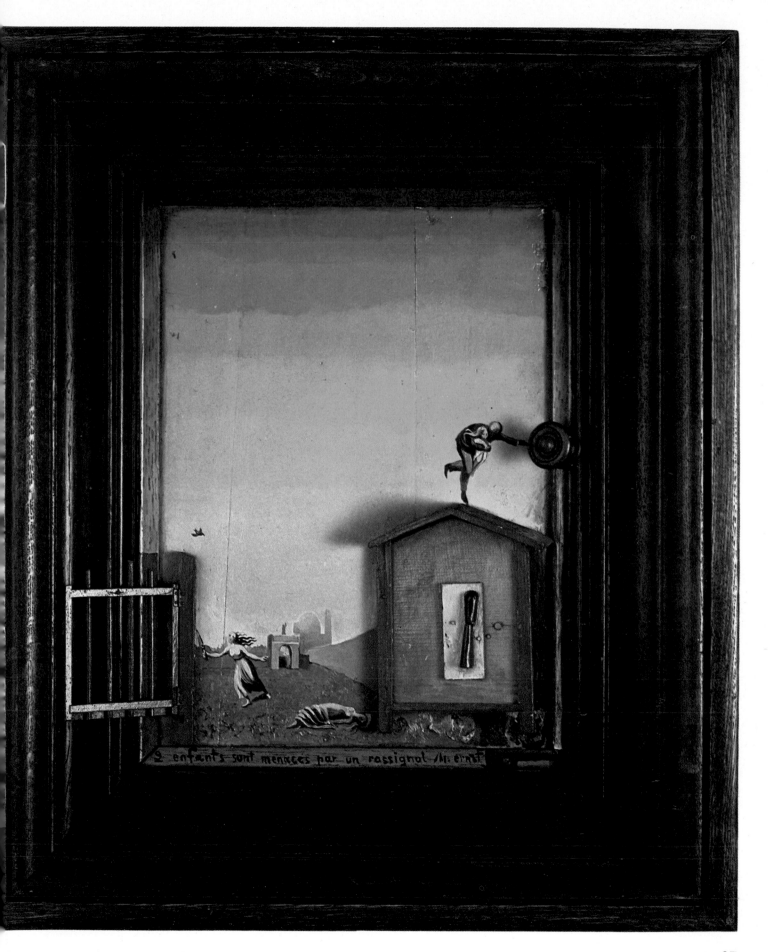

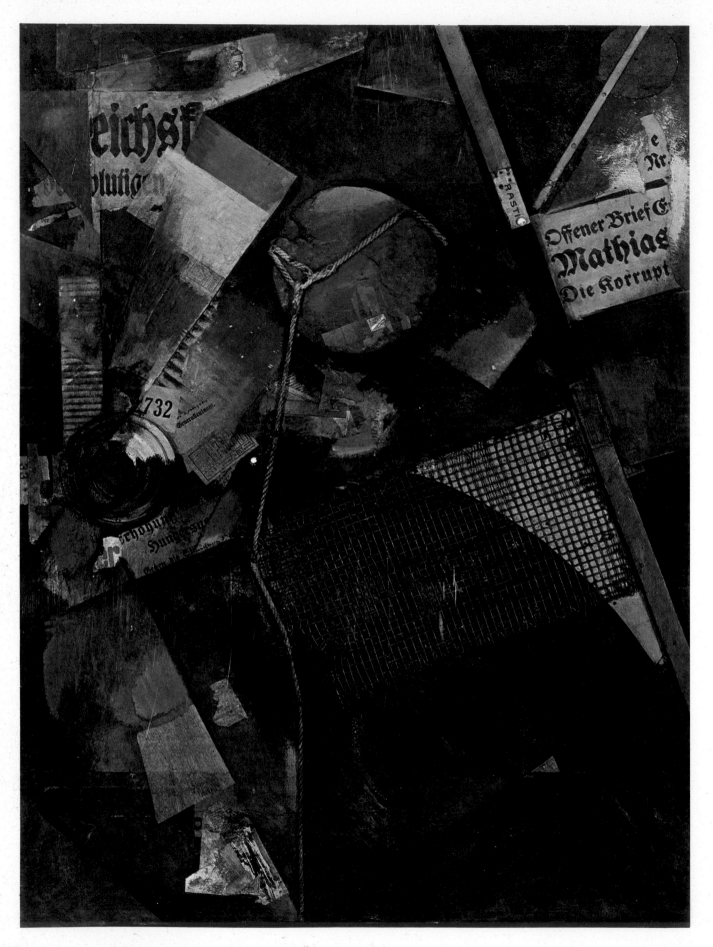

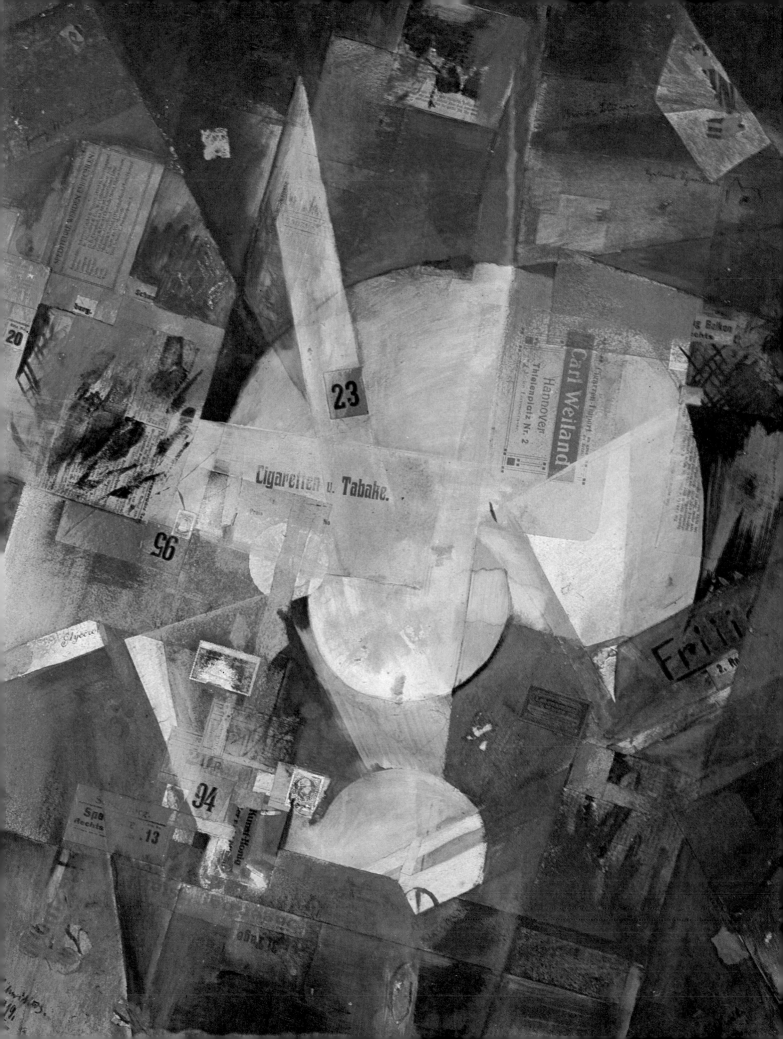

anyone, has the best claim to be regarded as the inventor of a purely abstract art. Yet for him abstraction had a very different significance from what some of his colleagues intended. For them it was a means of demystifying art, making it mundane; for Kandinsky, on the contrary, it was a way of heightening its spiritual and mystical content. Painting, for him, was as much a matter of explaining his own identity as it was for Soutine.

Kandinsky was born in Moscow in 1866, but did not take up painting until he was thirty. He moved from Russia to Germany, studying in Munich under the leading Symbolist Franz von Stuck, and soon making a name for himself as a leader of the avant-garde. To the influence of the German Jugendstil upon his own work, he added that of Fauvism. He also studied the colour theories of the French Pont-Aven group. His studies led him to the conclusion that the only law for the artist must be his own "inner necessity": "The harmony of colours and forms can be based on only one thing: a purposive contact with the human soul." Gradually Kandinsky began to loosen his own ties with the images he saw around him in nature, and in 1910 he painted his first wholly abstract picture. These early improvisations (Plate 18) are joyous outbursts of mystical feeling. They find their justification not in any duty the artist may feel he owes to society, but in his duty to himself, his need to make visible the inner core of his own being.

Even before Kandinsky joined the staff of the Bauhaus—an event which took place in 1922—his style had become more disciplined and less lyrical under the impact of Constructivism. But he could never submit to a purely utilitarian aesthetic. The little book he published in 1912, *Concerning the Spiritual in Art*, was to be a textbook for artists of a later generation, particularly in the United States.

The radicalism of the first Modernist generation did not express itself through abstract art alone. The First World War brought with it a revulsion against what the artists now saw as the meaningless and terrifying violence of their time—even though this violence was something which they, or at any rate their colleagues, had been anxious to instigate. The optimistic energy of Futurism was

succeeded by the frivolous or despairing nihilism of the various Dada movements which sprang up during the war. The most active Dadaist centres were Zurich and New York, both of them places on the fringe of the conflict. Those who participated in this new outburst of activity were poets as well as painters, and were wide-ranging in nationality—Dada was even more cosmopolitan than the various art movements that had preceded it. In essence, the most destructive aspect of Dada was the way in which it questioned the nature of art itself.

The most intellectual of the Dadaists, and the one whose importance seems greatest today, was Marcel Duchamp. Duchamp came from a family of artists. His elder brothers were the painter Jacques Villon and the sculptor Raymond Duchamp-Villon. In 1913 his painting *Nude Descending a Staircase* was the sensation of the already sensational Armory Show in New York. One newspaper described this rather derivative Cubo-Futurist work as "an explosion in a shingle factory", and, with the phrase, the painter's reputation was made.

But Duchamp never seems to have had a high opinion of his own talents as an artist. Instead, he set out to be the smiling philosopher of Modernism. The most devastating of his inventions was the "ready-made". In one sense, the ready-made is best described by reference to the inventor himself. "Duchamp's attitude," said an old friend in later years, "is that life is a melancholy joke, not worth the trouble of investigating. To his superior intelligence the total absurdity of life, the contingent nature of a world denuded of all values, are logical consequences of Descartes' *Cogito ergo sum*."

By asserting that any object could be turned into a work of art merely by labelling it as such, Duchamp gave free rein to a vein of distinctive irony. How amusing, for example, to submit a porcelain urinal (Plate 20) to an avant-garde art exhibition, under the signature "R. Mutt", and then wait for his fellow jurors to betray their own libertarian principles!

Yet the ready-mades do pose a very important question: How do we recognize a work of art *as a*

40

27.
Salvador Dali
Presage of Civil War; Construction with Boiled Beans
1936; 100 × 100 cm. (39 × 39 in.)
Philadelphia, Philadelphia Museum of Art

28. Overleaf
Salvador Dali
Persistence of Memory
1931; 24 × 33 cm. (9 × 13 in.)
New York, Museum of Modern Art

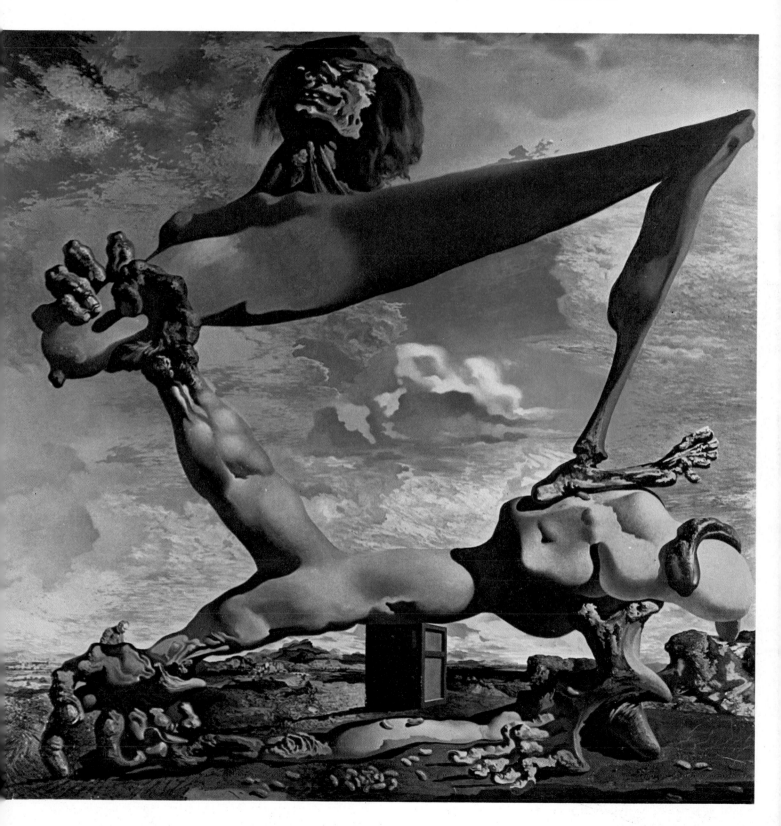

41

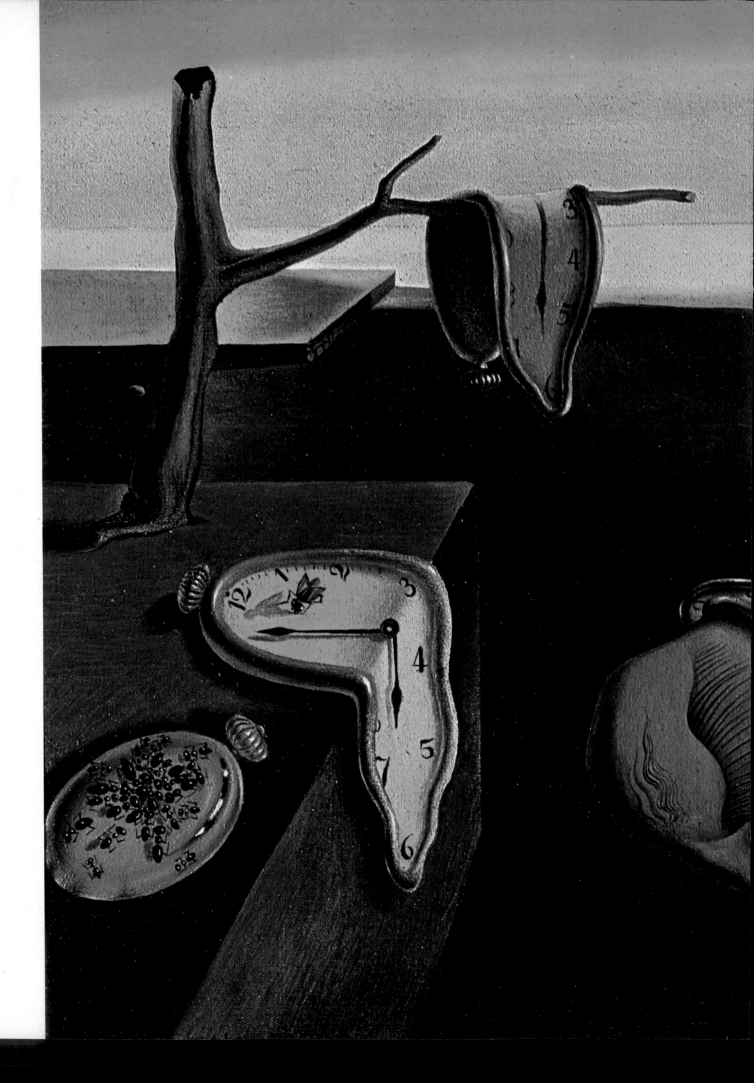

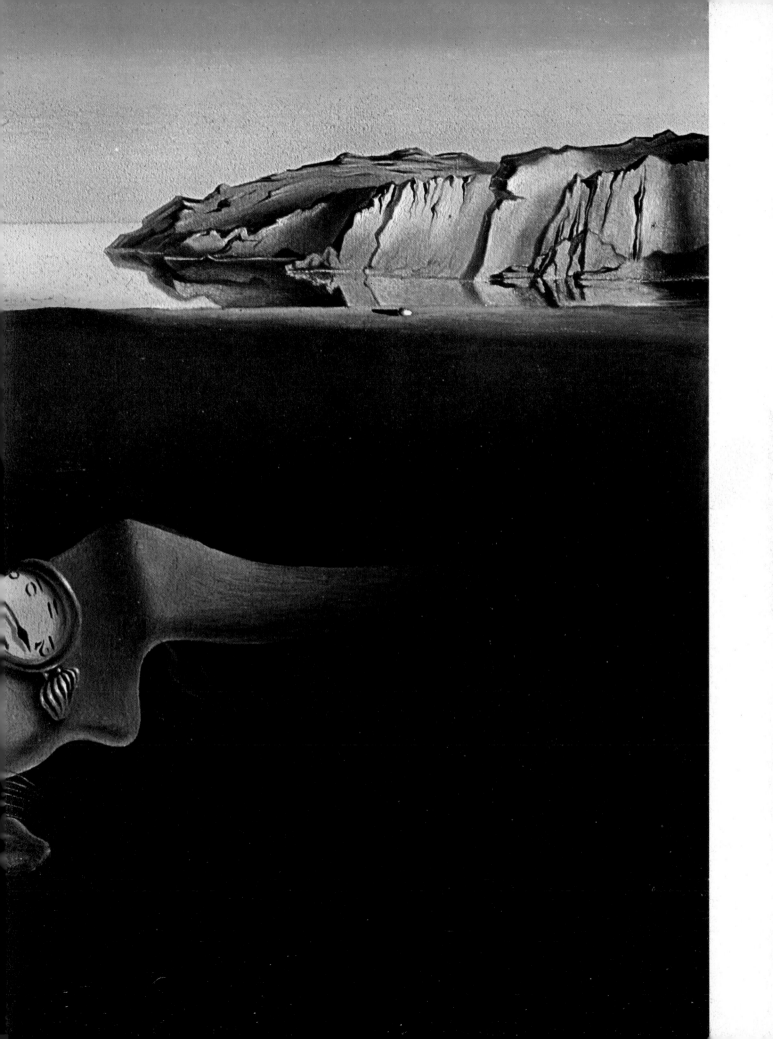

work of art? Duchamp offers a disconcerting answer: only because we are already prepared in advance to do so, to accept that the thing presented to us belongs to a special category. He was insistent that his choice of ready-mades "was never dictated by aesthetic delectation. The choice was based on a reaction of *visual indifference* with a total absence of good or bad taste . . . in fact a complete anesthesia." What Duchamp did was to cut the ground from under traditionally established criteria of aesthetic judgment. It has never been possible to stabilize the situation since.

Dada was too nihilistic to survive for long. Elsewhere there were already signs of the direction art might take. One of the most important of these signposts was supplied by Pittura Metafisica, which began as the personal expression of the young Italian painter Giorgio de Chirico around 1911 or 1912, and, during the war years, burgeoned into an art movement when De Chirico won the allegiance of the Futurist Carlo Carrà. De Chirico and Carrà wanted to revive the serenity of classic Italian painting—one of the qualities the Futurists had sought to destroy. At the same time they were aware of a profound change in consciousness. "We use painting," De Chirico said, "to create a new metaphysical psychology of things" (Plate 23). The visual world invented by the metaphysical painters often had an anguished, nightmarish quality underlying its apparent serenity, because it revealed, whether the artist desired it or not, hidden aspects of his own nature.

It was left to the post-war Surrealist movement to codify this discovery and to erect it into a principle. Surrealism was fascinated by the discoveries of Freud, and wanted to use art as a means of revealing the hidden world of the unconscious.

Max Ernst, who had formed a Dada group in Cologne in 1919, moved to Paris in 1922 and became perhaps the first recognizably Surrealist painter. *Two Children Are Menaced by a Nightingale* (Plate 24) is one of the best-known of his early Surrealist works. Technically it harks back to Analytic Cubism through the employment of collage, and one can also make a comparison to the

work of another German Dadaist, Kurt Schwitters (Plates 25 and 26). But Ernst's aim is different from either of these. Cubism seeks to stress the dichotomy between painted reality and "real" reality, by the sudden intrusion of the latter into the former. Schwitters tried to redeem what has been discarded as rubbish—old bus tickets and scraps of wrapping paper—by organizing it as art. What Ernst wanted to do was to bring us face to face with a universe full of fruitful but unexpected combinations. The objects he employed were chosen for their value as images.

Since Surrealism lays such stress on spontaneity and the intuitions of the subconscious, it is perhaps surprising to find that some of its best-known exponents are academic in technique—to the point where they seem to reject many of the discoveries of an earlier epoch. But artists such as Salvador Dali and René Magritte are so intent on showing us their vision as clearly as possible that they choose the mode of presentation they hope we will find most accessible (Plates 27, 28, and 29). It is one reason why an artist such as Magritte managed to remain stylistically static almost throughout his career. Paint was never an end in itself but merely a convenient method of communication.

A number of leading Surrealists thought this was a sacrifice of qualities that painting still ought to possess. One of these was Joan Miró, whose *Dutch Interior* of 1928 (Plate 30) shows a treatment of spatial problems which owes much to Cubism. In this painting we see the beginning of a style which Miró was to develop much further—a way of painting which is more like writing, where emblematic forms are deployed on the canvas as if they were a series of hieroglyphs. As we shall see in the next chapter this development was pregnant with consequences for art after 1945.

But what is worth considering at this juncture is not the development of individual Surrealists, however eminent, but the nature of the Surrealist movement itself. Its history, which embraces poetry and politics as well as the visual arts, is well documented, even if the interpretation of the facts is often a matter of controversy. The Surrealist movement was officially founded in 1924, with the

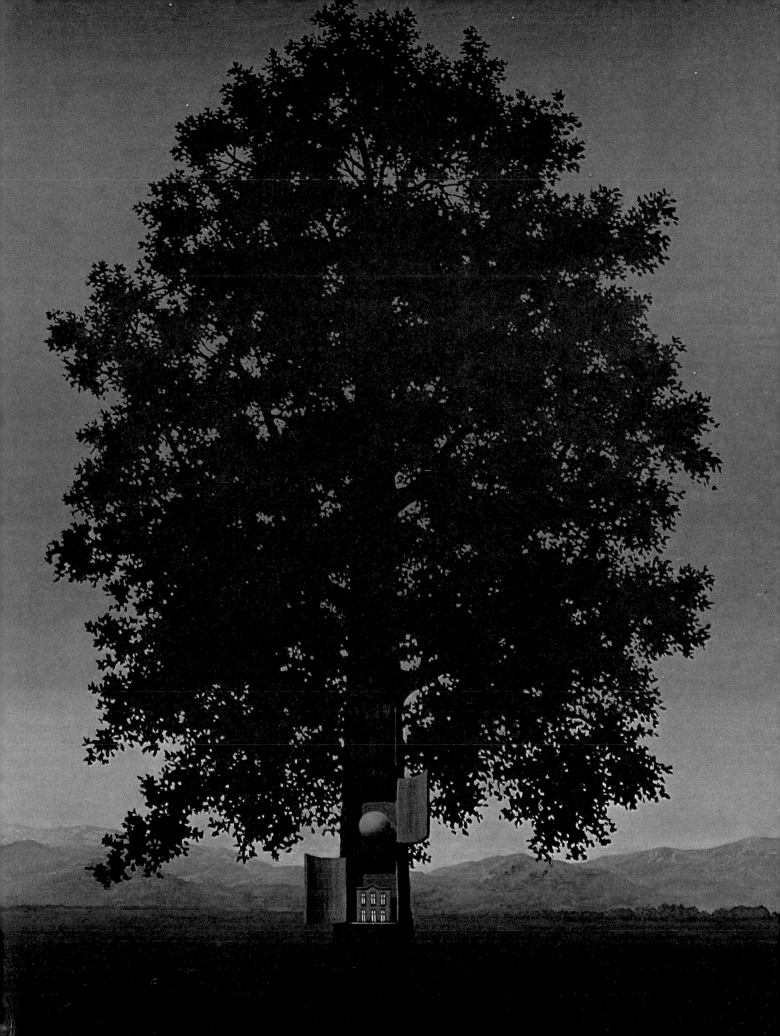

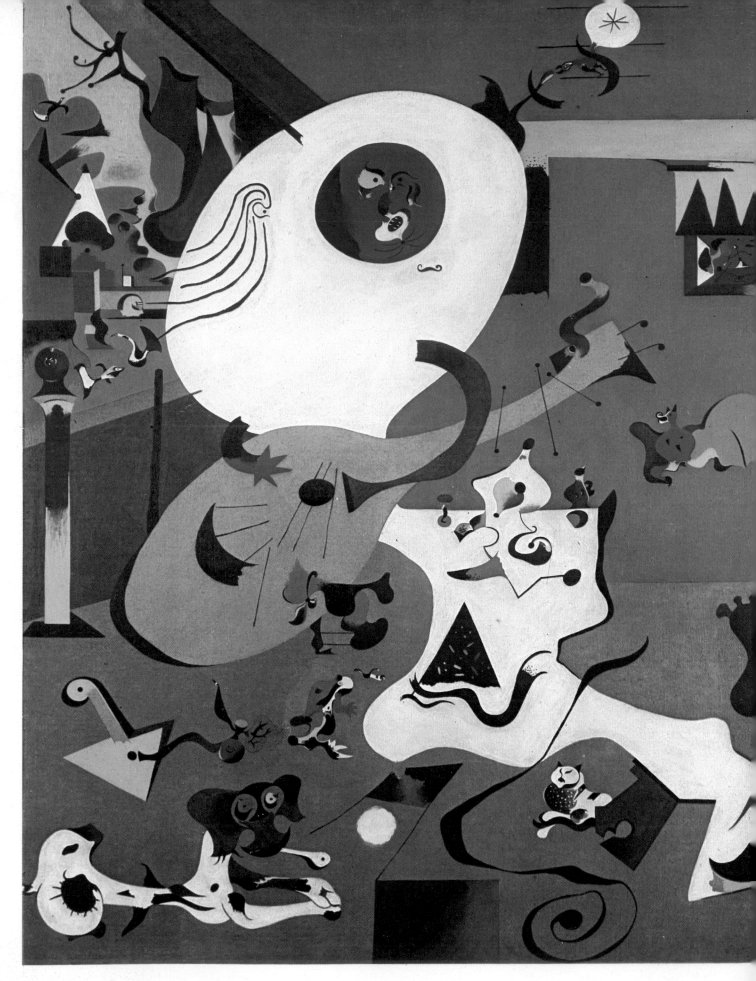

30.
Joan Miró
Dutch interior
1928; 91.8 × 73 cm. (36 × 28 in.)
New York, by kind permission of the
Museum of Modern Art

publication of the First Surrealist Manifesto, a document of comparable importance to the Futurist Manifesto of 1909. In it the word *surrealism* is defined thus: "Pure psychic automatism, by which an attempt is made to express, either verbally, in writing, or in any other manner, the true functioning of thought. The dictation of thought, in the absence of all control by the reason, excluding any aesthetic or moral pre-occupation." But soon enough this definition was to be stretched, and some might think distorted, by the effort to bring the movement into line with political events, and more especially with what was happening in Russia. When the poet Louis Aragon broke with his fellow Surrealists in 1930, to go over wholly to the cause of communism, this marked a turning point in the history of the movement as a whole. André Breton, the acknowledged "pope" of the Surrealists, continued to try to find a brand of left-wing politics in accord with his own aesthetic and philosophical principles, but never quite succeeded in doing so. Meanwhile, the Surrealists remained dependent, as the Fauves and Cubists had before them, on the financial support of a rich and fashionable elite.

In their different ways, Surrealism and Constructivism provide the first instances of the apparent incompatibility between radical art and radical politics, which was to continue to haunt committed Modernists in the period after 1945. In this connection, it is worth recalling what the Spanish philosopher Ortega y Gasset had to say on the subject fifty years ago—that is to say, at a moment when the evidence available to him was mainly that supplied by Cubism and its derivatives. "In my opinion," he remarked, in his famous essay "The Dehumanization of Art," "the characteristic of contemporary art 'from the sociological point of view' is that it divides the public into these two classes of men: those who understand it and those who do not. . . . Modern art, evidently, is not for everybody, as was Romantic art, but from the outset is aimed at a special, gifted minority. . . . Accustomed to dominate in everything, the masses feel that their 'rights' are threatened by modern art, which is an art of privilege, of an aristocracy of instinct." Increasingly, this is an unpopular, even a heretical, point of view. It is also one we shall have reason to consider carefully as this study proceeds.

Abstract Expressionism

In the repertoire of art styles after the Second World War, Abstract Expressionism enjoys a unique eminence. It is not only that it was the first in a long procession of stylistic experiments, but it also seems to mark a definite watershed, a handing over of power. Just as the United States emerged from the conflict as the most powerful nation on earth, so, too, the emergence of Abstract Expressionism seemed to mark the coming of age of American art, and the replacement of Paris by New York as the centre of the artistic universe.

Though this view does contain an element of truth, it must be qualified. Abstract Expressionism, though it was later to become a vehicle for the chauvinism of certain American critics, was in essence a reaction against narrowly nationalist sentiment. During the Great Depression of the Thirties, American art had been in an introverted phase. This introversion took different forms. There was the political conservatism of the regionalists, led by Thomas Hart Benton. Their work showed a nostalgic concern with rural America and the American past. In contrast to this there was the Marxism of many of the artists who participated in the Federal Art Project, beneath the umbrella of the Work Projects Administration set up to alleviate some of the worst miseries of the slump. The Federal Art Project produced little that was memorable, but did alter the relationship between artists and society by giving people a new consciousness of contemporary art. In addition, it fostered an esprit de corps among the artists themselves.

The regionalists were of course figurative, and so were most of the artists connected with WPA enterprises. Nevertheless, the authorities responsible for the scheme made no formal distinction between abstract and representational art, and this essentially democratic decision was full of consequences for the future.

Abstract art did survive during the American Thirties, though it had a hard time. In 1936 the Museum of Modern Art in New York organized an influential exhibition entitled "Cubism and Abstract Art", and in the same year the younger abstract artists banded themselves together in an association known simply as American Abstract Artists. Unlike most of their fellows, these painters did have a vision of modern art as an international community, but their own work remained derivative and dependent upon foreign, principally French, exemplars. A number of the members of AAA also belonged to the French critic Michel Seuphor's Abstraction-Creation group. The style that nearly all of these American painters favoured was strictly geometric. It derived ultimately from De Stijl and from Constructivism.

Even during the Thirties the American art scene began to be leavened by the arrival of talented refugees, among them Josef Albers, who had taught at the Bauhaus, and Hans Hofmann, who had taught in Munich from 1915 until 1932, the year he settled in the United States. Hofmann opened a new school, the Eighth Street School, in New York in 1934, and this became one of the principal channels whereby young Americans were introduced to advanced European concepts.

The decisive event, however, was the outbreak of war. This brought almost the entire Surrealist movement to New York, in flight from the conflict. Matta arrived as early as 1939. In the early Forties he was followed by Ernst, Dali, and André Masson among the painters, and also by André Breton, the "pope" of the movement. Breton still formed a focal point around whom most of the others revolved. Peggy Guggenheim, at that time married to Max Ernst, provided a home for the activities of the group by opening a gallery, Art of This Century, in 1942. This was to exhibit the

31.
André Masson
Sketch for the ceiling of the national theatre of the Odéon
1965; 220 × 200 cm. (86 × 78 in.)
Paris, Centre National d'Art Contemporain

32. Opposite
André Masson
Le Peintre et le temps
1938; 116 × 73 cm. (45 × 28 in.)
Milan, Galleria Schwarz

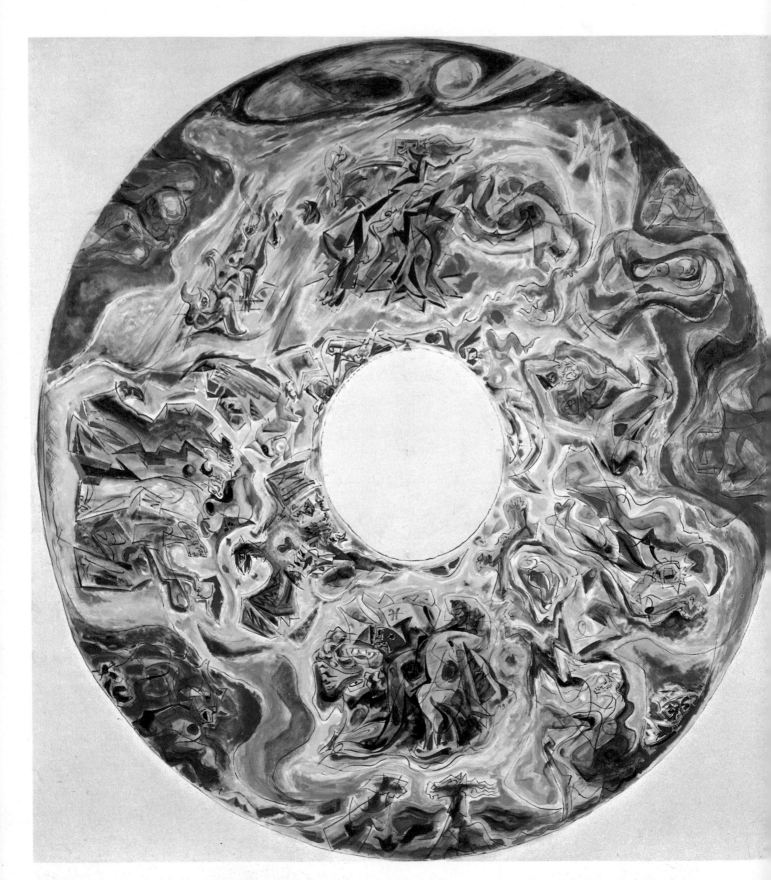

work of young American painters as well as that of the Surrealist exiles.

Contacts, however, were at first not easy. The Surrealists remained fiercely cliquish, and ill at ease with their surroundings. A number of them, notably Breton, refused even to learn English. One of the few American painters to build up a relationship with them was the Armenian immigrant Arshile Gorky, and it is Gorky's painting which forms the bridge between European Surrealism and what a new generation of Americans was to make of it, following the original Surrealist principle of transformation.

Before taking Gorky's work into consideration, it is necessary to say a word about the art of Masson and Matta, two Surrealists whose work differs in important respects from that of painters such as Dali and Magritte, whom I have already considered. Masson, born in 1896, had been an early adherent of the Surrealist movement, which he joined in 1924, at the time of his first exhibition. He was never happy with Breton's authoritarian rule, and by 1933 had broken with the group. His complaint, both then and later, was that official Surrealist doctrine paid too little attention to the painter's special needs: "The Surrealist Movement

34.
Matta (Roberto Matta Echaurren)
However
1947; 218 × 365 cm. (85 × 142 in.)
Amsterdam, Stedelijk Museum

is essentially a literary movement. . . . In literature the surrealists are as insistent on the exact word as Boileau; but when it comes to painting they are very liberal in matters of structure. The spiritual directors of surrealist painting are not of the profession" (André Masson, "Eleven Europeans in America," *Museum of Modern Art Bulletin,* Vol. XIII, Nos. 4–5 [1946], p. 4).

As can be seen from the typical example reproduced here (Plate 32), Masson's work is not veristic, in the manner of Dali and Magritte, but calligraphic. One critic has described his most typical compositions as "delirious germinations complicated to the point of becoming nothing more than labyrinthine tangles of vegetable, organic, or mental circuits." One is reminded, too, of the general comment made by the Greek-American writer Nicolas Calas: "In surrealist art, the artist *viewed as dreamer* becomes the subject of art."

One thing which is conspicuous in Masson's work is its close relationship to the Surrealist doctrine of automatism. For Surrealist writers, the technique called "automatic writing" had long been one of the principal means whereby the artist put himself in touch with his own unconscious.

Sitting before a piece of blank paper, a pen or pencil in his hand, the writer allowed his thoughts and associations to flow without impediment onto the paper. Similarly, Masson, despite his distrust of literature, allowed his calligraphic brushstrokes to conjure up the presence of images that were unknown to, or at least unsuspected by, their creator until the very moment of their appearance.

Matta was a much younger man than Masson, a Chilean who did not come into contact with the Surrealist group in America until the middle Thirties. Extremely intelligent as well as extremely ambitious, he was quick to realize that he must try to extend the scope of accepted Surrealist techniques if he was to make a worthwhile personal contribution to Modernism. As Calas

somewhat portentously put it, Matta "replaced the repressed microcosm with the unobtainable macrocosm". What he meant by that was that Matta's paintings often seem to suggest a parallel universe, of the kind we find in popular science fiction (Plate 33). Yet the imagery of Matta's paintings has an elusiveness which suggests, correctly, that much of it has been generated by the use of automatic gestures. What the artist did was to spread transparent washes of colour on the canvas, usually with a rag; he then developed forms from these beginnings which became more particularized and more illustrative as the work proceeded.

In this respect Matta's work forms a striking contrast to that of Arshile Gorky, whom Breton

35.
Matta (Roberto Matta Echaurren)
Watchman What of the Night
1968; 300 × 1000 cm. (117 × 390 in.)
Archives Alexandre Iolas, New York, Paris, Geneva,
Milan, Rome

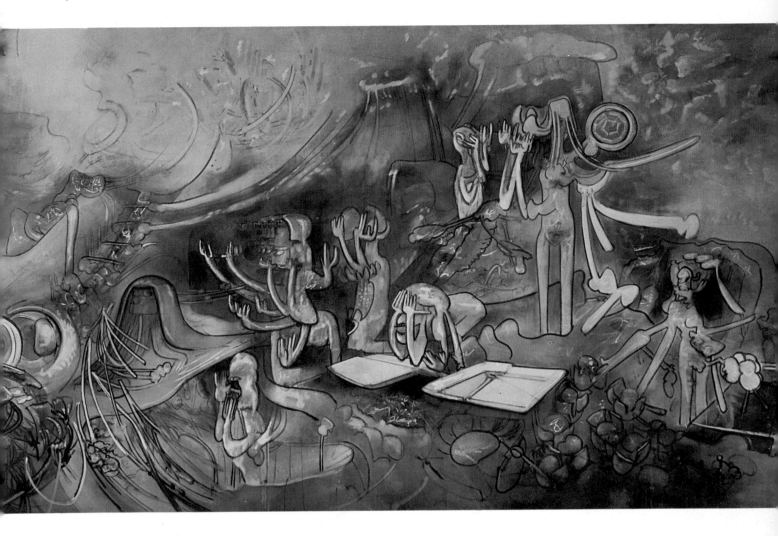

himself regarded as the most important American recruit to Surrealism. Gorky's late pictures make use of automatism, but they often take their starting point from drawings which are more specific than the paintings which derive from them. Gorky also differs from Matta (who was for a while not only an important influence but a close friend) in the fact that his characteristic imagery derives from the natural world—it alludes to ripeness, tumescence, flowering, and fruiting—while Matta's is mechanistic.

Before he became a Surrealist, Gorky underwent a long apprenticeship—chiefly to Cubism, although it also seemed that he discovered within himself the urge to recapitulate every accepted style of modern art. His subservience to Picasso

was the subject of ill-natured jesting in the New York art community. But when he finally reached artistic maturity these studies paid a considerable dividend. In particular, he was equipped to understand the Cubist use of shallow space which Miró, in particular, employed in many of his canvases. William Rubin, in one of the best studies of Gorky's work, puts the matter thus: "That it was possible for Gorky to synthesize Miró and Masson into his Cubism, whereas to do the same with surrealists like Dali and Tanguy would have been unthinkable, makes sense if we recall that Miró and Masson alone among the surrealists had earlier been convinced Cubists. While their organic forms strayed far from the morphology of Cubism, they rarely sacrificed the taste for shallow

(as opposed to deep) space and for disposing the composition comfortably inside the frame, which they had learned during their Cubist apprenticeship" (William Rubin, "Arshile Gorky", *Art International*, Vol. VII, No. 2 [February 25, 1963]).

Yet it is Gorky's sensibility as well as his technique which makes him such a pivotal figure in the history of twentieth-century American painting. When we look at a late Gorky, such as *The Betrothal* of 1947 (Plate 38), we are immediately aware that the canvas which confronts us is almost nakedly autobiographical. These apparently unspecific forms nevertheless speak with great precision about what the painter feels and is. We sense the painter's own masochism from the way in which the forms seem to attack one another.

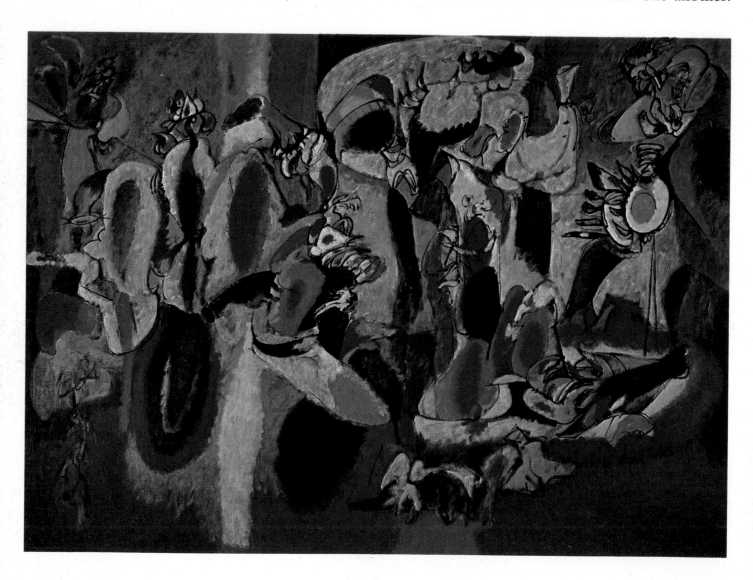

36.
Arshile Gorky
The Liver Is the Cock's Comb
1944; 72 × 98 cm. (28 × 38 in.)
Albright Knox Art Gallery, Buffalo.

37. Opposite
Arshile Gorky
Water of the Flowery Mill, detail
1944; 107.3 × 123.8 cm. (42 × 48 in.)
New York, Metropolitan Museum of Art

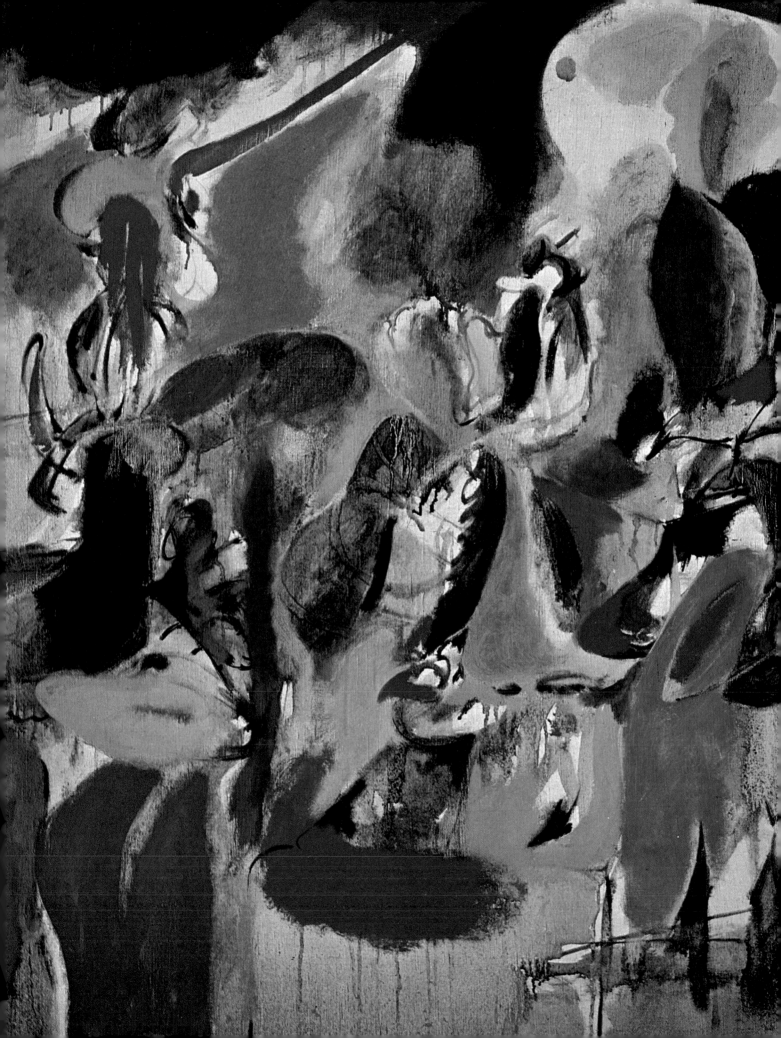

38.
Arshile Gorky
The Betrothal II
1947; 126.9 × 95 cm. (49 × 37 in.)
New York, Whitney Museum of American Art

Claws and tendrils sprout from what is apparently soft and harmless. Rubin has spoken of the painter's "emotional fragility", a phrase perhaps justified by Gorky's suicide, after a long series of personal misfortunes, in 1948. One is, however, aware that this fragility is also a form of aggression. Gorky exalts the "I" more openly than any European painter had yet dared to do.

If Gorky remained upon one side of the divide that separates Surrealism from Abstract Expressionism, then Pollock was the man who made the decisive step across the gap. Jackson Pollock began his career in the camp of the regionalists. In the years 1929–31 he studied with Thomas Hart Benton. Later, like many other American painters, he was supported by the WPA. In 1939 he worked in the studio of the Mexican social realist David Siqueiros, and he was also in contact with other leading Mexican painters of the same school.

By 1943 Pollock was in contact with the circle of Surrealist exiles and in particular with the Art of This Century gallery. In November of that year Peggy Guggenheim gave him a one-man show. His work in the early and middle Forties was based on automatic techniques, but could not be described as abstract (Plates 40 and 41). Pollock was at this stage making use of pictographs and ideograms which were in part suggested by his study of Jung and of Red Indian mythology, and in part prompted by the influence of Miró and Masson. But these works had a quality of American rawness which was immediately recognized as something new, even by critics who disliked Pollock's work and thought it uncouth. The rawness was a matter of choice. Later Pollock, describing his own technique, was to say: "I don't work from drawings or color sketches. My painting is direct. The method of painting is the natural growth out of a need. I want to express my feelings rather than to illustrate them. Technique is just a means of arriving at a statement. When I am painting I have a general notion as to what I am about. I can control the flow of the paint; there is no accident just as there is no beginning and no end" (commentary by Jackson Pollock for the film *Jackson Pollock*, made in 1951 by Hans Nemuth and Paul Falkenberg).

By 1947 Pollock had made the breakthrough to the series of drip paintings which are now considered not only his own most characteristic products, but perhaps the most characteristic products of the Abstract Expressionist movement taken as a whole. The artist once provided a description of the way in which a canvas such as *Autumn Rhythm* (Plate 43) was painted. Even though it is so very well-known, it is worth quoting again here: "On the floor [Pollock now worked with the canvas spread on the floor of the studio rather than placed on an easel] I am more at ease. I feel nearer, more a part of the painting, since this way I can walk round it, work from the four sides and literally be in the painting. This is akin to the method of the Indian sand painting of the West. When I am in my painting, I am not aware of what I am doing. It is only after a sort of 'get acquainted' period that I can see what I have been about. I have no fears about making changes, destroying the image, etc. because the painting has a life of its own. I try to let it come through. It is only when I lose contact with the painting that the result is a mess. Otherwise there is pure harmony, an easy give and take, and the painting comes out well" (Jackson Pollock, "My Painting", *Possibilities I*, New York, Winter 1947–48).

The sense of harmony which Pollock claims to have felt is reflected in the paintings themselves, which are astonishingly serene and decorative compared to the artist's earlier work.

Admiring as they are of Pollock's art, leading contemporary critics have often seemed at a loss as to how to interpret it. Bryan Robertson, author of the most important monograph on the artist, declares that "Pollock was never concerned with communicating in the sense of description." Irving Sandler, author of the standard history of Abstract Expressionism, speaks of "an expansive web of forces, suspended in front of the passive canvas plane". In a study which tries to link American painting of this kind to the tradition of northern Romantic art, Robert Rosenblum has this to add: "The classic Pollock of the late 1940s and early 1950s almost becomes a spectacle of nature, a whirlwind vortex of sheer energy that may take us to the cosmological extremes of

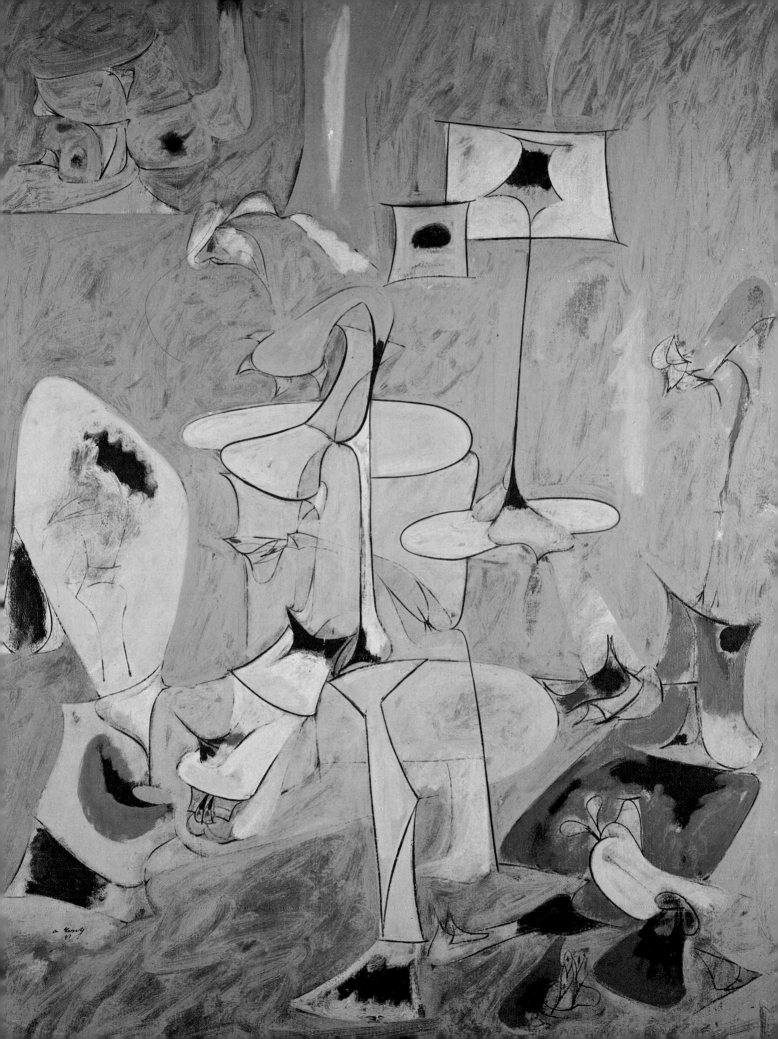

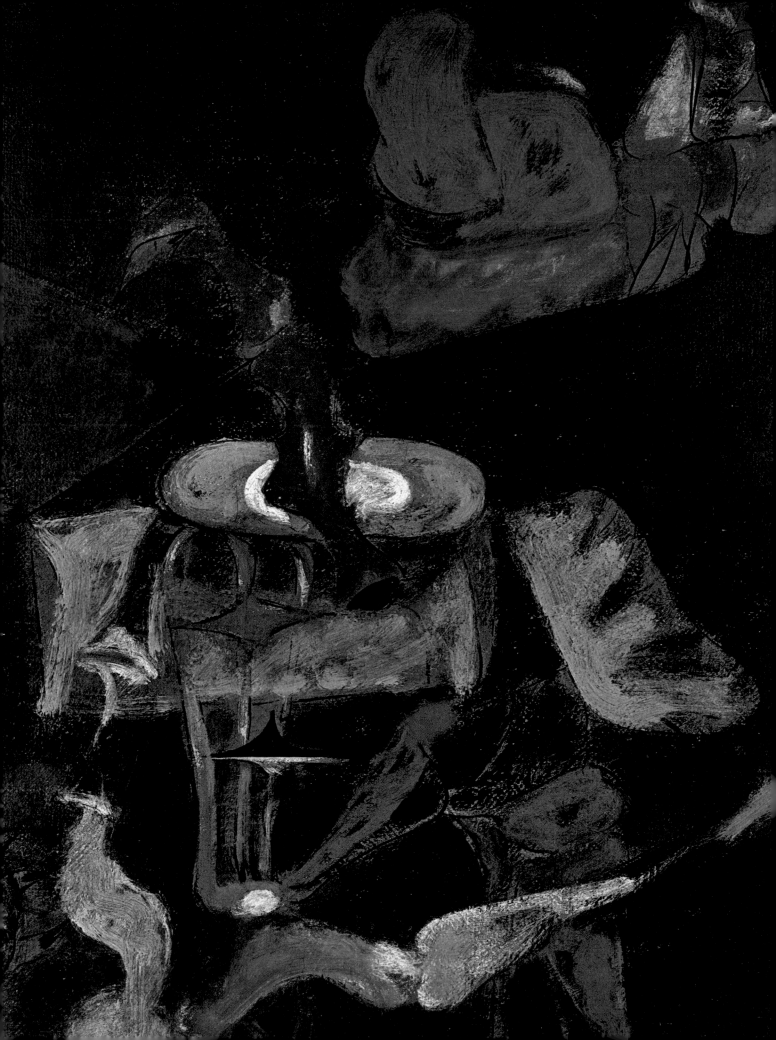

microscopic and telescopic vision—glimpses of some galactic or atomic explosion, or in more terrestrial terms, the overpowering forces of nature's most impalpable elements, air, fire and water" (Robert Rosenblum, *Modern Painting and the Northern Romantic Tradition*, London, 1975, p. 203).

There is a certain justice in this last interpretation, but it does not seem to account for the somewhat enclosed feeling one gets from Pollock's paintings, despite their physical expansiveness. What Pollock has to communicate is a sense of selfhood so all-pervasive that the outside world makes little impact upon the artist.

This theme can be examined from another angle by looking at the work of two other painters of decidedly lesser stature. One of these is Franz Kline, an Abstract Expressionist of a slightly later generation than that of the true founders of the school. Kline was always and primarily a draftsman, and his typical black-and-white canvases look at first glance like Chinese ideograms on an enormous scale (Plate 44). This comparison, however, gives a false impression of the painter's real sources, which were to be found in the techniques of graphic illustration, and in the scaffolding, girders, railways, and bridges of urban New York. The impact of these paintings is very powerful when one first encounters them, and there are those who continue to find them powerful still. The critic Robert Goldwater speaks of the way in which they seem "the spontaneous unretouched record of an impulsive mood, noted in broad, confident strokes". But he goes on to note an inherent contradiction in the way the paintings were created: "Only a few pictures were executed at one sitting. Many broad directional strokes, whose force seems the product of a single inspirational gesture, were actually painted with small brushes; many an entire outsize work had its model in one of Kline's innumerable small sketches" (Robert Goldwater, "Franz Kline: Darkness Visible", *Art News*, Vol. 66, No 1 [March, 1967], pp. 38 ff.).

The other painter who prompts a comparison with Pollock comes from a very different milieu. He is the West Coast artist Mark Tobey, who devoted a period of intense study to Japanese

39. Opposite
Arshile Gorky
Dark Green Painting, detail
c. 1948; 11.1 × 142.2 cm. (4 × 55 in.)
Pennsylvania, coll. Mrs. H. Gates Lloyd

40. Above
Jackson Pollock
Male and Female
1942; 186 × 124.4 cm. (73 × 49 in.)
Pennsylvania, coll. Mrs. H. Gates Lloyd

41.
Overleaf left
Jackson Pollock
Night Ceremony
1944; 182.9 × 109.5 cm. (71 × 43 in.)
New York, coll. Mrs. Barbara Reis Poe

42.
Overleaf right
Jackson Pollock
Lucifer, detail
1947; 104.1 × 268 cm. (41 × 105 in.)
New York, coll. Joseph H. Hazen

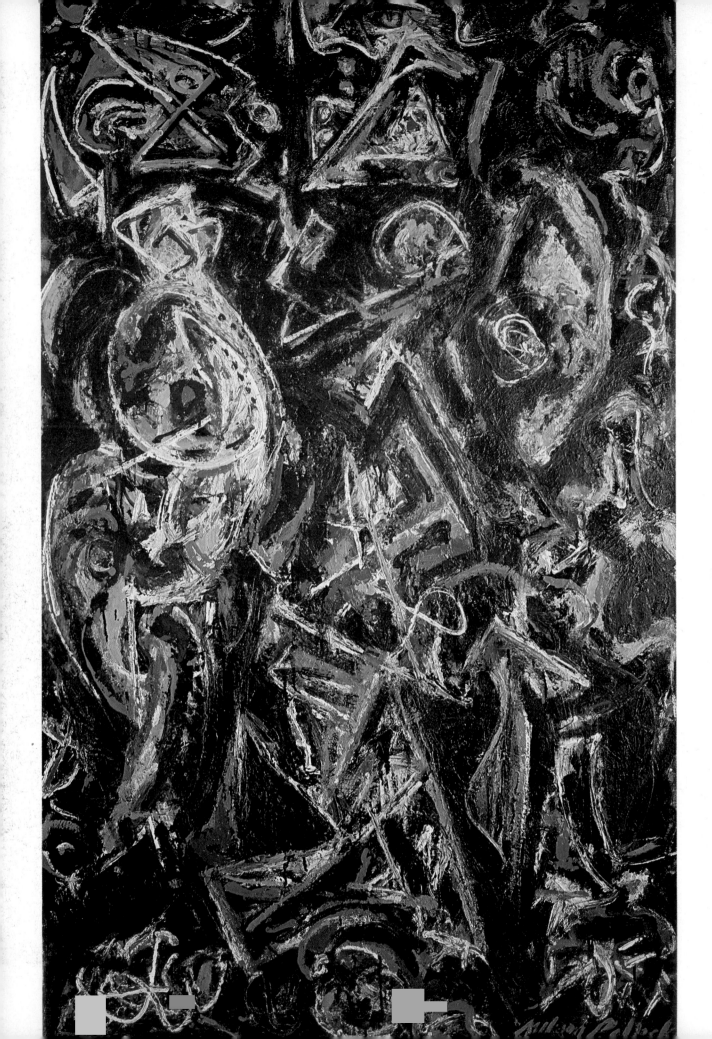

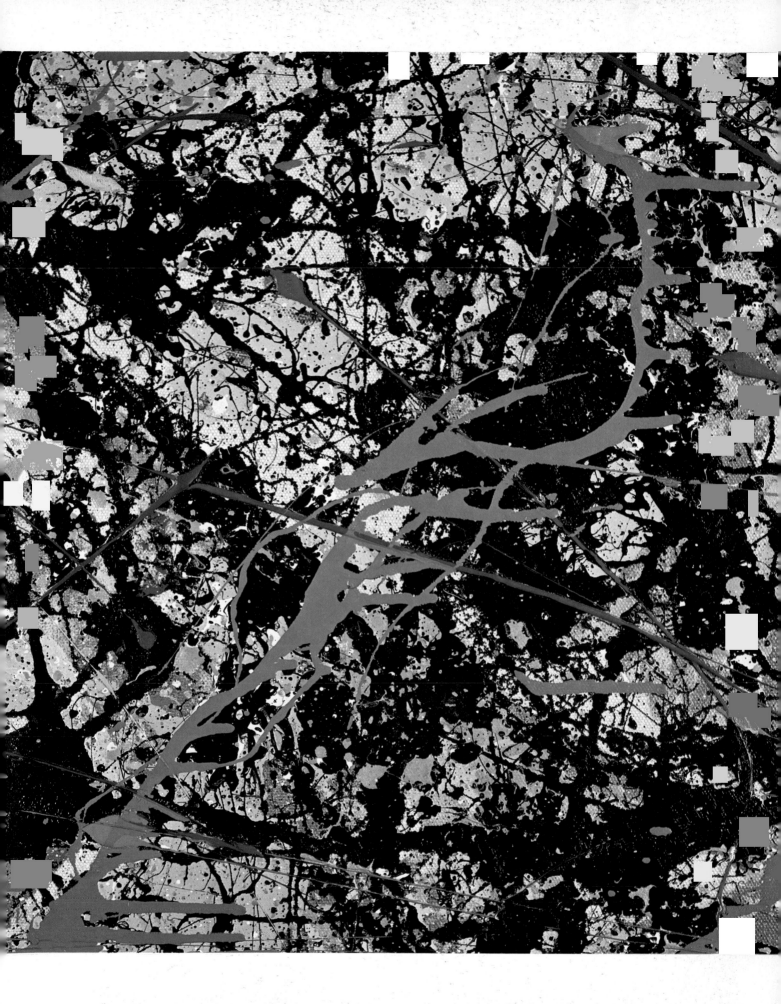

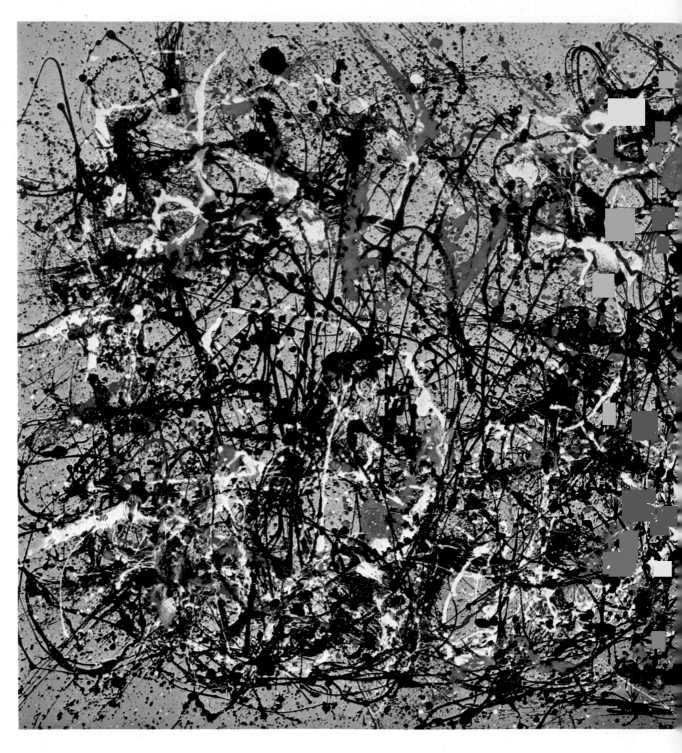

calligraphy (Plate 46). With Oriental source material as his direct inspiration, he developed the method he dubbed "white writing". But he had more weapons in his armoury than this. As he tells us himself, in the catalogue introduction to his retrospective exhibition at the Stedelijk Museum, Amsterdam, which was held in 1966: "Over the past fifteen years, my approach to painting has varied, sometimes being dependent on brush-work, sometimes on lines, dynamic white strokes,

43.
Jackson Pollock
Autumn Rhythm
1950; 266.7 × 525.8 cm. (88 × 205 in.)
New York, Metropolitan Museum of Art, property of Jackson Pollock, George A. Hearn Fund

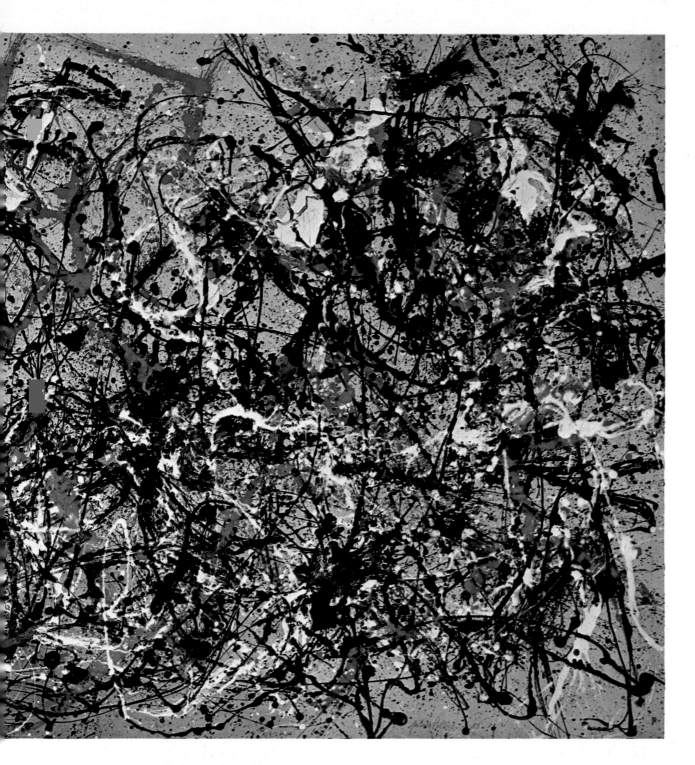

geometric space. I have nevertheless tried to pursue a particular style in my work. For me, the road has been a zig-zag into and out of old civilizations, seeking new horizons through meditation and contemplation. . . . I have sought to make my painting 'whole', but to attain this I have used a whirling mass."

Tobey differs from Pollock and Kline in two important respects—in his very different sense of scale and in his nostalgic feeling for what is ancient (something Pollock avoided even when he made use of primitive pictographs). But when we look at his paintings we get a feeling which we also sometimes get from theirs: that the supposedly "direct" language of gestural abstraction is in fact more special and hermetic, more thoroughly cut off from the society that produced it, than the historians of modern art have found it comfortable to admit. In fact, it is often as ambiguous as its own technical procedures.

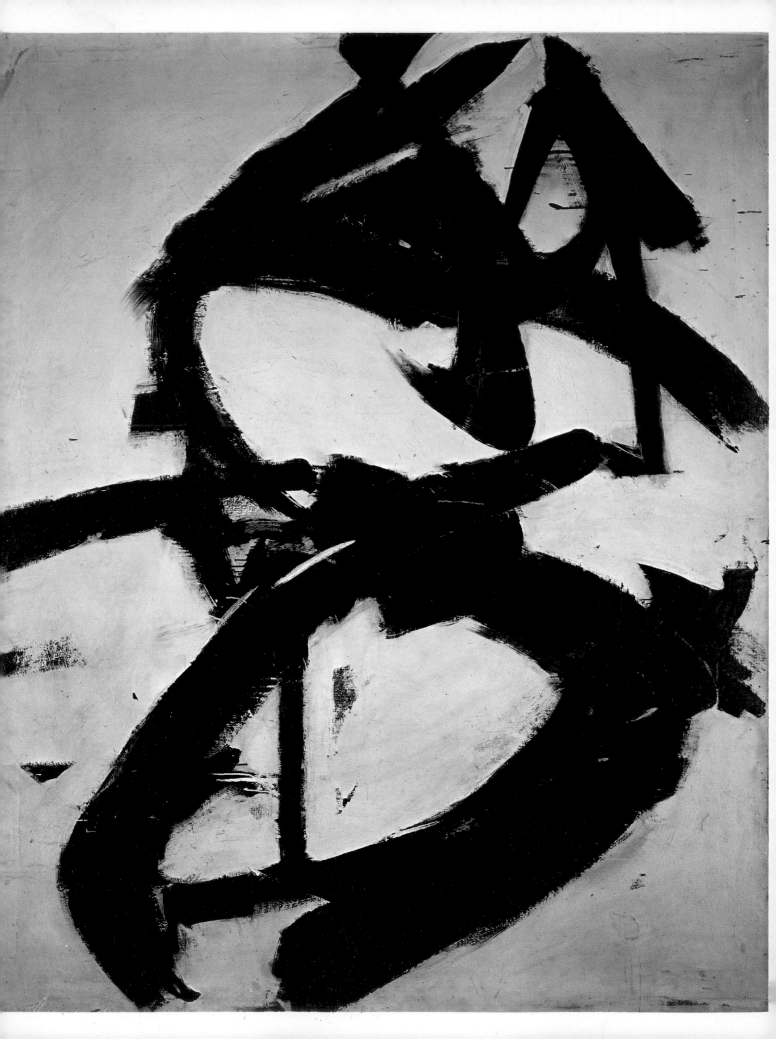

The Abstract Expressionists themselves, often well read in Marx as much as in Freud and Jung, were of course aware of the dangers they ran, and it is interesting to see some of the solutions which were proposed to the dilemma of the isolated artist. The most forthright and in a sense the most brutal was that proposed by Clyfford Still (Plate 48).

Still's *oeuvre* is somewhat monotonous. He was one of the earliest of the Abstract Expressionists to arrive at a personal and characteristic image, and he stuck to it doggedly thereafter. The monotony is implicit in Still's conception of the artist as an American pioneer: "It was a journey that one must make, walking straight and alone . . . until one had crossed the darkened and wasted valleys and come at last into clear air and could stand on a high and limitless plain. Imagination, no longer fettered by the laws of fear, became as one with vision. And the Act, intrinsic and absolute, was its meaning, and the bearer of its passion" (letter to Gordon M. Smith, dated January 1, 1959; published in the

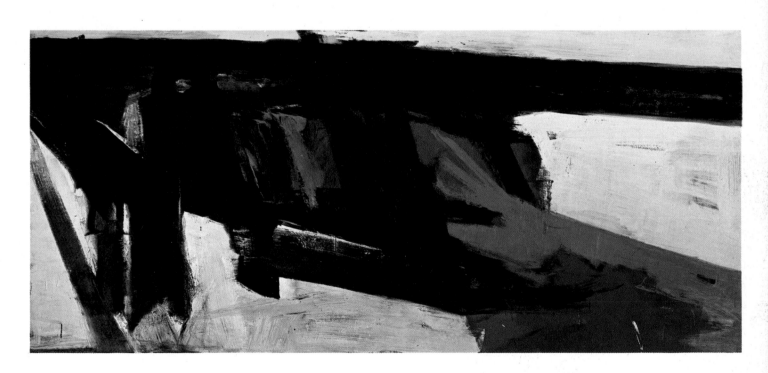

44. Opposite
Franz Kline
Figure Eight
1952; 204.5 × 161.3 cm. (80 × 63 in.)
New York, coll. William S. Rubin

45. Above
Franz Kline
Orange and Black Wall
1959; 168.9 × 365.8 cm. (66 × 143 in.)
New York, coll. Mr. and Mrs. Robert C. Scull

46. Overleaf left
Mark Tobey
Festival
1953; 100.5 × 75 cm. (39 × 29 in.)
Washington, coll. Mr. and Mrs. Bagley Wright

47. Overleaf right
Mark Tobey
Edge of August
1953; 121.9 × 71.1 cm. (48 × 28 in.)
New York, Museum of Modern Art

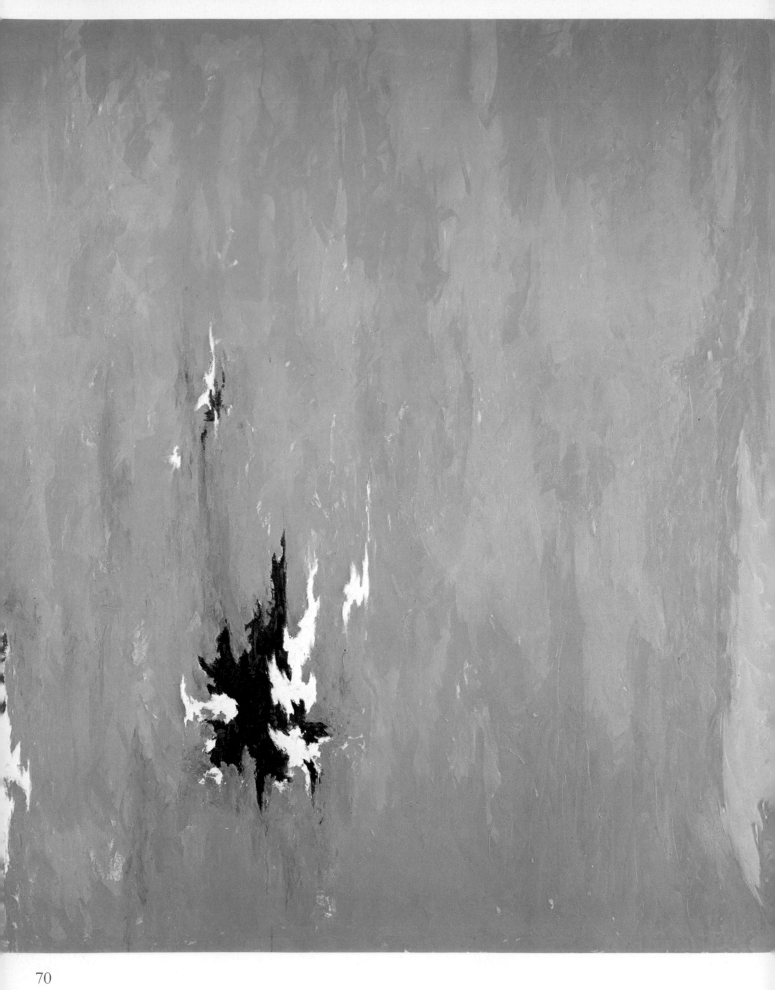

48. Opposite
Clyfford Still
Painting 1948-D
1948; 236.5 × 202.2 cm. (92 × 79 in.)
New York, coll. William S. Rubin

49.
Robert Motherwell
Work
1968; 28.4 × 36.1 cm. (11 × 14 in.)
California, coll. Mr. and Mrs. Frederick R. Weisman

catalogue to the Clyfford Still retrospective at the Albright-Knox Art Gallery, Buffalo, New York, 1959).

Robert Rosenblum has shrewdly compared Still's painting, with its shapes like flames or clouds or stalactites, to that of a slightly senior and much less celebrated contemporary, Augustus Vincent Tack, whose large, late Symbolist canvases are to be seen in the Phillips Gallery in Washington. Rosenblum demonstrates that Tack is the link between Still on the one hand and

American Romantics such as Albert Pinkham Ryder and even Albert Bierstadt upon the other. It must be said that this comparison does not really increase our respect for Still's achievement, which seems in this context both cranky and provincial.

At the opposite end of the spectrum from Still, both temperamentally and intellectually, is Robert Motherwell. Motherwell played a conspicuous role in the early history of Abstract Expressionism, and in particular was responsible for bringing a number of his colleagues into contact with the Surrealist exiles from Europe. He was more keenly aware of the historical development of the

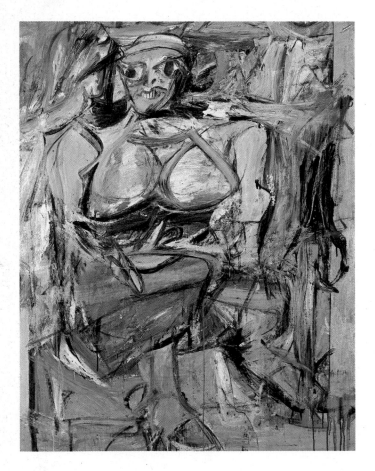

50 and 51
Willem de Kooning
Woman I
1950–52; 192.7 × 147.3 cm. (75 × 57 in.)
New York, Museum of Modern Art
Opposite, detail

Modernist aesthetic than any other American artist. An advocate of automatist techniques, he nevertheless was aware of their disadvantages, "To give oneself over completely to the unconscious is to become a slave." But he defended automatism by means of a paradox: "Plastic automatism though perhaps not verbal automatism . . . is actually very little a question of the unconscious. It is more a plastic weapon with which to invent new forms. As such it is one of the twentieth century's greatest formal inventions."

He tried to incorporate the moral force that some of the Abstract Expressionists claimed for their work into a more traditional aesthetic, declaring rather uneasily to the critic Dore Ashton: "Sometimes I have a painting which is aesthetically beautiful, and I pause. But then I go on because it doesn't really correspond to my judgment of the world." The slow rhythm of Motherwell's most typical compositions (Plate 49) runs the constant risk of seeming devitalized—and an Abstract Expressionist work which lacks vitality is by definition a failure.

No one could level the same accusation against the powerfully various work of Willem de Kooning. De Kooning's *oeuvre* is one of the places where the "expressionist" component of Abstract Expressionism becomes most clearly visible. One reason for this is that De Kooning is the most European of all the leading Abstract Expressionists, with the possible exception of Hofmann, having arrived in the United States in 1926, when he was already an adult. His best-known paintings are perhaps the various series of *Women* (Plates 50 and 51). These begin as a statement of raw sexuality, but later examples have a sugary prettiness which has suggested a comparison to Jean Honoré Fragonard. But within the apparent inconsistency can be discovered a certain steadiness of aim: "For De Kooning, the urge is to include everything, to leave nothing out, even if it means working in a turmoil of contradictions and, as has been suggested, a turmoil of contradictions is his favourite medium" (Thomas B. Hess, *De Kooning's Recent Paintings*, 1967).

De Kooning's perpetual restlessness has led him

72

52.
Willem de Kooning
Two Women with Still Life
1952; 59.7 × 56.5 cm. (23 × 22 in.)
Los Angeles, coll. Weisman

53. Opposite
Willem de Kooning
Police Gazette
1954–55; 109.9 × 127.6 cm. (43 × 50 in.)
New York, coll. Mr. and Mrs. Robert C. Scull

to explore a number of traditional genres. In addition to the series of female nudes, for example, there is a series of impressive landscapes which hover just on the border of total abstraction (Plate 54). A comparison of the artist's *Door to the River* with the landscape-derived paintings of minor Abstract Expressionists such as Grace Hartigan (Plate 55) or Helen Frankenthaler (Plate 56) reveals how brilliantly the balancing act is sustained. De Kooning contrives to convey the *genius loci* without ever lapsing into specifics, and the canvas thus retains its power to play upon the spectator's imagination. Yet his landscapes suffer from the defect we also discover in the landscape sketches of a romantic painter such as John Constable. They are unresolved; they propose no solution. In this sense they are just a fragment of experience wrenched out of context, and existing

in a moral void.

The question of a morality for painting was undoubtedly important to the Abstract Expressionists, as we find when we move on to examine the work of a group of artists who were somewhat different from those who have already been discussed. The gesture painters, such as Pollock and Kline, hoped to induce a kind of leap of communication which was somewhat akin to the spiritual leap of late medieval mystics. But they had colleagues who were somewhat less sanguine about the possibility of such a movement of the mind or soul. Among them were to be numbered men such as Adolph Gottlieb, William Baziotes, Mark Rothko, and Barnett Newman.

One of the things that drove them towards a new and radical art in the America of the 1940's was despair, within which paradoxically there was also a kind of hope. Barnett Newman was later to declare: "In 1940, some of us woke up to find ourselves without hope—to find that painting did not really exist. Or to coin a modern phrase, painting, a quarter of a century before it happened to God, was dead. The awakening had the exaltation of a revolution. It was that awakening that inspired the aspiration—the high purpose— quite a different thing from ambition—to start from scratch, to paint as if painting had never existed before. It was that naked revolutionary moment that made painters out of painters" (Barnett Newman, in "Pollock: An Artist" Symposium, Part 1. *Art News*, Vol. 57, No. 16 [October, 1958]).

Adolph Gottlieb said: "The situation was so bad that I know I felt free to try anything, no matter how absurd it seemed. What was there to lose? Neither Cubism nor Surrealism could absorb someone like myself—we felt like derelicts" (ibid.).

The "enormous vacuum" which Gottlieb described was to be filled, in the first instance, by an effort to re-create the force of primitive myth and symbol, things which would have contemporary value and yet be both "tragic and timeless", as Rothko and Gottlieb were to say in a famous joint letter to the *New York Times*, published in June 1943.

The concern with the pictograph was to be most thoroughly stable and constant in the work of William Baziotes. We find it expressed even in a late work, such as the handsome *Pompeii* of 1955 (Plate 57). Lawrence Alloway, in the catalogue preface for the exhibition of Baziotes's work staged at the Guggenheim Museum in 1965, gives a good survey of the artist's affinities, influences and sources: "The conversion of surrealist techniques in the direction of organically unified imagery and, in Baziotes' case, in the direction of 'beautiful painting', is characteristic of American art in the 40's. What Baziotes did in fact, with biomorphism, is indicative of the situation. He went around the movement, behind it to the original traditions of fantastic art. His slow automatism, prudent and sensitive, is closer to Paul Klee than it is to André Masson. . . Baziotes's anxious musing is more like the mysteries of Odilon Redon than the Surrealist's drama of revelation or exhortation."

As Alloway recognizes, in another passage in the same essay, Baziotes tended to remain somewhat apart from the other American artists of the same group, because "he retained an essentially scenic conception of the picture space, within which a cast of distinct forms is displayed". In this respect, he retains affinities to Gorky in particular.

Gottleib and Rothko, starting from much the same point, continued in a different and more dramatic way. Gottleib developed his pictographs until their large simplified forms were centralized, and came to dominate the canvas (Plate 58). But the sense of imagery remains, even when the glyphs have grown sufficiently large and dominant to shed their original function and identity: "The radical change of scale accomplished by the elimination of his pictographic vocabulary and the isolation of a few large forms on a field creates an imagery which, in its directness, has an immediate and total impact on the viewer. There are, however, secondary impulses. A body of minutiae in the play of textures, the brushstrokes, the delicate nuances of colour in them, complicate the way one sees the painting" (Diane Waldman, "Gottlieb: Signs and Suns", *Art News*, Vol. 66, No. 10 [February, 1968], p. 68).

Perhaps the most radical aspect of Gottlieb's

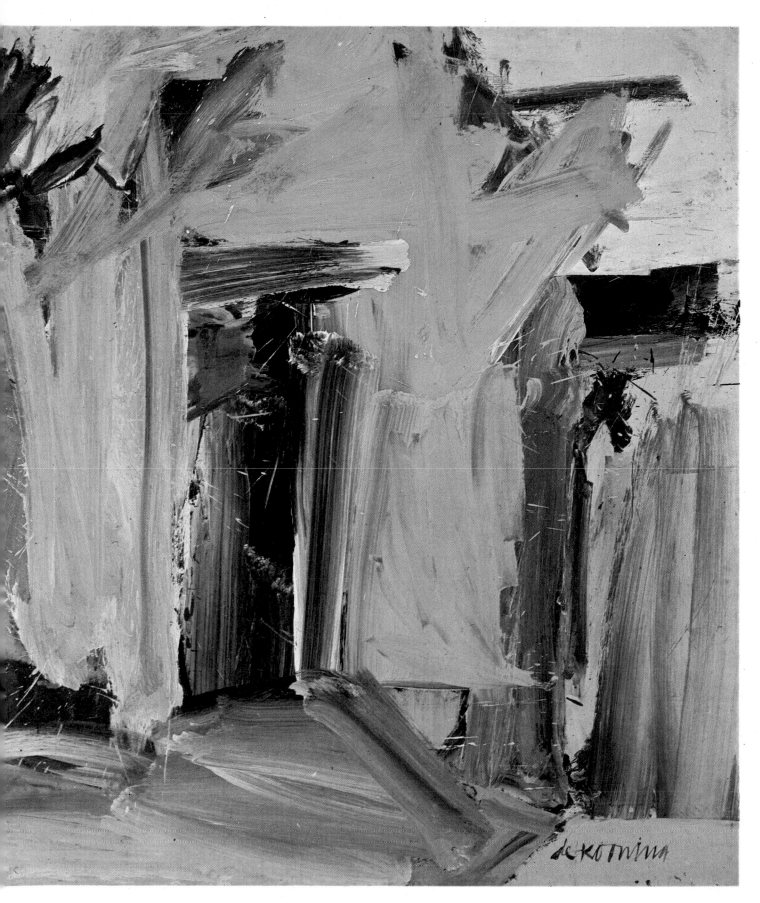

painting is, however, the abandonment of any pretence at traditional composition. The use of centralized, heraldic imagery is as fundamental to his mature painting as the freely calligraphic line is to Pollock's. Even Gottlieb did not press this development as far as Rothko and Newman, and it is for this reason, I suspect, that the two latter now seem the more commanding artists.

Rothko has more and more come to seem absolutely pivotal to any assessment of the achievement of Abstract Expressionism. His earlier works in the Abstract Expressionist idiom, such as *Entombment I* of 1946 (Plate 59), are pictographic, but more painterly than Baziotes, for example, was ever to be. But even before this picture was painted, Rothko had the yearning for

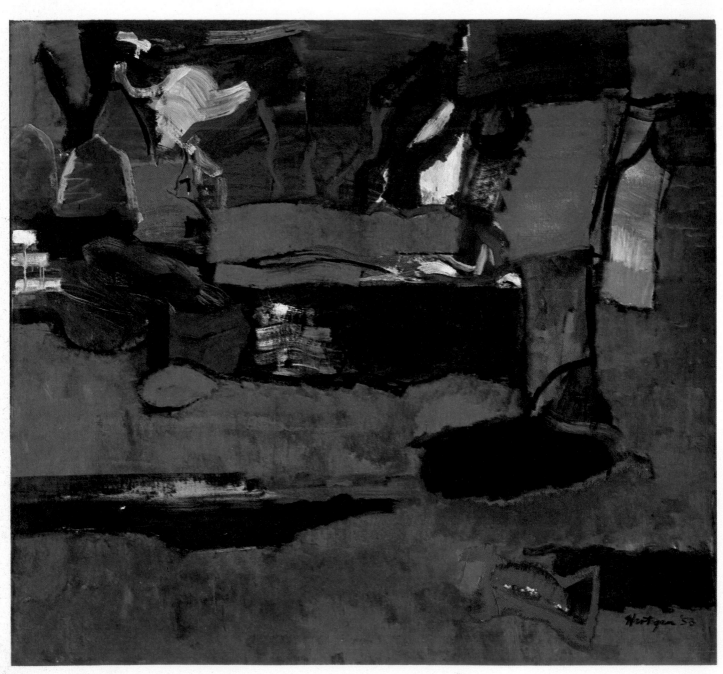

55. Opposite
Grace Hartigan
Frederickstead
1958; 207.3 × 225.7 cm.
(81 × 88 in.)
Brandeis University,
Massachusetts, Rose Art Museum

56.
Helen Frankenthaler
Blue Territory
1955; 287 × 147.3 cm.
(112 × 57 in.)
New York,
Whitney Museum of American Art

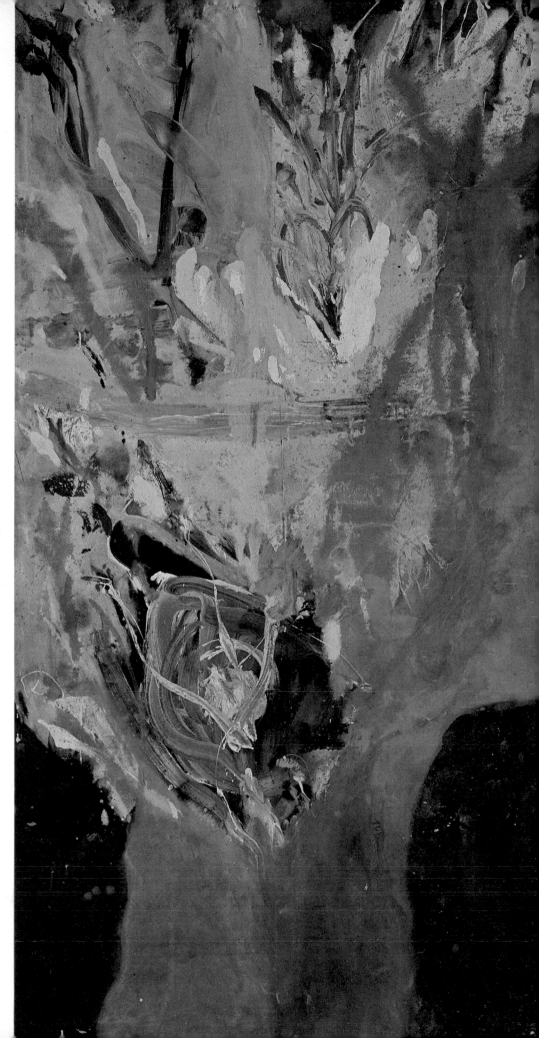

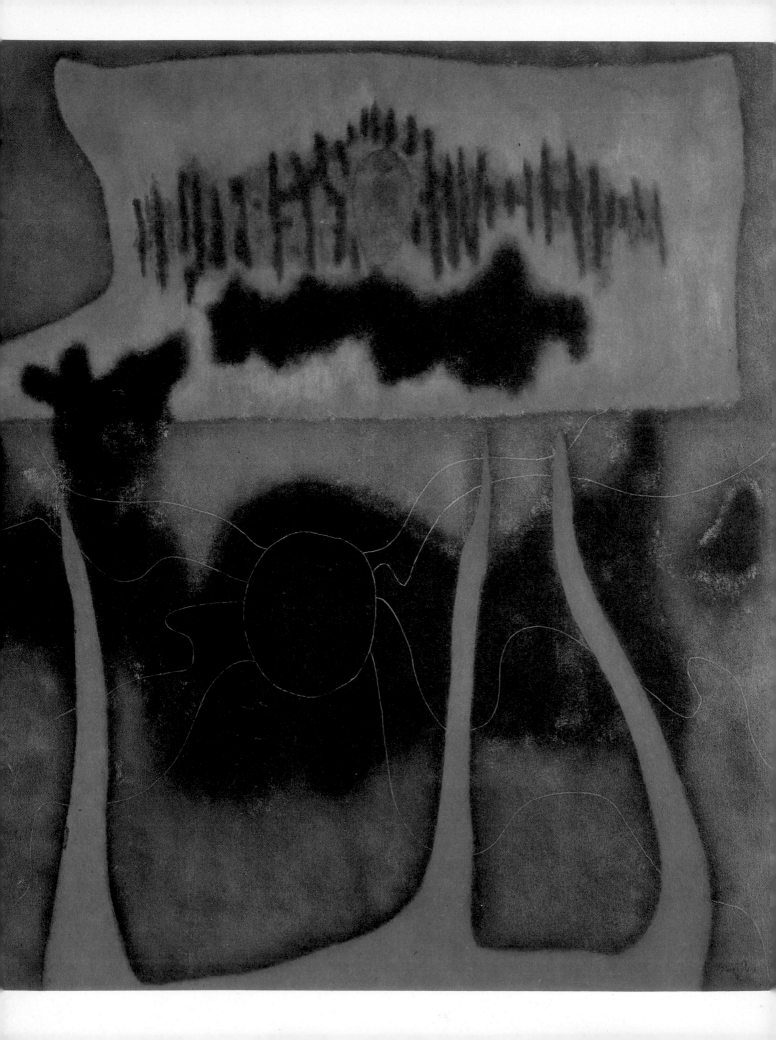

57. Opposite
William Baziotes
Pompeii
1955; 152.4 × 121.9 cm. (59 × 48 in.)
New York, Museum of Modern Art

58.
Adolph Gottlieb
Sign
1962; 228.6 × 213.4 cm. (89 × 83 in.)
New York, collection of the artist

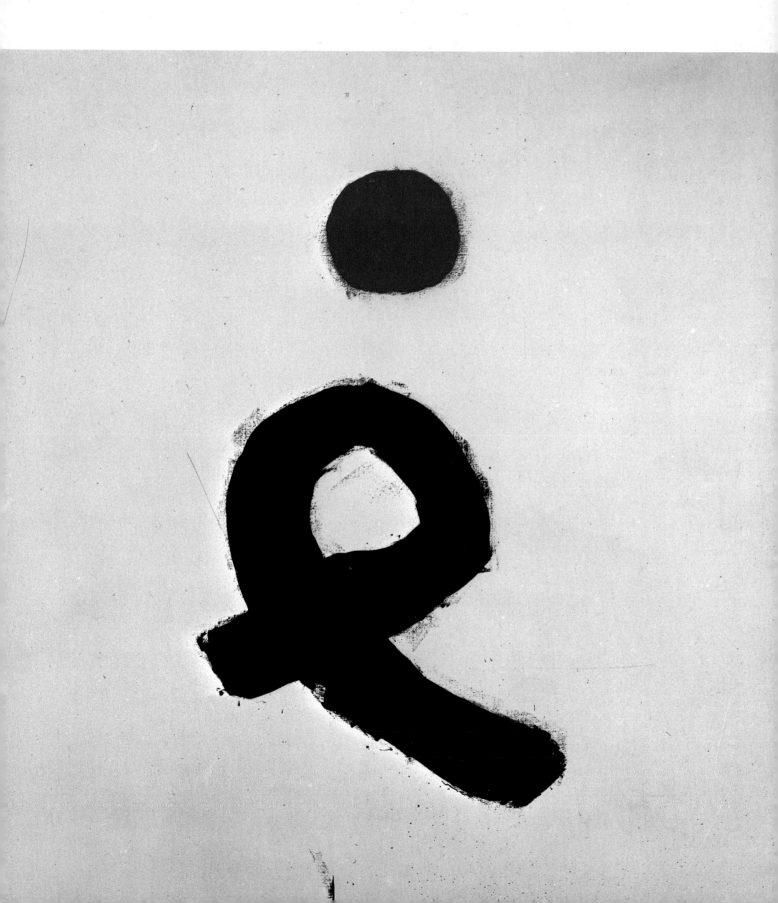

something which would be less specific and more unitary. By 1948 he was ready to assert that he wanted a mode which would have "no direct association with any particular visual experience", and the next year he called for "the elimination of all obstacles between the idea and the observer". His solution, in the search for what would be communicative yet unspecific, was to evolve the centred compositions of softly brushed rectangles of paint floating against a more thinly painted ground which are now associated with his name (Plate 60). Rothko had a clear idea of what kind of effect he wanted to achieve: "The progress of the painter's work, as it travels in time from point to point, will be towards clarity; towards the elimination of all obstacles between the painter and the idea, and between the idea and the observer. As examples of such obstacles, I give

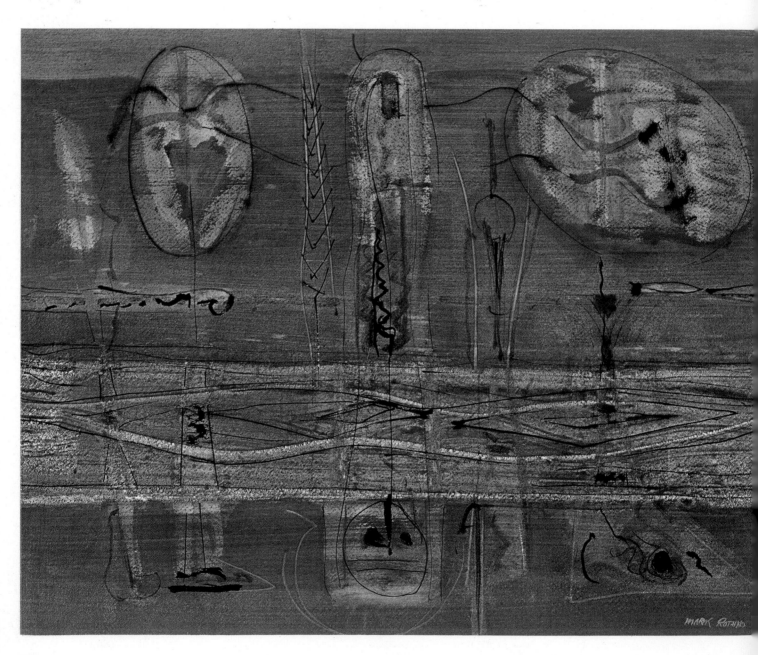

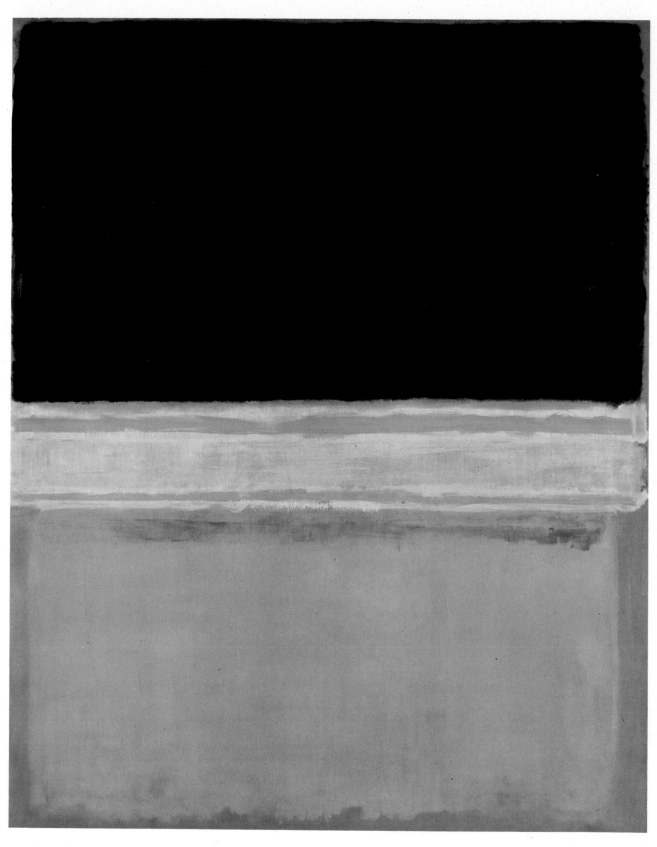

59. Opposite
Mark Rothko
Entombment I
1946; 51.8 × 65.4 cm. (20 × 26 in.)
New York, Whitney Museum of American Art

60.
Mark Rothko
Black, Pink, and Yellow over Orange
1951–52; 295 × 235 cm. (115 × 92 in.)
New York, coll. William S. Rubin

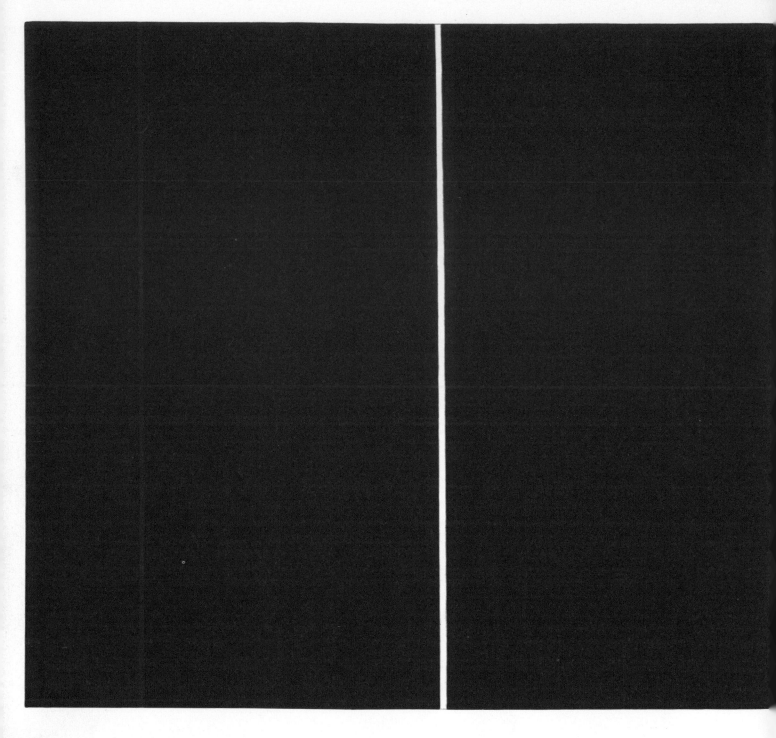

(among others) memory, history or geometry"
(Mark Rothko, in "Artists' Statements", cat-
alogue of the exhibition "New American Paint-
ing", Museum of Modern Art, 1958–59; the
statement first appeared in *The Tiger's Eye*,
October, 1949).

His success in reaching his declared aim can be
judged, not only from the absolute recognizability
of his art, but also from the sense of almost
religious communion which many people have
found in it. Yet there is, too, a certain justice in

61.
Barnett Newman
Vir Heroicus Sublimis
1950–51; 242 × 543 cm. (94 × 212 in.)
New York, Museum of Modern Art,
gift of Mr. and Mrs. Heller

Harold Rosenberg's comment that it remained escapist "in the deepest traditional sense—rich in the romance of self-estrangement".

This romance is apparently absent from the painting of Barnett Newman, one of the most articulate and most radical of the Abstract Expressionists, yet for this reason one of the slowest to achieve recognition. With Newman we see the beginning of a return to the idea of the painting as object, rather than that of the painting as the portrait of an individual soul. His huge canvases are even more uncompromising than Rothko's in their refusal to have anything to do with traditional ways of composing a picture (Plates 61 and 62), though the titles still tend to suggest a degree of aspiration. "Newman's art", comments one American critic, "is about color in relation to size and shape; it amounts to a strategy of scale. Where he differs from Rothko and Still, who are up to something similar, is in his absolute distaste for any atmospheric illusion and textural painting" (E. C. Goosens, "The Philosophic Line

of Barnett Newman", *Art News*, Vol. 57, No. 4 [Summer 1968], p. 63). Harold Rosenberg comments, with a certain asperity, that "In pushing painting as near as possible to extinction, Newman showed it to survive as an act of faith rather than as a normal attribute of modern culture" (*The Re-Definition of Art*, p. 97).

Rothko and Newman present the problem in a different form from the way in which it confronts us in Pollock, but they still bring us back to the question of how art is to function in a modern society. They also draw our attention to an aspect of the New York School of painting in the 1940's and 1950's which has perhaps received insufficient attention, which is its connection with traditional Jewish culture. Rothko was in fact, like De Kooning and Gorky, an immigrant. He was born at Dvinsk, within the Russian Pale of Settlement.

The more one studies the products of the nongestural wing of the Abstract Expressionist movement (and the majority of the artists who belonged to this group were indeed Jews), the more one perceives that it is in a way an extension of the Russian-Jewish Hassidic tradition, and the strangely transplanted expression of a culture

62.
Barnett Newman
Day One
1951–52; 335 × 133 cm. (131 × 52 in.)
New York, Whitney Museum of American Art

63. Opposite
Hans Hofmann
Fantasia in Blue
1954; 152.4 × 132.1 cm. (59 × 52 in.)
New York, Whitney Museum of American Art

64. Overleaf
Sam Francis
Moby Dick
1958; 236.2 × 370.8 cm. (92 × 145 in.)
New York, coll. Mr. and Mrs. Armand Bartos

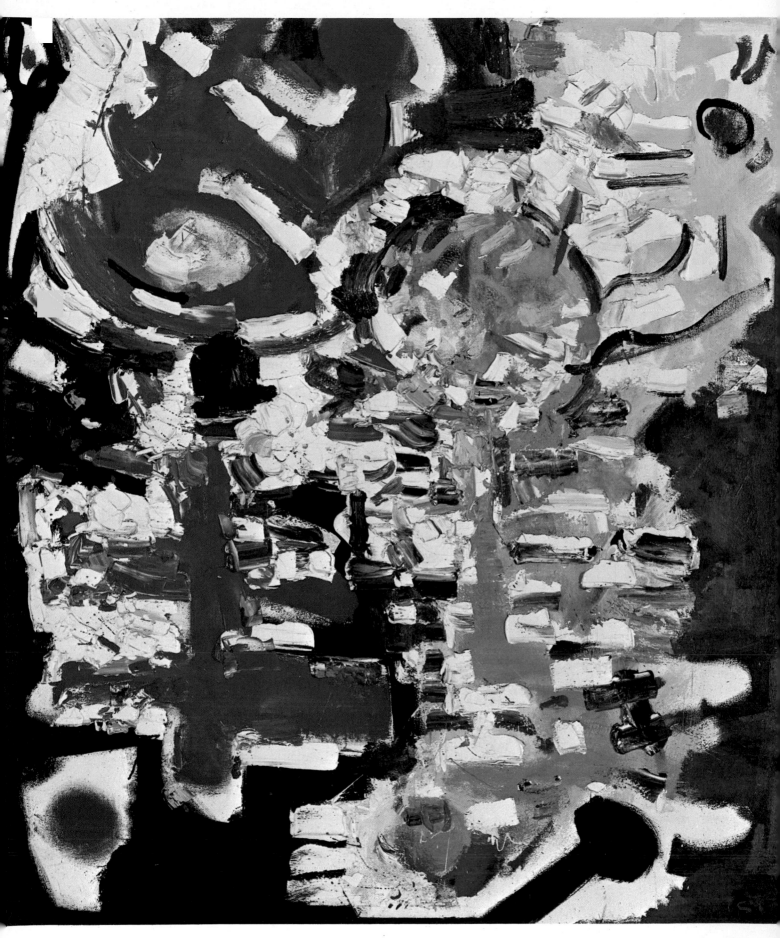

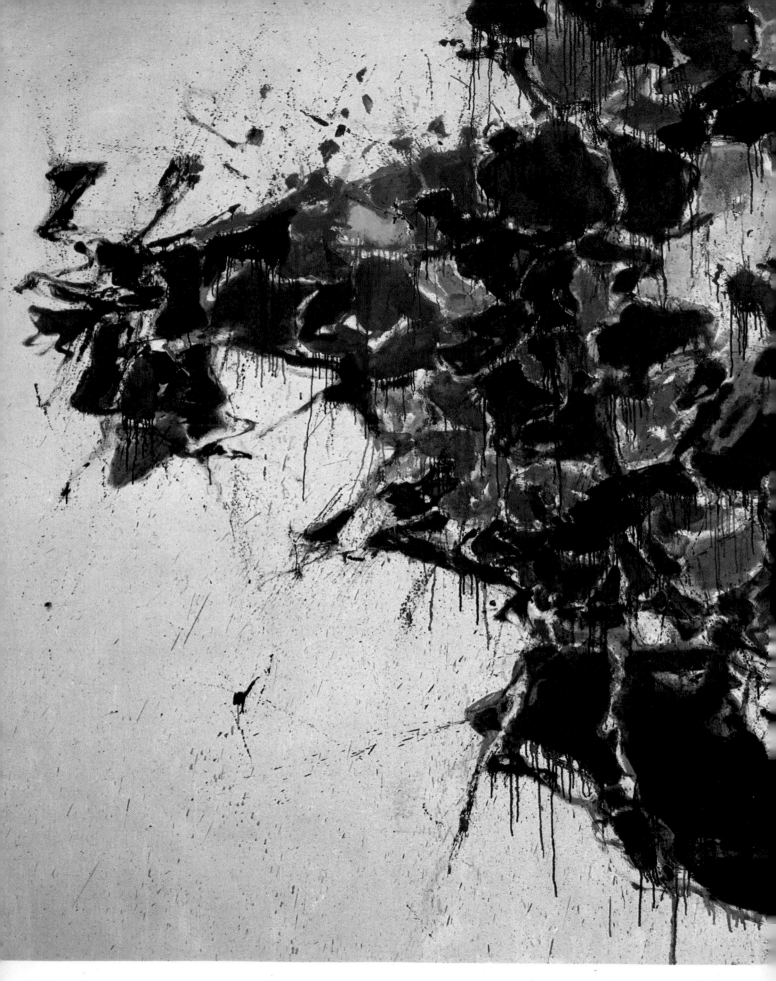

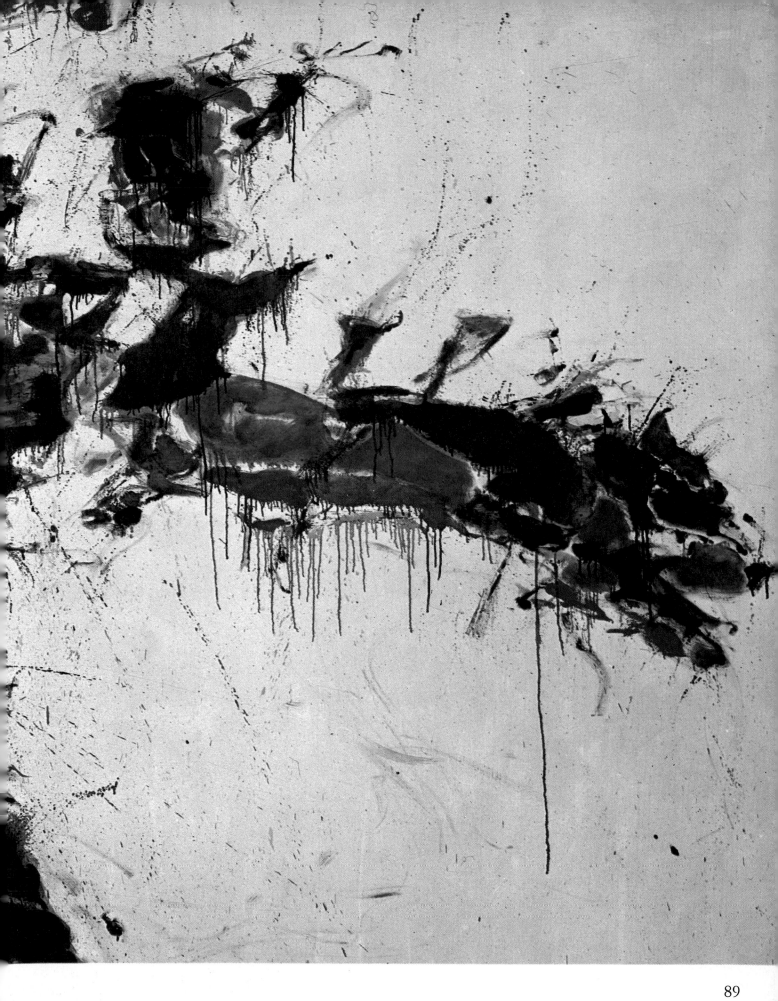

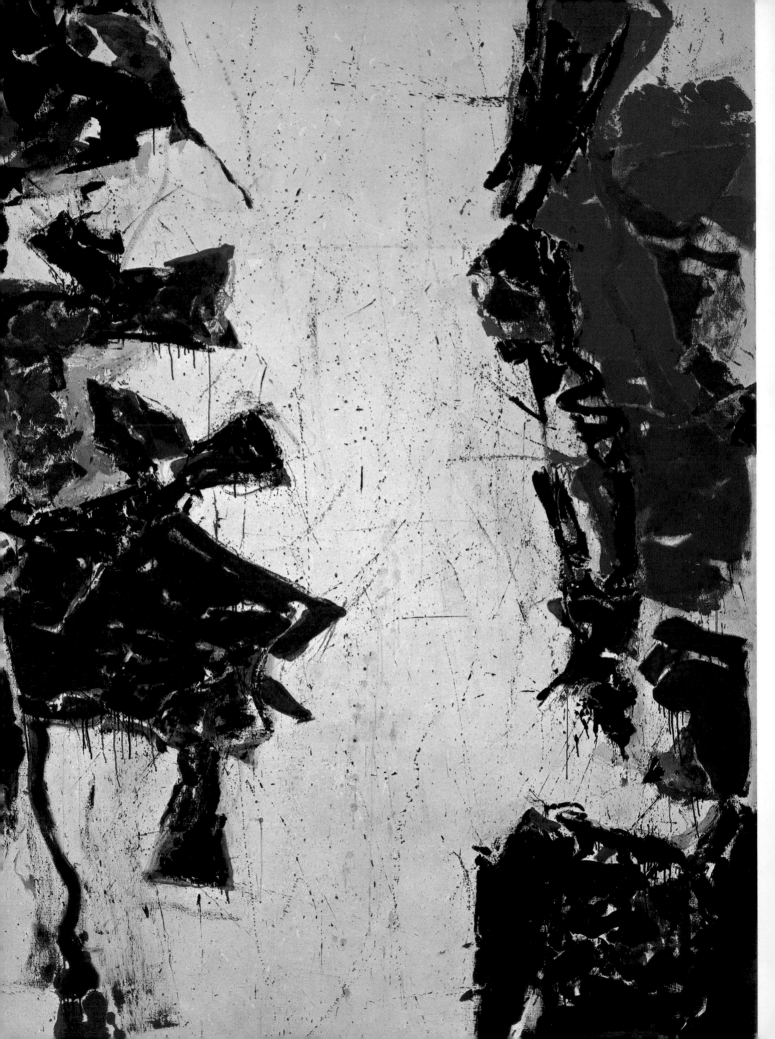

65. Opposite
Sam Francis
Untitled
1958; 274.3 × 191.7 cm. (107 × 75 in.)
California, Pasadena Art Museum

66. Overleaf
Ad Reinhardt
Red Painting
1952; 198 × 366 cm. (77 × 143 in.)
New York, Metropolitan Museum of Art,
Arthur H. Hearn Fund

which had already been destroyed in its native place. This seems to me as important as the connection that Robert Rosenblum has traced between the cosmic aspirations of a Romantic landscapist such as Caspar David Friedrich and similar sentiments as expressed by Rothko.

Once we recognize the connection, certain consequences follow. We note that the distaste for specific imagery is traditional in a Jewish sense, as well as radical in terms of the development of Western painting. We note, too, that the search for some kind of "ultimate" is linked to the Hassidic teachings which were so typical of the Pale. And, finally, one notes that the social impotence, the ability to make connections only within the art community, can be read as a curious and significant transmogrification of the ghetto mentality. With Abstract Expressionism, the artist takes up the position that art can only make an efficient contribution to society by becoming a substitute religion. More ordinary types of communication will not do.

Abstract Expressionism was in one sense an extremely powerful and fruitful artistic explosion.

One of the best proofs of its fertilizing power is what it did to Hans Hofmann's work towards the end of his career. Hofmann, who had been a commanding teacher rather than a commanding creative artist, became towards the end of his life "his pupils' best pupil", as Nicolas Calas has said, and produced canvases at least as powerful as those painted by other Abstract Expressionist leaders (Plate 63). On the other hand, the idiom could easily slip into being a pleasant decorative convention (Sam Francis, Plates 64 and 65).

The most powerful expression of the eventual bankruptcy of Abstract Expressionist ideas was provided by Ad Reinhardt, a painter who was the eternal gadfly of the movement without being able, in his own work, to make the final surrender of certain Abstract Expressionist aspirations (Plate 66). Reinhardt declared that his aim was "To paint and repaint the same thing over and over again, to repeat and refine the one uniform form again and again. Intensity, consciousness, perfection in art come only after long routine, preparation and intention" (Ad Reinhardt, "Art-as-Art", *Environments I*, No. 1 [Autumn 1962], p. 81).

Post-war Europe

In Europe, in the years that immediately followed the Second World War, the situation for modern art was paradoxical. On the one hand, the hostility of Nazism and fascism to the Modernist movement gave the latter a new respectability now that the dictatorships were defeated. Not unreasonably, people identified contemporary painting with the liberal spirit which the armies of the Allies had been fighting to preserve. The senior Modernist painters such as Picasso, Braque, and Matisse found themselves elevated, finally, to the status of Old Masters, and the public thronged to showings of their work. There was also a tendency to turn the artist himself into a revered cultural object, with an existence quite separate from that of his work, and young American GI's paid pilgrimages to Picasso's studio in much the same spirit as they would previously have gone to visit the *Venus de Milo* or the *Mona Lisa*.

The initial euphoria nevertheless did little to conceal the real difficulties that confronted a new generation of modern artists. The mass emigration of Surrealists to the United States (even if most of them returned to Europe shortly after the war was over) had meant a break in the continuity of modern painting. Young painters felt themselves overshadowed by the achievement of the Modernist pioneers, yet curiously without relationship to them. If on the one hand people recognized the birth of a new era, on the other hand the weariness and depression left behind by the war made them feel disinclined to strenuous activity.

The despair, indeed, struck deep, and some of the most characteristic post-war painting was an expression of it. One of the mushroom reputations of the late Forties was made by the young Frenchman Bernard Buffet. Significantly, he belonged to a group called L'homme témoin. Among its other members were French romantic realists such as Paul Rebeyrolle, Minaux, and Venard. Buffet's *Pietà* (Plate 67), painted when the artist was only eighteen, is representative of the mood which then prevailed. At the time when he first made his reputation, the public and many of the critics ignored Buffet's essential superficiality because he so exactly fulfilled their expectations.

In England another, and very different, artist made a striking success. This was Francis Bacon, whose *Three Studies for a Crucifixion* caused a sensation in London when it was first shown there in 1945. Bacon was a much older man than Buffet, and he had been a long time in discovering his true vocation as a painter, though he actually started to paint as early as 1929, when he was twenty. In 1936, he was refused a place in the large Surrealist exhibition then being organized in London, on the grounds that his work was insufficiently Surrealist. Bacon has since disowned the paintings produced during this period of search, and nearly all of them have been destroyed. When he began work on the *Three Studies* in 1944, he was making a completely new beginning as an artist.

Bacon's work excited people from the first because it seemed to reflect some of the more horrifying aspects of contemporary experience—war, starvation, the mass slaughter of the concentration camps. His early paintings, such as the untitled canvas of 1946 illustrated here (Plate 68), suggested a complex web of references—in the first place to Old Masters such as Velásquez and Rembrandt (here powerfully suggested by the flayed carcass hanging behind the figure), in the second place to Expressionists such as Soutine, and thirdly and more superficially to Surrealism. Yet Bacon was then, and was to remain, stylistically isolated.

Throughout his career he has continued to portray the themes of horror and suffering which announced themselves in his first mature canvases. The *Three Studies for a Crucifixion* of 1962 (Plate 70)

67.
Bernard Buffet
Pietà
1946; 172 × 255 cm. (67 × 99 in.)
Paris, Musée National d'Art Moderne

is an even more ferocious restatement of the material in the original triptych of seventeen years earlier. As Bacon once remarked to an interviewer: "One always loves the story and the sensation to be cut down to its most elemental state. That's how one longs for one's friends to be, isn't it? One can do so much without the padding" (quoted by Lawrence Gowing, in *The Irrefutable Image*, Marlborough Fine Art, London, 1968).

Yet, despite the professed search for essentials, the unprejudiced spectator will also detect in many of Bacon's works an element of rhetoric—a rhetoric of suffering, instantly recognizable, and not always, it seems, completely justified by the subject-matter. Bacon's paintings, when they first stunned the public, seemed to speak with a universal accent, and to find a form for what many people felt about the devastated world which surrounded them. As his career has progressed, he has come to seem more and more isolated, and his images are now almost claustrophobically special and personal. Great artist as he undoubtedly is, the main line of development in post-war European art does not run through him.

We are closer to the roots when we look at the work of two Paris-based painters of considerably lesser stature: Fautrier and Wols. In 1945, Jean Fautrier, who was already an established painter, exhibited his series of *Otages* at the René Drouin Gallery (Plate 72). These were inspired by the faces of the hostages whom the artist had seen being taken out to be shot during the war. Fautrier was by inclination an abstractionist—he had painted his first abstracts as early as 1928—and, in order to cope with his chosen subject matter, he had devised a technique which would be simultaneously abstract and figurative. It partook of the "psychic improvisation" pioneered by the Surrealists but contained other elements as well. Among these was an interest in child art, and a sophisticated appreciation of archaeology—a taste later to be popularized by André Malraux's propaganda for the concept of the *musée imaginaire*, or imaginary museum. The perhaps surprising thing about Fautrier's work was its consistently luxurious texture, which seemed to contradict its tragic subject-matter. Fautrier was one of the

96

97

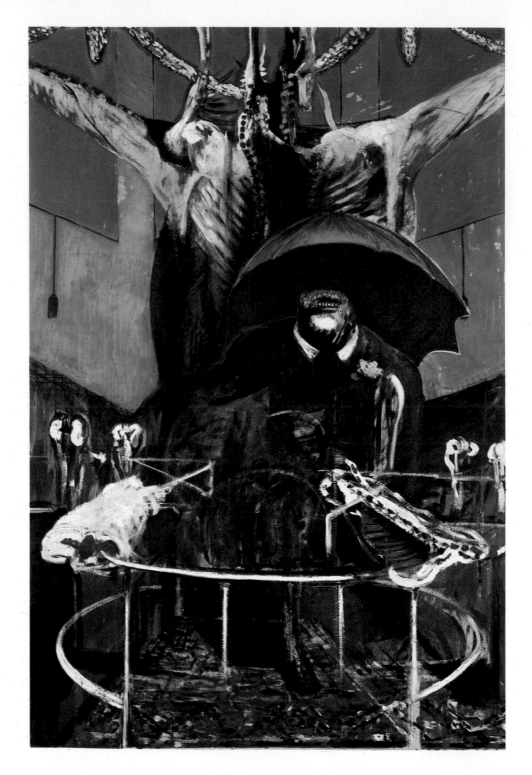

pioneers of the so-called *haute pâte* technique, which was to attract so many European abstractionists during the decade which followed. *Haute pâte* became a logical extension of the long-established French predilection for a sensual, painterly surface.

"Wols" was the pseudonym of a German artist, Wolfgang Schultze. He had studied briefly at the Bauhaus under Mies van der Rohe, in the early Thirties, and had moved to Paris in 1932, when the

68.
Francis Bacon
Painting
1946; 196.8 × 132.1 cm. (77 × 52 in.)
New York, Museum of Modern Art

69. Opposite
Francis Bacon
Lying Figure No. 3
1959; 198.5 × 142 cm. (77 × 55 in.)
Düsseldorf, Kunstammlung Nordrhein-Westfalen

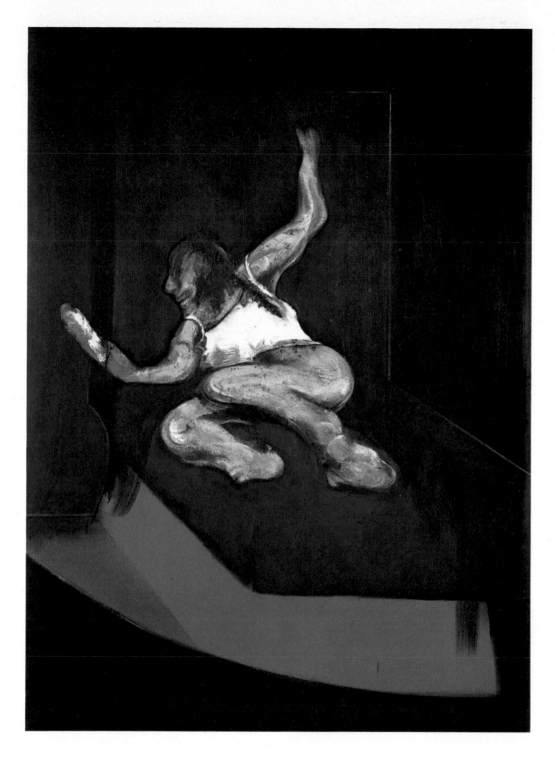

situation began to deteriorate in Germany. There he became an associate of the Surrealists, but worked as a photographer. It took a spell of internment during the war to turn him first into a draftsman, then into a painter. He then became linked to the new group of Existentialist philosophers and writers, led by Jean-Paul Sartre; and he, too, had a successful show at the Drouin Gallery in 1945.

The striking thing about Wols's work is its spontaneous, scribbled calligraphy. He was working on lines parallel to those of the American Abstract Expressionists at a time when their work was still unknown in Europe (1949). But Wols's influence was more than a merely technical one. In his own life he revived the Romantic idea of the artist as a doomed soul, condemned to being devoured by his art. He died in 1951.

Fautrier and Wols heralded the birth of European *tachisme*, a style which was to enjoy a

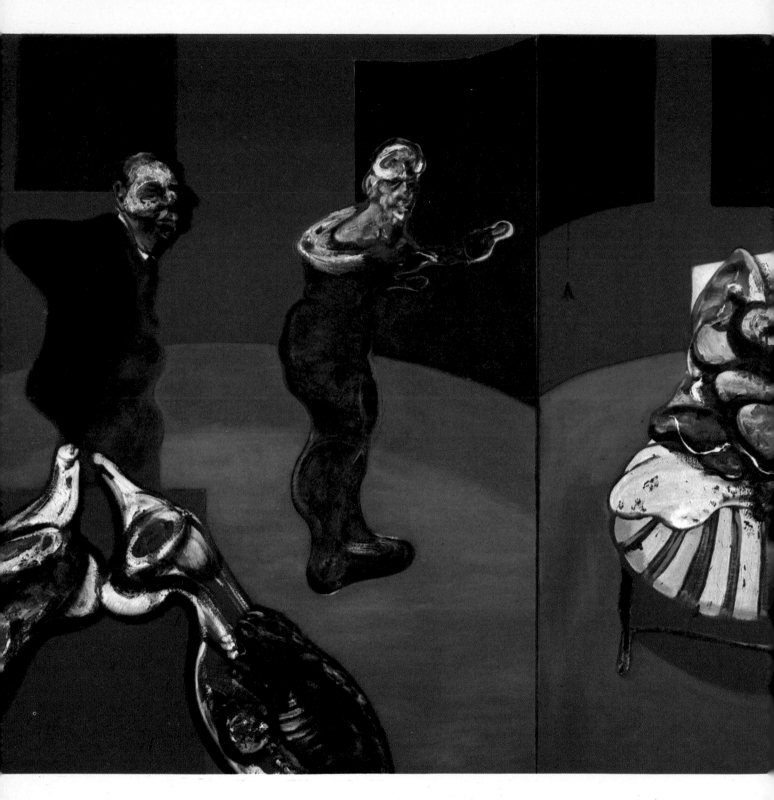

huge critical and financial success before it was
eclipsed by the rise of Pop Art. The painters
associated with this phase of Modernism are
currently very difficult to assess, so completely has
much recent critical opinion rejected them. Their
downfall has also been intimately connected with
the decline in prestige of Paris as an international
art centre.

70.
Francis Bacon
Three Studies for a Crucifixion
1962; 198.1 × 434.3 cm. (77 × 169 in.)
New York, Solomon R. Guggenheim Museum

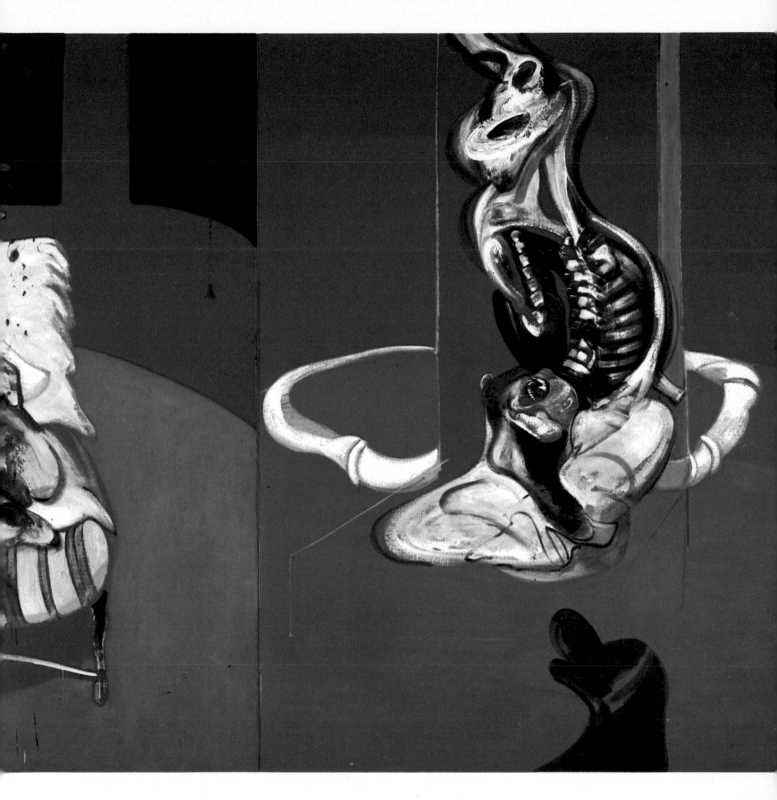

One of the most typical of European *tachistes* is Georges Mathieu. High claims have been made for Mathieu, even comparatively recently. Werner Haftmann, one of the most respected of the historians of Modernism, wrote of him as follows: "There are three concepts which return regularly and give a certain continuity to his work: *le jeu*, *la fête*, *le sacré*. It is round this triad of the playful, the festive and the sacred that his imagination plays. . . . [F]aced with the liberating emptiness of the canvas, he covered it with fleeting arabesques like personal signatures which, if the paintings succeeded, left behind a splendid and audacious pattern which represented his liberation from *angst*. It is this aspect of his painting which makes it like some grand decorative scheme, but it

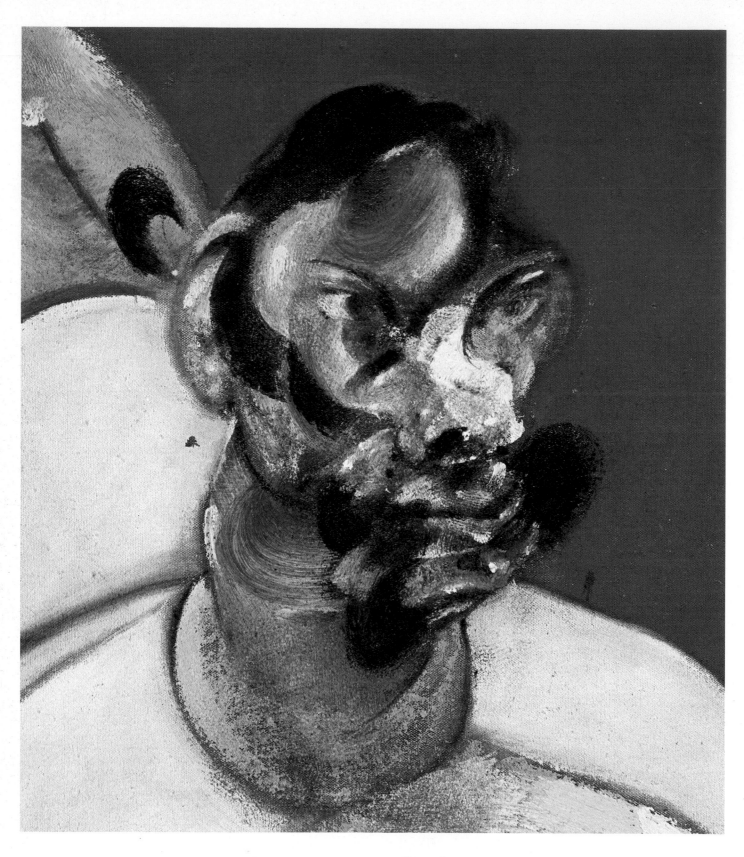

71.
Francis Bacon
Double Portrait of Lucien Freud and Frank Auerbach, detail
1964; 165 × 287 cm. (64 × 112 in.)
Stockholm, Moderna Museet

72. Opposite
Jean Fautrier
Tête d'Otage No. 1
1943; 35 × 27 cm. (14 × 11 in.)
Varese, coll. Giuseppe Panza di Biumo

73.
Wols (Alfred Otto Wolfgang Schulze)
Composition V
1946; 15.9 × 12.3 cm. (6 × 5 in.)
Paris, Musée National d'Art Moderne

74. Opposite
Wols (Alfred Otto Wolfgang Schulze)
Painting
1944–45; 79.7 × 80 cm. (31 × 31 in.)
New York, Museum of Modern Art,
gift of Dominique and John de Menil

75. Overleaf
Georges Mathieu
Composition in Red on Brown
1952; 129.5 × 195.6 cm. (51 × 76 in.)
Connecticut, coll. Mr. and Mrs. Burton Tremaine

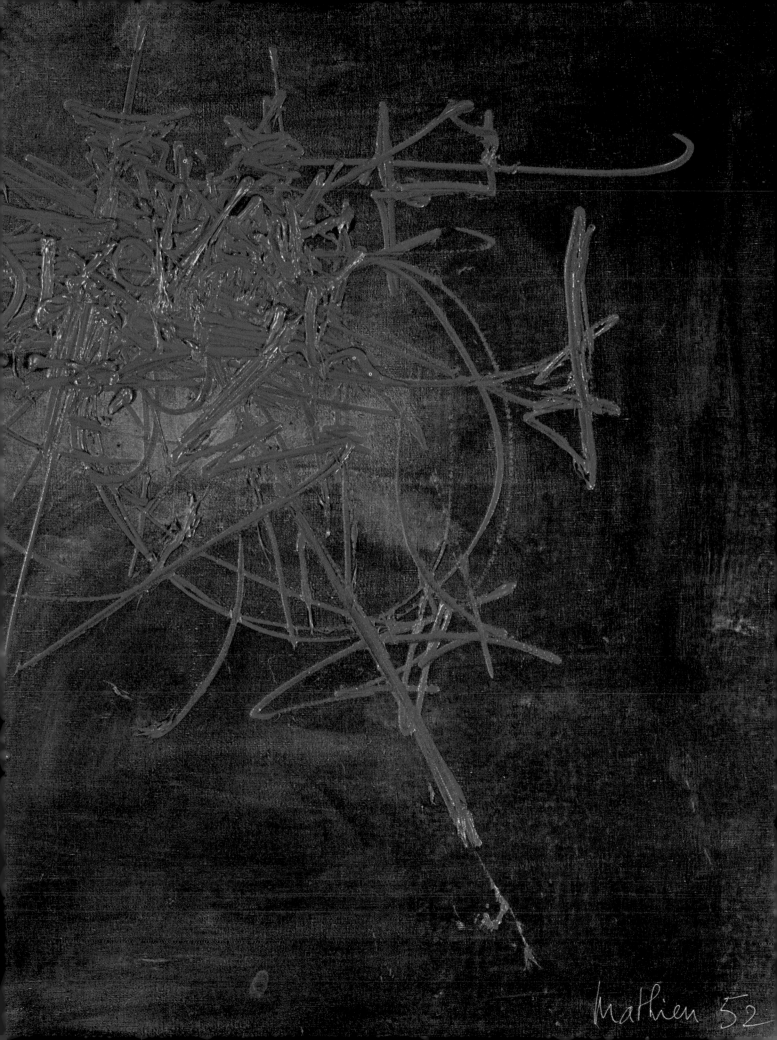

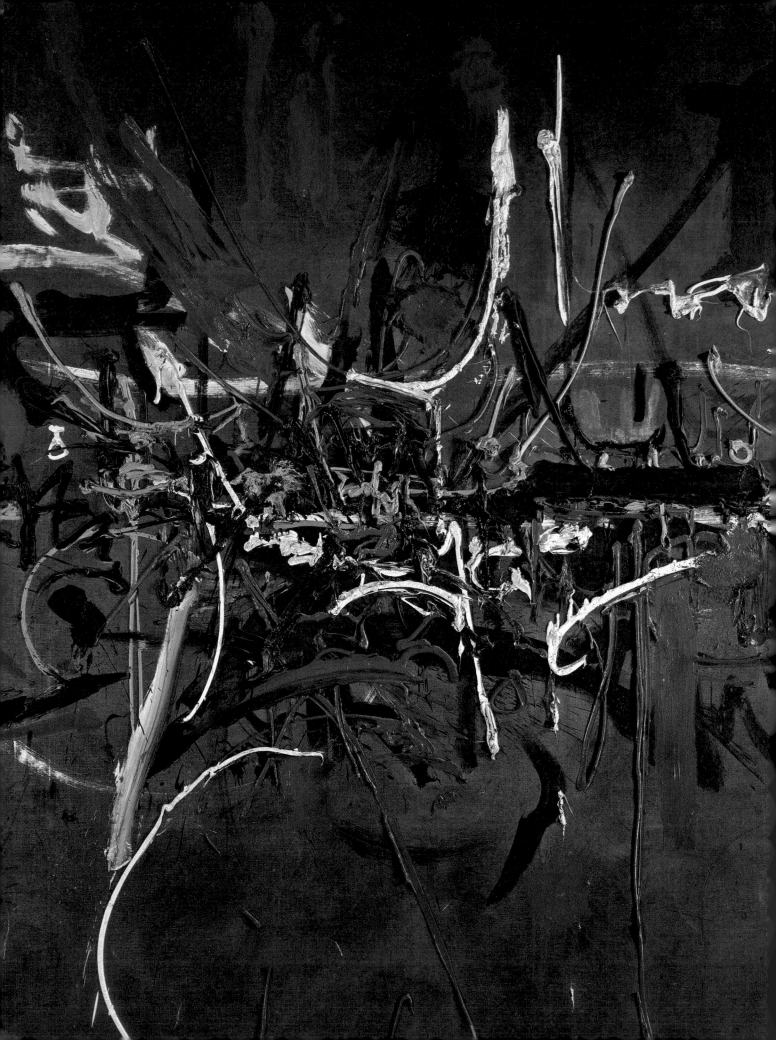

nevertheless retains its own peculiar meditative quality. It is rather like the painting of the age of Louis XIV which Mathieu so much admired" (Werner Haftmann, "Master of Gestural Abstraction", *Abstract Art Since 1945*, London, 1971, p. 48).

This summary does at least have the merit not only of telling us a good deal about the appearance of Mathieu's most typical paintings, but also of suggesting, if only between the lines, why severe criticism has been levelled at his work. Mathieu's art is in fact decorative, but in a perjorative sense. When we compare a large Mathieu (Plate 75) to a Pollock on the same scale, the former seems both superficial and inflated. Mathieu has spoken of an "intrinsic autonomy" as being "the only quiddity possible for the work of art in its relation with its own existence." But in his own work this autonomy all too often seems like mere egotism.

Mathieu's real importance lies not in his personal achievement as a painter, but in his function as an *animateur*. He was one of the first Europeans to realize the importance of the new American art, when actual specimens of this began to make their appearance in Europe in 1947—the year in which the Galerie Maeght in Paris showed work by Gottlieb and Baziotes. He was also eager to explore the resources of Oriental calligraphy and led other European painters to share his interest in this. Finally, he was an effective showman, capable of painting a huge painting on stage in a theatre, before an invited audience, as an attempted justification of his "aesthetic of speed".

Nineteen forty-seven was an important year for the growth of what came to be called Lyrical Abstraction. Jean Atlan exhibited with Maeght, and Hans Hartung at the Lydia Conti Gallery. Pierre Soulages made an impact with a canvas in typical style at the Salon des Surindépendants in the same year. There seemed to be some reason for critics to hail the rebirth of the prewar Ecole de Paris as a dominant force on the international art scene.

Of the three painters I have just mentioned, Soulages (Plate 77) is perhaps the one who currently seems the most impressive. The pattern of heavy black calligraphy is more than a little reminiscent of Kline, but one senses in Soulages' work a more profound respect for traditional methods of composing a picture, as well as a more succulent approach to the actual paint.

Hartung (Plate 78) is a desperately monotonous artist, with his seldom-varied formula of bundled sheaves of lines. Atlan (Plate 79) is eclectic rather than monotonous, striving to bring together Surrealist elements and Expressionist ones, morphological transformations with a lingering attachment to landscape.

Whatever one may think of it now, Lyrical Abstraction was certainly dominant in European painting during the late Forties and throughout the Fifties, and many versions of its basic attitudes were evolved. An artist such as Jean Bazaine (Plate 80) retained elements derived from Cubism in order to try and keep his links with the past. One is aware, too, of the concealed play of natural forms. Nature, lightly disguised, similarly plays her part in typical compositions by Alfred Manessier (Plates 81 and 82), while Manessier's near-namesake Jean Messagier (Plate 83) sometimes produces paintings which look like less successful versions of some of De Kooning's landscapes.

76. Opposite
Georges Mathieu
Les Capétiens Partout, detail
1954; 295 × 600 cm. (115 × 234 in.)
Paris, Musée National d'Art Moderne

77. Overleaf left
Pierre Soulages
Painting
1956; 194 × 129.9 cm. (76 × 51 in.)
New York, Solomon R. Guggenheim Museum

78. Overleaf right
Hans Hartung
Painting 54-16
1954; 130 × 97 cm. (51 × 38 in.)
Paris, Musée National d'Art Moderne

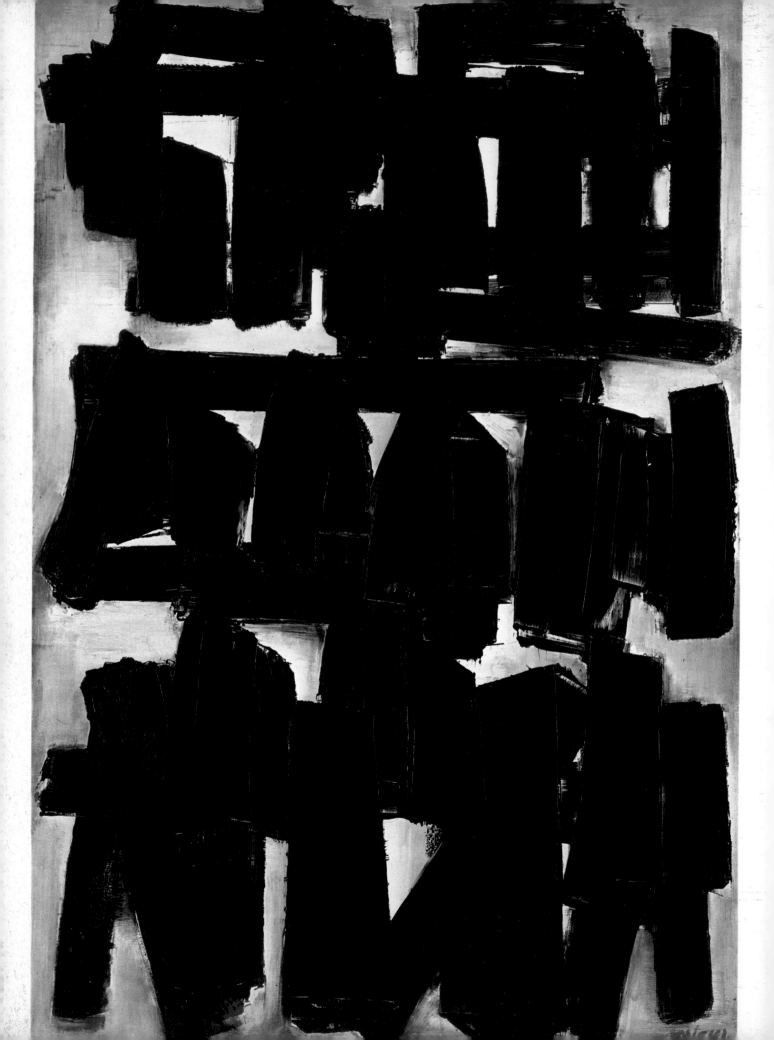

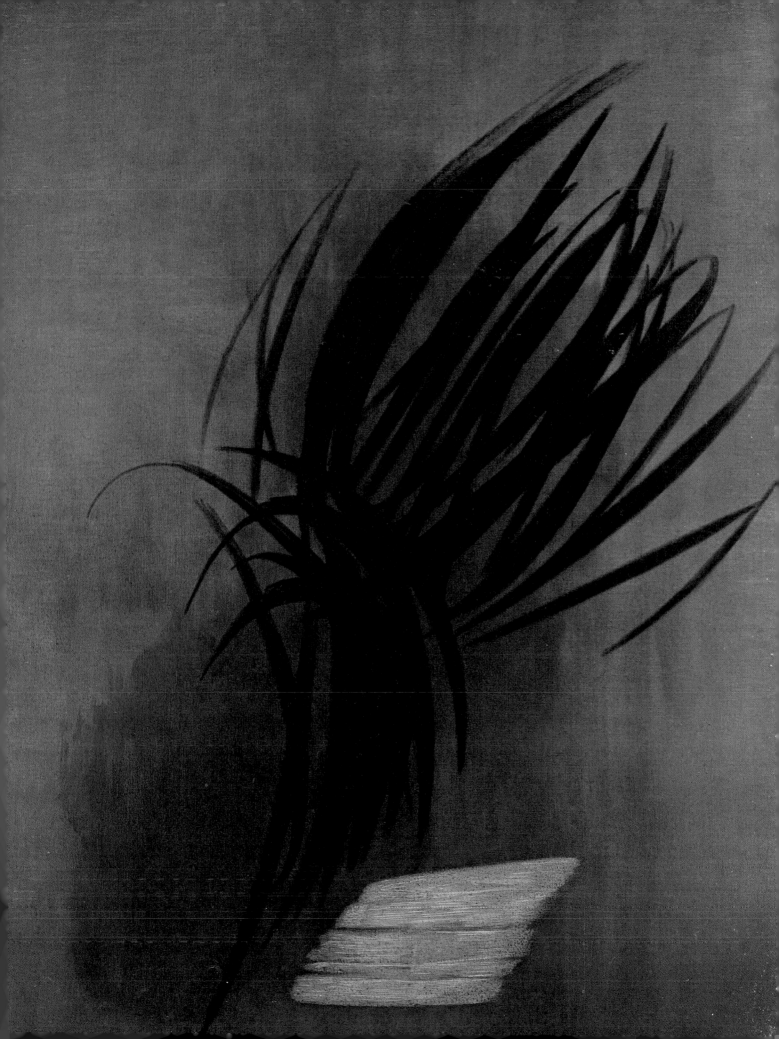

79.
Jean Michel Atlan
Composition
1958; 52 × 79 cm. (20 × 31 in.)
Copenhagen, coll. Henny and Aby Besjakov

80. Opposite
Jean Bazaine
Il palombaro
1949; 144 × 113 cm. (56 × 44 in.)
Cologne, Wallraf-Richartz Museum

One striking thing about the new school was its internationalism. We find versions of it among artists from all the principal European countries. For Germans such as Willi Baumeister (Plate 84) and E. W. Nay (Plate 85), free abstraction became a statement of liberation from the nightmare of the immediate past. Nay's work is interesting not only as an abstract version of things which had been attempted in figurative painting by the original German Expressionists, but also thanks to the artist's attempt to make freedom systematic through the use of colour disks "with each colour group of disks constituting an unobjective figuration".

We recognize a different kind of national sensibility at work in the paintings of the Franco-Russian painter Serge Poliakoff (Plate 86), where

the characteristic colour gamut has affinities with the colour schemes we find in Russian ikons.

Among Italian artists, some felt the traditional pull of Paris. One of these was Emilio Vedova (Plate 87), whose paintings certainly owe a great deal to Wols. Others, among them Giuseppe Capogrossi, were on the very fringes of Lyrical Abstraction, and produced work which was more personal (Plate 88). The appearance of Capogrossi's work has been well described by Roland Penrose: "The individual marks resemble, especially when arranged in series, alphabets in languages that we cannot read, yet the appearance of sequence and order is so strong as to imply the presence of meaning. . . . Capogrossi's pictures are like the bills and accounts of long-dead places . . . the clean, simple finish of his paintings is

81. Opposite
Alfred Manessier
Nuit de Gethsémani
1952; 198 × 148 cm. (77 × 58 in.)
Düsseldorf, Kunstsammlung Nordrhein-Westfalen

82.
Alfred Manessier
Fire
1957; 80 × 98.5 cm. (31 × 38 in.)
Cologne, Wallraf-Richartz Museum

impersonal and contemporary. It is of the same family as a piece of competent packaging, such as we might find in any city" (Roland Penrose, "Giuseppe Capogrossi", introduction to the catalogue of an exhibition at the Institute of Contemporary Arts, London, 1957).

The impersonal look of Capogrossi's work, which Penrose draws to our notice, is in fact one of the things that most sharply marks him off from his contemporaries.

Impersonality was never the aim of the Spanish painters who also began to attract attention during the Fifties, somewhat to the surprise of those who had expected little of interest to emerge from Franco's Spain, the last survivor of the Fascist dictatorships. Some of these painters, such as

115

83.
Jean Messagier
Mars à venir
1962; 132 × 191 cm. (51 × 74 in.)
Berlin, Galerie Springer

84. Opposite
Willi Baumeister
Monturi Diskus IA
1953; 185.4 × 135.2 cm. (72 × 53 in.)
Cologne, Wallraf-Richartz Museum

Antonio Saura (Plate 89), soon transferred their activity to Paris, and their work shows the inherent weaknesses which affected their Parisian colleagues, the inflated formlessness to which Lyrical Abstraction could all too easily lead.

One Spanish artist stands head and shoulders above the rest. This is the Catalan painter Antoni Tàpies. Where Lyrical Abstraction for the most part failed, Tàpies was able to show that many of its ideas, if badly executed by others, were not in fact worthless. Comparing a painting by Tàpies to one by a leading American Abstract Expressionist—for example, to the work of Motherwell (doubly relevant because the latter feels a fascination for Spain and things Spanish)—we note the extreme slowness of the rhythms, the patient way in which the work has been evolved: "The corroded surfaces, fissures, and peeled areas convey a sense of stratification, of one level below another, which is rich in evoked antiquity. The

85.
Ernst Wilhelm Nay
Gelbe Scheiben
1954; 60 × 80 cm. (23 × 31 in.)
Cologne, coll. Alfred Otto Müller

86. Opposite
Serge Poliakoff
Composition
1950; 130.5 × 97.2 cm. (51 × 38 in.)
New York, Solomon R. Guggenheim Museum

paint surfaces seem worn by a duration greater than that of an individual artist. . . . The processes of the hand as an analogy of time's shaping make elegance a natural result of partial destruction" (Lawrence Alloway, catalogue foreword for the exhibition "Antoni Tàpies", at the Solomon R. Guggenheim Museum, New York, 1962).

The sense of elapsed time in Tàpies' work is indeed very strong, and it is one element that gives his painting its continued power. It is worth comparing his sensitivity in the use of thick paint with the insensitivity of surface which one finds in the work of the French-Canadian artist Jean-Paul Riopelle (Plate 91).

An aspect that today tends to make us mistrust the talent of Riopelle—or of artists such as Mathieu or Hartung for that matter—is their monotony. There seems no reason to prefer one

work by the same hand to another, when all are essentially the same. Yet this standardization of the product has certainly contributed to the success of Lyrical Abstraction with collectors. The Fifties witnessed a massive growth in the market for modern art, and for the first time it was abstract art which was favoured. One reason for this was that many artists had evolved a way of painting which was so instantly recognizable that the artist himself became the subject of his picture. One collector, visiting another, would have no trouble in recognizing a work by Hartung, and would feel no need to know its title. A number of collections were formed on the "one of each" principle—by buying a specimen of the work of a whole list of "approved" artists. Another reason was that the style that had evolved from the anguish of the post-war period became, in the hands of the

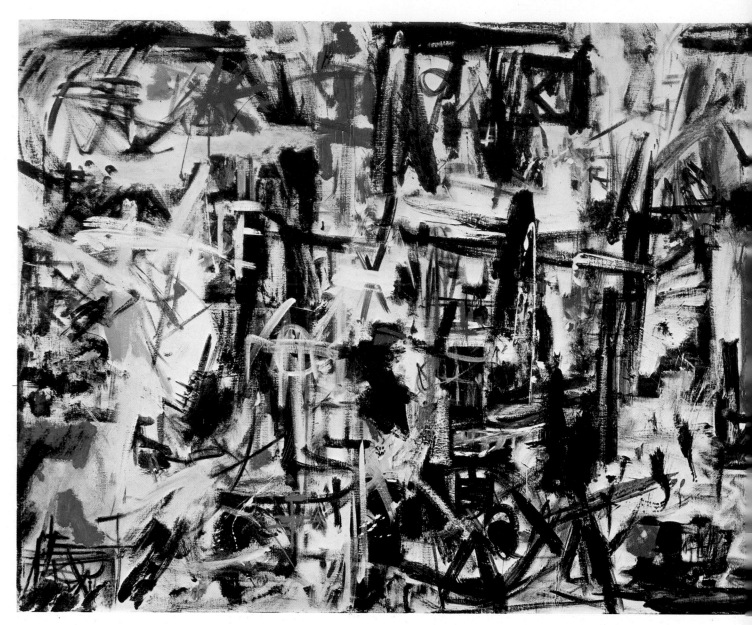

Lyrical Abstractionists, so purely decorative that it caused no discomfort to a clientele grown prosperous in the sudden boom. The opulent paint surface matched the opulence of the context.

Despite the post-war triumph of abstract art, a number of artists were uneasy. They were attracted by the new freedom the painter had received, but were unwilling to surrender the specific entirely. One of these was the Portuguese-born woman artist Vieira da Silva, who had once been a pupil of Léger. Her delicate paintings (Plates 92 and 93) suggest landscapes or townscapes without ever quite being specific about what is being shown. They bear a fascinating resemblance to the kind of work Mondrian produced in the period when he was moving towards total abstraction.

The most important of these painterly but figurative artists is, however, Nicolas De Staël, whom some critics have sought to see as one of the

half-dozen most important painters to have made a reputation since the war. De Staël deliberately moved against the prevalent current of his time. A Franco-Russian like Poliakoff, he began his career as an abstractionist, painting first in a geometrical style derived from Synthetic Cubism. Gradually, following the spirit of the time, he began to paint more freely, now making use of coloured blocks and cubes arranged in rhythmic patterns. Even at this stage De Staël's designs often seemed to have

hidden figurative connotations, and in 1952 the figuration became specific. De Staël's method was now to paint pictures which had the simplicity and discipline of his abstract work, but which nevertheless resolved themselves, on a second glance, into something recognizable—a figure or a landscape (Plate 94). His great gift was as a colourist. Perhaps no painter of the time showed a greater control of powerful hues. At the end of his life, he wrote to the critic and collector Douglas

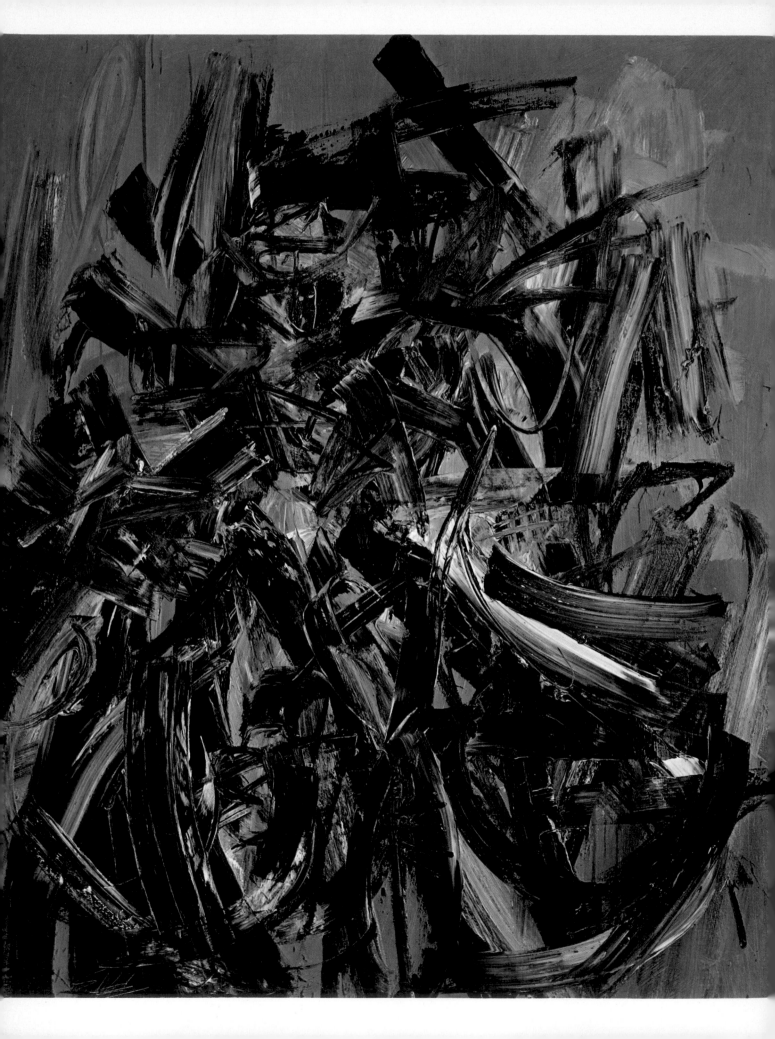

89. Opposite
Antonio Saura
Ingegerd
1958; 412.1 × 130.2 cm. (161 × 51 in.)
Brandeis University, Massachusetts, Rose Art Museum

90.
Antoni Tàpies
Large Painting
1958; 200.7 × 260.7 cm. (78 × 102 in.)
New York, Solomon R. Guggenheim Museum

Cooper: "The harmonies have to be strong, subtle, very subtle, the values direct, indirect, or even inverse values. What matters is that they should be true. That always. But the more the approach to this differs from one picture to another, the more absurd the way of achieving it seems, the more interested I am in pursuing it!"

It is possible to detect in this declaration, so apparently confident on the surface, a note of uncertainty. De Staël was pursuing not a synthesis of abstraction and figuration, but an impossible compromise—a method of painting which would give the finished canvas the acceptability of the figurative, and the new respectability which belonged to abstraction. His suicide, though ultimately attributable to personal tragedies, was also a response to an impasse in his work.

Of all the painters of the French school who

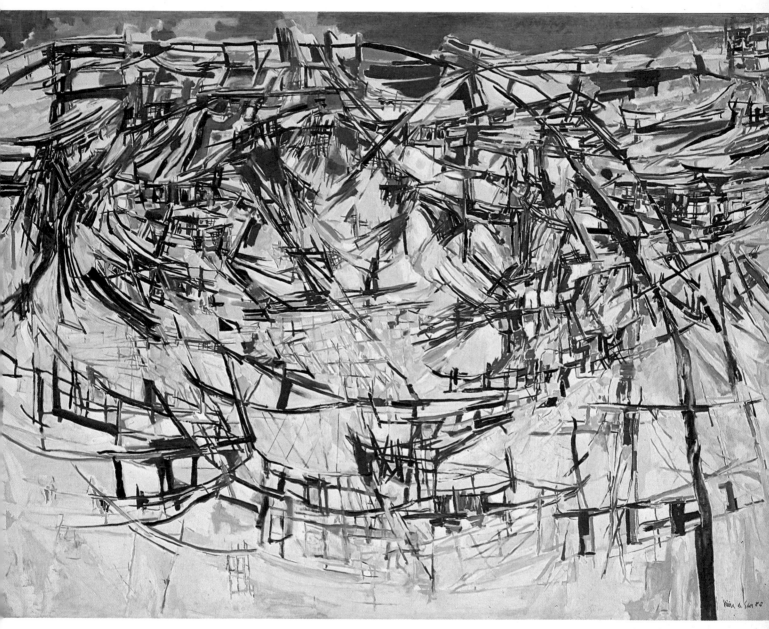

91. Opposite
Jean-Paul Riopelle
Suit of Stars
1952; 200 × 150 cm. (78 × 59 in.)
Cologne, Wallraf-Richartz Museum

92.
Vieira da Silva
Le Métroaérien
1955; 160 × 220 cm. (62 × 86 in.)
Düsseldorf, Kunstsammlung Nordrhein-Westfalen

93. Overleaft left
Vieira da Silva
Suspended garden
1955; 165 × 113 cm. (64 × 44 in.)
Paris, Musée National d'Art Moderne

94. Overleaf right
Nicolas de Staël
Figures au bord de la mer
1952; 161.5 × 129.5 cm. (63 × 51 in.)
Düsseldorf, Kunstsammlung Nordrhein-Westfalen

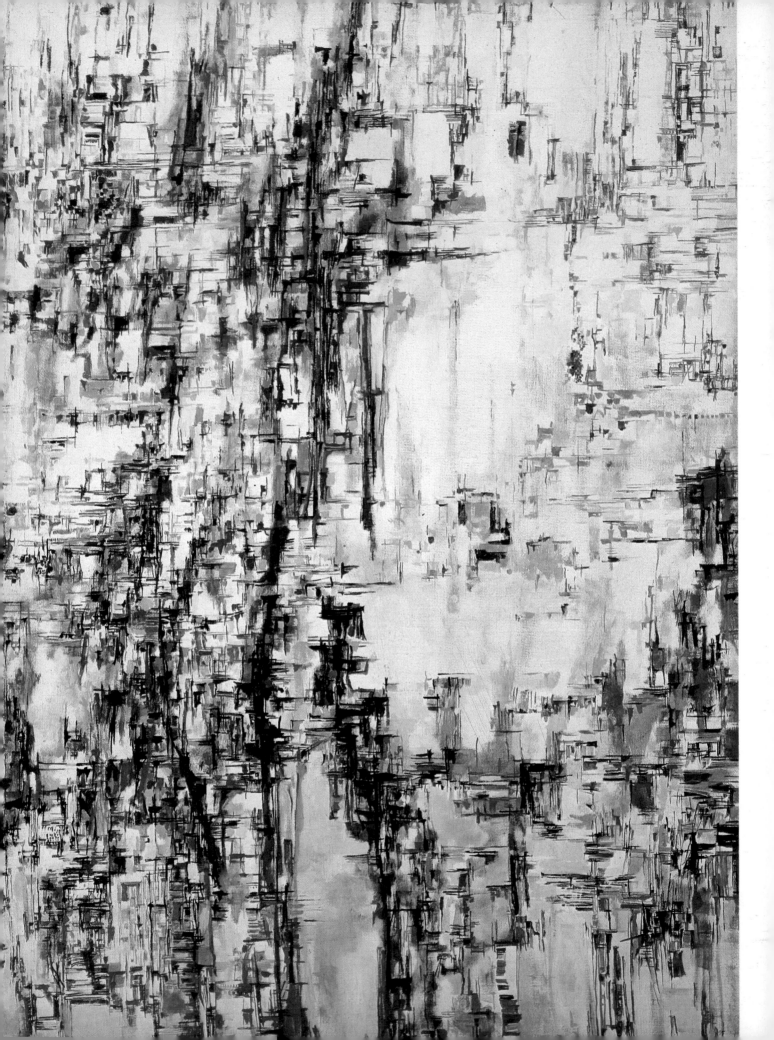

95. Opposite
Jean Dubuffet
Noeud au Chapeau
1946; 81 × 65 cm. (32 × 25 in.)
Stockholm, Moderna Museet

96.
Jean Dubuffet
Vie inquiète
1953; 130 × 195 cm. (51 × 76 in.)
London, Tate Gallery

have made a reputation after the war, the hardest to absorb, but ultimately the most significant, is Jean Dubuffet. Immensely prolific, Dubuffet is quite unlike any other post-war artist, though one may detect fleeting resemblances to a large number of different contemporaries. Born in 1901, he painted intermittently during the Twenties and Thirties. He did not turn to art full-time until 1942.

In the immediately post-war period, Dubuffet was influenced by the *haute pâte* technique of Fautrier and in a more general sense by the aesthetic of Paul Klee. A typical work of this period, like the *Noeud au Chapeau* of 1946 (Plate 95), shows the charm, the naïveté, the apparent lightness of what he was doing then. But beneath the frivolity lay a serious purpose. Dubuffet believed, for example, that there was more truth in child art and naïf art than in much so-called serious painting. From the Dadaists he had inherited a love of perversity, of "mistakes" and awkwardnesses which may or may not be deliberate. He preserves "The accidental blotches, clumsy blunders, forms clearly wrong, anti-real, colours that don't work and are inappropriate—all sorts of things that must be unbearable to some people and

97.
Jean Dubuffet
Menues pierres éparsés sur le chemin (Small Stones Scattered upon the Road)
1957; 120 × 148 cm. (47 × 58 in.)
Private collection

98.
Opposite
Jean Dubuffet
Topografia increspata
1959; 79 × 89 cm. (31 × 35 in.)
Vienna, Museum des 20. Jahrhundert

99. Overleaf left
Karel Appel
La Hollandaise
1969; 130 × 97 cm. (51 × 38 in.)
Paris, Galerie Ariel

100. Overleaf right
Karel Appel
Tête 2 (Femme cubiste)
1968; 166.5 × 126 cm. (65 × 49 in.)
London, Gimpel Fils

even make me a bit uneasy because they often destroy the effect. But I accept them, because in fact it keeps one aware of the painter's hand in the picture, and prevents the object from dominating and stops things taking shape too clearly" (artist's statement, catalogue of the Dubuffet exhibition, Tate Gallery, 1966).

In spite of this, Dubuffet is a master of his materials—one of the great "cooks" of contemporary art. He has the disconcerting habit of

101.
Pierre Alechinsky
Loin d'Ixelles
1965; 138 × 143 cm. (54 × 56 in.)
New York, private collection

102. Opposite
Lucebert (Lucebertus J. Swaanswijk)
The Golden Boy
1959; 64.5 × 52 cm. (25 × 20 in.)
Copenhagen, coll. Henny and Aby Besjakov

134

arriving at an effect or a surface for quite different reasons from what one might suppose. A painting such as *Small Stones Scattered upon the Road* of 1957 (Plate 97) looks at first glance like one of the all-over abstract compositions which both Americans and Europeans were then producing. But it has no ambitious programme behind it. Its intentions—quite literally—are down to earth.

Lacking pretentiousness, Dubuffet also lacks weight. His prolific output seems to stand to one side of the tradition of Modernist painting, just as the prose texts of his contemporary Francis Ponge stand aside from the main course of development of modern poetry. Ponge says that his ambition is to bestow upon any object he may happen to encounter "the good fortune to be born into words". Dubuffet offers the same chance-selected subject-matter the luck to be born into paint. Like Ponge, he recognizes "the object's basic rights, its inalienable rights in opposition to poetic objectives". Compared to Klee, however, Dubuffet seems to lack stringency. The rules of the games he plays, with himself and with the spectator, lack stringency.

There is sometimes a certain resemblance between Dubuffet's work with its reliance upon ideas taken from children's drawings, and the work of some members of the CoBrA Group. But there is also a fundamental difference of attitudes and sympathies. CoBrA represents a kind of Nordic protest against the attempt to renew the dominance of Paris, and we find in it more than a trace of the Expressionism of early Modernist masters such as Edvard Munch and Kirchner.

Despite this, CoBrA itself was formed at a meeting in a Paris café—by a group of painters from Denmark, Belgium, and Holland who named it by combining the first letters of the names of their respective native cities—Copenhagen, Brussels, Amsterdam. Prominent among them were Karel Appel, from Holland; the Belgians Pierre Alechinsky and Corneille; and the Dane Asger Jorn. Atlan, although of French Algerian origin, was also a member, but his work was never typical. The first CoBrA exhibition was held in 1949 in Amsterdam. This year also saw the publication of a magazine; it contained articles about children's art, folk art, and the art of schizophrenics.

The aim of the typical CoBrA painter was always the directest possible expression of personal fantasy: "My paint tube [said Karel Appel in 1956] is like a rocket which describes its own space. I try to make the impossible possible. What is happening I cannot foresee; it is a surprise. Painting, like passion, is an emotion full of truth and rings with a living sound, like the roar coming from the lion's breast" (quoted by Hugo Claus, *Karel Appel*, New York, 1962).

The bright colours of Appel's work (Plates 99 and 100) in fact convey an emotion very different from the one we find in the paintings of the pioneer Expressionists—something far less introverted and anguished. It is as if the artist now has such ready access to his own subconscious that he has little reason to fear what it contains. The same comment could be made about Alechinsky (Plate 101), whose work seems to invite a comparison with James Ensor's which it cannot sustain. Lucebert, another Dutch member of the group, repeats Appel's formulae in a more sombre key (Plate 102).

Corneille (Plate 103) is attracted to landscape rather than to the figure. His compositions are often distilled from experiences gathered during his extensive travels. Here one seems to feel the impact of the late Van Gogh—but can Van Gogh function as a mere tourist? Asger Jorn (Plate 104) was, though over-prolific and uneven, probably the most impressive of all the CoBrA artists. His paintings reflect his own wide-ranging curiosity and intellectual energy. We find in them allusions to magic, hermetic knowledge, alchemical secrets—the signposts are half-hidden beneath the turbulent paint surfaces. Jorn's lack of discipline is compensated for, in his best work, by the tremendous energy and commitment he displays.

Nevertheless, if we compare the work of any of the CoBrA group to their Expressionist predecessors of the period before the First World War, we are instantly aware that this is a lesser kind of art, one which has sacrificed complexity of allusion in return for apparent freedom. The anti-intellectual stance of the CoBrA painters now

makes their work seem simplistic, for all its restlessness of design.

The classic Surrealist movement, though it had lost much of its energy in the new conditions that prevailed after 1945, continued to put forth fresh shoots. A marginal but sympathetic role was played by the writer-painter Henri Michaux, whose calligraphic doodlings are an extension of his activity as a writer. He is one of the clearest examples of the direct link between the technique of automatic writing and automatism in painting (Plate 105). Michaux has said in this connection: "Instead of the one vision which excludes others, I would have liked to draw the moments that, placed side by side, go to make up a life. To expose the interior phrase for people to see, the phrase that has no words, a rope which uncoils sinuously, and intimately accompanies everything that impinges from the outside or the inside. I wanted to draw the consciousness of existence and the flow of time. As you would take your pulse" (quoted by John Ashbery, "Henri Michaux: Painter Inside Poet", *Art News*, Vol. 60, No. 1 [March, 1961], p. 65).

Even veristic Surrealism survived, and it attracted new recruits. One of the most powerful

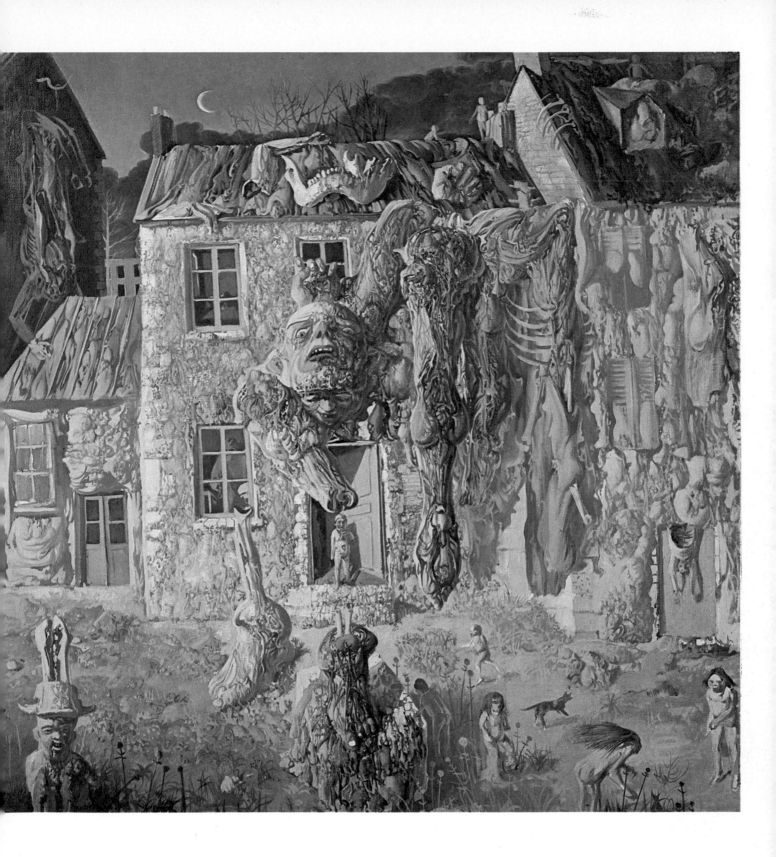

105. Opposite
Henri Michaux
Untitled
N.d. 49 × 64.5 cm. (19 × 25 in.)
Copenhagen, coll. Henny and Aby Besjakov

106.
Dado (Miodrag Djuric)
La Guerre civile
1967; 120 × 120 cm. (49 × 49 in.)
Paris, Galerie André François Petit

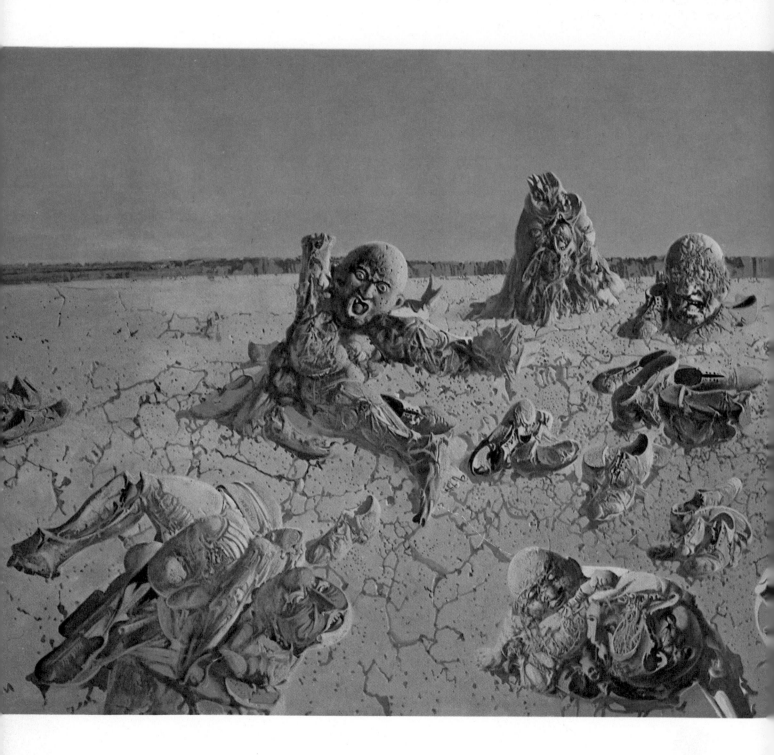

of these was the Yugoslavian artist Dado (Miod-rag Djuric), who made his way to Paris in the middle Fifties and made contact with Dubuffet. Compared to Dubuffet's wit and lightness, Dado's work (Plates 106 and 107) is curiously solemn.

One finds in it, though strangely transformed, the ambition to create those large-scale academic machines which obsessed the painters of the nineteenth century.

It is perhaps significant in this connection that

107.
Dado (Miodrag Djuric)
Grande plage bleue
1969; 162 × 403 cm. (63 × 157 in.)
Paris, Musée National d'Art Moderne, loan of the Centre
National d'Art Contemporain

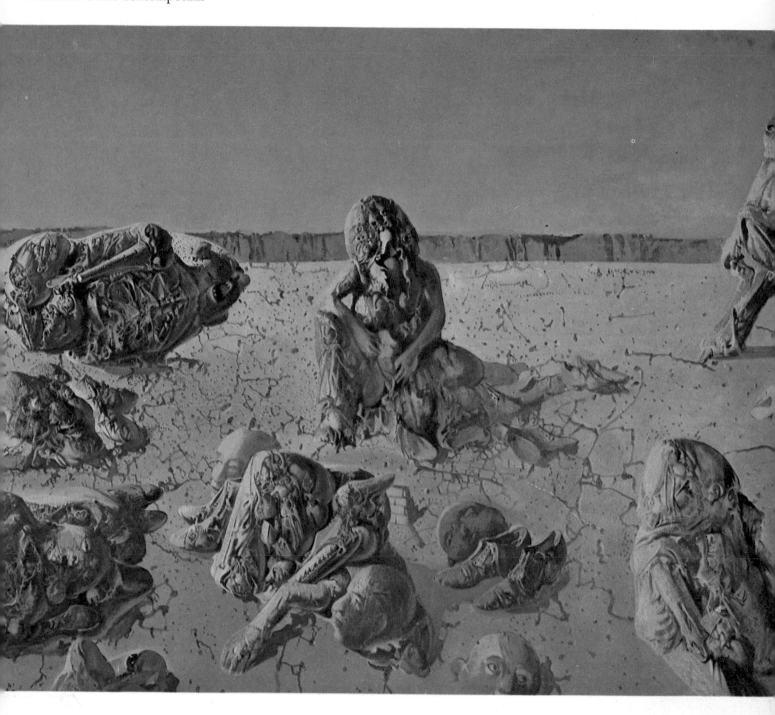

Dado comes from a country on the margin of the modern art scene. The place where veristic Surrealism has flourished most notably in the years since the Second World War is undoubtedly Austria. The work of Ernst Fuchs (Plate 108) is characteristic of what came to be dubbed the Vienna School: "His dreams and nightmares [one critic has written of Fuchs], as transmitted in his paintings, are autobiographical to the point where his own visage frequently emerges in his repre-

108.
Ernst Fuchs
Die Hochzeit von Unicorn
1952–60; 71 × 36 cm. (28 × 14 in.)
Vienna, collection of the artist

sentations of saints and deities. With biblical symbols and century-old techniques Fuchs creates complex ikons that speak of death and transfiguration and reflect his belief in redemption" (H. Seldis, "The Vienna School", *Art International*, Vol. X, No. 4 [April, 1966], p. 47).

What one notes in the work of Fuchs and his Viennese colleagues—among them Erich Brauer, Wolfgang Hutter, and Anton Lehmden—is the reversion to medieval modes. Hieronymus Bosch is as conspicuous an influence on their work as Yves Tanguy or Dali, and they have turned back to conservative values that André Breton would have condemned. Their art seems an appropriate expression of the provincialism of the Austrian cultural situation.

The emergence of "national" schools of this kind was, however, the exception rather than the rule in the conditions that prevailed after 1945. In the European democracies modern painting made an enormous upsurge. It matched in quantity, if not in quality, what was happening in the United States in the same epoch, and it established for itself a more or less international language. Any stylistic innovation was rapidly transmitted from country to country. The main organs of dissemination were exhibitions, art books and magazines, and the so-called dealer-critic network.

Major exhibitions of modern art were now a regular feature of the cultural scene in most capital cities. Museums were in the process of democratizing themselves and were making strenuous efforts to reach a new mass public. And this public was itself in the throes of making art into a kind of secular religion. The artist was increasingly admired as the ideal towards which everyone aspired—the truly liberated man. Technical progress in printing and publishing, and especially improved methods of colour reproduction, soon made the publication of art books one of the most flourishing activities of the whole European publishing industry, a situation which benefited modern art even more than it did the visual arts in general, as it was now worth a publisher's while to take the risk of producing books about it, given the seemingly inexhaustible thirst for new titles. The leading art magazines had a particularly strong impact on young students of painting and kept them keenly aware of new developments.

The dealer-critic network—the world of the private dealers and the critics who promoted their wares—was at its most powerful in the Fifties and early Sixties, because modern art itself had not as yet rebelled against the commercialism of the market. The Fifties witnessed a boom in contemporary art which matched the boom generated by the new industrial money of the nineteenth century. Abstract paintings sold almost as easily as the works of Ernest Meissonier had done eighty years previously. The fifteen years after 1945 saw modern art in perhaps the least self-questioning phase of its existence.

Assemblage and Neo-Dadaism

The renewed interest in collage and *assemblage* techniques, signalled by an important exhibition entitled "The Art of Assemblage", held at the Museum of Modern Art in New York in 1961, was visible evidence not so much of a change in attitude towards materials and the way they were used as of a change in the artist's attitude towards the society he lived in.

There had been no break in continuity from the days of Cubism and early Surrealism so far as technique itself was concerned. Throughout the Thirties and Forties artists had continued to explore the freedom which collage gave them. The American artist Joseph Cornell, for instance, had been making small-scale poetic *assemblages* in boxes since the early Thirties. His first one-man show, held at the Surrealist-oriented Julien Levy Gallery in New York in 1932, was entitled "Minutiae, Glass Bells, Shadow Boxes, Coups d'oeil, Jouets surréalistes". Cornell's work (Plates 109–110) perfectly exemplifies the point made by William C. Seitz in a book issued in connection with the "Art of Assemblage" show: "Figuratively, the practice of assemblage raises materials from the level of formal relations to that of associational poetry, just as words and numbers, on the contrary, tend to be formalized. Transmutation tends also to move in the opposite direction in Abstract Expressionist painting, in which the subject is absorbed into the medium" (William C. Seitz, *The Art of Assemblage*, New York, 1961, p. 84).

One must not, however, conclude that *assemblage* techniques were entirely hostile to the Abstract Expressionist sensibility. Alfonso Ossorio, a Philippine artist closely associated with the New York School, started to develop an elaborate collage technique during the late Fifties and employed it to increasing effect during the following decade (Plates 111, 112, and 113). In his work the frenzied accumulation of heterogenous forms and materials provides an equivalent for the complicated calligraphy one discovers in a Pollock, and serves the same purpose, to reveal the personal sensibility of the artist.

In fact, one of the striking things about *assemblage* is that the method itself tends to preclude the idea of a style. It can be used to great effect for humorous purposes, for example. The imaginary portraits created by the Italian artist Enrico Baj teeter just on the verge of caricature (Plates 114 and 115); they are first cousins to the kind of Saul Steinberg cartoon that would be printed in *The New Yorker*. Baj creates a dialogue between the materials used and what is being portrayed. The oddments of military finery which appear in Baj's collage *The General* are not there simply because they happen to be appropriate to the subject (though indeed they are). They are also present because the artist can use them to create exactly the form he wants. Comment and structure are fused, and a quality of visual punning gives the work its special flavour.

Compared to many of the artists who began to employ *assemblage* in the late Fifties and early Sixties, Baj is, however, unadventurous and retrograde. Having discovered a pleasing formula, he is quite content to stick to it. His work has none of the disturbing quality which fills that produced by the two Americans who are now most commonly thought of as the link between Abstract Expressionism and the Pop Art which was to follow. Jasper Johns and Robert Rauschenberg do indeed provide this link, but their work has other connections and characteristics which are perhaps even more important in the development of art after 1945. For one thing, they were the twin standard-bearers of the Dada revival which was to have such a tremendous influence over the thinking of all young artists during the 1960's and early 1970's. The revival itself had started as early

147

109.
Joseph Cornell
Bird in a Box
1943; 32 × 29 × 7 cm. (12 × 11 × 3 in.)
Krefeld, Kaiser Wilhelm Museum, coll. Lauffs

110.
Joseph Cornell
A Pantry Ballet (for Jacques Offenbach)
1942; 26.7 × 45.7 × 15.2 cm. (10 × 18 × 6 in.)
New York, coll. Mr. and Mrs. Richard L. Feigen

as 1951, when the leading Abstract Expressionist painter Robert Motherwell published an important anthology devoted to the work of the Dada painters and poets. But it was Johns and Rauschenberg who changed Dada from being a historical phenomenon, something safely encapsulated and neutralized, into something which was once again vivifying and controversial. In his introduction to the catalogue of the Jasper Johns retrospective exhibition held at the Whitechapel Art Gallery, London, in 1964, the American critic Alan R. Solomon wrote: "The plain fact remains that the issues of sensibility raised by Dada (apart from whatever significance it may or may not otherwise have), and subsequently raised again by the new generation of American artists, together with a broad re-examination of the meaning of objective reality stimulated by exploration of these issues, challenge all of our basic premises defining the aesthetic experience." A statement of this kind would have been unthinkable even a decade before. The rapidity as well as the magnitude of the change wrought in modern art during the late Fifties is a tribute to the influence exercised by these two American artists.

Of the two, it is Rauschenberg who at first seems the more accessible. Lawrence Alloway remarks: "Johns's imagery is characteristically monolithic—with a massive central object—or serial, as in the parades of alphabets or numbers. Rauschenberg's work is characteristically scenic, with a cluster of points of equivalent interest distributed like islands. Where Rauschenberg accepts the abundance which jumps fully formed from society's head, Johns is elegiac or memorial. . . . Rauschenberg's art samples a plenty that reflects both the sensory input of the city dweller and the industrial output of material goods and waste. Johns's art is concerned with subtle minimums, laconic in style and sceptical in timing.

He opposes a malicious monumentality to Rauschenberg's documentary sense" (Lawrence Alloway in *Figurative Art since 1945*, London, 1971, p. 202).

This description admirably establishes the parameters within which the two artists seem to operate. The most formative part of Rauschenberg's early career was undoubtedly the years 1948–49, which he spent at the experimental Black Mountain College in North Carolina. This institution was briefly the focus of a number of important talents. Albers taught there, and so did the poet Charles Olson. Rauschenberg's most important contact was not with these but with the avant-garde composer John Cage. It was Cage who implanted in Rauschenberg's mind the notion of "acting in the gap between art and life" which was to result in the creation of the combine-paintings and combine-objects which are his most typical productions.

Works such as *Interview* (Plate 117) or *Retroactive I* (Plate 116) undoubtedly contain elements that

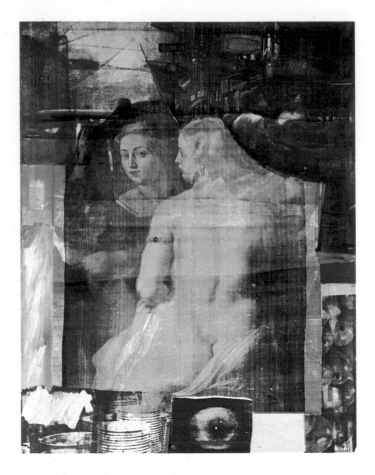

(G. S. Whittet, *Studio International* [April, 1964], p. 158). To which another critic has subsequently replied: "Life has penetrated his work through and through, and each work, rather than impose a definition of art, springs from a questioning of all the possible contexts in which art can happen" (Andrew Forge, *Rauschenberg*, New York, 1970, p. 15).

In fact, these comments probably set the boundaries too wide. Rauschenberg is undoubtedly experimental not merely because that is what a modern artist ought to be, but because he himself is possessed by the spirit of exploration. The famous combine-object *Monogram* (Plate 120) of 1955–59, whose principal component is a stuffed goat, proposes to the spectator a dizzying leap of sensibility. How and why should this be considered a work of art? It is only a work of art if the conjunction of elements provides a certain kind of *frisson*, and that *frisson* can no more be explained than the psychic shock that the reader gets from certain images in modern poetry.

But much of Rauschenberg's work does not impose such strenuous tests. One of the logical elements in his creative career has been his relationship to the urban and technological society which surrounds him. The conjunctions of imagery which we discover in what he does are not juxtapositions peculiar to himself, but ones which assail us at every moment of urban existence. Rauschenberg was the direct pioneer of many of the innovations afterwards attributed to Pop Art. In 1955, he made a series of paintings using comic strips. He has also interested himself in the distortions imposed on the art of the past by modern techniques of mass reproduction. We frequently find in the combines the notion of re-using and recycling urban detritus, of "redeeming" it, as Schwitters did before him.

But Rauschenberg does not confine his associative leaps (the ones he makes himself and the ones he imposes on the spectator) to purely contemporary and popular material. He has a habit of using his work to reflect aspects of the art and culture of the past. A striking example of this is the series of drawings made as illustrations to Dante's *Inferno*. In creating these Rauschenberg was

derive from Abstract Expressionism. As late as 1964 Max Kozloff was afraid that the artist would "continue to be dismissed as a belated Abstract Expressionist, one whose dribbles and splatters of paint have merely thinned and shrunk to give way to objects or reproduced images of daily life". But in fact his originality was quickly recognized. To the fluidity which was a leading characteristic of the painting of the Pollock-Kline group of Abstract Expressionists, he opposed images which remained discrete and themselves, which insisted on maintaining a value and identity which had nothing to do with their own presence in the picture. This put traditional criticism in a dilemma. As one reviewer remarked, concerning the retrospective at the Whitechapel Art Gallery which made Rauschenberg's European reputation: "Art by being absent does nothing to assist our reaction to life; Rauschenberg offers *neat* life; it is for us to find the art in it for ourselves"

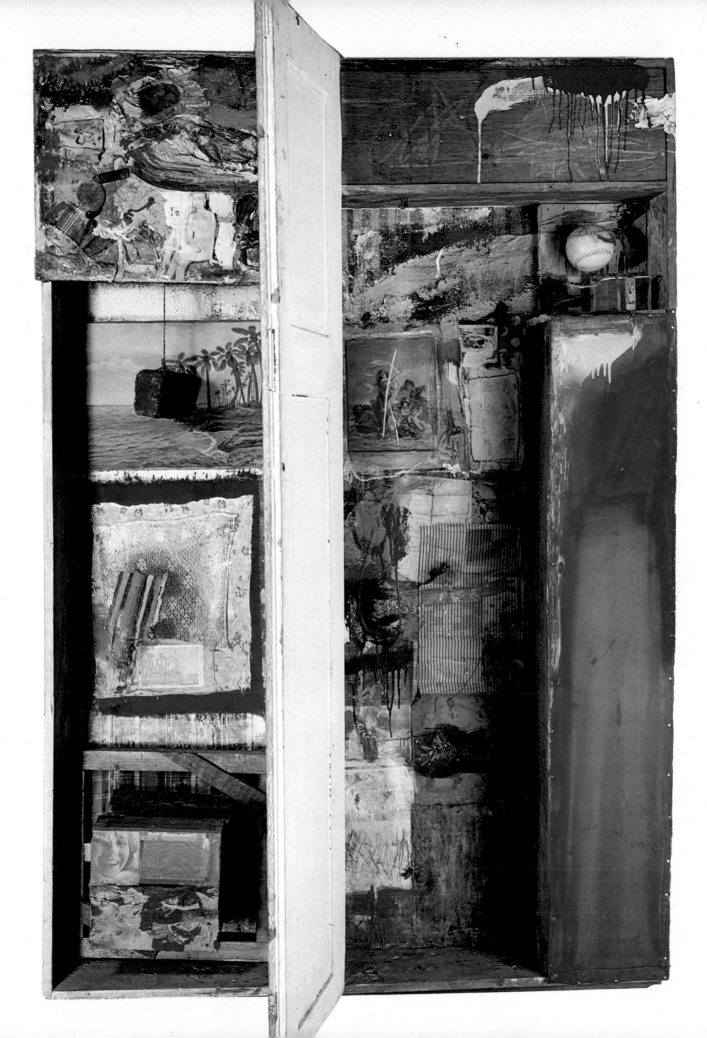

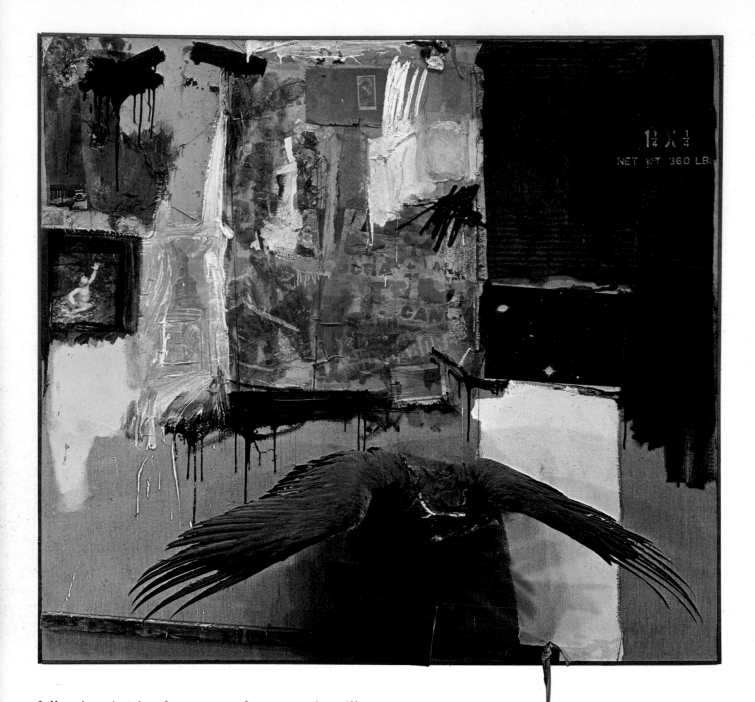

following in the footsteps of many other illustrators of Dante, among them William Blake and Sandro Botticelli. His achievement is to show the continuing relevance of the great poet, by relating his poem directly to the things we see about us. The city, he reminds us, may be a mechanism for alienation, but on the other hand it offers the key to many varieties of human achievement. The great museums are as typically urban as slums and decaying rubbish dumps.

Jasper Johns's career offers many parallels with Robert Rauschenberg's, and, at a crucial point in their joint development, the two artists shared a New York studio. Johns, too, has concerned

118.
Robert Rauschenberg
Canyon
1959; 216 × 176 × 58 cm. (84 × 69 × 23 in.)
California, Pasadena Art Museum

156

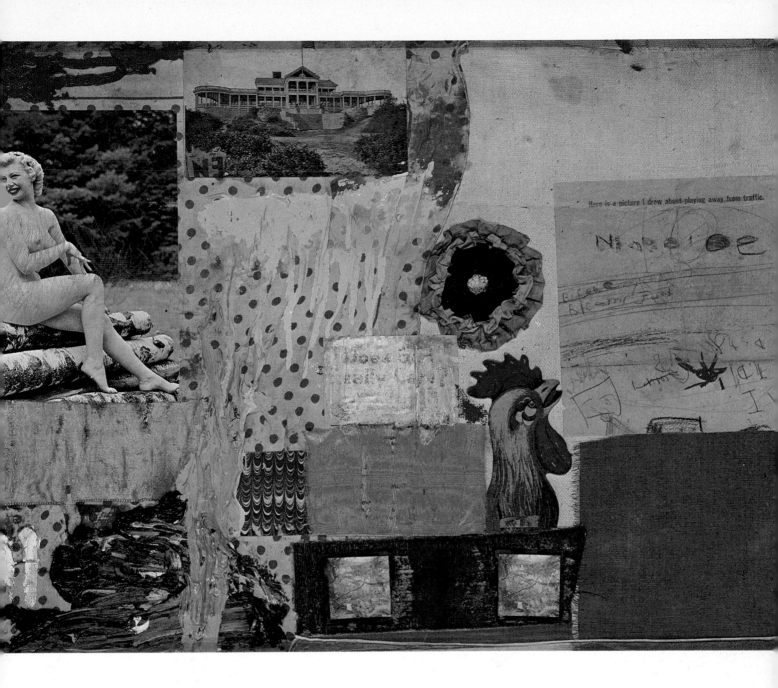

119.
Robert Rauschenberg
Untitled
1955; 39.4 × 52.7 cm. (15 × 21 in.)
New York, coll. Jasper Johns

120. Overleaf
Robert Rauschenberg
Monogram
1955 59; 163 × 160.5 × 95 cm. (64 × 63 × 37 in.)
Stockholm, Moderna Museet

himself with the different layers of reality: "I am concerned with a thing's not being what it was, with its becoming other than what it is, with any moment in which one identifies a thing precisely and with the slipping away of this moment, with any moment seeing or saying and letting it go at that" (quoted by G. R. Swenson, "What is Pop Art? Part II, Jasper Johns", *Art News*, Vol. 62, No. 10 [February, 1964], p. 43).

Assemblage is very much part of Johns's technical armoury, and there is, too, a popular, urban component in his work. But unlike Rauschenberg he is not tremendously interested in recording the way that urban experience impinges

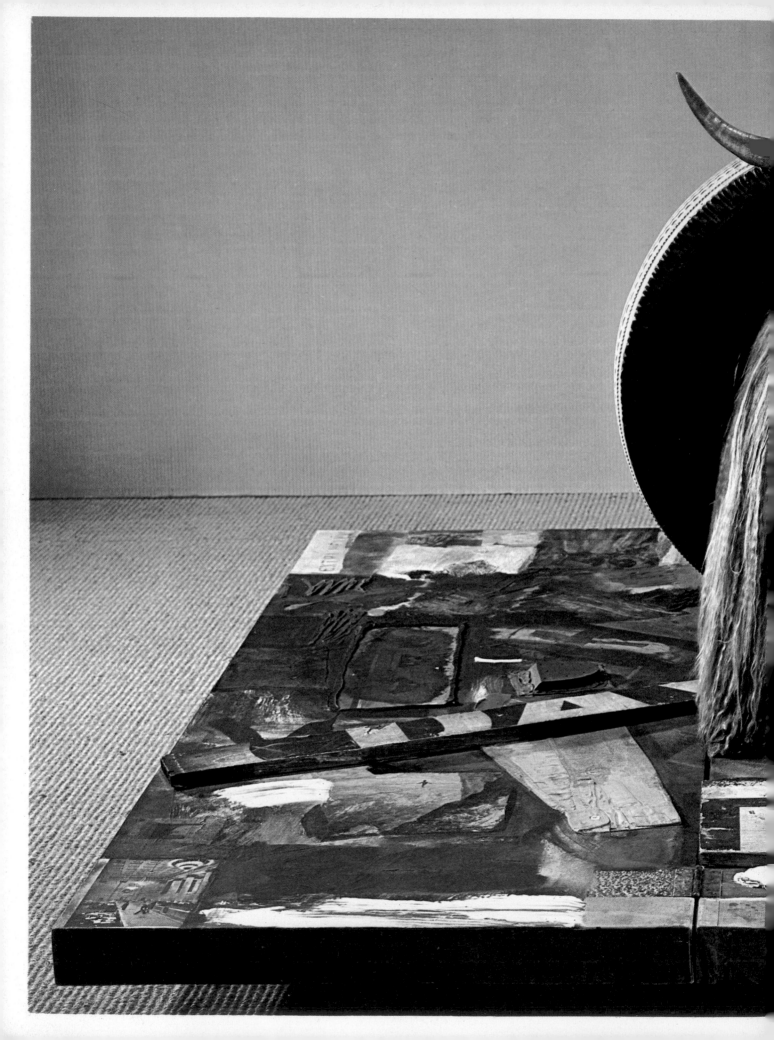

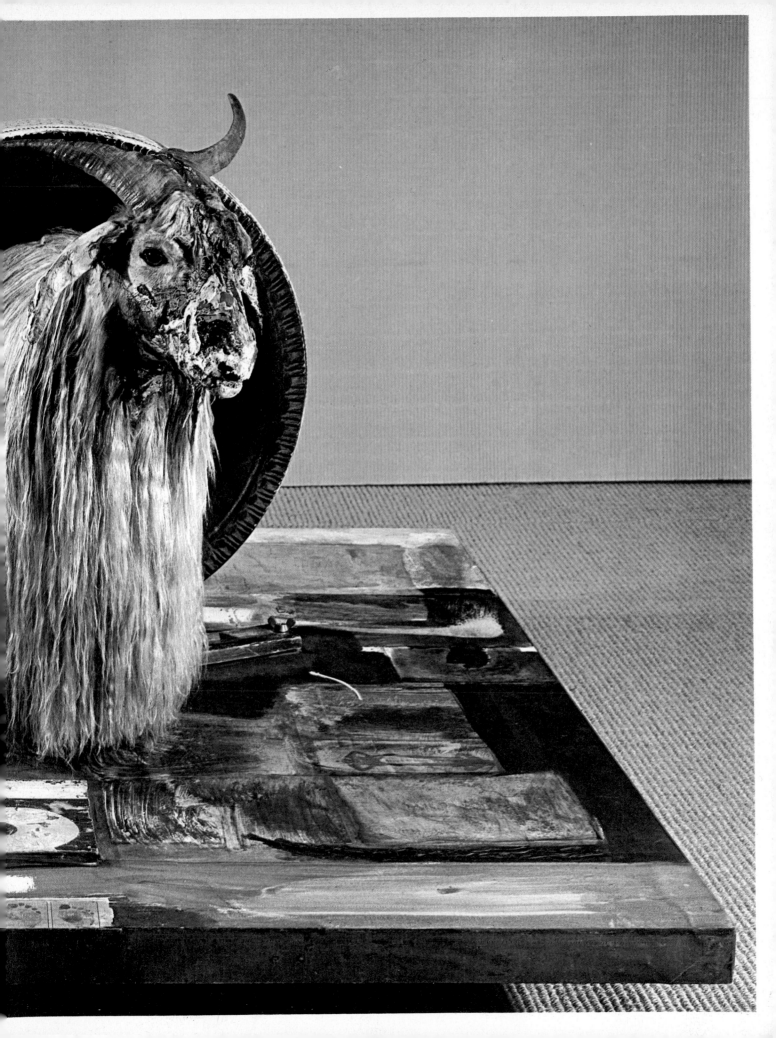

upon his own sensibility. His work has ikon-like characteristics which link it directly to that of a man like Rothko upon the one hand and to Pop artists such as Roy Lichtenstein and Andy Warhol upon the other. In a series of works painted during the middle Fifties he used the American flag as his chosen image (Plate 121). The familiar pattern is presented completely frontally, so that the spectator is forced to ask himself what difference exists between a real flag and this simulacrum of one which is presented as "art". Johns himself said that he chose for his iconography "things the mind already knows. That gave me room to work on other levels." His view is that "Meaning is determined by the use of a thing, the way an audience uses a painting once it is put in public."

An examination of Johns's flag paintings does

nevertheless reveal an "art" component of a perfectly traditional kind. This is to be found in the way they are painted. For these works Johns made use of encaustic, a medium he handles with the utmost refinement, and the marks that go to make the image, though in no sense rhetorical or even gestural, are instantly recognizable as the artist's personal handwriting.

Another inert sign which Johns made use of at this period was the target. Subsequently targets were to have a long career in American art and were to be used for a number of different reasons. Johns's reason does seem to be connected with the function of a target as a mark to be aimed at. One of the best-known works from this particular series is the *Target with Four Faces* of 1958 (Plate 122). The faces are life masks of a nose and mouth

160

only. They are identical and are placed in a row above the target itself. Situated thus, they have an air of vulnerability which is disturbing. But, as if to protect the spectator from any discomfort he might feel, the faces are provided with a hinged cover which can be used to conceal them.

This, however, is only one possible interpretation of a profoundly ambiguous work. Lawrence Alloway, discussing it, sees the principal function of the faces as being to reinforce the symmetry of the target itself, thanks to the repetition of identical forms. This repetition, he believes, cancels out any sense of mutilation we might have because the mask is incomplete. "The whole form of the target . . ." he adds, "is echoed by the all-or-nothing cover."

123.
Jasper Johns
Painted Bronze II: Ale Cans
1964; 137 × 20 × 11.2 cm. (53 × 9 × 4 in.)
New York, collection of the artist

124. Opposite above
Jasper Johns
The Critic Smiles
1959; 4 × 18.1 × 3.8 cm. (2 × 7 × 1 in.)
New York, collection of the artist

125. Opposite below
Jasper Johns
High School Days
1964; 30 cm. (12 in.)
New York, collection of the artist

126.
Yves Klein
Suaire ANT-SU 2
1962; 128 × 66 cm. (50 × 26 in.)
Stockholm, Moderna Museet

127. Opposite
Yves Klein
Relief eponge bleu: RE 19
1958; 200 × 165 cm. (78 × 64 in.)
Cologne, Wallraf-Richartz Museum

Johns's irony and ambiguity link him very closely indeed to Duchamp, and the link is stressed by a small series of Sculpmetal objects, which are the American artist's equivalent of the Duchamp ready-mades. One, a pair of beer cans on a plinth, is said to have been made as a retort to the remark that Johns's dealer, Leo Castelli, "could sell anything, even a can of beer". Another, *The Critic Smiles*, features a toothbrush and is a directer-than-usual assault on the state of criticism.

The most endearing of these objects is probably the one the artist has entitled *High School Days* (Plate 125). This is a Sculpmetal cast of a teen-ager's shoe. Johns means it to be emblematic, not only of aspects of the American growing-up process, but also of his own nostalgia for that period in his own life. At the same time we are conscious of a deliberate attempt—also discernible in the paintings of flags and of the maps of the United States—to acclimatize the avant-garde in terms which would be purely American. In this sense Johns continued the effort already begun by the Abstract Expressionists.

That which most closely corresponded to what Johns and Rauschenberg were doing, so far as Europe was concerned, was the work of the New Realism group, organized by the French critic Pierre Restany. New Realism did not officially come into being until 1960, though a number of the artists who participated in the group had already made reputations for themselves during the late Fifties. Among the founding members were Yves Klein, Fernandez A. Arman, Martial Raysse, Daniel Spoerri, and Jean Tingueley. The sculptor César gave his adherence soon afterwards, and a later recruit was the Bulgarian artist Christo. Some of these members, such as Raysse and Tingueley, no longer seem particularly relevant to the aims of New Realism. Raysse is better considered in the context of European Pop Art and Tingueley in that of Kineticism.

The striking personality was Yves Klein. Restany relates how Klein, on the beach at Nice in 1946, when he was eighteen, received a revelation of the "energetic infinity" of the sky. Because birds in their passage disturbed the purity of the blue he saw above him, he wanted to kill them.

128. Opposite
Yves Klein
Monogold: MG 18
1961; 78.5 × 55.5 cm. (31 × 22 in.)
Cologne, Wallraf-Richartz Museum

129.
Fernandez Arman
Poubelle I (Dustbin I)
1960; 65 × 40 × 10 cm. (25 × 16 × 4 in.)
Krefeld, Kaiser Wilhelm Museum

130. Overleaf left
Fernandez Arman
Nucléide
1964; 123 × 92 cm. (48 × 36 in.)
Amsterdam, Stedelijk Museum

131. Overleaf right
Fernandez Arman
Soyeux Temps modernes: accumulation d'engranages
1965; 79.5 × 60 cm. (31 × 23 in.)
Paris, Galerie Mathias Fels

What Restany calls the "tendency towards a visionary monopoly" was early implanted in the artist.

In practical terms, the results were unpredictable. Klein was one of the most gifted creators of artistic scandals of his time and, until his premature death in 1962, managed to keep the European art world in a ferment. Klein's drive was always towards the boundless, the immaterial. This was the real point of the exhibition he staged at the Iris Clert Gallery in Paris in April, 1958. This was entitled "*Le Vide*"—"The Void"—and at the preview the invited guests discovered that the artist meant precisely what he said. The gallery walls were entirely bare, and the space was "sensitized" only by the artist's presence.

Later Klein was to say: "To sum up, mine is a dual proposal: first of all to record the imprint of man's affectivity in present-day civilization, and then to record the trace of precisely that which has engendered the same civilization, which is to say, that of fire. And all this because my essential preoccupation has always been with the void, and I hold it as assured that, in the heart of the void as in the heart of man, there are fires that burn" (written in New York in 1961; from the catalogue of the exhibition "Yves Klein", Iolas Gallery, Paris, 1965).

These words were written in connection with the group of paintings in which Klein used "natural" forces to achieve his effects: a flame-thrower, rain falling on a canvas which was first tied to the roof of a car, then driven through the wet. But Klein experimented with a number of other methods as well. For example, he made use of human paintbrushes. Girls were asked to strip and then to dip their bodies in paint. After this they impressed their outlines upon the canvas, or allowed themselves to be dragged across it (Plate 126). Klein often turned these painting sessions into public ceremonies—some people count them among the earliest happenings. His genius for publicity certainly at least equalled that of Mathieu.

Today his most typical works seem to be his monochromes. Many of these were painted in a special shade of blue which the artist patented under the name of International Klein Blue (Plate 127). The sponges attached to the surface of some examples were another favourite material of Klein's, presumably because the substance was both formless and absorbent. Perhaps the most beautiful of all the monochrome works are the *Monogolds*. These are usually dented as if the artist had struck them with a padded hammer, as if to draw attention to the parallel between resonance of sound and the visual resonance of the surface (Plate 128).

There is a strong resemblance between these *Monogolds* and the plain gold screens sometimes produced by the Japanese. This draws attention to the link between Klein's cosmic transcendentalism and Zen philosophy. This connection is not an accidental one. Klein, in addition to his activities as an artist, was an expert in judo, and wrote a handbook on the subject. The strong element of Dada provocation in his activities must therefore be balanced against a strain of quietism which also appears in the work of Johns and Rauschenberg. Rauschenberg, for instance, produced a series of all-white paintings during his sojourn at Black Mountain College, in which the only "figuration" was produced by the cast shadows of those who moved in front of them. Zen, of course, exercised a profound influence over the musical activities of John Cage.

Klein's closest associate—they were friends from the time of their youth in the South of France—was Arman. But the latter did not develop rapidly as an artist. From 1946, when he first met Klein, until 1956, he was no more than a Sunday painter, recapitulating the historical progression of Modernist styles from Fauvism to abstract post-Cubism. After this he progressively abandoned the practice of painting, in favour of a method of accumulation—what he came to call "the language of quantity". Objects would be presented in random accumulations, as in the *Dustbin I* of 1960 (Plate 129). To show the chance-selected contents of a dustbin as a work of art is surely an idea to delight any Dadaist. Another gambit of Arman's was to embed a mass of objects of the same type in a matrix of liquid polyester, which imparted to them a spurious preciousness

171

135. Overleaf
Daniel Spoerri
Tableau Piège
1966; 109 × 185 × 30 cm. (43 × 72 × 12 in.)
Paris, Galerie Mathias Fels

and glamour, as if the cogwheels in *Nucléide* (Plate 130) were diamonds in a jeweler's shop-window Arman said, in the catalogue-preface to a retrospective exhibition of his work held at the Stedelijk Museum, Amsterdam, in 1969: "My technique of accumulation consisted in allowing [the objects I used] to compose themselves. In the long run there is nothing more controllable than chance. Since chance depends on laws, on quantity, for instance, it is no longer chance. Chance is my basic material, my blank page." The last sentence of this quotation might certainly have been attributed to Duchamp rather than to Arman.

The effect of these random accumulations is nevertheless not particularly Duchampian. They have a quality of "all overness" which immediately reminds one of the compositional formulae of a drip painter, such as Pollock. As with Pollock's work the eye is given no place to settle. One's glance continually zigzags across the surface of the composition, without being able to decide what the most important segment of it is.

Arman was not the only artist using *assemblage* as a primary method to employ random accumulation as a method of composition which superseded more traditional ones. The wooden relief composed of piano parts by Vic Gentils illustrated here (Plate 132) is close to Arman's *assemblages* that use destroyed violins as their basic material. The same can be said of *Film Star* (Plate 133), which is the work of another English artist, John Latham. *Film Star* was produced at a time when Latham's basic concern was with mutilated books, and it is interesting to recall the moral shock which these works caused when they were first shown in England—something perhaps out of proportion to their real originality. Arman's dismembered musical instruments have a similar effect. We feel, rightly or wrongly, that the artist has in fact made a significant choice, in choosing to assault an object emblematic of traditional cultural values.

Arman is certainly capable of the kind of black humour which has always been associated with Dada and Surrealism. Perhaps the best known of all his works is the *Glove Torso* of 1967 (Plate 134). This uses the familiar method of embedding a

large number of objects, all of them belonging to a single category, in transparent polyester. On this occasion the objects are a multitude of rubber gloves, and the polyester has been shaped to form a female torso. The effect is not neutral but powerfully erotic. It is as if the gloves are hands, feeling this resilient flesh. They may be a doctor's hands, conducting some kind of intimate and slightly humiliating medical examination. Or else they may be the hands of someone who is making a sexual assault on the woman.

Other members of the New Realist movement who call for a comment here are Daniel Spoerri and Christo. Spoerri is of Roumanian birth and began his career as a dancer. He has been a pioneer in several fields, for example in that of multiple art, but is best-known for his "trap-pictures" (Plate 135). This particular example shows a selection of objects from the artist's room. The aim is not to produce a work of art in any conventional sense, but to take possession of a particular moment. Spoerri himself describes the method employed as follows: "Situations discovered by chance in order or disorder are fixed (trapped) just as they are upon their support of the moment (chair, table, box, etc.), only the orientation with respect to the spectator is altered. The result is declared to be a work of art (attention—work of art). What was

horizontal becomes vertical—for instance, the remains of breakfast, put on a board resting on a chair, are fixed in their positions, and the whole thing hung on the wall" (statement from the catalogue of Spoerri's exhibition at CNAC, Paris, 1972).

The trap-pictures often have a somewhat sinister air, and Spoerri's work has in fact grown increasingly black in mood. One series called *The Dangers of Multiplication* consisted of a number of boxes with the bones of rats, a child's shoes, and other debris. In the early Seventies, Spoerri made a group of works with death as their announced subject matter. In these he employed the cadavers of animals and the weapons used to kill the victims. Yet, at the same time, he is one of the artists who have tried to break down the museum situation, and who have wanted to marry avant-gardism to populism. In 1965, for instance, Spoerri opened his hotel room at the Hotel Chelsea, New York, as a public exhibition.

Christo is famous for his obsession with the mysteriously wrapped object (Plates 137 and 138). It seems that there is nothing he will not attempt to turn into a package, from an adding machine to a mile-long stretch of coastline in Australia. The direct ancestor of these *empaquetages* is the wrapped sewing machine by the American Dadaist and photographer Man Ray, which its author has entitled *The Enigma of Isidore Ducasse*. Christo's intention is identical: to evoke disquiet by alienating the everyday.

An artist who did not participate in the New Realist movement, but who seems in some respects closely related to both Spoerri and Christo, is the Greek-American Lucas Samaras. Samaras, like Joseph Cornell, puts much of his work into boxes. But the boxes are not chosen merely for convenience of format. Samaras from early childhood has been fascinated by the idea of erotic, forbidden objects. His boxes have strongly sadomasochistic overtones (Plate 139). Samaras seems to regard art chiefly as a means of "declassifying hush-hush feelings", whatever these may happen to be. This was certainly the motivation for a long series of Polaroid self-portraits which he exhibited at the Kassel

139.
Lucas Samaras
Untitled
1966; 21.6 × 27.9 × 20.3 cm. (8 × 11 × 8 in.)
California, coll. Robert Halff and Carl W. Johnson

140.
Edward Kienholz
Gossip
1963; 60 × 35 × 45 cm. (23 × 14 × 18 in.)
Los Angeles, coll. Mr. and Mrs. Melvin Hirsh

141. Opposite
Edward Kienholz
Odious to Rauschenberg
1960
Los Angeles, coll. Mr. and Mrs. Melvin Hirsh

Documenta of 1972. These made an extraor-dinarily candid record of both physical and spiritual self-obsession.

The wide range open to the assemblagist is neatly illustrated by the contrast between Samaras's boxes and the vast environments often con-structed by another American, Edward Keinholz, whose enormous political tableau, *Five Car Stud*, was shown in the same Kassel Documenta. This represented the castration of a Negro by five southerners, who have caught him drinking at night in his pick-up truck with a white woman. A tableau of this type is a precise contemporary equivalent of the large-scale historical scenes (Paul Delaroche's *The Execution of Lady Jane Grey* is a well-known example) which it was customary to exhibit in the large Salons of the nineteenth century.

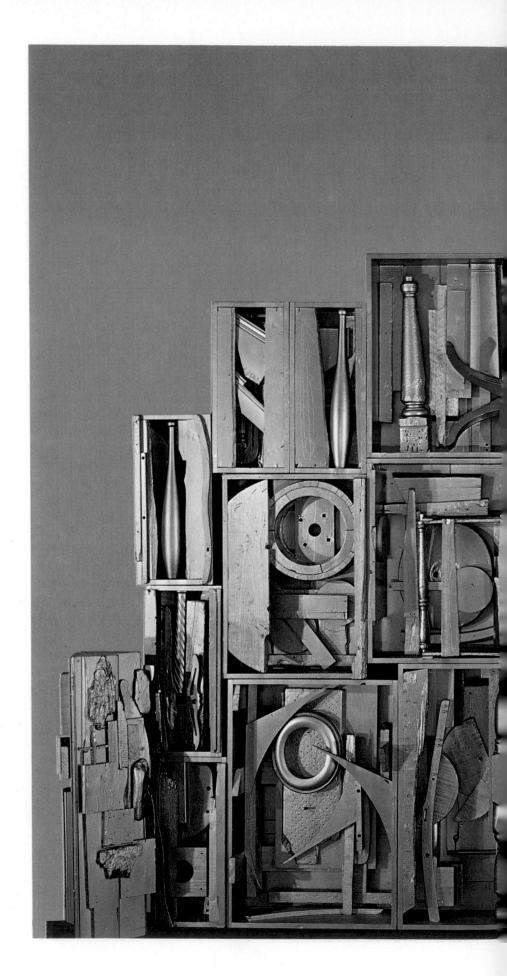

142.
Louise Nevelson
Royal Tide IV
1960; 335.3 × 426.7 cm. (131 × 166 in.)
Cologne, Wallraf-Richartz Museum

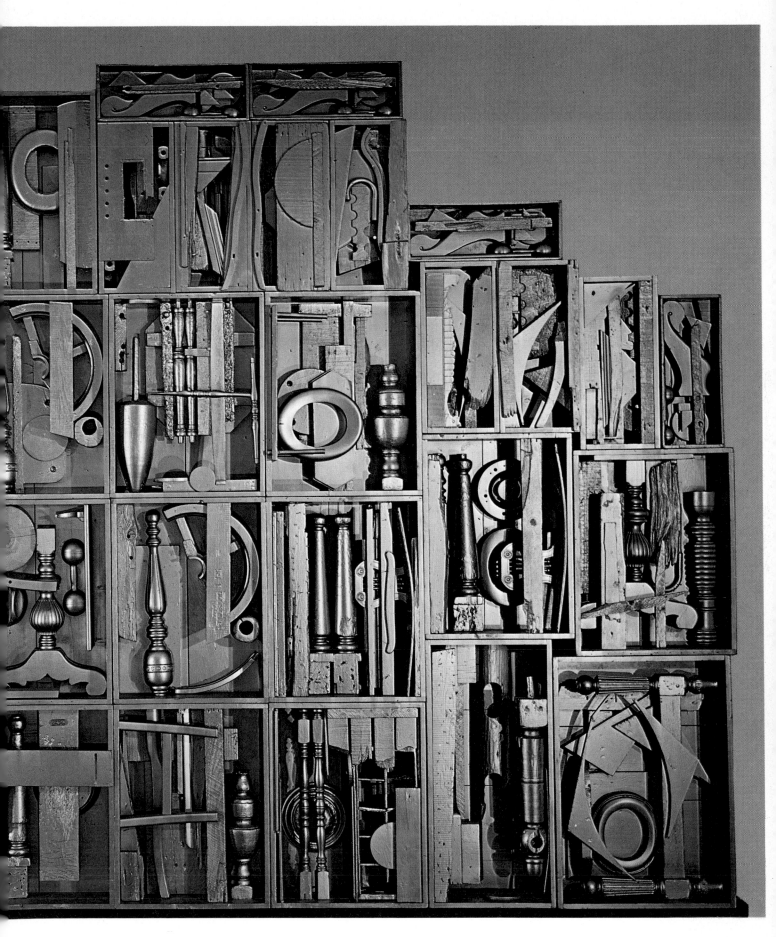

143.
John Chamberlain
Dolores James
1962; 190 × 243 × 97.5 cm. (74 × 95 × 38 in.)
New York, Leo Castelli Gallery

144. Opposite
César (César Baldaccini)
The Yellow Buick
1961; 149 × 79 × 62 cm. (58 × 31 × 24 in.)
New York, Museum of Modern Art

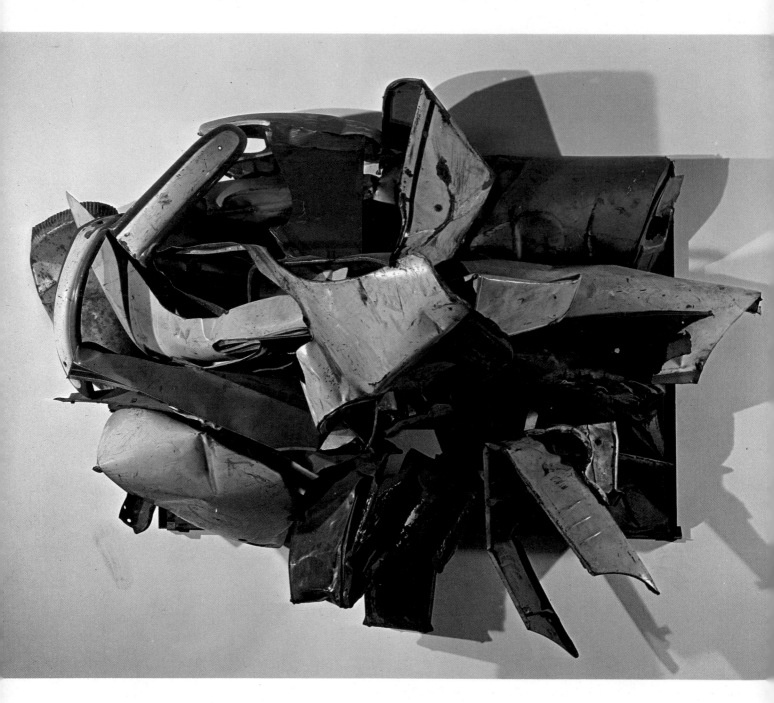

Keinholz's work was not always so specific or so academic. The earlier piece entitled *Gossip* (Plate 140), which is illustrated here, shows a freer and more Surrealist combination of elements, and a more suggestive and less literary end result.

On the whole, it is the American *assemblage* artists who have been the more concerned with urban context, if not with the need (as Keinholz has) to convey a social message. One of the most respected American sculptors of the post-war years, Louise Nevelson, is a perhaps unexpected example. Nevelson works in wood, for the most part, though more recently she has also experimented with metal. Her wooden sculptures are

constructed on the box principle which seems to attract so many assemblagists, perhaps simply because of its convenience. The boxes are then themselves combined to make massive reliefs, wall-like and wall-sized (Plate 142). The vocabulary of forms Nevelson uses is not for the most part invented by herself, but is selected from the surrounding environment. She uses offcuts and fragments of natural wood, but also found objects, such as parts of chairs, other fragments of furniture, door panels and stair balusters.

Wood is a material with its own connotations—connotations of natural growth and decay—and this has perhaps tended to conceal the fact that Nevelson's is essentially an art of the New York environment, feeding off the city's detritus, its demolitions, its continual process of change. Nevelson has said: "My total conscious search in life has been for a new seeing, a new image, a new insight. The search not only includes the object, but the in-between place. The dawns and the dusk" (quoted in *Time* magazine, "One Woman's World", [February 3, 1958], p. 58). But these dawns and these dusks are those Hart Crane celebrated in *The Bridge*. They belong emphatically to a particular place. It is not for nothing that a big Nevelson *assemblage* tends to have a haunting resemblance to typical New York architecture.

But there is another point which is worth noticing about Nevelson, in addition to her close connection to the spirit of place. And this is the way in which she straddles the gap between "the art of *assemblage*" and true sculpture. It is generally agreed that there is a gap between "objects" and true sculptures, and that most *assemblages* fall into the former category. As we have noted, the object works by means of suggestion and association; the sculpture through the impact of form. Nevelson was one of the first to pioneer the use of ready-made parts to make what are recognizably sculptures, and in this she stands on the same footing as David Smith, who is generally considered the most important of American post-war sculptors. Her custom of painting her wooden sculptures one colour, black or gold, emphasizes the formal relationships of the parts.

It is an easy move, in one sense, from

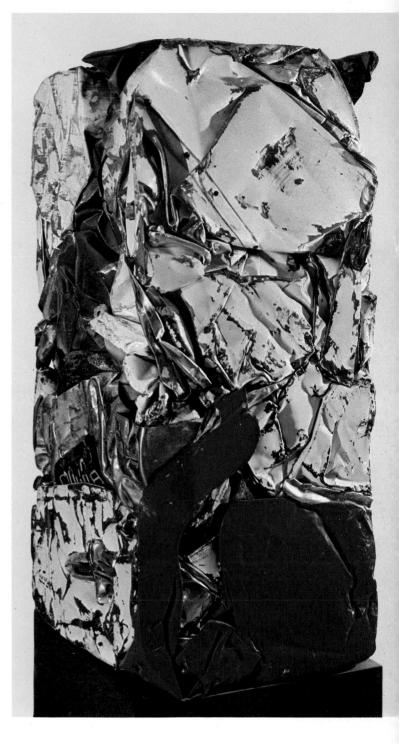

Nevelson's work to that of her compatriot John Chamberlain, and thence to that of yet another New Realist, the French sculptor César.

Chamberlain's characteristic material is fragments of wrecked automobiles; César, too, has made use of this modern and urban form of detritus, often producing effects which at first

145.
Ernst Trova
Power Kit
1965; 35.6 × 44.5 × 108 cm. (14 × 17 × 42 in.)
Colorado, coll. Kimiko and John Powers

sight seem almost indistinguishable from those obtained by his American colleague (Plates 143 and 144). Chamberlain, however, is interested in the result, while César seems to be fascinated chiefly by the process that leads to that result. For Chamberlain the chosen material has several attractions—its connotations, because by using it the artist is recycling waste and redeeming squalor much as Schwitters did with his collages of discarded labels and bus tickets; and the further possibility of using colour without sentimentality. Unlike Nevelson, he welcomes polychromy. César, who began his career as a "traditional modernist", in the group of post-war romantics which included Germaine Richier, used the automobile sculptures as the most startling means

he could discover of announcing his adherence to a new philosophy. They were made with the help of the baling machines employed in scrapyards, and for this reason the artist dubbed them his "controlled compressions". Unlike Chamberlain, he had no intention of imposing a style upon the material, and quickly moved on to something else.

The battle of style versus theory or process was often, it seems, the battle of American versus European art in the years after 1950. The work of Ernst Trova, for example, has qualities which make it seem characteristically American. Trova makes *assemblages*, but of a very different sort from those we have encountered hitherto. Since the early Sixties, nearly every piece he has produced has included the manikin-like image of the

146.
Ernst Trova
Falling Man Series: Six Figures
1964; 40.6 × 48.3 × 48.3 cm. (16 × 19 × 19 in.)
New York, Whitney Museum of American Art, Larry
Aldrich Foundation Fund

147.
Lucio Fontana
Tela tagliata
c. 1960
Private collection
(Photo: Ugo Mulas)

"Falling Man" (Plate 146) which Trova first invented as a symbol of purification from the expressive, romantic art which he had produced formerly (Plate 145). The manikin rapidly became a recognizable trademark, the sign that the product was an authentic Trova. The commercial quality of Trova's work links him to Pop Art—like Warhol's paintings, his *assemblages* are ironic, though we are never certain whether the irony is directed at the artist himself or at the audience that solemnly receives them as art. Yet the irony cannot destroy their status as glossy, expensive toys, tributes to the spending power of the collector who buys them.

At first sight the work of a typically European artist such as Lucio Fontana has an equivalent glossy elegance (Plates 147, 148 and 149). Fontana did indeed produce commercial decorative works for a large part of his career, but he was also one of the first to become impatient with the limits of easel painting, and to think about how these might be overcome. The "black spatial environment" which he created in 1947 anticipated the obsession with environmental works which was to obsess the avant-garde by considerably more than a decade. But it is the "holed" and "slit" canvases by which Fontana is best remembered today. Those with holes were produced as early as 1948, those with slits a decade later. These had a shock effect at the time, and they continue to be cited as examples of the nihilism of modern art.

Fontana's own attitude towards them was different. He said: "As a painter, while working on one of my perforated canvases, I do not want to make a painting; I want to open up space, create a new dimension for art, tie in at the cosmos as it endlessly expands beyond the confining plane of the picture. With my innovation of the hole pierced through the canvas in repetitive formations, I have not attempted to decorate a surface, but, on the contrary, I have tried to break its dimensional limitations. Beyond the perforations a newly gained freedom of interpretation awaits us, but also, and just as inevitably, the end of art" (quoted by Jan Van der Marck in the catalogue introduction to the Lucio Fontana exhibition, Walker Art Center, Minneapolis, 1966).

There is an obvious relationship to be discovered between this statement and some of the attitudes expressed by Yves Klein. Klein's feeling for the "energetic infinity" of the sky parallels Fontana's desire to open up spatial possibilities to the utmost. In addition, both artists seem to see the true purpose of art as being its own abolition. One is also reminded of Ad Reinhardt's declaration that he was "just making the last painting that anyone can make", though Reinhardt does not seem nearly so typical of the aesthetic situation of the American artist.

It has been possible to combine the extremes in this chapter—works of rigorous purity and works which refuse to edit the artist's experience at all—because, however different they are in superficial appearance, they were responses to the same situation. If Abstract Expressionism and *tachisme* had been, in their various ways and with whatever private hesitations, symptoms of faith in the continuing possibilities of art, then the revival of Dada was a clear signal of doubt. Either the artist, through the development and extension of *assemblage*, plunged himself into the "real" and submitted his inspiration to the pre-existing facts represented by his materials, or else he retreated into a transcendental ivory tower. Pop Art was to be an attempt to find a way out of this impasse.

Pop Art in America

Pop is generally considered to be the typical art style of the 1960's—as characteristic of the decade as Abstract Expressionism had been of the late Forties and early Fifties. Because it is thought of as something fully developed and coherent, it has already attracted a lot of attention from the historians of modern art.

In fact, Pop, like all art movements, had roots deep in the past. The deepest of these, as I have already suggested in the preceding chapter, were in Dada. But it had other sources as well. In America, for instance, the language of Cubism had developed an accent of its own, particularly in the work of Stuart Davis. Born in 1894, Davis was already using commonplace domestic objects—an electric fan, a rubber glove, and an egg-beater—as material for the still lifes he painted in the late Twenties. By the late Forties he was making extensive use of lettering as the basis for his compositions. At this period he spoke of the "need to neutralize certain emotional irrelevancies". An ambitious late painting, such as *Switchsky's Syntax* (Plate 150), can therefore contain many of the elements we now recognize as typically Pop, while not being in any sense an attempt made by an older artist to ape his juniors.

For art historians Pop Art has shown a geographical as well as a purely temporal divide. They have made a distinction between American and British Pop Art, and between British Pop Art and what happened in the rest of Europe. Many of them have pointed out that the Pop phenomenon was recognizable earlier in Britain than it was in the United States. They cite the exhibitions "Collages and Objects" (1954) and "Man, Machine & Motion" (1956) at the Institute of Contemporary Arts in London; and in particular they point to Richard Hamilton's contribution to the "This Is Tomorrow" show at the Whitechapel Art Gallery in 1955. Nevertheless, it seems to make better sense to look first at what happened in the United States, because America and the quality of American life were the basic inspiration of most Pop artists, wherever they happened to hail from.

The quality of this involvement varied according to the individual's own temperament. There is a tremendous difference for example, in attitude as well as in method, between the work of Andy Warhol and that of Jim Dine. Both, however, are leading American exponents of the Pop style.

In his technique Dine represents a direct development from the Neo-Dadaism of Johns and (especially) Robert Rauschenberg. He makes extensive use of collage, and it is even possible to speak of the painterly quality which is inherent in his work (*Three Panel Study for Child's Room*, Plate 151). Dine himself has declared that he cannot see any sharp break between his own attitudes and those of the Abstract Expressionists: "Pop Art is only one facet of my work. More than popular images I'm interested in personal images, in making paintings about my studio, my experience as a painter, about painting itself, about color charts, the palette, about elements of realistic landscape—but used differently" (interview with G. R. Swenson, *Art News*, November, 1963, reprinted in *Pop Art Redefined*, by John Russell and Suzi Gablik, London, 1969, p. 61).

For Dine, as for Pollock, what counts is the problem he sets himself, rather than the eventual solution: "I paint about problems of how to make a picture work, the problems of seeing, of making people aware without handing it to them on a silver platter" (ibid., pp. 62–63). Yet there are elements in Dine's painting which make him recognizably part of the Pop pantheon. One of these is his sly eroticism (Plate 153), which is an ironic commentary on the degree of commercial eroticism in our society. Another is his passionate interest in the banal—his collage elements, almost

193

exclusively, are thoroughly commonplace objects, ties, coats, shoes, a washbasin and its fittings. A third, though many would claim that this is what makes him inferior to the best of Pop, is his sentimental attachment to the everyday; his desire to make "ordinary life", as everyone experiences it in the urban and industrial societies of the West, into something which has the dignity of art.

Warhol is a far more enigmatic personality than Dine, and, many would claim, a more important innovator. His background was not a conventional fine-arts one, but commercial illus-

tration. He did window displays and made drawings for shoe illustrations and greetings cards. He recalled later, when answering an interviewer's questions, his own absolute submission to what the client wanted; and the amount of emotion—not his own but the client's—which nevertheless went into the work. These years of commercial experience seem to have given him a desire for art that would be absolutely blank, without "style" or emotion of any kind.

Warhol's transition from commercial art to "high art" was perfectly logical. He achieved it via

151.
Jim Dine
Three Panel Study for Child's Room
1962; 210 × 180 cm. (82 × 70 in.)
Colorado, coll. Kimiko and John Powers

152.
Jim Dine
The White Suit
1964; 183 × 92 × 7.5 cm. (71 × 36 × 3 in.)
Amsterdam, Stedelijk Museum

the comic strip. The earliest Warhols were blown-up versions of the Dick Tracy comic strip which were used as part of a window display for the New York department store Lord and Taylor's (Plate 154). Just before these he had made some drawings, also based on comic strips, which were shown at the novelty shop Serendipity and also at an art gallery. One of the interesting things about the Dick Tracy paintings is undoubtedly the uncertainty of their technique. Warhol has never been a "natural" artist like Dine, and this may account for his subsequent development towards a kind of art in which all emphasis on handling, on the painter's personal thumbprint, has been abolished.

The next phase in Warhol's career is the one which established him as being among the most prominent of the new Pop artists. It was also the one in which he adopted—"invented" would perhaps be too strong a word—the most famous of his images, the Campbell's soup can (Plate 155). When an interviewer asked him why he started painting these cans, Warhol gave a typical but not very enlightening reply: "Because I used to drink it. I used to have the same lunch every day, for twenty years I guess, the same thing over and over again. Someone said my life has dominated me; I liked that idea. I used to want to live at the Waldorf Towers and have soup and a sandwich, like that scene in the restaurant in *Naked Lunch* . . ." (interview with G. R. Swenson, *Art News*, November, 1963, reprinted in *Pop Art Redefined*, by John Russell and Suzi Gablik, London, 1969, p. 117).

From single representations of soup cans Warhol soon progressed to multiple ones, where

153.
Jim Dine
All in One Lycra Plus Attachments
1965; 120 × 150 cm. (47 × 59 in.)
Eindhoven, Van Abbe Museum

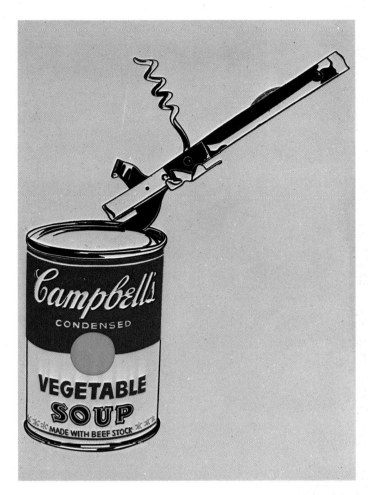

the same image is repeated over and over again, as if to remove any air of significance it might have possessed when viewed on its own, in isolation. From this in turn it was an easy step to the abandonment of handwork in favour of a mechanical process, in this case silk-screen. Warhol produced a series of ikons of well-known personalities—Marilyn Monroe, Elizabeth Taylor, Jacqueline Kennedy, Elvis Presley. Silk-screen in the Marilyns (Plate 158), and indeed in all the others, is used with deliberate crudity, and it is not even certain that Warhol has himself intervened personally in the production of the images that now bear his name. This is because he believes that art should have the egalitarian anonymity of the life he observes around him. "Everybody looks alike and acts alike," he avers, "and we're getting more and more that way." It is this feeling which prompted his famous statement, often quoted and often misunderstood: "The reason I'm painting this way is that I want to be a machine, and I feel that whatever I do and do machine-like is what I want to do" (ibid., p. 117).

Warhol's nihilism, however, goes even deeper than this. Another characteristic series of paintings are those he has dubbed the *Disasters*. These are silk-screened images of ghastly car crashes, of race riots, and of the electric chair (Plates 159 and 160). The shocking image is often slicked over and partly obscured by a wash of Day-Glo colour, orange or mauve or pink. These pictures are at one and the same time an acknowledgment of a deep streak of negative emotion, and a deliberate cauterization of that emotion: "When you see a gruesome picture over and over again, it doesn't really have any effect."

It comes as no surprise that Warhol's development eventually took him away from painting altogether. First he began to concentrate increasingly on films, then, as the films themselves became commercial rather than avant-garde, he became celebrated merely for being Warhol, and scarcely intervened in the activity which still went on around him, and which continued to bear his name.

Yet it took far more than the activities of Dine and Warhol to exhaust the possibilities of Pop. A very different aspect of the American movement is revealed by the work of Roy Lichtenstein. Lichtenstein was early fascinated with Americana. Paintings done in the early Fifties deal with subjects like cowboys and bathing beauties, though not yet in the style that was to become associated with the artist's name. His approach to Pop Art, when an abrupt stylistic change came over his work in 1961, was largely negative—"anti-contemplative, anti-nuance, anti-getting-away from the tyranny of the rectangle, anti-movement-and-light, anti-mystery, anti-paint-quality, anti-Zen, and anti all of those brilliant ideas of preceding movements which everyone understands so thoroughly" (from an interview with Lichtenstein in "Picasso to Lichtenstein" exhibition catalogue, Tate Gallery, 1974). But the

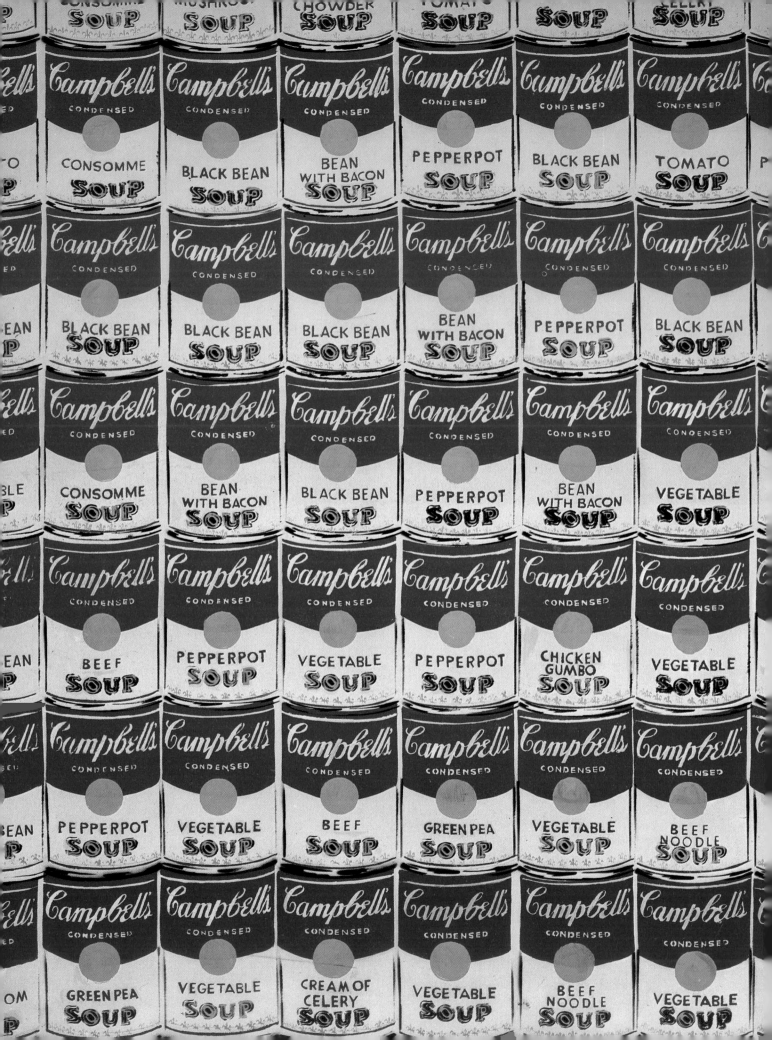

156. Opposite
Andy Warhol
Campbell's Soup Cans 200, detail
1962; 183 × 254 cm. (71 × 99 in.)
Colorado, coll. Kimiko and John Powers

157.
Andy Warhol
Elvis I and II, detail
1964; 208.3 × 208.3 cm. (81 × 81 in.)
Toronto, Art Gallery of Ontario, donated in 1966 by the
Women's Committee Fund

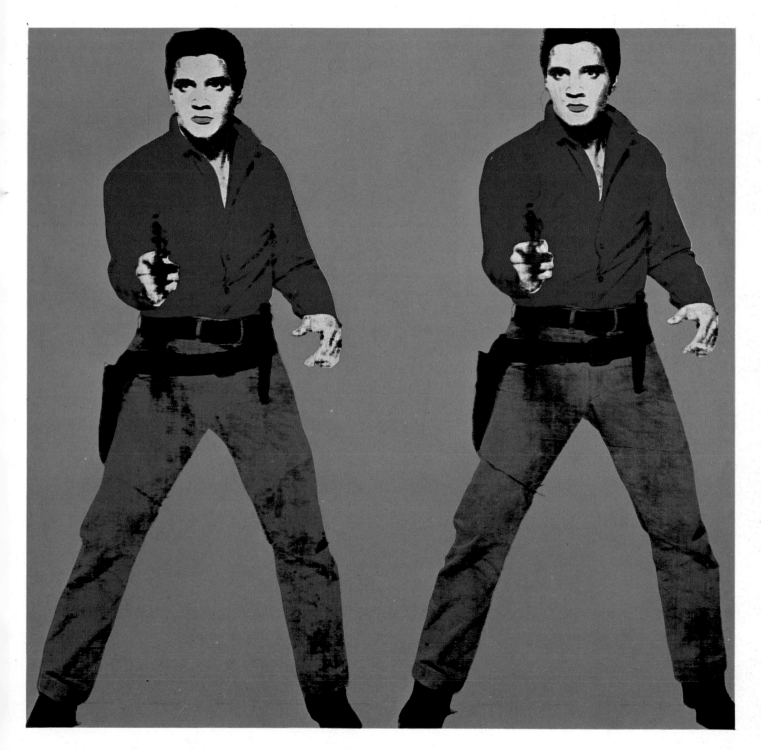

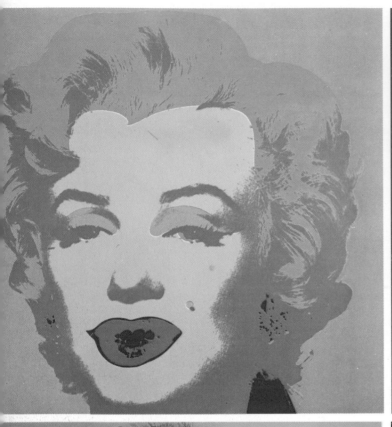
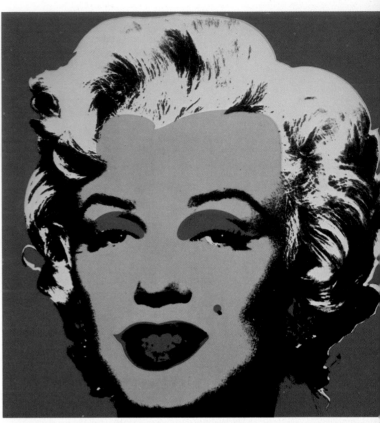
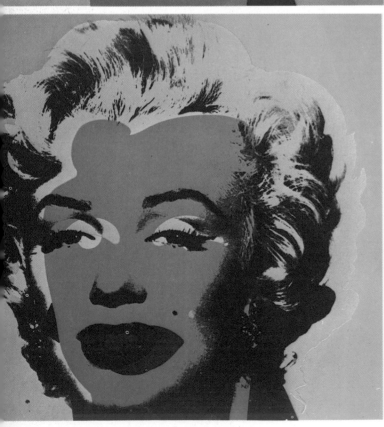
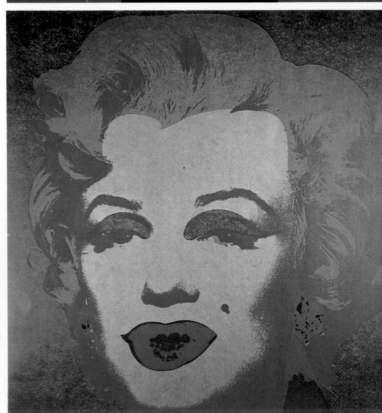

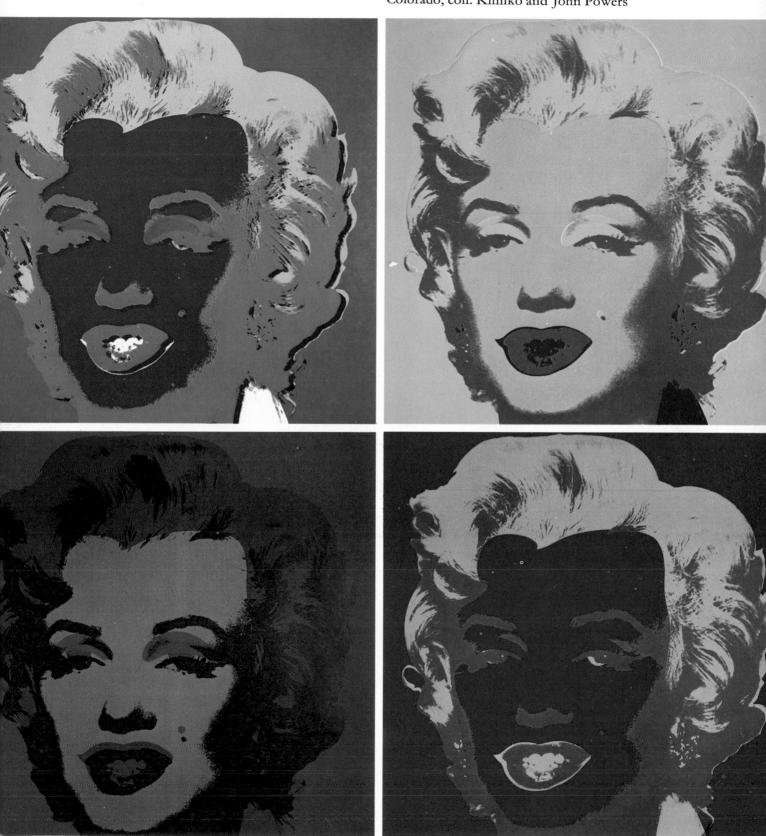

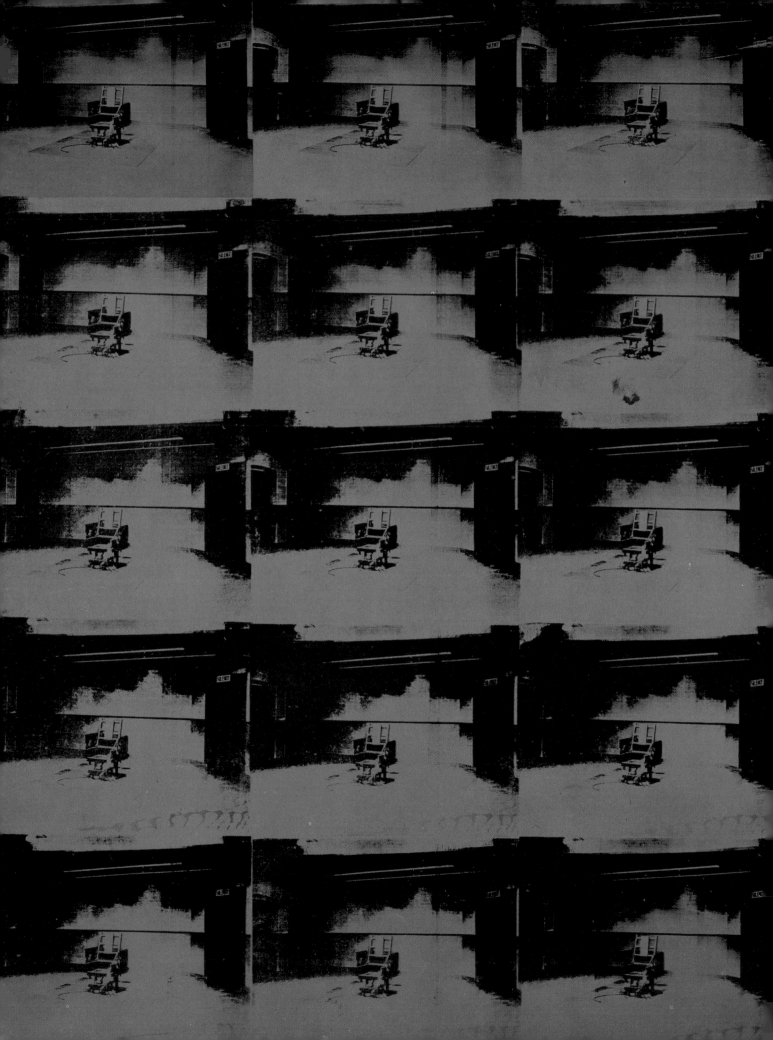

impulse to say no sprang from very different motivations from those which had directed Andy Warhol.

Lichtenstein, unlike Warhol, is deeply interested in questions of style, though the interest is often expressed in an extremely paradoxical and ironic way. To say, as Lichtenstein did, that the idea was "to get a painting that was despicable enough so that no one would hang it" nevertheless implies a keen interest in the paintings that people do in fact put on the wall, in art galleries, and in their own homes.

Lichtenstein's first material, like Warhol's, was the comic strip, but the material extracted from this source was treated in a particularly refined and subtle kind of way. The artist might reproduce all the conventions he found in his material—the black outlines, the coarse screen of dots characteristic of cheap colour-printing (*M-Maybe*, Plate 161)—but in fact the material is substantially revised. Lichtenstein declares: "What I do is form, whereas the comic strip is not formed in the sense I'm using the word: the comics have shapes but there has been no attempt to make them intensely unified. . . . And my work is actually different from comic strips in that every mark is really in a different place, however slight the difference seems to some. The difference is often not great, but it is crucial. . . . One of the things a cartoon does is to express violent emotion and passion in a completely mechanical and removed style. To express this thing in a painterly style would dilute it; the techniques I use are not commercial, they only appear to be commercial—and the ways of seeing and composing and unifying are different and have different ends" (interview with G.R. Swenson, "What is Pop Art?", *Art News*, Vol. 62, No. 7 [November, 1963], p. 24–27).

This approach soon led the artist to apply the same techniques to totally different subject matter, not initially connected with comic strips at all, though translated into comic-strip terms. Thus Lichtenstein painted a series of large *Brushstrokes*, which were intended as a satire on Abstract Expressionist pretensions to total artistic freedom. He also made revised versions of works by the greatest Modernist innovators—Cézanne, Mon-

drian, and Picasso. In these one finds a dual strategy. On the one hand, Lichtenstein seems to be trying to distance the paintings he chooses to copy, so that a rational assessment can be made of them. On the other, he seems to ask us to consider how our reaction to a representation changes when the convention used for that representation is altered.

At his best Lichtenstein has some of the traditional monumentality of Georges Seurat or even of Poussin. Strangely enough, this happens most often with the paintings that derive from comic strips. None of his transpositions of Picasso has anything like the authority possessed by a painting such as *Whaam!* (Plate 163), in the Tate Gallery. At his weakest, on the other hand, Lichtenstein seems the very opposite of a truly popular artist. He is claustrophically obsessed with art itself and ideas about art. This may be one reason why he has been one of the most successful of the American Pop artists with European audiences.

Dine, Lichtenstein, and Warhol have all made reputations for activities on the margin of what they have achieved as painters. Warhol's film making has already been mentioned. His earlier and more personal films used a fixed camera and

205

161.
Roy Lichtenstein
M-Maybe
1965; 152.4 × 152.4 cm. (59 × 59 in.)
Cologne, Wallraf-Richartz Museum, coll. Ludwig

162.
Roy Lichtenstein
Pow!
N.d.; 96 × 71 cm. (37 × 28 in.)
Aachen, Neue Galerie, coll. Ludwig

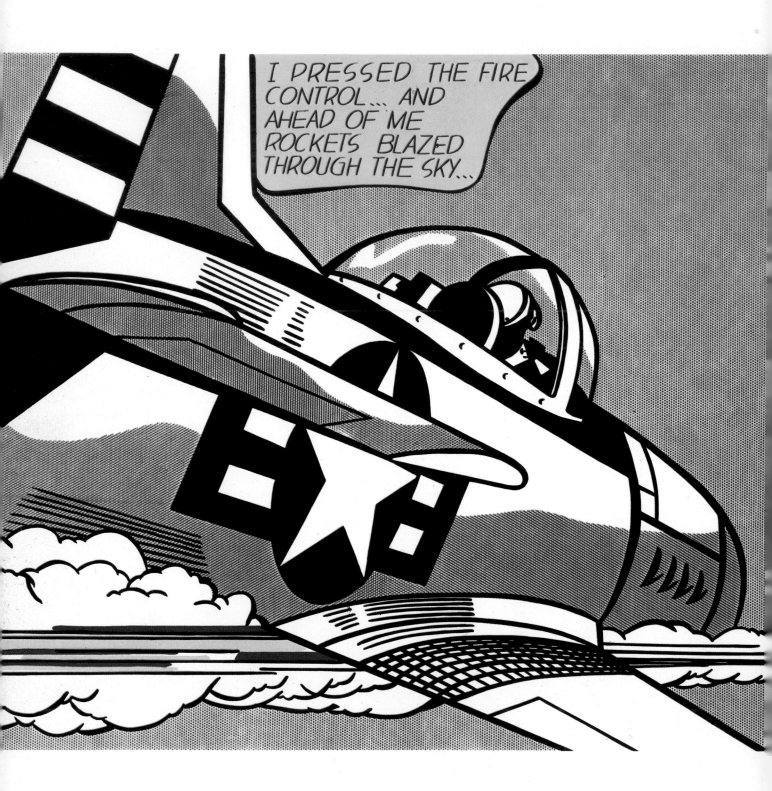

163.
Roy Lichtenstein
Whaam!
1963; 173 × 406.5 cm. (67 × 159 in.)
London, Tate Gallery

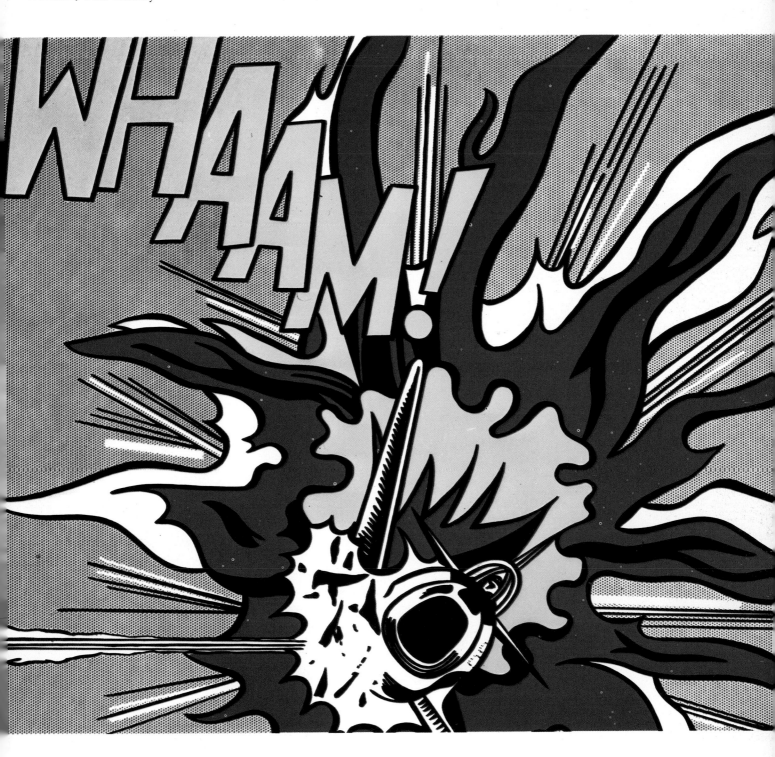

164.
Roy Lichtenstein
Ceramic Head with Blue Shadow
1966; 38.11 cm. (15 in.)
Connecticut, coll. Mr. and Mrs. Burton Tremaine

165. Opposite
Roy Lichtenstein
Wall Explosion No. 1
1964; 251 × 160 cm. (98 × 62 in.)
Cologne, Wallraf-Richartz Museum, coll. Ludwig

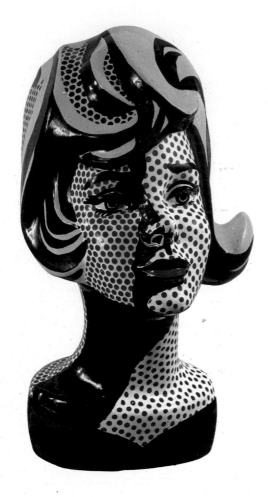

the transition being noticeable. It was a case of the scenery creating the theatrical event, rather than vice versa.

Lichtenstein extended his work in a very different direction still. From being a painter, he also became a sculptor (Plates 164 and 165). His sculptures are in general much weaker and less interesting than his work in two dimensions. They make more clearly evident the degree of mannerism which is also found in his painting.

Pop Art has indeed included, within its stylistic boundaries, work in three dimensions. Perhaps the most important of the Pop object makers is Claes Oldenburg. Oldenburg was born in Sweden and educated in the United States and in Scandinavia. He thus has a dual perspective on American urbanism and industrialism, and this perspective reveals itself not in a horrified rejection, but in a curiously joyous acceptance of the American scene. Like the other important Pop artists, Oldenburg had been practising as an artist for some time before he suddenly reached the point of breakthrough into a new style. In 1959, he began work on a project he called *The Street*, a collection of graffiti-like sketches and objects made from discarded material. At this time he became friendly with Dine and with Allan Kaprow. Kaprow, like Dine, was one of the progenitors of the Happening. A second version of *The Street*, which was exhibited in 1960, was accompanied by a number of group performances. It was followed by a second project called *The Store*.

The Store launched Oldenburg into a career as a maker of objects. Sometimes these objects, like *Salmon Mayonnaise* of 1964 (Plate 166), were merely reproductions, or more often over-scaled versions, of things that existed in real life. The subjects were not, however, items that would traditionally have been considered worthy of a sculptor's attention. In reproducing the mummified, artifically coloured food he saw in delicatessens, Oldenburg was following the example of the commercial artists and sign makers. His sources were window displays and the strange objects that loom up by the side of American

Gradually Oldenburg came to understand the

were essentially explorations of our power to endure boredom. There was also the idea that the fixed, unblinking scrutiny of the camera lens would eventually force the subject, whether animate or inanimate, to yield up secrets which might otherwise remain unrevealed. Dine's extra-curricular work was in total contrast to this. He was responsible for staging some of the earliest "Happenings". The Happening was a theatrical event in revolt against then prevalent theatrical conventions. Instead of a plot it offered a collage of sensations, and was essentially an extension of the interest in collage, especially collage which had grown to monumental size, and which surrounded the spectator after the manner of the *Merzbaus* or environmental constructions made of found material created by Kurt Schwitters. If sounds and moving bodies were added, the static environment became the dynamic Happening, almost without

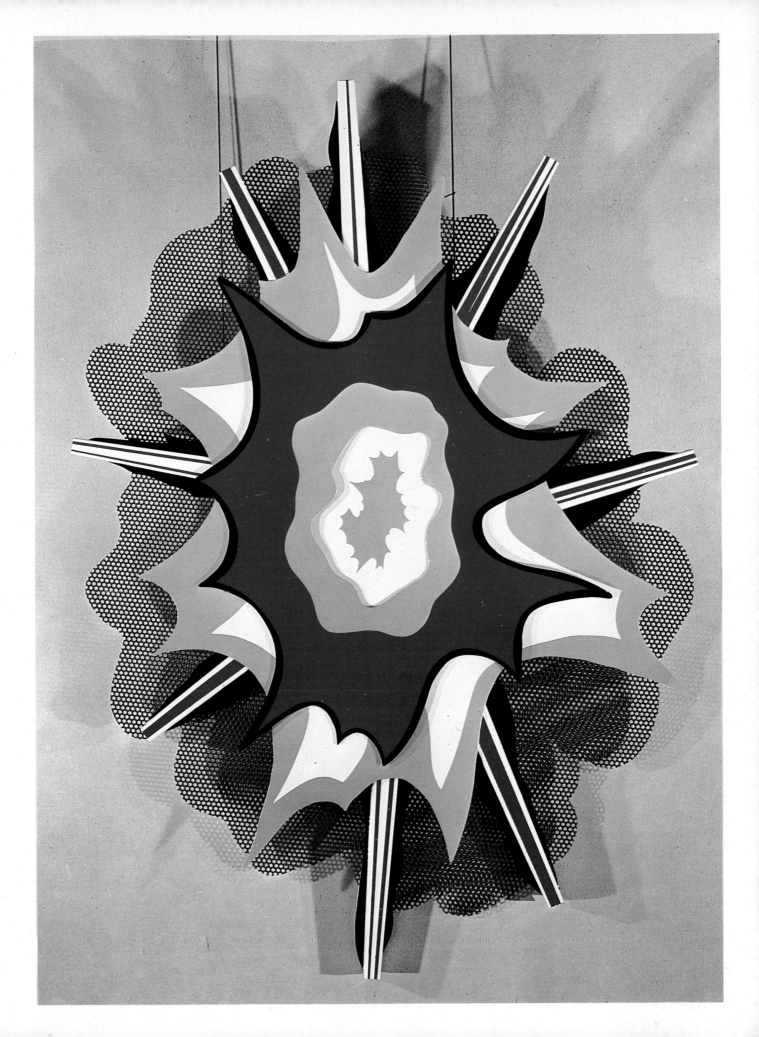

166.
Claes Oldenburg
Salmon Mayonnaise
1964; 12.7 × 44.5 cm. (5 × 17 in.)
New York, coll. Mr. and Mrs. Robert C. Scull

167. Opposite
Claes Oldenburg
Trowel, Scale B
1971; 12.2 m. (40 ft.)
New York, collection of the artist

168. Overleaf left
Claes Oldenburg
Giant Soft Swedish Light Switch
1966; 130 cm. (51 in.)
Cologne, Wallraf-Richartz Museum, coll. Ludwig

169. Overleaf right
Claes Oldenburg
Giant Fireplug Sited in the Civic Center, Chicago
1968; 26.3 × 20.6 cm. (10 × 8 in.)
Colorado, coll. Kimiko and John Powers

effects that could be derived not merely from making his objects over-scale, but also from using inappropriate materials, and even from allowing the original form to assume an inappropriate shape. This is what has happened to *Giant Soft Swedish Light Switch* (Plate 168), which is representative of a whole series of soft sculptures made of vinyl or other material and loosely stuffed with kapok. The forms, often extremely erotic, assumed by these transformations of ordinary objects are part of the artist's campaign to make us re-examine the world that surrounds us. He has expressed this desire in another way in his projects for open-air monuments. The *Giant Fireplug Sited in the Civic Center, Chicago* (Plate 169) is only one of a very considerable number of these. "I am for an art", Oldenburg once said, "that is political-erotical, mystical, that does something other than sit on its ass in a museum."

There are no other Pop sculptors or object makers who achieve anything like Oldenburg's vitality and impact. The work of the Venezuelan sculptor Marisol, however, does have personality and charm. Her slightly Surrealist wooden sculptures (Plates 170 and 171) have been classified as Pop Art for a number of not entirely convincing reasons. The first of these is that she has clearly been influenced by some aspects of the work of Johns and Rauschenberg, notably their use of plaster casts of parts of the human body as ingredients in some of their *assemblages*. Secondly, Marisol made her reputation in New York in the early Sixties, just at the time when Pop became the "boss" style, and when any figurative artist who happened to be attracting attention was immediately assimilated into it.

Her true source is nevertheless thoroughly American. She often seems to be a less gifted reincarnation of Elie Nadelman. Nadelman's late work shows a brilliant assimilation of American folk art, and there is more than a trace of this in Marisol. Her inclusion here is a reminder of the sentimentally populist side of Pop Art, which so many artists and critics have attempted to deny.

More central, and certainly far more important in historical terms, is the sculpture of George Segal. Segal, after working under Hans Hofmann,

and painting figurative work in the manner of Matisse, of Pierre Bonnard, and of the Abstract Expressionists—a range of styles which revealed his own stylistic uncertainty—began experimenting with life-size figures made of plaster and wire in 1958. By late 1960 he had stopped painting altogether and had started making casts of identifiable models which were then placed in architectural settings.

The point of Segal's work is very simple. It consists in the contrast between his ghostlike plasters and what surrounds them (Plates 172 and 173). Segal has said: "I use the premise of walking into a real space, intensifying it by working very carefully with the space between the figures and the objects surrounding them" (from the introduction by Martin Friedman to the catalogue of the exhibition "Figure/Environments" at the Walker Art Center, Minneapolis, 1970).

The plasters themselves remain surprisingly academic in style despite the far-from-academic technical method by which they have been produced. It was possible to go in two different, indeed opposite, directions from the position at which Segal found himself when Pop was at its height in the middle and late Sixties. One is that chosen by the various Super Realist sculptors, among them Duane Hanson and John de Andrea. Their effort has been to make the figure as lifelike as possible, by giving it glass eyes and real hair, colouring it naturalistically, etc. Segal has gone the other way, and has more and more edited his figures to look like the traditional *beaux-arts* work of the end of the nineteenth century. Recent

170. Opposite
Escobar Marisol
Ruth
1962; 167.6 cm. (65 in.)
Brandeis University, Massachusetts, Rose Art Museum

171. Overleaf
Escobar Marisol
Party
1965–66
New York, by kind permission of Sidney Janis Gallery

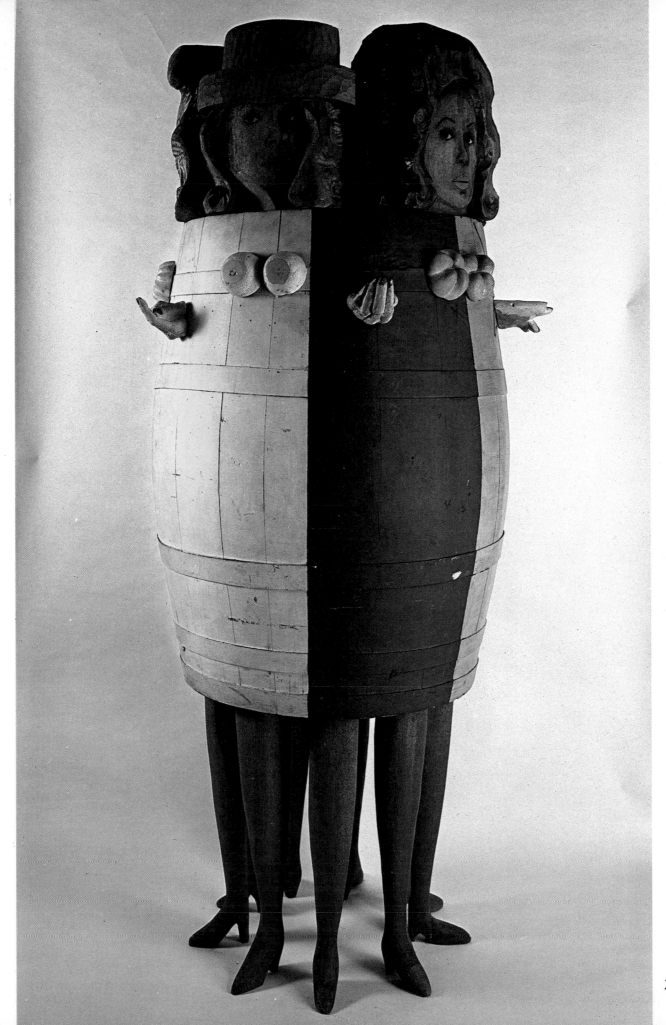

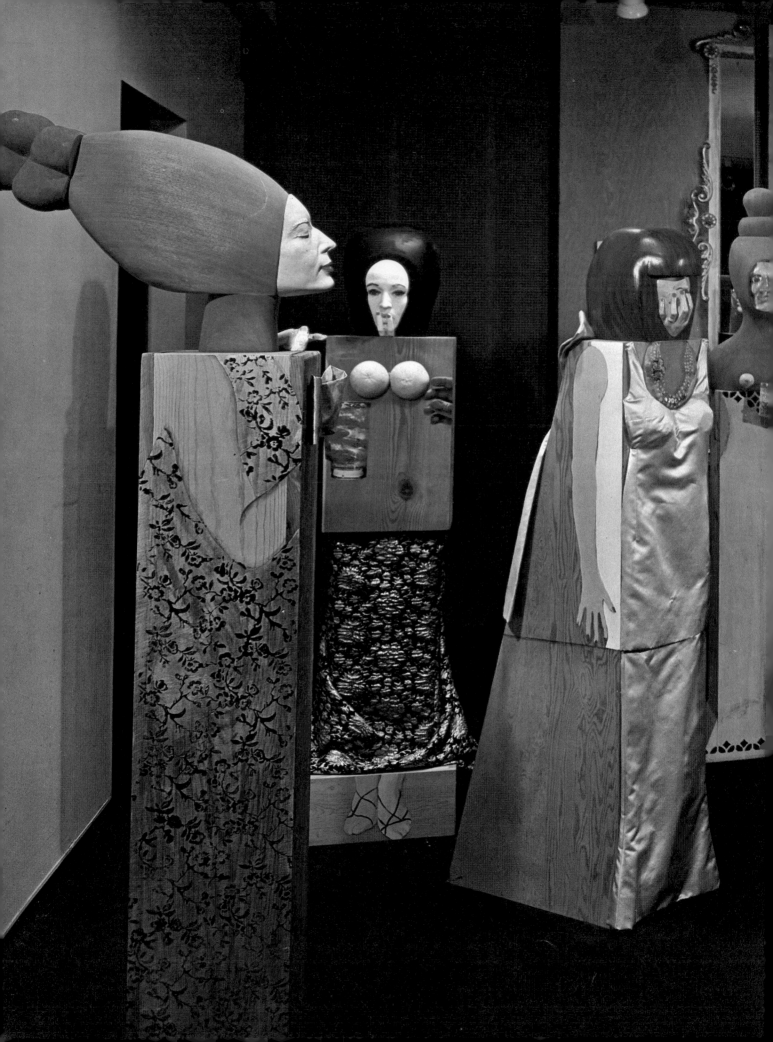

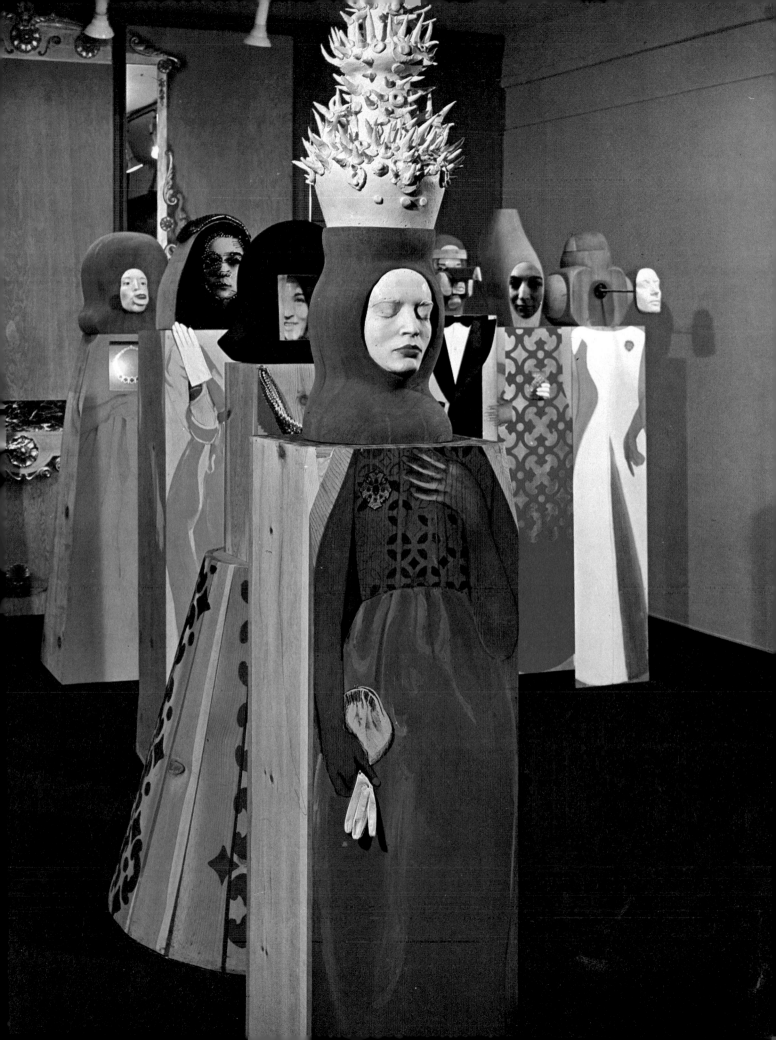

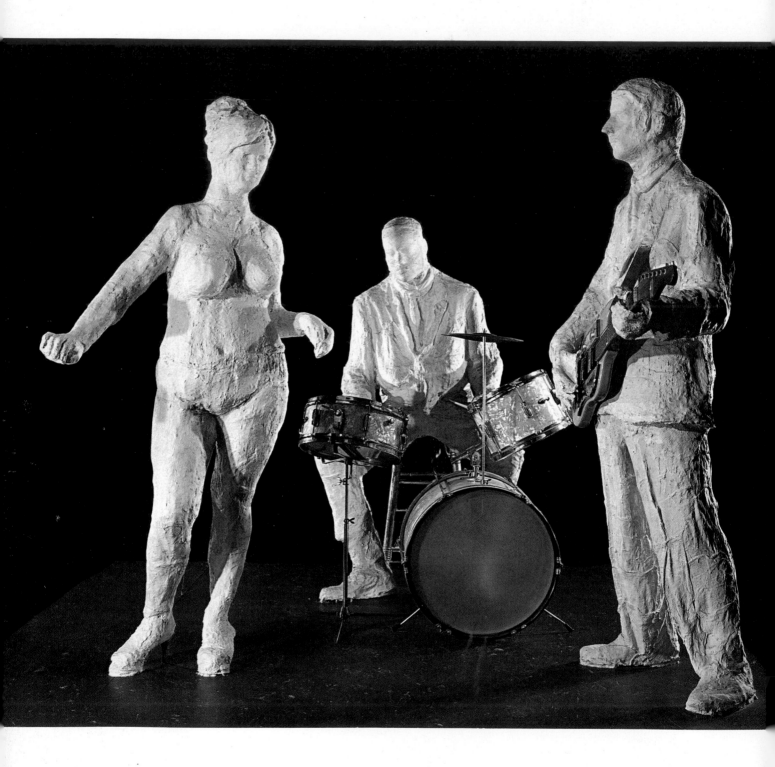

172.
George Segal
Rock 'n Roll Combo
1964; 186 × 190 × 145 cm. (73 × 74 × 57 in.)
Darmstadt, Hessisches Landesmuseum, coll. Karl Strobel

173. Opposite
George Segal
Film Poster
1967; 188 × 71.1 cm. (73 × 28 in.)
Colorado, coll. Kimiko and John Powers

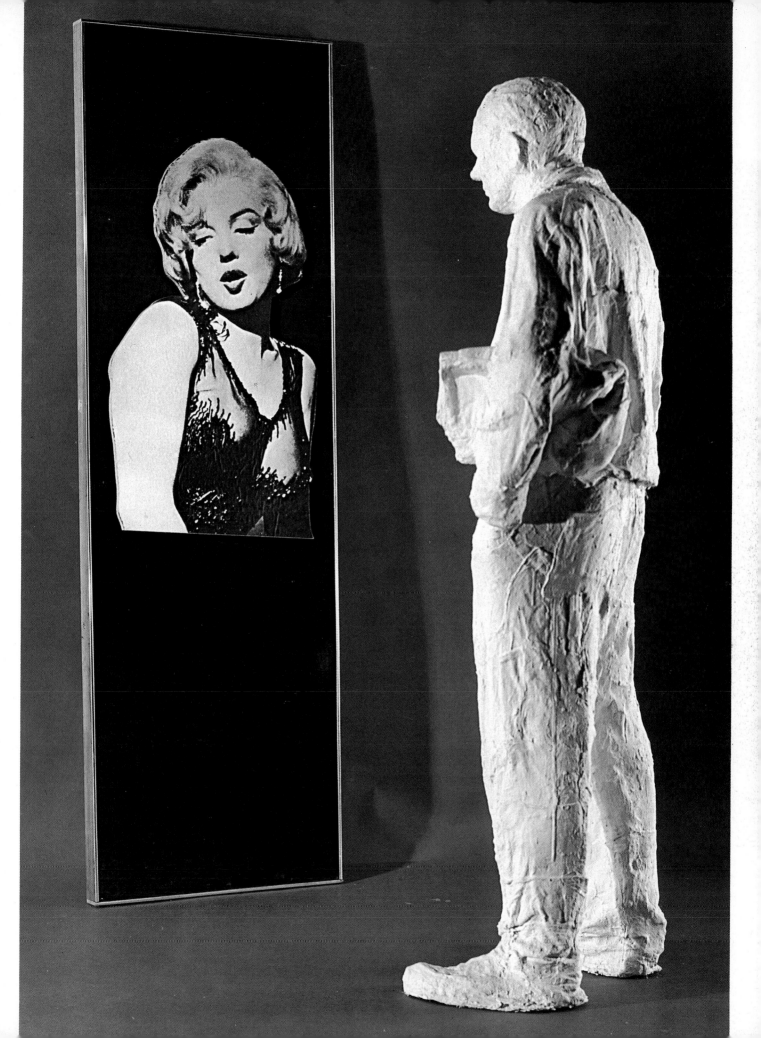

174.
Tom Wesselman
Great American Nude No. 8
1961; 119.7 cm. (47 in.)
Connecticut, coll. Mr. and Mrs. Burton Tremaine

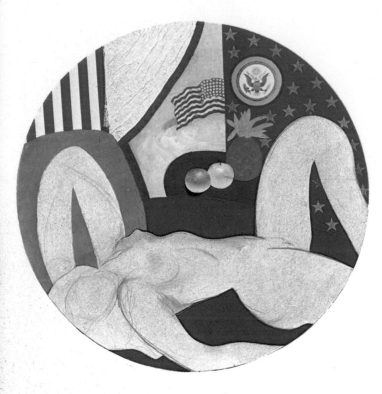

175 and 176.
Tom Wesselman
Bathtub Collage No. 3
1963; 213 × 270 × 45 cm. (83 × 105 × 18 in.)
Cologne, Wallraf-Richartz Museum, coll. Ludwig
Opposite, detail

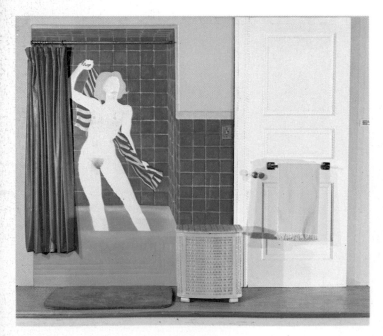

reliefs, showing figures and parts of figures emerging from a rough plaster surface, have been feeble tributes to Michelangelo and Rodin.

Of the American Pop artists who have not so far been mentioned, the most interesting is probably Tom Wesselman. Wesselman claims that his first important influence was the work of De Kooning. "That," he declares, "was what I wanted to be, with all its self-dramatization." But though he liked De Kooning's subject-matter, especially the nudes, the sloppiness of Abstract Expressionism distressed him. He found that what he wanted to do was to establish an absolutely concrete situation which was nevertheless full of jarring yet stimulating contrasts: "throughout the picture all the elements compete with one another."

Most of Wesselman's work can be divided into two major series, the nudes (Plates 174, 175, 176, and 177) and the still lifes (Plate 178). Often these have included collage elements, in order to get the contrasts the artist desires, but he is capable of producing much the same shocks without these added elements. What impresses about Wesselman's work is a rather brash energy. The nudes in particular demonstrate the male chauvinism of a great deal of Pop to perfection. The girls themselves are reduced to what is most erogenous—to eyes, nipples, patches of pubic hair. But there is no evidence that this depersonalization is as deliberately engineered as it is in Warhol's work. It is just something that happens to be there.

In addition to the major creative figures in the movement, Pop inevitably produced a swarm of less important but still interesting artists. Some people might feel that James Rosenquist deserves better than to be put in this category. Certainly, if scale is anything to go by, Rosenquist is important. Some of his canvases are among the biggest ever painted by a Pop artist. This interest in large scale may have been due to Rosenquist's experience, in the late Fifties, as a painter of billboards. While he was doing this to earn a living, he was also attending a drawing class organized by Claes Oldenburg and Robert Indiana, whose work will also be discussed in this chapter.

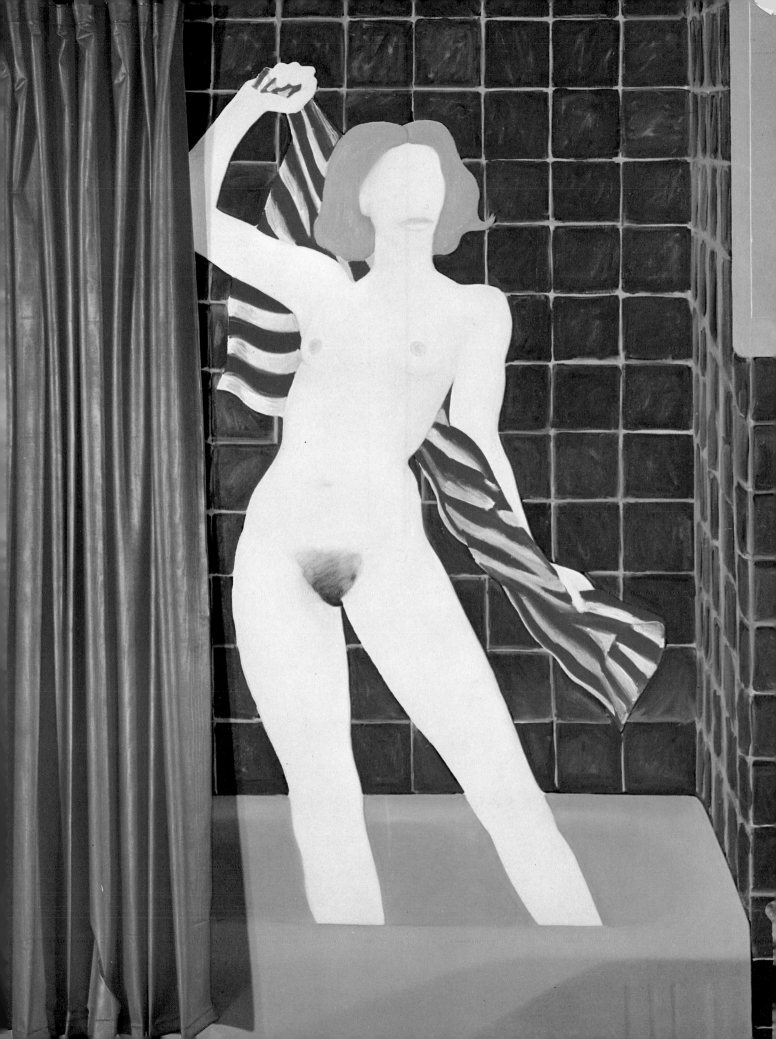

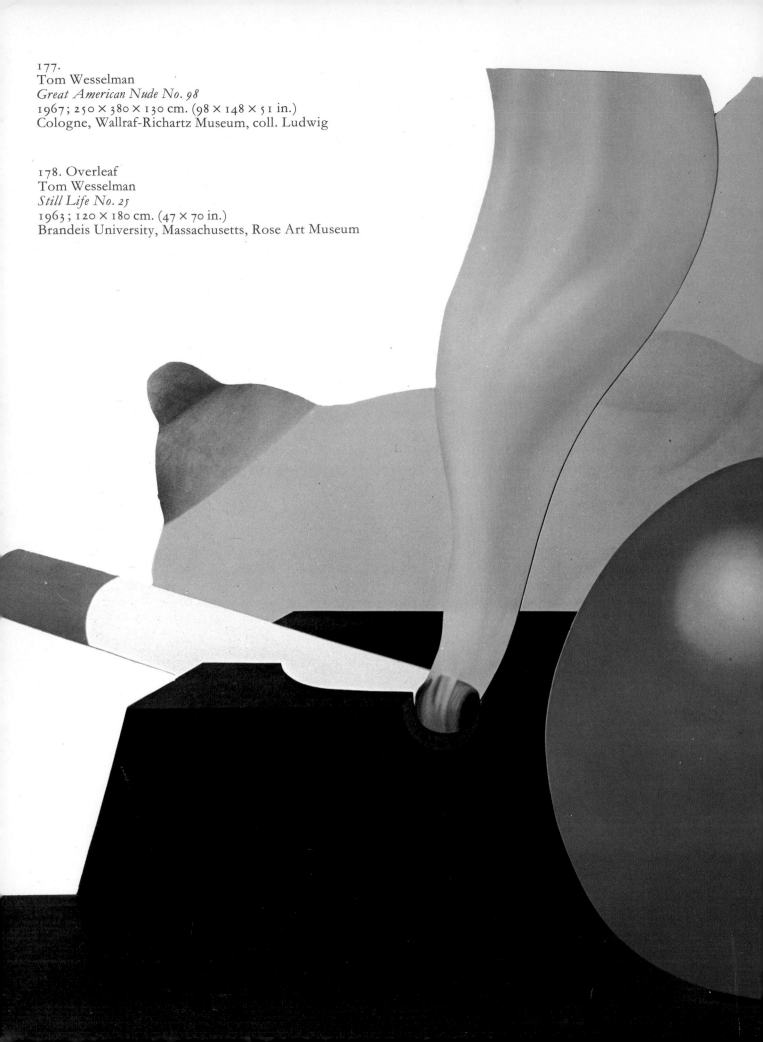

177.
Tom Wesselman
Great American Nude No. 98
1967; 250 × 380 × 130 cm. (98 × 148 × 51 in.)
Cologne, Wallraf-Richartz Museum, coll. Ludwig

178. Overleaf
Tom Wesselman
Still Life No. 25
1963; 120 × 180 cm. (47 × 70 in.)
Brandeis University, Massachusetts, Rose Art Museum

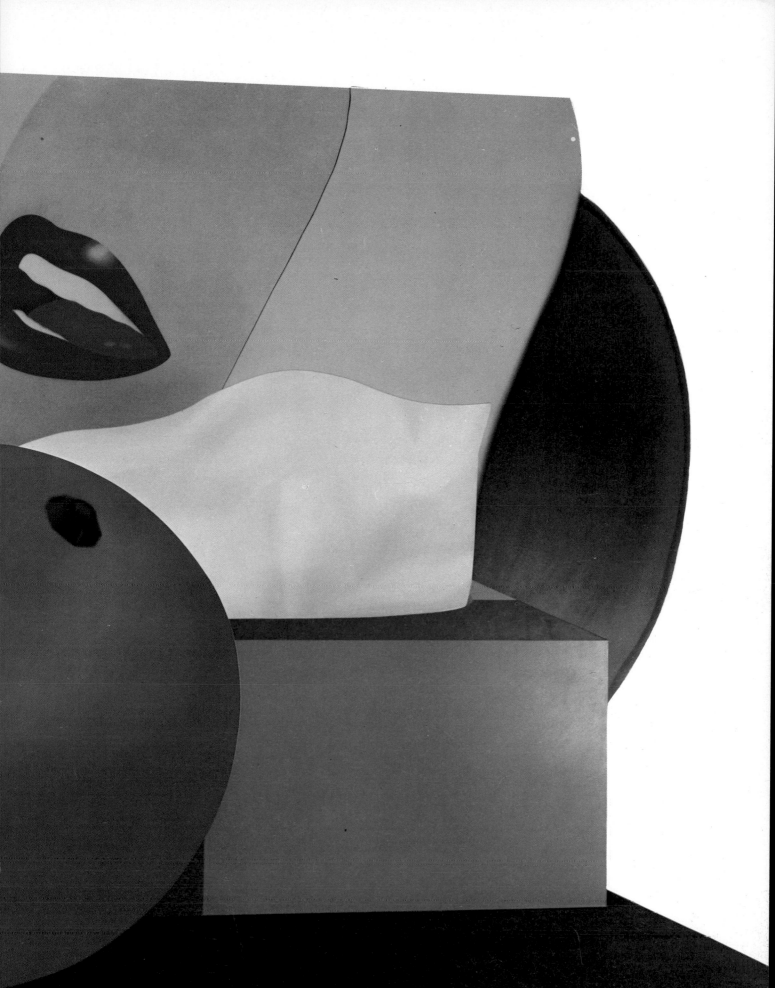

179.
James Rosenquist
I Love You with My Ford
1961; 210 × 237.5 cm. (82 × 93 in.)
Stockholm, Moderna Museet

180. Opposite
Robert Indiana
The American Dream
1961; 180.3 × 150.3 cm. (70 × 59 in.)
New York, Museum of Modern Art, Larry Aldrich
Foundation Fund

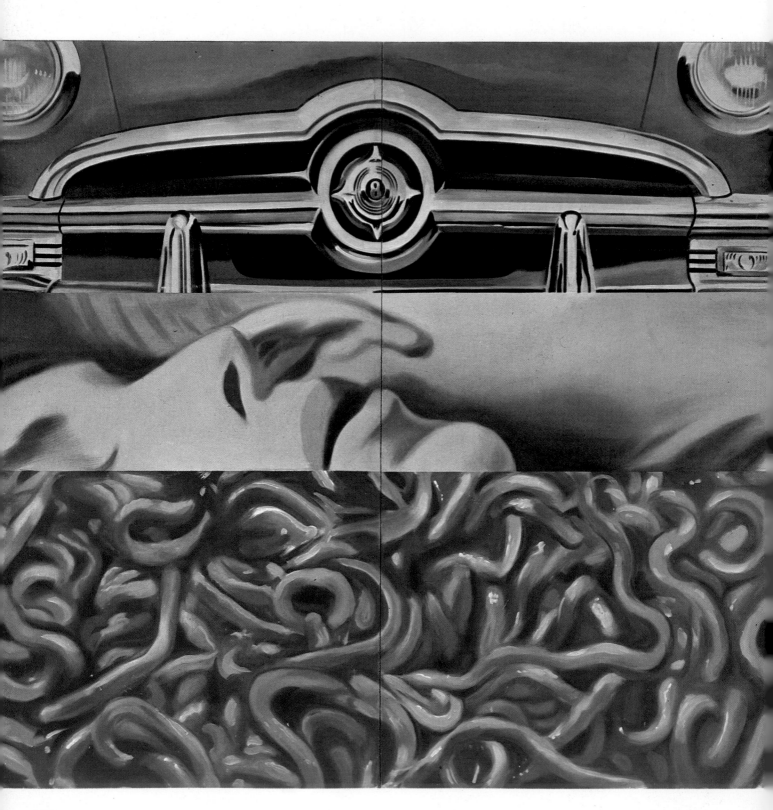

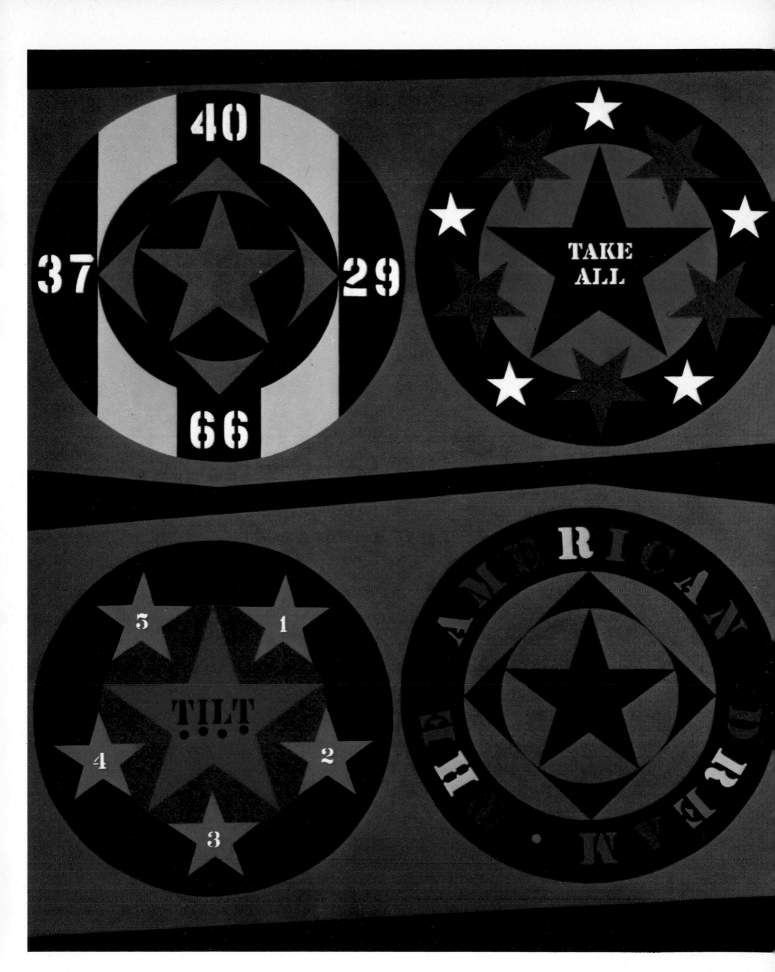

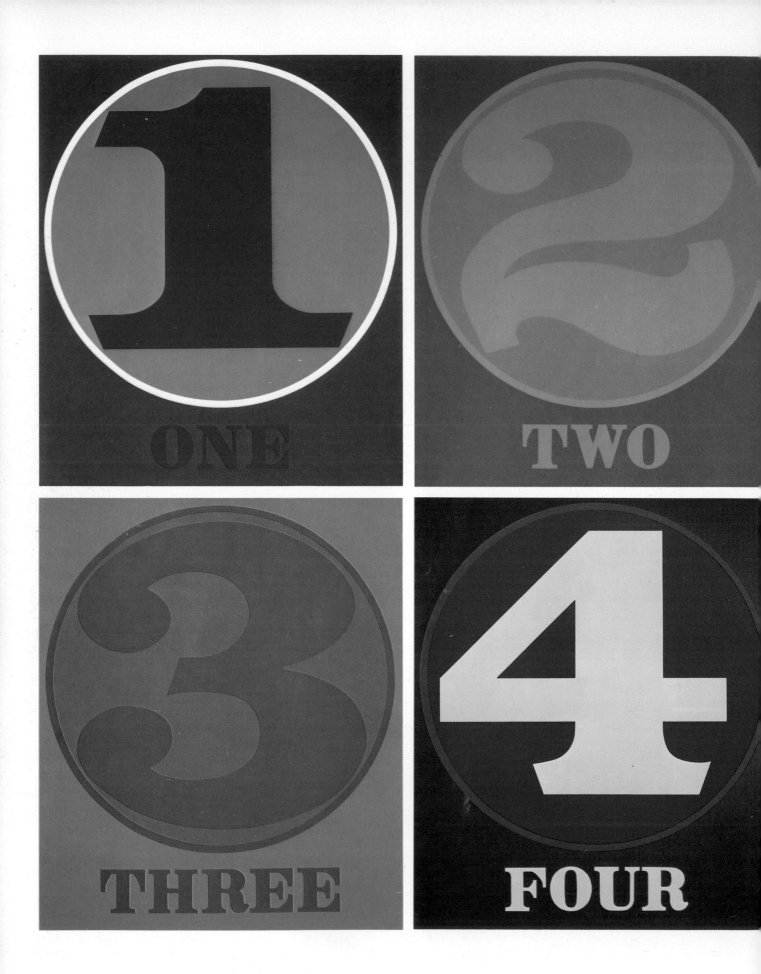

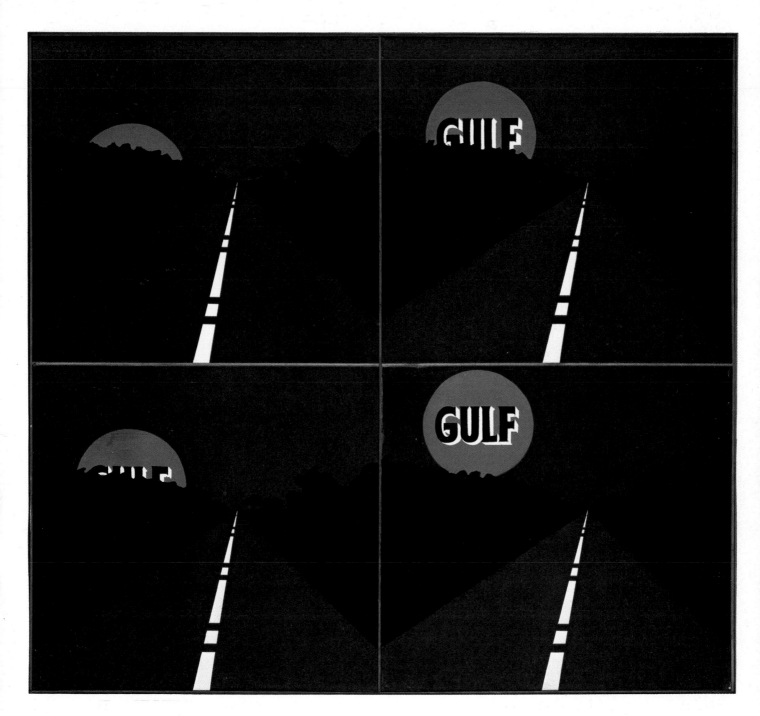

What Rosenquist does (Plate 179) is to put together in collage various images painted in billboard style, in the hope that something significant will emerge from the conjunction. He sees himself as a willing collaborator with the commercial society he lives in: "I geared myself, like an advertiser or a large company, to this visual inflation—in commercial advertising which is one of the foundations of our society. I'm living in it, and it has such impact and excitement in its means of imagery. Painting is probably more exciting than advertising—so why shouldn't it be done

231

with that power and gusto, with that impact? ...
My metaphor, if that is what you can call it, is my
relations to the power of commercial advertising
which is in turn related to our free society, the
visual inflation which accompanies the money that
produces box tops and space cadets. . . ." (from an
interview with G. R. Swenson, *Art News* [Feb-
ruary, 1964], reprinted in *Pop Art Redefined*, by
John Russell and Suzi Gablik, London, 1969, p.
111).

The difficulty is that this uncritical acceptance of
his surroundings makes Rosenquist into a rather
insensitive painter as compared with, say, Roy
Lichtenstein. There is no real subtlety of visual
arrangement in his work, which eventually

becomes as monotonous to look at as the billboard
art from which it derives.

Robert Indiana (born Robert Clark) is another
Pop artist who has committed himself to the
American dream, in much the same way that
Rosenquist has. In fact, one of his most typical
canvases is actually entitled *The American Dream*
(Plate 180). It derives its basic imagery from
pinball machines, and it might seem possible at
first glance to read its message as ironic. But this
would not appear to be in line with the painter's
own interpretation. In his view the American
dream, using the words in a general rather than a
specific sense, is "optimistic, generous, and
naïve".

183.
Ed Ruscha
Hollywood
1968; 31.7 × 103.5 cm. (12 × 40 in.)
Düsseldorf, coll. Heinz Beck

Indiana's strength is his hostility to closed systems and to art for art's sake. Pop, he says, "is death to smuggery and the Preconceived-Notion-of-What-Art-Is diehards". He opposes himself utterly to the idea that great art must be difficult art. In a mass society these are undoubtedly sympathetic doctrines. But there is something disconcertingly bare and bleak about the work that Indiana proposes to substitute for the things he attacks.

A painter who in some ways resembles Indiana is Allan D'Arcangelo. In his painting, too, we find an emphasis on lettering, a crisp, no-nonsense way of presenting the image. But where images are juxtaposed, they tend to be similar rather than contrasted (Plate 182). D'Arcangelo can thus at moments resemble an optimistic Warhol. The most important aspect of his work, however, is not so much the way he presents his imagery as the imagery itself. D'Arcangelo, among Pop artists, is the poet of the highway, the celebrator of American distances.

The artist who shares this particular pre-occupation is Ed Ruscha, who is a somewhat isolated figure in the American Pop school taken as a whole. What tends to set Ruscha apart is his commitment to the West rather than the East of the United States, to Los Angeles rather than New York. Some of Ruscha's work (Plate 183) is a refined and elegant version of Pop, with a

sleekness that seems typically Californian. But much of the rest has nothing to do with Pop Art at all, but belongs to the category which is labelled "process art" by some critics. This is true, for instance, of the long series of books and booklets which Ruscha has issued. One of these is called "Stains", and each page contains a stain made by some common substance. Ruscha is an example of the fact that one can produce Pop Art without being a full-time Pop artist.

There are also several painters who lie on the margins of the Pop school because some aspect of their work seems consistently untypical. Two who come to mind are Wayne Thiebaud and Larry Rivers, and in each case what makes them seem exceptional is their handling of paint, which has an individuality which is uncommon in Pop Art, at least in America. Wayne Thiebaud's technique (Plate 184) can make him seem a descendant of the American realists of the Thirties, particularly Edward Hopper. There is the same blunt but extremely personal touch. Thiebaud's chosen subject-matter is remarkably narrow. He devotes himself to food, and in particular to pies (Plate 184). In this connection he once remarked: "A pie has all kinds of marvellous complex associations. The whiteness of meringue becomes for me of great poetic preoccupation: it's like snow, like frost, like the concept of purity, and, from a painter's standpoint, white both absorbs light and reflects light—it's composed of all colours, like Chardin's tablecloths" (from an interview conducted by Le Grace G. Benson and David Shoarer in *Leonardo*, Vol. 2, No. 1, Oxford, 1969).

The implied comparison to Chardin is a reasonably shrewd piece of self-assessment, but also implies the deliberate self-restriction which has prevented Thiebaud from becoming a major figure.

Far more difficult to assess than Thiebaud, and certainly much more uneven, is Larry Rivers. Rivers has a most seductive fluency with the brush (Plate 186). He seems to aim at re-creating the effects caught by Edouard Manet, using opalescent colour and loose, virtuoso handling. But the subject-matter he chooses is often Pop-oriented, though the most important reason for choosing it often appears to be a rather childish desire to shock. In the early Fifties, before Pop itself arrived on the scene, Rivers painted a series of brilliant female nudes, which owed a technical debt to the male nudes of Théodore Géricault. For most of these the subject was his ageing mother-in-law, Berdie. This was also the period at which he defiantly painted a large historical picture, *Washington Crossing the Delaware*, which was quite specifically intended as a revival of nineteenth-century academic art. It caused a satisfactory uproar among the New York avant-garde of the period.

Later in the decade Rivers was using commonplace objects as his subject-matter, though by now employing a less solid and more vaporous technique which was related to Abstract Expressionism. But when the Pop movement began, the artist, with pliant flexibility, began to explore the kind of material that was in vogue with the new group. He painted paraphrases of commercial packaging, such as the Camel cigarette pack, and employed collage techniques. One of his most successful series resulted from the absorption of Pop influence. Called *Parts of the Body*, it explored the possibilities offered by the conjunction of crude, stencilled lettering, and of figures and heads painted in Rivers's usual virtuoso style.

Rivers is such a gifted artist that it may seem surprising that he has had so little influence on the development of American painting. This failure must be attributed to his constant changes of direction, and to the apparent lack of conviction which seems to motivate them. He often seems little more than a highly talented ventriloquist.

A movement as successful as American Pop Art naturally attracted foreign adherents. Those who found it easiest to assimilate themselves to the New York scene were usually young Englishmen. Many English artists spent long periods in the city, which they found a far more sympathetic environment for modern art than the London they had left. One or two came to identify themselves with America almost entirely. The most gifted of these was Gerald Laing. He seems to have felt the impact of the highly competitive New York art world chiefly as a stimulus to ambition, rather than

185.
Larry Rivers
Girlie
1970; 76 × 46 cm.
(30 × 18 in.)
New York,
Marlborough Graphics

186. Opposite
Larry Rivers
*Parts of the Body:
French (cut out)*
1964; 33 × 21.6 cm
(13 × 8 in.)
New York, by kind
permission of the
Dwan Gallery

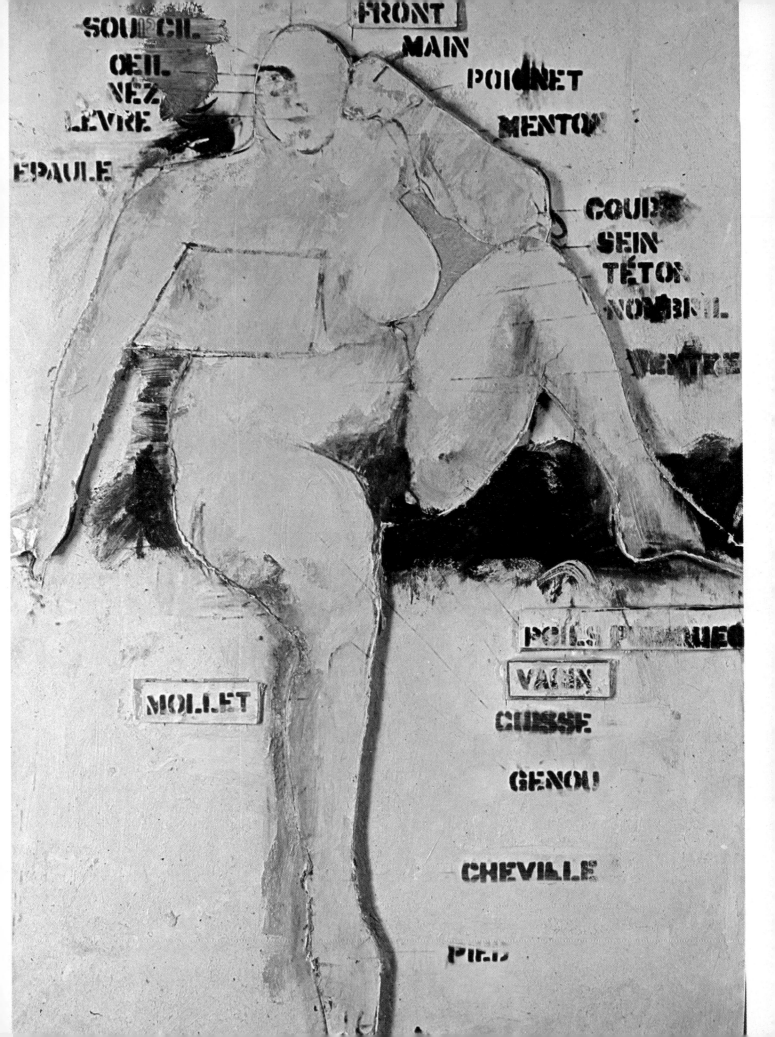

as something which prompted any radical process of rethinking or change of style. In 1964, when he participated at a group show at the Institute of Contemporary Arts in London, his catalogue statement read in part: "My work is developed from the idea of the hero-image as presented by mass-media. In the first instance I began painting newspaper photographs of people, rather than the people themselves. Since then I have been trying to create images using mass-media techniques— half-tone areas and flat areas of colour as used in printing." This statement would have been just as applicable to the work he was doing some five years later, after his departure from London (Plate 187), except that it was now more elaborate and much larger in scale. One feels that Laing was already so committed to America even before he got there that the country had little to tell him.

A more interesting case is that of the much older German artist, Richard Lindner. Lindner was born in Hamburg in 1901. He fled from Germany in 1933, subsequently living and working in France. After he came to America in 1941, at first he worked as an illustrator; and only in the early Fifties did he give up illustration for painting. By 1953 he had established a basic visual vocabulary, including the corseted woman, "Lulu", who frequently appears in his paintings (Plate 188). Though Lindner's work seems to owe much to the artists of the Weimar Republic, such as George Grosz, and to memories of the pre-war German theatre, it also owes a good deal, especially from about 1961 onwards, to the New York environment. A "typical" Lindner certainly has a distinctly Pop look to it, and it is difficult to decide how much of this was already inherent in

238

187.
Gerald Laing
The Loner
1969; 152.4 × 648.6 cm. (59 × 253 in.)
Richard Feigen Gallery, New York, Chicago

188. Overleaf left
Richard Lindner
Ice
1966; 177.8 × 152.4 cm. (69 × 59 in.)
New York, Whitney Museum of American Art

189. Overleaf right
Richard Lindner
Cushion
1966; 177.8 × 152.4 cm. (69 × 59 in.)
Cologne, Wallraf-Richartz Museum, coll. Ludwig

Lindner's style, formed as it was in isolation from the main currents of modern painting, and how much was due to a fresh current of inspiration. One thing, however, is indisputable, and that is Lindner's power to create erotic images of obsessional force, and of far greater psychological complexity than most of those which appear in the Pop Art created by men who are considerably junior to him.

Pop was basically a one-generation phenomenon. Few of those who did not belong to the first wave succeeded in making any contribution to the movement. In America the exception to this has been Mel Ramos. Ramos' aims as an artist are essentially straightforward. He says: "I try to celebrate folk heroes and sex queens in a straightforward manner. While their likeness is not faithful, their character is obvious" (from the

239

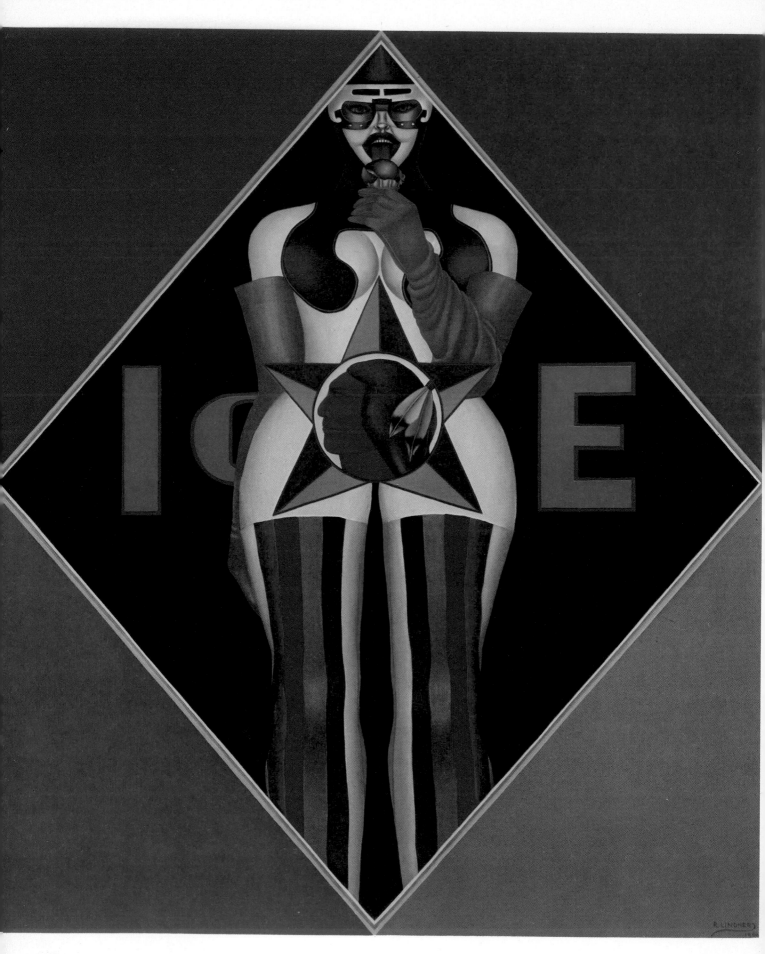

190.
Mel Ramos
Hippopotamus
1967; 180 × 247 cm. (70 × 96 in.)
Aachen, Neue Galerie, coll. Ludwig

introduction to the "Six More" exhibition at the Los Angeles County Museum of Art, 1963).

What makes Ramos's work attractive, in addition to its straightforwardness, is its technical confidence (Plate 190). If one compares a painting of his to those using similar subject-matter done by artists who made their reputations slightly earlier, one notes that Ramos approaches the material with utter confidence, and also with a total lack of self-consciousness. Lawrence Alloway, always a shrewd judge, has noted the way in which the "painterly handling ripples through the heraldic scheme".

Of all the art styles that have arisen since the war, Pop Art, and especially American Pop, was the one which seemed to mesh most successfully with the society that produced it. In this connection it is important to note that its success was made by dealers and collectors, rather than by critics. When the first Pop works made their appearance in the New York galleries, they were eagerly welcomed by buyers, but the reaction from established writers on modern art was almost universally unfavourable. Just as Pop Art was making its first impact, Harold Rosenberg, who had been one of the chief supporters of Abstract Expressionism, issued the following denunciation: "The new American illusionist contrivances have a deeper identification with commercial art than the plagiarism or adaptation of its images. They share the impersonality of advertising-agency art-department productions. They are entirely cerebral and mechanical; the hand of the artist has no part in the evolution of the work but is the mere executor of the idea-man's command, though in this case the artist himself is usually the idea-man (sometimes the idea for a work comes from friends or sponsors). Nor is the self of the artist involved in the process of creation" (Harold Rosenberg, *The Anxious Object*, London, 1965, p. 75). This was fairly typical of what the most-respected critics had to say on the subject.

It was only towards the mid-Sixties that some art theorists became more tolerant. In an article published in 1964, Robert Rosenblum pointed out that the Pop label had already been used to cover a whole diversity of styles. He was ready to declare,

242

191.
Mel Ramos
Miss Corn Flakes
1964; 183 × 152.5 cm. (71 × 59 in.)
Colorado, coll. Kimiko and John Powers

indeed, that the boundary between Pop and abstract art was an illusory one. This article, for all the good sense which it displayed in detail, was nevertheless a sign that Pop was being painlessly absorbed, that it was becoming part of the art consensus. For there are several ways of approaching Pop Art. One is to regard it as a cultural conspiracy, a plot by both ends against the middle. In this case the respective ends are the mass and the avant-garde. The avant-garde takes up and uses the characteristic images and artifacts of mass culture as a way of disconcerting the bourgeois centre, whose members regard themselves as the custodians of culture. In this interpretation, the most important aspect of Pop is its irony.

But, as has appeared from a number of the artists' statements that I have quoted in this chapter, Pop was also celebratory. The artists actually liked the source material they drew upon—it gave them pleasure to contemplate it. They liked it for its own sake, and because it was emblematic of aspects of the culture around them which they enjoyed: its speed, energy, eroticism, enthusiasm for novelty. Because of the dissident position traditionally occupied by members of the avant-garde, it took some courage for artists to make the declaration that they were not in fact disaffected, that on balance they enjoyed the context that surrounded them. They had to overcome deep-seated blockages within themselves in order to paint Pop pictures and create Pop objects, and it was this which gave the images they made a certain emotional force.

Enjoyment of Pop culture was also linked to a certain nihilism. This nihilism was different from the same emotion as it manifested itself in Dada because society had undergone so many transitions in the interval. The Pop artist admired the "cool" of the jazz musician and the street hipster; he wanted to demonstrate that he, too, belonged to the same breed. Acceptance of modern industrial society, with all its crudity and ugliness, was a way of preserving oneself from emotional damage. If the label Pop covered a wide variety of artistic styles, it nevertheless designated quite accurately a concern for "stylishness" which had its roots in a willed emotional distance.

The relationship between Pop Art and its audience was a good deal more complex than it appeared on the surface because the public tended to be impervious to irony and did not share the artists' concern with the nuances of a vocabulary of representation. Nevertheless, Pop was the nearest that avant-garde art had got, during its more than fifty years of activity, to achieving a broad-based popular acceptance.

Pop Art as an International Style

As has already been noted, artists in Britain were quick to discover the possibilities offered by Pop imagery—even quicker, in fact, than artists in the United States. The man who, where British Pop was concerned, occupied a position analogous to that of Rauschenberg and Johns in America was Richard Hamilton. The similarity is increased by the fact that Hamilton has taken a lifelong interest in Dada. He became a personal friend of Marcel Duchamp towards the end of the latter's life, and was responsible for the reconstruction of the *Large Glass* shown in the Duchamp restrospective exhibition at the Tate Gallery.

Hamilton has always been an artist with a strong element of social consciousness, and it is this perhaps which prevents him from being a pure Dadaist in the Duchamp mould. Another thing which has influenced his work is the fact that he is virtually an autodidact. He left elementary school at the age of fourteen, and worked in advertising while attending evening classes at various art schools. He thus, like Warhol, had personal experience of the kind of source material he was afterwards to use. A third powerful influence on Hamilton's painting is his own experience as a teacher—he taught for a long time, not fine art, but courses in design. This led him to place great stress on the idea of problem solving. It also turned him into an habitual pragmatist. The English critic Richard Morphet has commented on his "aversion from predetermination of the character of the work by fidelity to style as such".

Despite the extensive use he makes of American material, Hamilton could never be mistaken for an American artist, not least because whatever he does has a consistently dandified quality which is the signal that he is happy to use what the Pop milieu offers him, but by no means to identify himself with it. He is always very willing to supply explanations, often elaborate ones, of his own work, and these explanations give many clues to his attitudes. The painting *She* (Plate 192), for instance, is the subject of a long exposition, some excerpts from which are worth quoting here. "Art's Woman in the fifties [Hamilton remarks] was anachronistic—as close to us as a smell in the drain; bloated, pink-crutched, pin-headed and lecherous; remote from the cool woman image outside fine art. There she is truly sensual but she acts her sexuality and the performance is full of wit. Although the most precious of adornments, she is often treated as just a styling accessory. The worst thing that can happen to a girl, according to the ads, is that she should fail to be exquisitely at ease in her appliance setting—the setting that now does much to establish our attitude to woman in the way that her clothes alone used to. Sex is everywhere, symbolized in the glamour of mass-produced luxury—the interplay of fleshy plastic, and smooth, fleshier metal" (*Architectural Design*, October, 1962).

She is a compilation from various advertising sources—a picture of a "cornucopic" refrigerator, advertisements for vacuum cleaners and other electrical appliances, an *Esquire* pin-up photograph.

A somewhat later painting, *I'm Dreaming of a White Christmas* (Plate 193), subjects a clip from a movie to an elaborate series of transformations. In particular, the artist has substituted colour-negative for colour-positive, so that the singer is transformed into a Negro, as an ironic allusion to the title of his song. The element of irony does not, however, rule out nostalgia. Hamilton's work, in common with that of other British Pop artists, has a sentimental tinge which makes it seem more charming and less deliberately aggressive than the work produced by his American colleagues.

An interesting, though only partial, exception to this rule is the work of the American artist

R. B. Kitaj. Kitaj is an émigré who has spent the most important part of his career in England, first arriving in 1958 to study at the Royal College of Art. What Kitaj has in common with Hamilton is that his painting, like Hamilton's, is filled with complex ideas which often require verbal as well as visual expression to make themselves fully apparent. Kitaj is a great admirer of the American expatriate poet Ezra Pound, and his paintings (Plate 194) seem meant to contain, and to sustain, a whole complex of allusions, many of them deliberately hermetic, as if the artist were trying to produce a painted equivalent of one of the more involuted segments of Pound's *Cantos*. Kitaj is an intensely literary painter, probably the most literary which the post-war period has so far produced. But he is also a humanist. As Wieland Schmied remarked in the catalogue preface to the Kitaj exhibition at the Kestner Gesellschaft, Hanover, in 1970, the canvases are meant "to bear the possibility or occasion of delivering something like human character into picture making". The honesty and the defects of Kitaj's humanism are well suggested by the qualifications which fill out this description. His work is indeed full of possibilities—it seems meant to keep the artist's

194.
Ronald B. Kitaj
London by Night
1964; 145 × 183 cm. (57 × 71 in.)
Amsterdam, Stedelijk Museum

choices, as well as the spectator's, completely open. In this respect it is unlike most of the rest of Pop Art because it so entirely lacks the brash directness associated with the style.

Kitaj exercised a significant influence over the English artists with whom he came in contact at the Royal College of Art, and the college itself played an important role in the formation of an English Pop style. There was, however, room for artists of very different persuasions within the walls of the institution, room even for those interested by the same kind of source material. Peter Blake, for instance, remained the most resolutely English of artists, despite his enduring affection for popular

195.
Peter Blake
Drum Majorette
1957; 84 × 64 cm. (33 × 25 in.)
Private collection

artifacts of all kinds (Plate 196). What Blake valued about Pop was simply the sense of freedom which it gave him: "Pop Art changed a lot of things in the way people look at pictures—so now I don't have to step from one to the other—one day I can do a drawing for a magazine and the next day a drawing for an exhibition, and they will be identical. I don't have a graphic style: it is exactly the same sort of drawing as I would be doing as fine art" (artist's statement from the catalogue *Three Painters: Blake, Dine, Hamilton*, Midlands Art Centre, Birmingham, 1967).

The nostalgic element in his work is even stronger than it is in Hamilton's, so much so that Blake can seem a Victorian artist born out of his time, never more so than in a beautiful series of illustrations for Lewis Carroll's *Alice's Adventures in Wonderland*. When Blake makes use of a specifically twentieth-century technique, such as collage, he immediately manages to remind us that the method was in fact taken to heights of considerable elaboration by Victorian amateurs pasting scraps onto screens. Even the basic materials of Blake's collages are often reminders of his roots in an earlier sensibility. He makes extensive use of Victorian and Edwardian post-cards, as well as of modern pin-ups.

The boy wonder of the British Pop scene of the 1960's was not Peter Blake but David Hockney. From the sociological (though not from the artistic) point of view, Hockney provides a British equivalent for the meteoric career of Andy Warhol, and in their different fashions they both of them illustrate the way in which the successful artist suddenly became the culture hero of the period, in London as well as in New York.

One of Hockney's characteristics is the marked lack of an American accent in his work, despite the importance of the American experience to his personal development. When he was a student, his work showed distinct signs of the influence of Dubuffet, and this influence is still traceable in the paintings produced during the early Sixties, when Hockney first made his reputation (Plate 198). It was apparently Dubuffet who first aroused Hockney's interest in child art. He has always been an artist with a tremendous gift for draftsmanship, and these early pictures rely heavily upon the sensitivity of his line, to the point where they can seem to be enlarged drawings, rather than works which necessitated the elaboration of oil paint. But one should not overlook the sophistication of his approach to the problems of visual representation. Discussing the picture in Plate 198, he once said: "I placed [the two figures] in the painting in a rather ambiguous setting. It looks as though they are standing on a desert island with white sand and a palm tree. But the white at the bottom is only a base for them to stand on, and the rest of their setting is intended to be slightly out of focus, apart from the ecclesiastical shape in the bottom left-hand corner (an association with marriage). I called

196.
Peter Blake
The Love Wall
1961; 124.5 × 236.2 × 23 cm. (49 × 92 × 9 in.)
London, The Calouste Gulbenkian Foundation

199.
Peter Phillips
Futuristic Revamp
1968; 59.5 × 94 cm. (23 × 37 in.)
Düsseldorf, coll. Heinz Beck

it *First Marriage* because I regarded it as a sort of marriage of style. The heavily stylized female figure with the not so stylized 'bridegroom'" (from an article in *Cambridge Opinion*, 37, 1963, reprinted in the catalogue of the David Hockney exhibition at the Whitechapel Art Gallery, London, 1970).

What Hockney was able to do, in this early phase of his work, was to combine two very different approaches. On the one hand he was interested in exploring the workings of accepted visual convention, and on the other he created paintings which seemed uniquely accessible because of the mixture of confessional autobiography and genial wit.

America was important to Hockney because he found it personally liberating. Though his famous suite of etchings *The Rake's Progress*, which records his first visit to New York, is full of criticisms of the American scene, what comes across most strongly is a sense of euphoria. New York and later Los Angeles were for the artist the legendary Land of Cockaigne, where any kind of experience was possible, and where all feelings of guilt and constraint could be shed. Hockney came to stand for an opposition to English provincialism. He himself was a provincial boy from the industrial town of Bradford—the pictures he painted represented a process of self-transformation. Their unique quality was their detachment, their ability to record the artist's follies and foibles without indulging them.

Most of the other artists connected with the English Pop movement were distinctly more conventional in their approach. The most typical of them, in many respects, were Peter Phillips and Allen Jones. Phillips (Plates 199 and 200) represents the nearest approach by an Englishman to the Pop ikons produced in America—his

200.
Peter Phillips
Tribal 1 × 4
1962; 107 × 99 cm. (42 × 39 in.)
Paris, Galerie Mathias Fels

201.
Allen Jones
Curious Woman
1964–65; 121.9 × 101.6 × 10.2 cm. (48 × 40 × 4 in.)
Colorado, coll. Kimiko and John Powers

202. Opposite
Allen Jones
Perfect Match
1966–67; 280 × 93 cm. (109 × 36 in.)
Cologne, Wallraf-Richartz Museum, coll. Ludwig

203. Overleaf
Allen Jones
Hatstand, Table, Chair
1969; 184 × 76 × 62 cm. (72 × 30 × 24 in.)
Aachen, Neue Galerie, coll. Ludwig

versions differ from the native product only
because of their romanticism. Many of Phillips'
favourite images have a fetishistic tinge, but he has
consistently denied that this is an important part of
their meaning: "My crash-helmets and motor-
cycles are not 'kinky'; I use them for different ends
than just fetishism. The imagery is not important
or significant for itself; it is the way it is painted
and used that matters" (quoted by Mario Amaya,
Pop as Art, London, 1965, p. 132).

Despite this specific denial, the spectator
remains aware of a sexual overtone. But it is
carefully distanced by the technique, especially in
those canvases from the mid-Sixties onwards in
which the artist makes use of the impersonal finish
which can be got with an airbrush. This was
adopted as part of a search for mechanical
perfection. "I don't want to be a machine like
Warhol," Phillips said, "but I love the idea of
using one." Yet it also seems to be a device for
holding violent and perhaps threatening emotions
at a safe distance.

The eroticism in Allen Jones's work is more
openly acknowledged, though he also said in 1965,
at about the time when *Curious Woman* (Plate 201)
was produced: "I have no special regard for
figuration; it is simply a means of commencing,
and any recurrence of an image could be said to
reflect the inability to solve a pictorial problem"
(quoted by Michael Compton, *Pop Art*, New
York, 1970, p. 69). Much of the basic material of
his earlier painting came from the kinkier kind of
girlie magazine, but translated into terms of
Matisse's brushwork and colour-schemes. Jones is
a gifted painter. He has outstanding inventiveness
with both imagery and colour, combining and
recombining stringently patterned and freely
painterly elements, breaking up human anatomy to
re-arrange it in new ways. In the early Sixties, at a
time when he was working in New York, he was
deeply interested in the theme of hermaphro-
ditism, and played a series of inventive variations
upon it. Americans were fascinated by the way in
which he managed to combine the traditional
preoccupations of European painting with the
new, and on the surface very different, concerns of
Pop. Jones at that stage seemed to work with

204.
Antony Donaldson
Girl Sculpture "Red'n Gold"
1970; 75 × 448 cm. (29 × 175 in.)
London, Rowan Gallery

205. Opposite
Anthony Green
The Red Chair
1970; 216 × 211 cm. (84 × 82 in.)
London, Rowan Gallery

262

greater technical freedom than either Tom Wesselman or Richard Lindner, both of whom had something in common with him so far as subject-matter was concerned.

More recently, Jones's fetishistic obsessions have often seemed to get the better of his artistic judgment. He has made a series of sculptures (Plate 203) which are expressions of sadistic sexual fantasy, and the Super Realist style in which these pieces are executed makes it difficult to decide in what way the spectator is intended to react to them. Are they an ironic commentary on the limited nature of contemporary eroticism? Or does the artist present these images with complete confidence in their intrinsic interest?

Obsessional eroticism is one of the leading characteristics of British Pop Art, far more so than with American Pop. Few of the leading British artists of this group are free from it—we encounter it not only in Phillips and Jones but also in the art of Hockney and Peter Blake. Yet another example is the work of Antony Donaldson, who has a visual repertoire based on variations of the pin-up.

Donaldson's paintings can look rather tame when put beside those of some of his rivals, but he is one of the few Pop artists to have become more inventive as he grew older, and his recent streamlined sculptures (Plate 204), combining the architectural features of Los Angeles with typical girlie-magazine images, are a witty new variation on a rather worn theme.

One British artist, connected to Pop Art but not in the mainstream, who shows a rather different kind of eroticism in his work is Anthony Green. Green employs some of the conventions of naïve painting without being in any sense a naïf. He has described his own paintings as follows: "They tell stories about my immediate surroundings, about people who are close to me—my wife, relatives, children. I want them to reach a wide section of the community, the expert as well as the 'man on the street' because I feel the appreciation of paintings exists on many levels" ("Anthony Green at Rowan Gallery", *Studio International*, Vol. 184, London [November, 1972]). But the artist's candour makes no concessions. He paints his wife,

206.
Joe Tilson
Is This Che Guevara?
1969; 101.6 × 68.6 cm. (40 × 27 in.)
London, Tate Gallery

calm and naked (rather than nude) in the surroundings of their apartment (Plate 205), and he has even painted a group of canvases which are candid, and also touching, depictions of the act of love.

In seeking for an explanation of this powerful erotic streak in the British art of the Sixties, one is tempted to point to the difference in social context between Britain and America. In many ways, the sexual sense not least among them, the Sixties were a more thoroughly liberating decade in London than they were in New York. The reason is simple: prosperity came more suddenly, and the British had greater freedoms to win. The sexuality in American Pop Art tends to be of two kinds—either it is a tribute to a revered cultural object, in this case the pin-up; or else (as in Warhol's movies) it is 'a covert expression of American violence. That is to say, it is sexual only at some secondary level. In Britain things are different. There is a feeling of confessional release and self-discovery in the images used by British Pop artists.

On a different plane, it is also interesting to note differences of technique. American Pop artists created ikons or fully developed three-dimensional objects. Their flirtations with the shaped canvas were comparatively mild. In Britain experiments of this type assumed a great deal more importance. At an early stage in his career, Hockney employed shaped canvases, but one associates them chiefly with the work of Peter Phillips, Allen Jones, and Richard Smith—the third named is one of the few artists to have made the move from Pop figuration to complete abstraction. The shaped paintings produced in Britain invite a comparison with a quite different school in the United States, that of the Post-Painterly Abstractionists (see Chapter VIII), and particularly with the work of Frank Stella. The resemblance indicates the more eclectic and more prolix nature of British art.

Unlike American Pop, but like some of that produced in Europe, British Pop had a political component. Richard Hamilton was again one of the leaders in this field, with the series of canvases *Swingeing London*, inspired by the arrest on drugs charges of the Rolling Stones, and with the large-

edition print inspired by the shootings at Kent State. Another artist who produced a good deal of politically oriented work was Joe Tilson, whose print *Is This Che Guevara?* (Plate 206) became one of the best-known "radical" images of the decade. Tilson has always been an intellectual—interested in language games (which form the subject of the series of painted reliefs entitled *Geometry*), and interested in the way the visual and verbal language of the mass media affects the way in which we apprehend the world. He said to an interviewer: "I am interested in the environment of the mind, what goes on inside rather than outside. . . . By celebrating the ephemeral you change people's attitudes towards it, make them more aware of non-permanence and the inevitability of change" (Richard Cork, "Talking with Tilson", *Art and Artists*, Vol. IV, No. 12, London [March, 1970], p. 27).

As it happens, Tilson's own work has a certain air of transience, based on the triviality of his approach to the subject-matter, which seems circumscribed by Pop conventions. *Is This Che Guevara?*, though it dates from the very end of the decade, now seems even more of a period piece than most examples of Sixties Pop Art. Looking at it, one recalls that a fashion boutique called Che Guevara was founded in London at almost the same moment, in inappropriate tribute to the Cuban guerrilla leader's death.

There is one British painter usually classified as Pop who stands in striking contrast to the rest of those who find themselves placed in that category. This is Patrick Caulfield. Caulfield's work has much in common with that of Roy Lichtenstein (Plate 208). His source material is not comic strips, but the cheapest kind of department-store art reproduction. From these he has deduced a set of conventions which he applies to a wide range of subject-matter. Like Lichtenstein, Caulfield uses what seems on first sight to be a harsh and cruel technique with surprising subtlety and classicism, using a heavy black line to divide the canvas into colour areas, and pitching the colours themselves against one another with such skill that one never notices the total absence of modelling. Caulfield has stuck even more firmly than Lichtenstein to

207. Opposite
Joe Tilson
OH!
1963; 124.5 × 94 cm. (49 × 37 in.)
Boston, The 180 Beacon Collection

208.
Patrick Caulfield
Pottery
London, Tate Gallery

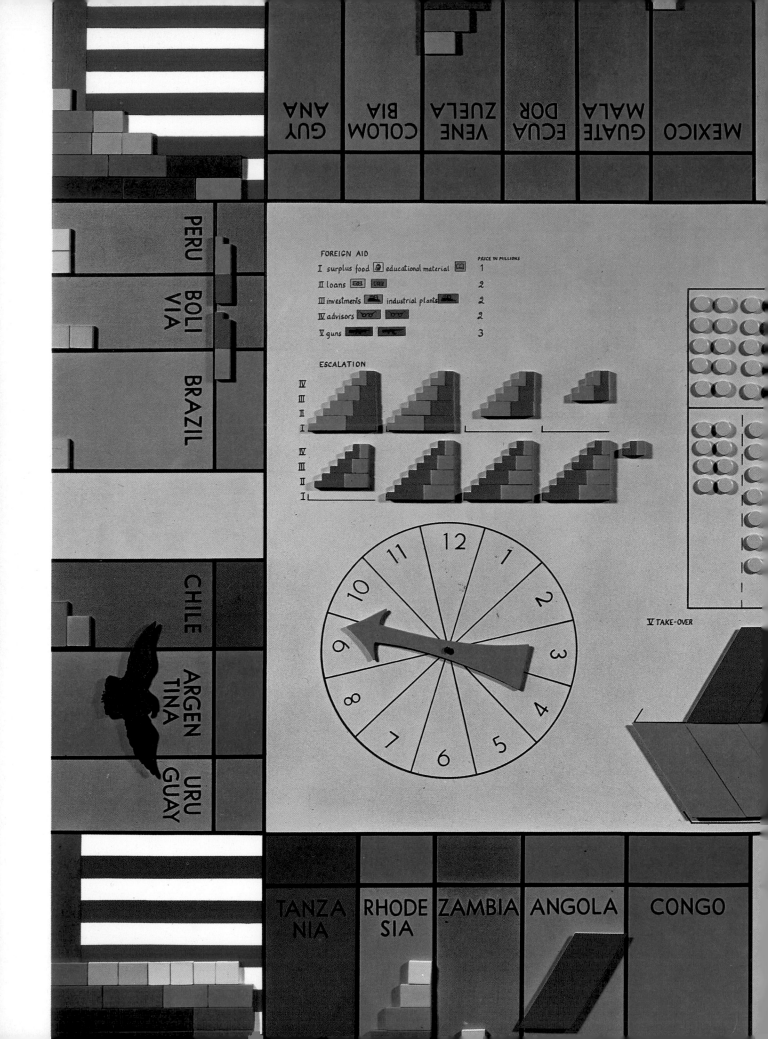

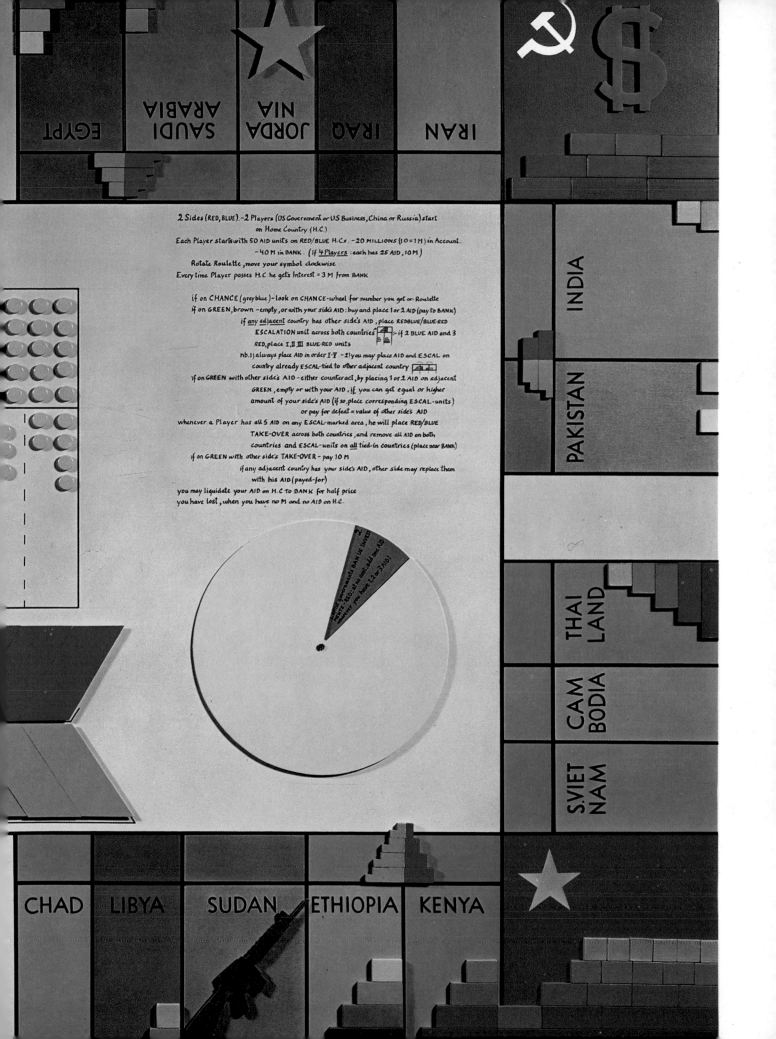

EGYPT | SAUDI ARABIA | JORDANIA | IRAQ | IRAN

INDIA

PAKISTAN

THAI LAND

CAM BODIA

S.VIET NAM

CHAD | LIBYA | SUDAN | ETHIOPIA | KENYA

2 Sides (RED, BLUE). – 2 Players (US Government or US Business, China or Russia) start
on Home Country (H.C.)

Each Player starts with 50 AID units on RED/BLUE H.C.s. – 20 MILLIONS (10 = 1 M) in Account.
– 40 M in BANK. (If 4 Players: each has 25 AID, 10 M)

Rotate Roulette, move your symbol clockwise

Every time Player passes H.C. he gets Interest = 3 M from BANK

if on CHANCE (greyblue) – look on CHANCE-wheel for number you got on Roulette

if on GREEN, brown – empty, or with your side's AID: buy and place 1 or 2 AID (pay to BANK)

if any adjacent country has other side's AID, place REDBLUE/BLUE-RED
ESCALATION unit across both countries — if 2 BLUE AID and 3
RED, place I,II III BLUE-RED units

nb.1) always place AID in order I-V. – 2) you may place AID and ESCAL on
country already ESCAL-tied to other adjacent country

if on GREEN with other side's AID – either counteract, by placing 1 or 2 AID on adjacent
GREEN, empty or with your AID, if you can get equal or higher
amount of your side's AID (if so, place corresponding ESCAL-units)
or pay for defeat = value of other side's AID

whenever a Player has all 5 AID on any ESCAL-marked area, he will place RED/BLUE
TAKE-OVER across both countries, and remove all AID on both
countries and ESCAL-units on all tied-in countries (place near BANK)

if on GREEN with other side's TAKE-OVER – pay 10 M

if any adjacent country has your side's AID, other side may replace them
with his AID (payed-for)

you may liquidate your AID on H.C to BANK for half price

you have lost, when you have no M and no AID on H.C.

209. Overleaf
Öyvind Fahlström
World Trade Monopoly
1970; 63.5 × 98 cm. (25 × 38 in.)
New York, by kind permission of the Sidney Janis Gallery

210.
Öyvind Fahlström
Eddie in the Desert
1966; 77.5 × 128 cm. (30 × 50 in.)
Stockholm, Moderna Museet

his métier as a painter, and has produced an increasingly impressive body of work.

Pop has often been thought of, in the English-speaking countries, as an exclusively Anglo-American phenomenon. The large survey exhibition, "Pop Art Redefined", organized by John Russell and Suzi Gablik in London in 1969 contained only one artist not usually domiciled either in Britain or in the United States. This was the Swede Öyvind Fahlström, who in any case keeps in close touch with what is going on in New York. But his work, nevertheless, has traits which mark it off from the British or American product. The chief of these is its didacticism. Fahlström tells himself to "Consider art as a way of experiencing a fusion of 'pleasure' and 'insight'. Reach this by impurity, or multiplicity of levels, rather than by reduction. . . . The importance of bisociation (Koestler). In painting, factual images of erotic or political character, for example, bisociated, within a game-framework, with each other and/or with 'abstract' elements (character-forms), will not exclude but may incite to 'meditational' experiences. These, in turn, do not exclude probing on everyday moral, social levels" (statement from *Pop Art Redefined*, by John Russell and Suzi Gablik, London, 1969, p. 68). What he means by this may perhaps be deduced by looking at a work such as his *World Trade Monopoly* (Plate 209), where the political situation of 1970 is interpreted in terms of a well-known board game.

The humour in Fahlström's work is, despite his close links with the American art world, recognizably European in character, with an irony which resembles that of Bertolt Brecht rather than that of Andy Warhol because it is directed towards making an absolutely specific moral point.

The Pop Art produced by Scandinavian or German artists does in fact have a rigorous, uncompromising quality which seems to mark it off from that created elsewhere. The Icelandic painter Erró has been associated with the Paris avant-garde, but his teeming *Foodscape* (Plate 211) has an Expressionist quality which gives Pop subject-matter a completely new twist and which seems recognizably northern in its satire upon an oppressive abundance. By contrast, there is a

northern bleakness about the highway image in Peter Brüning's *Autobahndenkmal* (Plate 212) which makes the image seem different from those created by Ruscha and D'Arcangelo, though these have clearly exercised an influence.

For northerners, Pop might seem a contemporary extension of the long-standing realist tradition. For Frenchmen, on the other hand, its status was more controversial. By the time Pop Art arose, the Paris art world was already worried by the threat to its hegemony represented by New York. Pop, with its American accent, was not sure of a welcome, and French artists who adopted Pop techniques and attitudes ran the risk of arousing the chauvinism of their own countrymen. In addition to this, Pop culture was less deeply rooted in France than it was in either Britain or America, and what was commonplace in the English-speaking countries (the excesses of consumer advertising, for example) still seemed exotic in France.

Despite this, the attraction of the Pop movement was so powerful that a number of French artists were drawn into its ranks. The one who achieved the most widespread international reputation was Martial Raysse, partly through his association with the New Realism group formed by Pierre Restany. Among Raysse's most typical works are his new versions of classic paintings—for instance, the paraphrase of an Ingres *Baigneuse* illustrated here (Plate 213). The artist has always denied that there is any sarcastic intention in these works, and the claim has been repeated by his admirers: "Martial Raysse has taken the colors and textures of this attractive world of the supermarket and made a poem of them. The colors are the lurid pastel and fluorescent ones of useful articles: the textures are those of new aluminum, plastic and nylon . . . unlike some of his colleagues he is not trying to put across an ironic message. Things are left as they are. 'I want everything in my work to be good-looking and brand-new,' he once said wistfully" (John Ashbery, from the catalogue introduction to the "Raysse Beach" exhibition at the Dwan Gallery, Los Angeles, 1965). Otto Hahn has spoken of Raysse's desire to artificially penetrate life, to beautify, to reach

271

212.
Peter Brüning
Autobahndenkmal
1968; 42 × 75.5 cm. (16 × 29 in.)
Düsseldorf, coll. Heinz Beck

213. Opposite
Martial Raysse
Made in Japan in Martialcolor
1964; 116 × 89 cm. (45 × 35 in.)
Archives Galerie Alexandre Iolas, New York, Paris,
Geneva, Milan, Rome

by any means the highest degree of intensity".

What this means in practice is the extensive application of "bad taste"—neon tubes in garish colours, surfaces flocked with plastic fibres in vivid colours—to images which are usually considered the height of "good taste". It is as if Raysse feels that these images have lost all intensity, and need to be rescued by the means that lie closest to hand, however drastic the process may seem.

Other French Pop artists such as Alain Jacquet and Jacques Monory give the same impression of being burdened to the point of rebellion by the artistic tradition which they have inherited. Jacquet (Plates 215 and 216) has made extensive use of photomechanical processes as a way of alienating familiar material, and of making the

spectator look at it with a fresh eye. Monory (Plate 217) also relies heavily on the transforming power of the camera, and on the emotional distance imposed by his monochrome colour schemes: "What Monory does is to bring us back to this prison of familiar gestures whose significance eludes us like certain faces in the blue and rose mist of his canvases. A certain lassitude seems to be the price of this effort to achieve lucidity without illusions, where woman plays the role of sovereign palliative and omnipresent idol" (Gérald Gassiot-Talabot, catalogue introduction to "Jacques Monory—Velvet Jungle/NY", Amsterdam, Stedelijk Museum, 1972).

Much of Monory's work has the same fugitive quality and the same emotional ambiguity as the films of French New Wave moviemakers.

214.
Martial Raysse
Simple and Tranquil Painting
1965; 129.5 × 175.6 × 16.5 cm. (51 × 68 × 6 in.)
Cologne, Wallraf-Richartz Museum, coll. Ludwig

215. Opposite
Alain Jacquet
The Rape of Europa
1965; 76 × 53.5 cm. (30 × 21 in.)
Düsseldorf, coll. Heinz Beck

The extreme degree of contrast between the women who appear in Monory's work and the cheerful "Nanas" created by Niki de Saint-Phalle (Plate 218) prompts one to reflect on what now, in the mid-Seventies, seems the least acceptable aspect of the Pop Art movement in general, which was its conspicuous streak of male chauvinism. Almost everywhere they appeared in Pop painting or in Pop sculpture, women were represented as mere objects. They were allowed no independent existence outside the confines of male fantasy. Saint-Phalle's figurines offer a striking contrast to Allen Jones's fetishistic sculptures. Bulging and brightly decorated, they seem to echo female,

rather than male, fantasies about the female body and female existence. As "sculpture" they are essentially and endearingly unpretentious.

Another French artist who produced sculpture in a recognizably Pop idiom was the chameleon-like César, whose giant versions of his own thumb (Plate 219) fall into this category, and seem to offer a Parisian equivalent to Oldenburg. But it is difficult to find these mammoth examples of self-glorification original or significant, especially as they seem, though unconsciously, to echo so many Renaissance notions concerning the artist as divine creator.

Pop also had its impact upon the art scene in

216.
Alain Jacquet
Déjeuner sur l'herbe
1964; 175 × 197 cm. (68 × 77 in.)
Rome, Galleria Nazionale d'Arte Moderna

217. Opposite
Jacques Monory
Hypersensitive
1970; 201 × 150 cm. (78 × 59 in.)
Aachen, Neue Galerie, coll. Ludwig

218.
Niki de Saint-Phalle
Un Ensemble de "Les Nanas"
1965;
Archives Galerie Alexandre Iolas, New York, Paris,
Geneva, Milan, Rome

219. Opposite
César (César Baldaccini)
Le Pouce
1976; 90 × 50 × 42 cm. (35 × 20 × 16 in.)
Paris, Galerie Claude Bernard

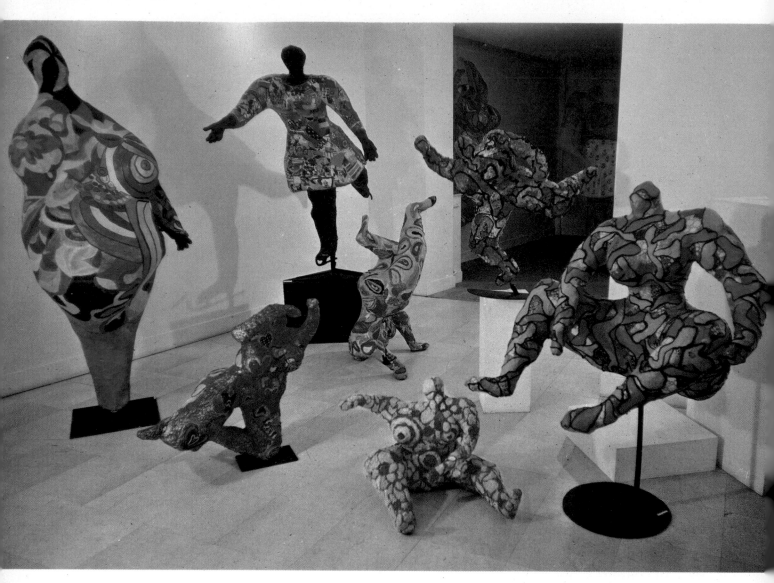

Italy, and here the results were perhaps more interesting than they were in France. Some Italian artists had close connections with those in Paris. One of these was Mimmo Rotella (rather older than most Pop artists, since he was born in 1918), who, like Raysse and César, formed part of Restany's band of New Realists. Rotella's place in the Pop pantheon was earned by a series of collages made of torn posters and newspapers mounted on canvas (Plate 220). These were a translation into "gallery" terms of the accidental conjunctions which the artist saw in the streets.

Another Italian artist who won widespread acceptance in Paris was Valerio Adami, who in 1970 was the subject of a large-scale retrospective at the Musée de l'Art Moderne de la Ville de Paris. From the point of view of technique, the nearest equivalent to Adami's work is that of Patrick Caulfield. We meet again there the hard black outlines, with the intervening areas filled with flat colour (Plate 221). But Adami does not depict his subject-matter with Caulfield's literalism. He declares: "I think the spectator should relive, in his own way, the formative process which the image

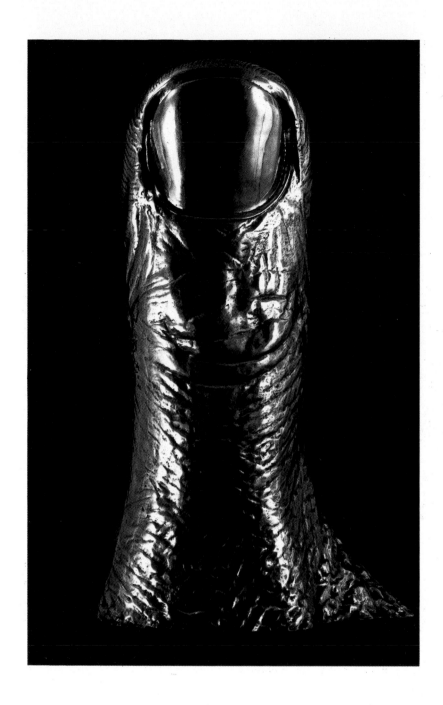

has followed. He should not find himself faced with a closed, immobile object. He should find himself implicated in something which is still in the process of happening. The picture is a complex proposition in which anterior visual experiences form unpredictable combinations; the imagination creating incessantly new associations—one image expands into another and its original form is in continual transformation" (from the catalogue of the exhibition "Adami Privacy Galerie", by B. Mommaton, Paris, 1968).

In practice this means a compromise between Surrealism and Pop. The metamorphoses familiar from Surrealist paintings present themselves, in Adami's work, not with the three-dimensional actuality familiar from the painting of Dali and Tanguy, or with the melting painterliness which we find in the mature works of Arshile Gorky, but with heraldic flatness and toughness of outline.

Other Italians connected with the Pop movement show a fascination with observed reality which takes us back to the great tradition of Italian art, and especially to Caravaggio. The most literal interpretation of "realism" is that provided by

220.
Mimmo Rotella
Omaggio al Presidente
1963; 82 × 175 cm. (32 × 68 in.)
Paris, Galerie Mathias Fels

221. Opposite
Valerio Adami
Interno coloniale
1976; 198 × 147 cm. (77 × 57 in.)
Paris, Musée National d'Art Moderne, loaned by the
Centre National d'Art Contemporain

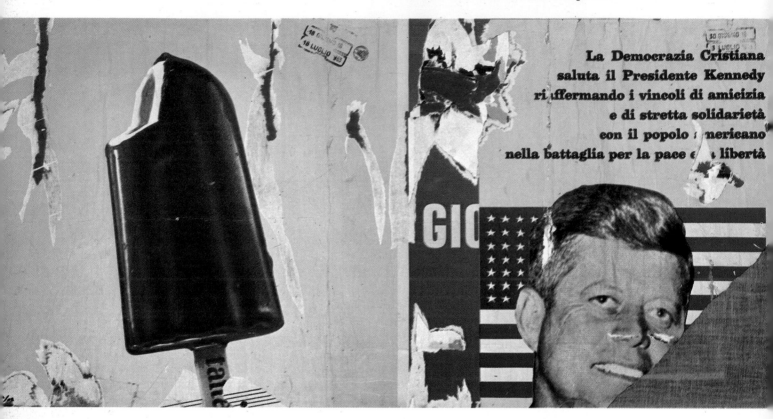

Michelangelo Pistoletto. He made a series of "mirror paintings" by reproducing photographs of people and everyday objects on sheets of polished steel. To these the spectator becomes a random addition, as he stands in front of the work (Plate 223). This has led the critic Henry Martin to deny that Pistoletto is a Pop artist in any recognizable sense: "His paintings are the meeting place of several different kinds of vision, and the meaning of the paintings lies in the way that these kinds of vision interact and manage to transform themselves into a single new and different and perhaps 'visionary' vision. Whereas Pop, along with its equivalents and predecessors, is a search for metaphor within reality and with respect to objects abstracted from their representation of reality. Pistoletto is at one step removed—he plays a game with the various orders of reality and does not fall in love with the photographic reality he reproduces. The absolute staticness of the photographs became the absolute immobility of the represented figure. The 'instant death' quality of

the photograph became translated into the figure's absolute expressionlessness" (Henry Martin, introduction to the catalogue of the Pistoletto exhibition, Museum Boymans-van Beuningen, Rotterdam, 1969).

Piero Gilardi has a more romantic, even sentimental, approach, with his painstaking three-dimensional reproductions of natural things (Plate 222). He says: "I have faith in our technological civilization, because it can reproduce the facts of nature while triumphing over death." Fragments of existence, separated from the context in which we usually find them, and brought to our attention without apparent editing, take on a strangely touching and vulnerable quality.

Another Italian artist with an interest in the apparently insignificant fragment was the late Domenico Gnoli. Gnoli's speciality was extreme close-up views of perfectly ordinary things, but particularly of clothing (Plate 224). These, in his hands, acquired hallucinatory intensity, thanks chiefly to an accomplished but never showy

222.
Piero Gilardi
Orto
1967; 160 × 160 cm. (62 × 62 in.)
Boston, The 180 Beacon Collection

223. Opposite
Michelangelo Pistoletto
Uomo che legge
1968; 228 × 120 cm. (89 × 47 in.)
New York, Kornblee Gallery

technique. Gnoli's paintings communicate the value and the strangeness of quotidian existence, and in this sense they are outside the Pop tradition and in direct line of descent from the still-life painting of Giorgio Morandi. Gnoli's wonderful control of tone and texture was in marked contrast to the deliberate cheapness of much of the fashionable painting produced during the 1960's.

In Spain, hardly any art appeared which deserved the Pop label, chiefly, and quite logically, because Spain was still to a large extent a preindustrial society. The nearest approach to convincingly popular imagery was to be found in the ominous paintings of Juan Genovés (Plate 225), which looked like excerpts taken at random from news reels showing riots, executions, civil

war, and revolution. It was a strange kind of art to make its emergence under the still repressive regime of General Franco. In fact, Genovés seems to intend his paintings not so much as a report on the condition of the world as it is now, but as a kind of prophetic dream of an apocalyse to come. They thus, like Adami's work, contain a strong Surrealist element. What does relate them to Pop Art, however, is the decision to rely on the way the camera sees, as recorded on film, rather than on the way the eye sees (or upon the mind's interpretation of what is brought to it by the eye).

Finally, something must be said about the progress of Pop Art in the only fully industrialized nation in Asia. The style enjoyed an enormous success in Japan, far greater than that of other

226. Opposite
Tadanori Yoko-o
A Document of Marilyn Monroe's Sex Life
1970; 85 × 60.2 cm. (33 × 23 in.)

227.
Tomio Miki
Ear Pink 12
1967; 270 × 144 × 98 cm. (105 × 56 × 38 in.)

kinds of avant-garde painting which might actually be said to owe something to Oriental calligraphy or the quietism of Zen philosophy. A work such as Tadanori Yoko-o's *A Document of Marilyn Monroe's Sex Life* (Plate 226) strangely combines Japanese and European elements, making use of material borrowed from Japanese prints at the tail end of the *ukiyoe* tradition as well as of photographic images such as an American or a European would have used. But perhaps it is significant that the choice of Marilyn herself seems to have been *de rigueur*.

Often Japanese Pop is indistinguishable from what was being produced elsewhere. Tomio Miki's giant ears (Plate 227) exhibit no essential point of difference from César's giant thumbs.

Pop's universal success was a tribute to its appositeness to the time which produced it, and to its ability to communicate to a broad spectrum of people. But it also deserves examination as an instance of unconscious cultural imperialism—a visual language imposed by technologically advanced societies upon those which were less thoroughly developed.

Op Art and Kinetic Art

At the height of their vogue, optical (nicknamed Op) and kinetic art were often presented as the destined successors of Pop—the logical response in a dialogue of styles. There was some truth in this idea, but as a theory it was too superficial. In many respects, these developments were the reassertion of a long-established tradition within Modernism, a reaction not to Pop as such, but to the attitude towards society which formed the background to the activities of Pop artists and to their success with the public. If Pop had its roots in Dada, then Op and kinetic art had theirs in the rich soil of Futurism and Constructivism. Pop was simultaneously celebratory and ironic, while those who gave their allegiance elsewhere tended to think of themselves as being opposed to the present in the cause of the future. At the same time, however, they often retained a romantic love of the machine which Pop had outgrown. Pop artists liked not the machine, but its consequences.

Op and kinetic art grew up simultaneously with Pop in the Sixties, but were somewhat slower in attracting the attention of the mass public. Indeed, experiments of this type were already being made by many artists during the middle Fifties, as they moved towards a new attitude to abstract art in general. Almost from the beginning, these experiments attracted the attention of informed and intelligent critics. As a result, this phase of post-war Modernism has been the subject of a considerable amount of intelligent analysis. Perhaps the most useful book on the subject is Frank Popper's *Origins and Developments of Kinetic Art* (London, 1968; first published in French in 1967), and it is Popper's system of categories that I shall make use of here.

He divides art of this kind into six classifications. The first of these he calls "Abstract Visual Inducements". By this he means work which induces a psycho-physiological reaction in the spectator, by the use of dazzle patterns or moiré effects. Works of this kind are, strictly speaking, the only ones that can be described as purely optical. Next there are works that in some way require the intervention of the spectator. He must himself move in order to activate them. Thirdly, there are actual machines. Then there are "mobiles"—things which have real movement of their own, but are not machine-powered. Popper's two final categories are works that incorporate both light and movement; and those, more elaborate still, which are best thought of as spectacle and environment rather than as independent objects.

None of these categories was completely new in the 1960's, and artists had made experiments with many of them almost from the beginning of Modernism itself. Both the Russian Futurist Alexander Rodchenko and the Dadaist Man Ray had made suspended mobiles as early as 1920. Naum Gabo, the great Constructivist sculptor, produced a simple kinetic piece powered by a motor in the same year, but did not follow up the experiment. In the early Twenties, Marcel Duchamp was experimenting with optical illusions produced by means of rotating discs.

Perhaps the first artist to establish himself almost entirely through works which incorporated movement as an essential part of their effect was the American Alexander Calder. Born in 1898, Calder graduated as a mechanical engineer from the Stevens Institute of Technology in 1919. He continued to work as an engineer while studying at the Art Students League of New York during the middle Twenties. And in 1926 he made the then (for American artists) mandatory pilgrimage to Paris. It was at this period that he made the miniature circus with personages of wire and wood which has come to be recognized as the precursor of the mobiles which made him famous.

228 and 229.
Alexander Calder
Two mobiles: opposite
Little Spider; c. 1940; 140 × 127 cm. (55 × 50 in.)
New York, Perls Galleries

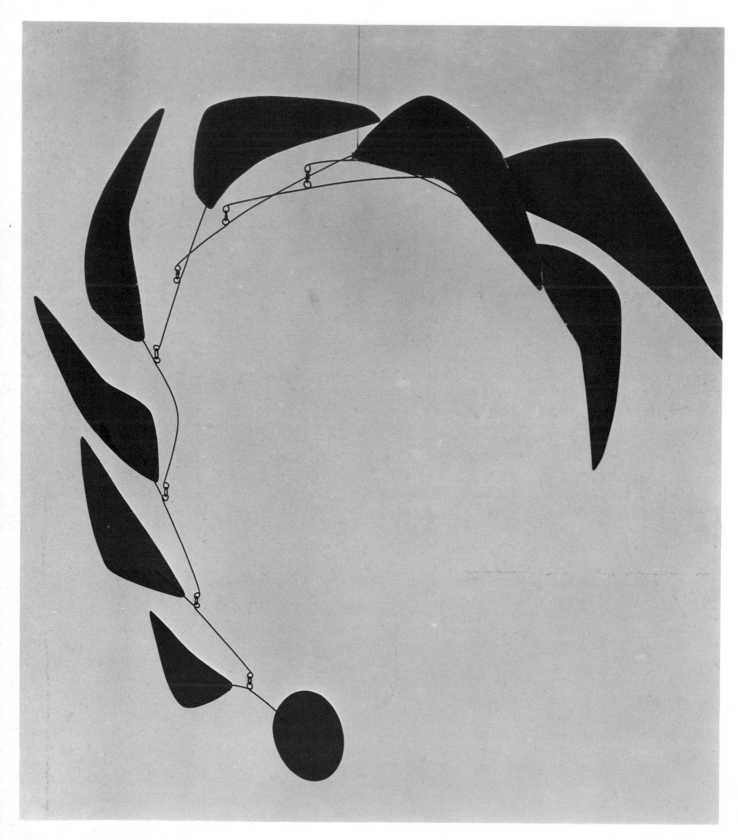

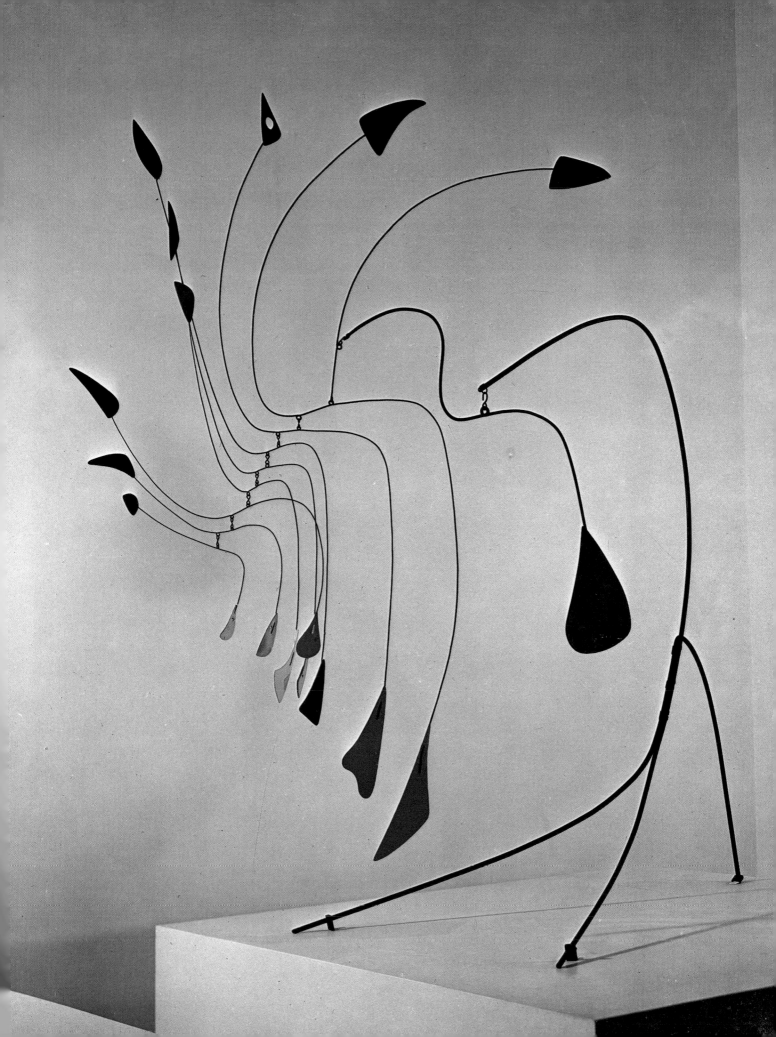

230.
George Rickey
Six Lines Horizontal
1964; 61 cm. (24 in.)
Colorado, coll. Kimiko and John Powers

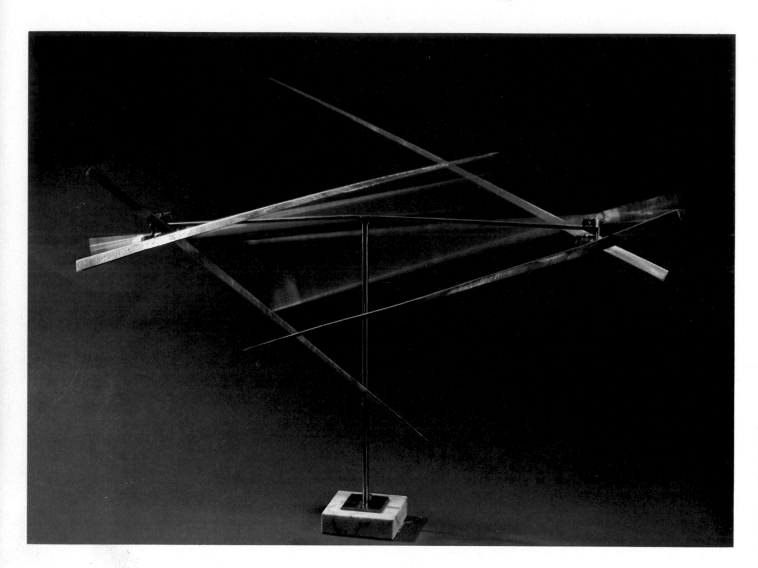

The first of these were exhibited in 1932.

Calder's mobiles, even at this time (Plates 228 and 229), were fully developed works of kinetic art, dependent for the effect they made on the movement of forms, rather than upon the forms themselves. The essential difference between the mobile and the powered object is that the mobile is random, and dependent upon chance for its juxtapositions; though it is true, of course, that the experienced maker of these objects can calculate with some precision what kind of effects he is likely get. Indeed, it has sometimes been complained that the apparent freedom given by random movement conceals within itself such stringent limitations that the mobile, however skilfully made, soon begins to pall, and does not have the presence of true sculpture. This complaint, however, applies to unsuccessful examples. In successful ones, as another American maker of mobiles, George Rickey, remarks, the "movement is as intrinsic as that of a Gramophone record or an airplane in flight; without it the object would be something else."

Rickey's own mobiles are more solidly con-

231.
Günter Haese
Oase
1964; 28 cm. (11 in.)
Cologne, Wallraf-Richartz Museum, coll. Ludwig

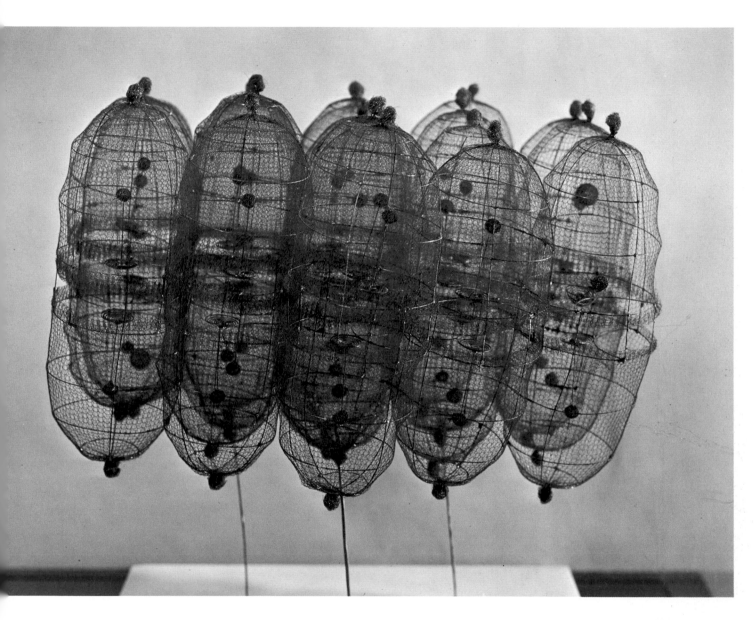

structed than Calder's (Plate 230), and the possible range of movement is apparently more restricted. He believes that one can establish a theoretical classification of, at most, six or eight types of motion, and is himself content to use only two or three of these types—yet he feels, with justification, that the effect produced is always a surprise. "When you construct an object in movement," he remarks, "you are always surprised by the movement itself: however well worked out the design may be, the movement seems to come from somewhere else." One thing

which Rickey and Calder have in common, in addition to American nationality and their interest in mobiles as opposed to kinetic machines, is their tendency to stand firmly outside the groupings that abound in kinetic art. These have served to reinforce the "scientific" and deliberately experimental, rather than purely aesthetic, character of the movement. Also entirely opposed to this tendency is the poetic work of the German sculptor Günter Haese. Haese makes small-scale constructions out of wire. Typically, a framework which is itself delicate and flexible will contain

numerous vibrating elements (Plate 231). A German critic has spoken of them as being "a kind of graphic art in space", and the resemblance in spirit, if not in form, to the drawings of Paul Klee is indeed striking. Haese seems to recapture in three dimensions much of Klee's wit, and there is, too, a similar vein of ambiguity and melancholy. Nor is Haese an abstract artist in the true sense of the word, any more than Klee was, and in this also his sculpture differs from the more typical

232.
Victor Vasarely
Zett-Kek
1966; 140 × 140 cm. (55 × 55 in.)
New York, by kind permission of the Sidney Janis Gallery

233. Opposite
Victor Vasarely
Aran
1964; 81 × 81 cm. (32 × 32 in.)
Colorado, coll. Kimiko and John Powers

manifestations of kinetic and optical art.

In Europe, which has been the stronghold of the movement, the dominating influence has undoubtedly been the Hungarian-born painter Victor Vasarely, and it is of great importance that Vasarely made his early studies at the Mühely, the Budapest Bauhaus. The spirit of the Bauhaus has always pervaded his own work, and he has passed on essential elements of the Bauhaus tradition to the younger artists who have entered his orbit.

Though Vasarely's name is now connected with pure abstraction, he moved towards this through the study of nature, a fact which he himself has been perfectly willing to recognize. But he feels that it was essential to his own art, and will be essential to others, to leave behind the last traces of figuration, in pursuit of a vision of the "new city—geometrical, sunny and full of colours," in which art will be "kinetic, multi-dimensional and communal. Abstract, of course, and closer to the

234.
Pietro Dorazio
Murale
1965; 170 × 110 cm. (66 × 43 in.)
Berlin, Galerie Springer

sciences." Vasarely goes well beyond Kineticism as such, and envisages a new function for the artist and his work in a society changed by the hoped-for social revolution. In this he echoes not only the ideas of the Bauhaus, but also those put forward by the Russian Constructivists during their most extreme phase: "If the art of yesterday signified 'to feel and to do', today it signifies 'to conceive and to order to do'. If yesterday the durability of the work resided in the excellence of the materials, in the technical perfection and in the mastery of the hand, today it rests in the knowledge of a possibility for *re-creation*, *multiplication* and *expansion*. Thus the artifact disappears with the myth of uniqueness and the diffusible work triumphs

finally, thanks to, and through, the machine" (Vasarely in Aldo Pellegrini, *New Tendencies in Art*, London, 1966, pp. 166–7).

The element of movement in Vasarely's work can therefore be regarded as a substitute for things which the hand-made object possesses, and which the machine-made one can no longer have. It supplies the animation which formerly came from the evidence of the artist's touch.

One of Vasarely's most typical devices is that of opposing systems of perspective (Plate 232, *Zett-Kek*). These call attention, as much as his writings do, to the strongly architectural character of his work. He also makes use of another of the typical tools of Op art—the opposition of colour areas which are violently contrasted in hue, but the same in tonal value. A black-and-white photograph of *Aran* (Plate 233), for instance, would consist of almost identical tones of grey.

But Vasarely has not been content to work on pictures and prints alone. He has experimented with designs painted on layers of cellophane or acrylic sheets, which were then superimposed and placed at some distance from one another, so that the effect altered as the spectator changed position. He has also been concerned with large-scale decorative projects which involved the animation, by optical means, of outside walls and facades. One such project was carried out at the University of Caracas.

Nevertheless, it is true to say that his followers have been more intimately concerned than he has been himself with the three-dimensional object. In contrast to this, the optical painters who have flourished since the war have pursued interests somewhat different from Vasarely's. One reason for this is that the most prominent of them have been English or American, and have therefore inherited a very different tradition. One of the few to share some of Vasarely's preoccupations has been the Italian Piero Dorazio (Plate 234), who also, though in less complex form, reproduces some of the former's effects. Interestingly enough, Dorazio began his career, in the immediately post-war epoch, as a painter of social realist themes.

In the United States, where Op art enjoyed a brief period of violent popularity in the middle

235.
Richard Anuskiewicz
Luminous
1965; 61 × 61 cm. (24 × 24 in.)
Los Angeles, coll. Mr. and Mrs. Melvin Hirsch

Sixties, the most skilful exponent of purely optical effects was Richard Anuskiewicz (Plate 235). Anuskiewicz was an inheritor of the Bauhaus tradition, but only in the limited sense that he studied for a period with Josef Albers at Yale. A brilliant technician, he devised some of the most striking dazzle patterns to appear on canvas, and imbued them with a typically American elegance. But there is something limited and even monotonous about his talent. His tendency to organize his patterns in squares and diamonds suggests, of course, an affinity with Albers, who was his master. It also suggests an informative comparison with the work of Ad Reinhardt, whose glimmering rectangular patterns produce surprisingly powerful optical effects if one gazes at them for long enough.

Reinhardt is often thought of, not as a true Abstract Expressionist, but as the link between Abstract Expressionism and Post-Painterly Abstraction (the art movement which will be dealt with in the next chapter). He is thus equivalent to Arshile Gorky, whose career provides the bridge between Surrealism and Abstract Expressionism. Another American painter who occupies a similarly indeterminate position is Larry Poons. As Kermit S. Champa pointed out in an article in the influential magazine *Artforum*, Poons and Pollock have much in common: "Like Pollock's great works of 1949–50, Poons's have accepted responsibility for more of the available surface area, and they have worked that area in a way which stresses continuity rather than focus. The image which is characteristic of both painters continually restates the whole of the painted surface through the cadenced repetition of similar pictorial units. Pollock's units were primarily linear, Poons's primarily coloristic, but the function is identical" (Kermit S. Champa, "New Paintings by Larry Poons", *Artforum*, Vol. VI, No. 10 [Summer, 1968], pp. 39–42).

Yet it is interesting to note that Poons, even more than Reinhardt, can properly be described as an Op painter during an important phase of his career. *Double Speed* (Plate 236), which dates from 1962–63, is representative of this aspect of his work. The design consists of not one but two superimposed patterns of colour dots, though the dots in each system are identical in colour. The eye, trying to distinguish one pattern from another, soon becomes unable to focus properly, thanks to the brilliance of the colour contrast; and because of this the dots themselves seem continually to change position. The effect is reinforced by the fact that the design is carried right up to the edges of the canvas. There is even a hint that it continues beyond the edges of the area provided.

Poons was not to persist with these strongly optical effects. The colour, instead of being clear and forcefully contrasted, became muddy, while the dots were enlarged and took on the shapes of the slipper bacilli which can be seen with the help of a microscope in a drop of muddy pond-water. Though these paintings are less attractive than the earlier ones, they retain a sense of movement and energy which differentiates them from the inertia of a more "central" Post-Painterly Abstractionist such as Kenneth Noland.

Energy is one of the most striking qualities of the painting of the English artist Bridget Riley, who has claims to be thought of as the most successful of all the painters who have experimented with optical effects during the period since 1945. In his introduction to the catalogue of Riley's exhibition at the Venice Biennale of 1968, David Thompson said: "One of the most distinctive characteristics of Bridget Riley's art is that it 'insists' with such concentration that it changes sensory response into something else. The sensation which Riley offers is closely related to the creation of visual analogues expressive of emotion, or, more exactly, to the creation of visual analogues for sharply particularised states of mind. The very intensity of the assault which her painting makes on the eye drives it, as it were, past the point at which it is merely a matter of optical effect to the point at which it becomes acute physical sensation, apprehended kinesthetically as mental tension or mental release, anxiety or exhilaration, heightened self-awareness of heightened awareness of unfamiliar or even alien states of being" (David Thompson, "Bridget Riley", catalogue to the British Pavilion exhibit, Venice Biennale, 1968).

237.
Bridget Riley
Current
1964; 135 × 150 cm. (53 × 59 in.)
New York, Museum of Modern Art, Philip Johnson Fund

238.
Bridget Riley
Cataract III
1967; London, coll. British Council, by kind permission of
the Rowan Gallery

239.
Bridget Riley
Apprehend
1970; 163 × 405 cm. (64 × 158 in.)
London, by kind permission of the Rowan Gallery

What Thompson acutely seizes upon in this passage is the fact that Riley's work, though intensely energetic, is not expressive of energy alone. Unlike many of the kinetic artists who are her contemporaries, she is not satisfied with quasi-scientific investigation of optical properties, but wants to use the effects she discovers for personal ends, to express some element in her own personality. In this she differs from the detached and impersonal spirit of communal art, as advocated by Vasarely and his followers.

Riley's early influences included the work of Georges Seurat (she made some beautiful Neo-Impressionist paraphrases during her student years) and the Italian Futurists, though she did not discover the latter until she made a journey to Italy in 1960. Her first optical paintings date from the same year.

During the early 1960's, and indeed until 1967, Bridget Riley worked entirely in black and white. *Current* (Plate 237), which dates from 1964, is typical of what she was producing at this time. Riley's paintings are very much dependent on the precise scale chosen by the artist (one reason why she dislikes nearly all reproductions of her work), but the optical effect here is so powerful that the design has a powerful impact even when it has been greatly reduced in size. As the title suggests, the work, though abstract, has accepted a

suggestion from what the artist has observed in nature. The pattern seems to be a formalization of the pattern of ripples observed upon the surface of a stream.

The landscape element, so astonishingly persistent in British art, reappears in Riley's *Cataract III* of 1967 (Plate 238). Here the ripple pattern of the earlier picture has been smoothed out and regularized. The artist has been able to do this because she has now begun to introduce colour, and it is colour which supplies the place of the disturbance in the pattern which served to animate the earlier picture. For the first time, although the hues are not pure, we encounter the phenomenon of "optical bleed", which was to fascinate the artist henceforth. Optical bleed is the mechanism whereby the eye can be induced to see a colour which is not in fact present, projecting complementary after-images onto areas which lie beside those where the colour itself is strongest.

By 1970, when *Apprehend* (Plate 239) was painted, Riley felt sure enough of her command over colour to abandon the use of all but the simplest patterns—stripes, and sometimes elongated chevrons. It is the relationship of the various hues which now provides the picture with its drama. Since simple stripes form so important a part of the repertoire of recent American painting, it is instructive to compare the use which Riley

240.
Peter Sedgley
Yellow Attenuation
1965; 122 × 122 cm. (48 × 48 in.)
London, Tate Gallery

241 and 242.
Yaacov Agam
Double Metamorphosis
1968–69; 127 × 188 cm. (50 × 73 in.)
Paris, Centre National d'Art Contemporain

makes of the device with that way in which it is employed by Kenneth Noland or Frank Stella. She still maintains the tremendous energy which was associated with her earlier work, even in a format which critics have tended to associate with a willed passivity.

Riley was anticipated in this particular method of using colour stripes by another British artist, Peter Sedgley, whose *Yellow Attenuation* (Plate 240) dates from 1965. Sedgley and Riley have been closely associated, and their work shows signs of mutual influence. Sedgley has, however, essayed a format which never seems to have tempted Bridget Riley: the circular target pattern which has played so conspicuous a role in recent American art. Here, too, there is a difference of effect which seems to sum up some of the differences between American and European abstract painting. Where Noland's targets remain static, or at most suggest a slow rotation through the use of actual colour bleed at the edges of the design, Sedgley's show powerful illusory pro-

jection and recession, so that the whole surface of the picture becomes unstable.

Sedgley has used these target paintings as a basis for further experiments. He has illuminated them with colour filters and has set them in actual physical motion with the use of rotors. In 1969, these experiments culminated in an ambitious kinetic environment, making use of a light programme inside a dome.

British artists have been less active in exploring true kinetic effects, as opposed to purely optical ones, and in this sense have stood a little aside from the international kinetic movement, which has had its home base in Paris, but which has included artists from all over the world. The essential impersonality of this kind of art—something we have already encountered in the work of Vasarely—has perhaps made it easier for artists from very different backgrounds to discover a common language.

The Israeli artist Yaacov Agam and the Venezuelan Carlos Cruz-Diez supply a case in point, since they work along lines which are very similar. Both have chiefly concerned themselves with work which, to revert to Frank Popper's system of classification, "requires the intervention of the spectator". More specifically, what they make only has its intended effect when the spectator moves his position in relation to it.

Agam's work spans a wider gamut than this description might suggest. Jasia Reichardt, in her study of the artist, has this to say about his creative attitudes: "To Agam, a static picture approximates an idol. As such, it cannot be acceptable to him, since it is contrary to the very essence of what he believes. Precariousness and change are the only permanent concepts recognized by the Hebrew religion, and Agam's involvement with them as exemplified by movement and change, appearance and disappearance, is as strongly related to them as the basic formal aspects of creating a work of art" (Jasia Reichardt, *Yaacov Agam*, London, 1966).

The pursuit of movement and change has involved Agam in a great variety of experiments since he first began to create transformable works in 1951. The first series could be changed either by the use of a pivoting element, or by means of elements whose relationship to one another the spectator himself could modify. These led, in turn, to works which unfolded either "contrapuntally" or "polyphonically" as the spectator passed in front of them (Plates 241 and 242). Agam has said about the paintings which he has labelled polyphonic: "The surfaces of these paintings are composed of parallel triangles in relief, which set up a rhythmic measure over which the different themes are painted. I can paint up to eight distinct themes in one work: these appear to be integrated with one another if one stands straight in front of the picture, but they separate and recompose in turns when one moves to the right or the left" (quoted by Frank Popper, *Origins and Development of Kinetic Art*, London, 1968, p. 111).

Agam has also ventured into a field related to the mobile by making paintings with elements attached by means of springs, which vibrate at the slightest contact, and in turn give rise to various optical illusions.

Cruz-Diez adopted a slightly different system from that used by Agam in his polyphonies. Instead of painting the design on parallel triangles with their points turned towards the spectator, he uses narrow slats placed at right angles to the picture plane. It is these which carry the actual colour, which is reflected onto the surface of the picture plane (Plate 243). Once again, the effect varies as the spectator changes position.

There is a relationship between Cruz-Diez's work and that of his fellow Venezuelan J. R. Soto, because both make use of the moiré effect which also plays such a prominent part in the early works of Bridget Riley. In Soto's case, however, there is an even clearer link to the tradition of hard-edge abstraction founded by Mondrian. Though his later work has moved a long way from what would conventionally be thought of as "painting", the artist nevertheless sees himself as searching for an art which would be its own master, wholly independent of the natural world, in much the same way that Mondrian did.

Soto's earliest notable works, produced soon after his arrival in Paris at the beginning of the Fifties, consisted of works which made use of

identical and multipliable elements. The aim, said the artist, was to reduce the sign to total anonymity, in the effort to get away from subjective art. He then began to use interchangeable colours which were arranged by chance. The transition to kinetic art came in 1955, when Soto began making Plexiglas superimpositions. Spirals traced upon Perspex were superimposed in depth. The optical movement that resulted was in direct relationship to the interval between the surfaces.

It was from these superimpositions in Perspex that Soto moved to a different kind of superimposition. Now he began to place suspended wires and other metallic elements in front of a striped background (*Vibration*, Plate 244). The effect of the striped background is strange—it seems to attack, and partly to dissolve, the forms which are placed in front of it. The effect is enhanced by any movement of the spectator's body or head. The English critic Guy Brett has spoken of the lack of "mystification" in Soto's work. "It establishes a concrete relationship with our perceptions," he asserts, "however diffuse the experience may be." It is certainly true to say that the artist makes use of optical illusion in a curiously anti-illusionistic way. This is true even

244.
Jesus Rafael Soto
Vibration
1965; 158 × 107 × 15 cm.
(62 × 42 × 6 in.)
New York, Solomon R.
Guggenheim Museum

245. Opposite
Jesus Rafael Soto
*Gran muro panoramico
vibrante*, detail
1966; 273 cm. (106 in.)
Rome, Galleria Nazionale
di Arte Moderna

247.
Sergio de Camargo
Rilievo No. 267
1970; 100 × 100 cm. (39 × 39 in.)
London, Gimpel Fils

of his occasional ventures into environmental art. Some of the most impressive of his works consist simply of metal rods or nylon threads hung from the ceiling, so as to envelop the space. The spectator's perception of the architecture that surrounds him is thereby completely dissolved. A sense of complete disorientation results (Plate 245).

The *Nailreliefs* of the German artist Günther Uecker (Plate 246) produce a somewhat similar effect on a smaller scale. The white-painted nails driven into an equally white surface have the effect of partly dissolving the physical identity of the work, as the eye no longer has a stable plane surface to rest upon. A somewhat similar device animates the white-painted wooden reliefs of the Brazilian artist Sergio de Camargo (Plate 247). Here the surface is covered with segments cut from a small-diameter rod. Each segment is sliced at a different angle, and, while the curved sides of each volume attract shadow, the sliced ends catch and distribute the light in a multitude of different directions. Yet another variant of this play of light over a white surface is encountered in the canvases of Enrico Castellani, where nails and cuts are used to produce an irregular grid pattern in low relief (Plate 248). It can be no accident that both Uecker and Castellani were influenced by Yves Klein, since each of them seems to use a moderate degree of optical illusion (perhaps not enough for their work to be classified as fully kinetic) in the effort to make the work of art less solidly and soberly material. Castellani has spoken of "the myopia of subjectivism" and of "the necessity of the absolute"—both strikingly Kleinian concepts.

For the large audiences who flocked to the major kinetic art exhibitions of the Sixties, none of the art which has so far been discussed in this chapter would seem particularly relevant to their own concerns in visiting these shows. What the public was excited by, and looked for, was art which had made a successful alliance with the machine, and which could therefore be thought of as having attuned itself to modern technological civilization.

In a sense, this alliance was a polite fiction. Modern artists have very seldom had access to the most advanced technology our society can offer,

and on those few occasions when the two have come together, the results have been disappointing. The "Evenings in Art and Technology" staged in New York in 1966, as an attempted collaboration between artists and engineers, were generally thought disappointing; and during the succeeding decade no attempt has been made to repeat them. It is significant in this connection that the United States, though technologically the most advanced society in the world, has not been in the forefront where kinetic art is concerned. It is better to think of machine-powered art as an expression of feelings about the machine, rather than as an attempt to discover what the machine can in fact do for the artist. This is the case whether the artist describes himself as "experimentally" oriented or not.

In some cases, indeed, the artist has been anxious to preserve the mystery of the mechanical means he employs to get his effects. This is the case with the Belgian artist Pol Bury. For him, movement should be "anonymous, silent, and supernatural", and his pieces can be regarded as a contemporary equivalent of the automata produced by eighteenth-century craftsmen. Bury's roots are in the Surrealist movement, not in Futurism or Constructivism, and in the late Forties he became a member of the CoBrA group. He has shown great ingenuity in the use of simple mechanisms, with a particular penchant for slow movement, often so slow as to be almost imperceptible. The temptation is, as Frank Popper suggests, to see the slowly waving metal or nylon stalks of some of Bury's works as metaphors suggested by marine life—the movements of sea-urchins and sea-anenomes—and to perceive in others ideas taken from planetary movements. The artist himself does not approve of romantic interpretations of this kind, and wishes only to present movement for movement's sake—an idea which emerges clearly from the example illustrated here, with its ranged balls and cubes (Plate 249).

Bury's attitudes towards the machine may be contrasted with those of Jean Tingueley. Tingueley is fascinated by the machine for its own sake. He celebrates it and satirizes it at one and the same time, and uses it, too, to satirize aspects of

315

249.
Pol Bury
16 Balls and 16 Cubes on 7 Shelves
1966; 80 × 40 × 20 cm.
(31 × 16 × 8 in.)
London, Tate Gallery

250. Opposite
Jean Tingueley
Baluba No. 3
1959; 144 cm. (56 in.)
Cologne, Wallraf-Richartz Museum,
coll. Ludwig

251.
Jean Tingueley
Kamikaze Monument 1962–1969
1969; 500 × 300 × 200 cm. (195 × 117 × 78 in.)
Kanagawa, open-air museum of Hakone

contemporary art. He has, for example, devised mechanisms capable of making "Abstract Expressionist" paintings or drawings. But the satire is never wholly disrespectful to the machine itself. "From Tingueley's point of view," Frank Popper remarks, "the machines which he devises are living creatures which inspire him at one stage with fear, and at another with astonishment or admiration." Instead of the neatness of Bury, Tingueley's pieces have an endearing raffishness (Plate 250, *Baluba No. 3*). Some, indeed, are programmed chiefly to destroy themselves, as with the chief actor in the "Machine Happening" which the artist devised for the Museum of Modern Art in 1960. Others place great emphasis on the capacity of the machine to undergo a rapid process of deterioration (Plate 251, *Kamikaze Monument*). Almost always his constructions have an unmechanical waywardness: "With their unpredictable and unique movements and sequences, Tingueley's machines exist in an enviable freedom. Their vitality, spontaneity and lyricism bring us ecstatic moments of life divorced entirely from moral precept or inhibition, from work and evil right and wrong, beautiful or ugly . . . they subvert the established order and convey a sense of anarchy and individual liberation which would otherwise not exist" (K. G. Hulten, in the introduction to the catalogue of the exhibition "Two Kinetic Sculptors: Nicolas Schöffer and Jean Tingueley", at the Jewish Museum, New York, 1966).

Tingueley himself paradoxically affirms that "Movement is the only static, final, permanent and certain things. . . . Today we can no longer believe in permanent laws, defined religions, durable architecture or eternal kingdoms. Immobility does not exist. All is movement. All is static" (From *Zero 3*, Dusseldorf, 1961, p. 44).

If Pol Bury demonstrates that kinetic art, though its origins for the most part lie elsewhere, is not necessarily irreconcilable with Surrealism, Tingueley's prolific *oeuvre* is a reminder of the link between kinetics and Dada. In particular, he is a direct descendant of Marcel Duchamp.

Yet another approach to this kind of art can be found in the work of Takis. With Takis, it is not the machine as such which is the focus of his activity; it is what the machine makes visible. It is for this reason that he makes widespread use of magnets in his work: "At one blow the magnet provided him with an entirely new language of space. . . . the magnet freed Takis from the architects' and engineers' methods of construction which, for example, Gabo had used. The construction system in a Takis sculpture is a flexible network of electro-magnetic energy, not unlike a planetary system" (Guy Brett, *Kinetic Art: The Language of Movement*, London, 1968, p. 28).

In a typical Takis work (Plate 252), an electromagnet supplies a pole of energy which is switched on and off in a regular rhythm. When the magnet is on, it attracts positive magnets in its surroundings and repels negative ones. When it is off, the positive and negative magnets are drawn towards one another. Whenever the machine is active, all its components are therefore engaged in a perpetual dance. In other magnetic sculptures, the artist makes use of needles which apparently defy gravity as they float in a magnetic stream.

Since Takis's sculptures are concerned with energy rather than matter, they have no formal qualities as such. If the machine is switched off, it has no hint of the presence it possesses when activated, unlike a work by Bury or Tingueley. On the other hand, at those times when they are working, the sounds Takis's sculptures emit are often nearly as important as the spectacle they present.

Light and sound are quite commonly important additional elements in kinetic sculpture. The *Silberroter* of Heinz Mack (Plate 253) provides a simple example of the importance of light. As the disk within the piece revolves, so reflected light begins to ripple off its surfaces.

The most ambitious works in this category are, however, those which have been produced by Nicolas Schöffer. Like Vasarely, Schöffer was born in Hungary, and he has since settled in France. Since 1959 he has been developing what he has dubbed "spatiodynamics" and "luminodynamics" (Plate 254). Moving metal constructions are used in combination with lights which are reflected from their surfaces, and transmitted

through sheets of coloured plastic Sometimes a musical accompaniment is added. Schöffer often works on a very ambitious scale—his sound-equipped luminodynamic tower made for the

Bouverie Park, Liège, in 1961 is 52 metres (171 feet) in height. The theatrical nature of what Schöffer does is accentuated by his own attitudes towards it. He regards the necessary dynamism

254.
Nicolas Schöffer
Sculptures Spatio-Dynamiques
N.d.; 107 × 90 × 75 cm. (42 × 35 × 29 in.)
Paris, Musée National d'Art Moderne

within the work as being very much the product of the chaos of emotion and intuition from which it arises in the first place, and the elaborate engineering of his constructions by no means rules out the idea of random motion, and therefore includes the kind of unpredictable relations which are part of the excitement of true theatre.

Schöffer's kinetic constructions take us to the very borders of both environmental art and of the Happening, and therefore demonstrate another of the ways in which the apparently closed and specialized world of kinetic and optical art stretches out to make contact with what is being done elsewhere on the contemporary scene.

Post-Painterly Abstraction

The art movement commonly dubbed Post-Painterly Abstraction presents the critic writing in the 1970's with some of his most ticklish problems of judgment. The reason for this is the considerable literature which has already accumulated about a kind of art which, viewed superficially, might not seem to lend itself to verbal elaboration.

The tone of the criticism devoted to work by leading members of the group is best represented by quotation from Michael Fried's essay *Three American Painters*, published in 1965. The three painters concerned were Kenneth Noland, Jules Olitski, and Frank Stella, but the remarks cited here were intended by Fried as a general comment upon the situation of both the painter and the critic: "While modernist painting has increasingly divorced itself from the concerns of the society in which it precariously flourishes, the actual dialectic by which it is made has taken on more and more of the denseness, structure and complexity of moral experience—that is, of life itself, but of life lived as few are inclined to live it: in a state of continuous intellectual and moral alertness.

"The formal critic of modernist painting, then, is also a moral critic: not because all art is at bottom a criticism of life, but because modernist painting is at least a criticism of itself. And because this is so, criticism that shares the basic premises of modernist painting finds itself compelled to play a role in its development closely akin to, and only somewhat less important than, the paintings themselves" (Michael Fried, *Three American Painters*, Cambridge, Massachusetts, 1965, pp. 9–10).

It will be seen that Fried not only claims a moral as well as a physical autonomy for certain kinds of modern art, but that he ranks the critic as a kind of collaborator of the painter, though at the same time conceding that this may be "an intolerably arrogant conception" of his task.

In fact, it seems to me that criticism has tended to obfuscate, rather than to elucidate, important aspects of Post-Painterly Abstraction. One of these is the question of its precise ancestry. The more enthusiastic of the supporters of artists such as Morris Louis, Noland, and Stella have wanted to see them as the direct descendants and true heirs of Abstract Expressionism, forming the second and perhaps more important phase of an American art which outclasses its European rivals, and which in fact owes nothing to anything which has happened in Europe since 1940, though an ultimate debt to the "shallow space" of Cubism is more or less proudly admitted. While there is, indeed, some truth in the contention that Post-Painterly Abstraction is a natively American style, its origins are more complex and the actual quality of the painting is more questionable than its supporters have been prepared to admit.

Fried's essay, which is the most important, and also the most closely argued, manifesto issued on behalf of the painters of this group, seeks to derive their work in the first place from the all-over drip paintings produced by Jackson Pollock in the years 1947 to 1950, and in the second place, though in a more muted way, from Barnett Newman. He also admits—and it is, after all, a well-established historical fact—the impact made by Helen Frankenthaler's work on Morris Louis and on Noland when they visited her studio in 1953.

Nowhere, however, does one find a discussion of two subjects which seem to be closely related to his argument. The first of these is the relationship between figurative and abstract art in the America of the 1960's, and the second is the relevance of certain hard-edge abstract painters, notably Josef Albers and Ellsworth Kelly, to what the Post-Painterly Abstractionists were trying to do.

Figurative art in these circumstances can only mean Pop Art, and if Fried ignores this, it is

255.
Josef Albers
Homage to the Square Series: Assertive
1958; 81 × 81 cm. (32 × 32 in.)
New York, by kind permission of the Sidney Janis Gallery

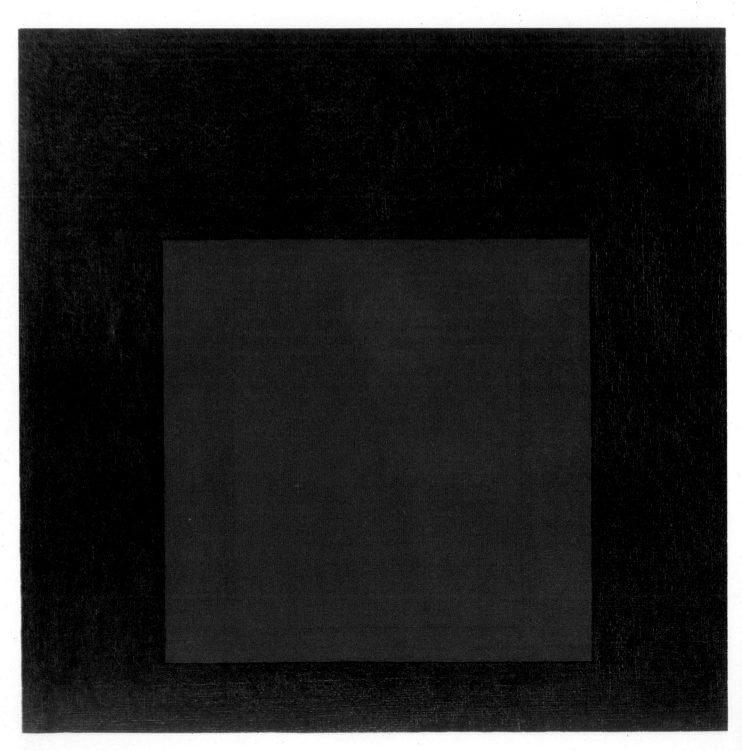

256.
Josef Albers
Homage to the Square Series: Fall Fragrance
1964; 102 × 102 cm. (40 × 40 in.)
New York, by kind permission of the Sidney Janis Gallery

257. Overleaf
Ellsworth Kelly
Red, Blue, Green
1962; 213 × 396 cm. (83 × 154 in.)
California, Pasadena Art Museum

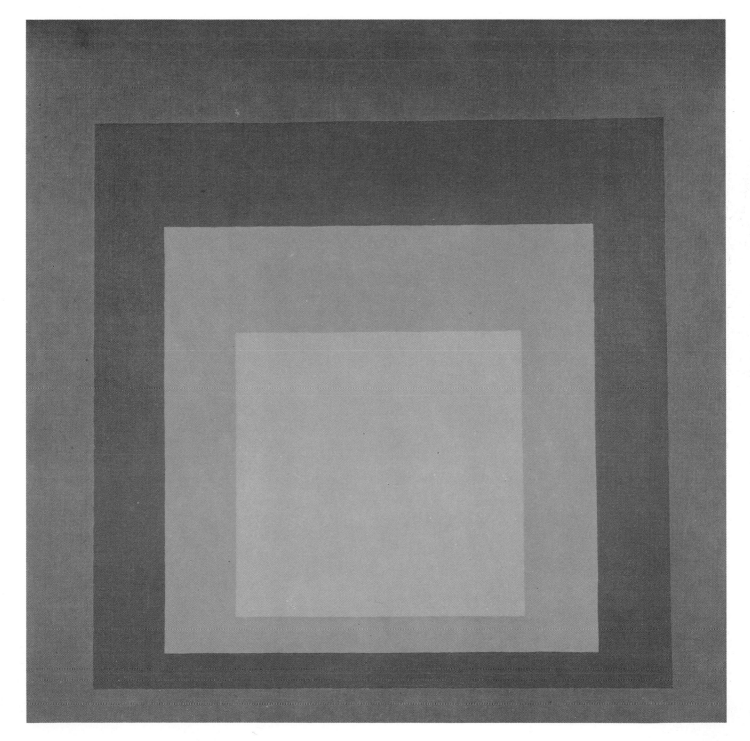

258.
Morris Louis
While
1959; 245 × 347 cm.
(96 × 135 in.)
New York, coll. of the
Harry N. Abrams family

manifestly because he thinks that Pop Art is not only worthless, but in his terms immoral—a deliberate debasement of what art ought to be. This opinion was fairly generally shared by major American art critics, who had great difficulty in coming to terms not only with Pop Art itself, but with its success with the public. In particular, those who had supported Abstract Expressionism tended to see the Pop reaction against it as a cynical betrayal of everything American art had achieved during the Forties and Fifties.

In this respect Post-Painterly Abstraction is a conservative rather than a radical style But this must not lead us into asserting that it grew up in direct opposition to Pop Art. On the contrary, this new version of American abstraction had already started to evolve in the mid-Fifties, and chronologically reached a recognizable maturity somewhat before Pop did.

The precise terms that art critics and theorists elected to use, when discussing artists such as Louis, Noland, and Stella in the years after 1960, were, however, strongly influenced by distaste for the alternative, which was Pop figuration.

The relevance of Albers, and to a lesser extent of Kelly, springs to the eye when one looks at the paintings themselves. Josef Albers, after teaching at the Bauhaus, emigrated to America in the early Thirties and found himself at Black Mountain College. His work, after an early Expressionist phase, which can be studied in surviving woodcuts, became imbued with the logically experimental Bauhaus spirit, which can also be detected in the work of Moholy-Nagy. The study of colour became a particular preoccupation with Albers during his American years. In 1949 he wrote: "A painter works to formulate with or in color. Some painters regard color as a concomitant of form, and hence as subordinate. For others, and in ever-increasing proportion, color is the chief medium of their pictorial language. Here color attains autonomy. My painting represents the second trend. I am particularly interested in the psychic effect, an aesthetic experience that is evoked by the interaction of juxtaposed colors" (quoted by Eugen Gomringer, *Josef Albers*, New York, 1968, p. 104).

This statement, so relevant not only to Albers' own art but to the colour stripes of Louis and Noland, was written before Albers embarked on the *Homage to the Square* series by which he is best known. These paintings, apparently so simple in their format, are a fascinating fusion of European and American themes. They are European because the artist sums up in them the best of his Bauhaus experience. The squares, for example, are proportioned according to a strict mathematical formula—the pictures are composed according to a horizontal and vertical division consisting of ten units in each case. The optical quality of the colour, deliberately sought, has its roots in Bauhaus investigations of illusion, and thus has a direct relationship to the Op art produced in postwar Europe. Albers arranges his hues so as to persuade the planes to separate from the ground on which they are painted, and float free in space (Plates 255 and 256).

What is un-European about these works is their symmetry—the refusal to compromise the search for fully activated colour by resorting to traditional compositional devices. There is a relevant comparison here between Albers and Rothko. Rothko's centred rectangles of colour float free of the ground in just the same way that Albers' do, though the technical means used to achieve the effect is different in each case.

If Ellsworth Kelly's work conveys a slight sense of isolation from the rest of the New York scene, this may be due to the pattern of his training and development. He studied painting in Paris under the G. I. Bill and did not return to America until the middle Fifties, when he had already absorbed the lessons of European Constructivism. Impressed by the scale and power of Abstract Expressionism, he adjusted the scale of the clear, flat images he had inherited from the Constructivists so as to conform to the new mode (Plate 257). But this adjustment meant an increased concentration upon colour. As Lawrence Alloway remarks: "The center of his work is a painterly command of color. Not color in terms of glazes, or variations, or light and shade, but solid color. His hues are controlled not by gradation but by exact adjustments of their internal density and

their outer contours" (Lawrence Alloway, cat-
alogue to the American Pavilion, Venice, Espo-
sizione d'Arte, 1966).

If one compares Kelly's works to Albers's, one
notes that the former does not resort to effects
which are definably "optical", at least as that
adjective is commonly used in connection with
painting. But it is nevertheless the colour which
forces adjustments on the eye. The conception one
forms of the various areas into which the canvas is
divided depends as much on one's reaction to the
hues they are painted as on one's estimate of their
size and shape.

Curiously enough, the resemblance between
Albers and Kelly and Morris Louis is far less than
the resemblance between the same two artists and
the later work of Noland and Stella. It is in Louis's
painting that one is most conscious of the genuine
and intimate connection between Post-Painterly
Abstraction and Abstract Expressionism. Louis
supplies us with an outstanding example of what

has been called the break-through phenomenon in
contemporary American art. Before 1954, Louis,
though a dedicated artist, had made only a minor
contribution. After 1954, he gradually came to be
seen as a painter of major importance. The key
event was a visit which Louis, who lived and
worked in Washington, paid to New York in
1953. He was accompanied by Kenneth Noland,
already a friend of his, and one of the people whom
they saw was the critic Clement Greenberg, and it
was Greenberg who took them to Helen
Frankenthaler's studio.

For Louis, Frankenthaler's work had the force
of a revelation, but it was a revelation of a very
special kind. What impressed him was not so much
the content of her work as some aspects of her
technique, in particular the habit of using thinned
acrylic paint and of letting this stain the canvas as if
it was watercolour used upon absorbent paper.
Greenberg tells us: "The crucial revelation he got
from Pollock and Frankenthaler had to do with

260. Opposite
Morris Louis
No. 180
1961; 226 × 186 cm. (88 × 73 in.)
California, Pasadena Art Museum

261.
Morris Louis
Hot Half
1962; 161 × 161 cm. (63 × 63 in.)
Washington, D.C., coll. Mrs. Abner Brenner

facture as much as anything else. The more closely color could be identified with its ground, the freer it would be from the interference of tactile associations" (Clement Greenberg, *Art International*, Vol.IV, No. 5 [May, 1960], pp. 26–9).

When Louis adopted a new range of techniques, these involved important consequences for his art. For one thing, the paintings became more impersonal, though they remained painterly. The colour was either poured onto the horizontal canvas, or applied to it with commercial rollers, and there was no place for the bravura touch of an Abstract Expressionist such as De Kooning. While the staining might produce the illusion of painterliness, it was only an illusion.

At the same time, the colour was no longer on but actually *in* the weave of the canvas, and this was particularly true after Louis abandoned the use of sized canvas for unsized cotton duck. This caused the painter, and later the spectator, to think of the work itself in new terms, as a homogenous object, an independent addition to a world of objects.

Thirdly, and this applied chiefly to Louis's

262.
Jules Olitski
11th Move
1969
London, Kasmin Gallery Ltd.

earlier and freer experiments, the staining pro-
duced a contour which was not drawn; and
repeated streams of paint would actually produce a
contour *within* a contour, if that was what the artist
wanted (*While*, 1959, Plate 258).

Once the initial breakthrough was made, Louis,
like many contemporary artists, tended to work in
connected series or groups. The *Veils* were
followed by the *Unfurleds* (*Alpha-Pi*, 1961, Plate
259), and these in turn by a series in which the
colour was arranged in simple stripes (*No. 180*,
1961, Plate 260). In some final canvases, executed

just before Louis's final illness and death, the
stripes were arranged diagonally (*Hot Half*, 1962,
Plate 261). The development of his work is always
towards the more stringent, the more rigorous,
the more fully controlled. It is possible to imbue
the *Veils* and the *Unfurleds* with some kind of
transcendental or mystical meaning, or at any rate
to see them as "objects for meditation" on more or
less the same footing as Rothko's later painting,
but the stripes reject interpretations of this kind.

The work of Kenneth Noland is generally
discussed in close association with that of Morris

263.
Kenneth Noland
Reverberation
1961 ; 244 × 244 cm. (95 × 95 in.)
Colorado, coll. Kimiko and John Powers

264. Opposite
Kenneth Noland
17th Stage
1964 ; 244 × 213 cm. (95 × 83 in.)
New York, coll. Mr. and Mrs. Eugene Schwartz

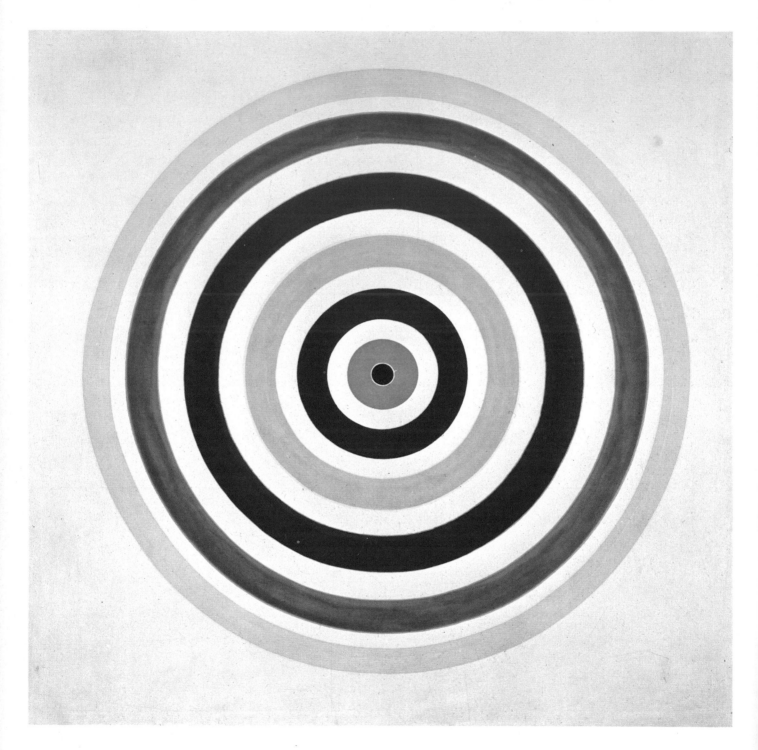

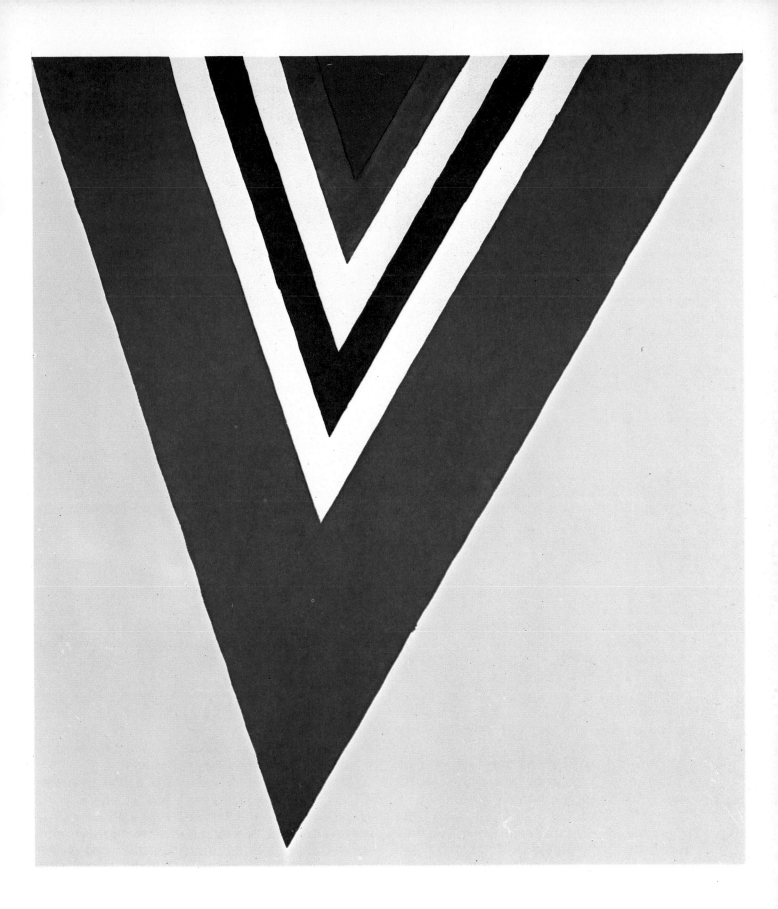

Louis, simply because the two artists were not only personal friends but shared important phases of artistic development. But before passing to Noland's work, we have good reason to consider that of Jules Olitski. Olitski's fascination with veils of tender colour has a relevance to Noland's earlier work, just as Noland's stripes can be referred to what Louis did later.

Olitski's paintings have provoked some extravagant comparisons. Fried, for example, has compared him to Van Eyck: "Putting aside for a moment their obvious differences, what the paintings of Van Eyck and Olitski have in common is a mode of pictorial organization that does not present the beholder with an instantaneously apprehensible unity." This sounds like a critic desperate to justify a preference, and in fact one of the striking things about Olitski is the difference of sensibility to be found between his art and that of the painters with whom he is usually grouped. The difference can be summed up by saying that he has a different area of failure: he seems sentimental (Plate 262) on occasions where they would seem numb. Olitski's background—liky Ellsworth Kelly, he spent some of his formative years in Paris—may help to explain this. The gap between his work and Louis's is similar to the gap that exists between that of Franz Kline and Soulages.

What deserves respect in Olitski's work, despite its fundamental uncertainty and lack of poise, is its respect for feeling. This emotionalism stands firmly opposed to the cynicism of a great deal of Pop Art, and to the schooled indifference of so much that has followed it.

Kenneth Noland, though he was a friend of Louis's from 1952 onwards, and though he accompanied Louis on the latter's all-important visit to New York in the following year, was slower to find his own identity as an artist. His first wholly individual paintings date from 1958–59. Since he had, during the middle years of the decade, been deeply under Louis's spell, it is worth enumerating some of the differences between them. There was, for instance, Noland's tendency to leave more of the canvas unpainted, and his preference at that time for a precisely centred image—often the target pattern that Jasper Johns used in such a different sense (*Reverberation*, Plate 263). The large areas of raw canvas to be found in Louis's *Unfurleds* derive from Noland, rather than vice versa.

By 1962 Noland had come to feel that the centred image was too confining, and this year saw the appearance of the first chevron paintings (*17th Stage*, 1964, Plate 264). Later still, he began to fill the entire canvas with stripes of colour, at first using a lozenge-shaped support, so as to keep some of the visual dynamism of the chevrons, and later relying on horizontal stripes on immense canvases, where the sheer size of the picture kept the eye moving by preventing it from settling on any one area, or indeed from apprehending the work as shape rather than colour.

One of the main impressions made by Noland's painting (and in this he is quite the contrary of Olitski) is its single-mindedness. Barbara Rose remarks: "To create the most powerful impact he was willing to jettison anything that interfered with the instantaneous communication of the image. This included the elimination of any kind of detail or internal inflection within the work, even such minor surface variations as those created through transparency" (Barbara Rose, "Retrospective Notes on the Washington Color School", in the catalogue of the Vincent Melzac Collection, Corcoran Gallery of Art, Washington, 1971, p. 31). A corollary of this is that it is easier to define what Noland does in negative rather than positive terms. It has no reverberation, either physical or emotional, beyond itself. It exists simply as visual information, and reaches out into no other field of activity or experience.

Rigorous as it is, Noland's art is less rigorous than the early work of Frank Stella, who is both the youngest of the leading Post-Painterly Abstractionists and the member of the group who seems to mark a transition to another and rather different way of thinking about the visual arts, though it is a transition he himself has been unable to accomplish fully.

Stella first made his reputation with a series of monochrome paintings, based, once again, on the theme of the stripe. Now it was monochrome

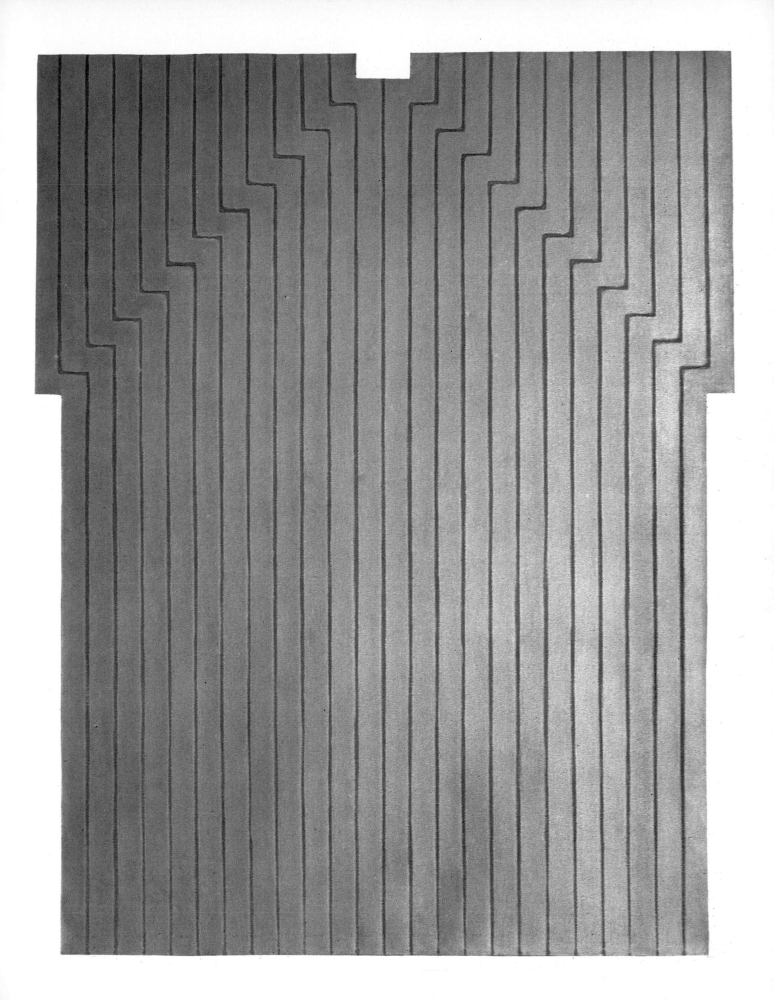

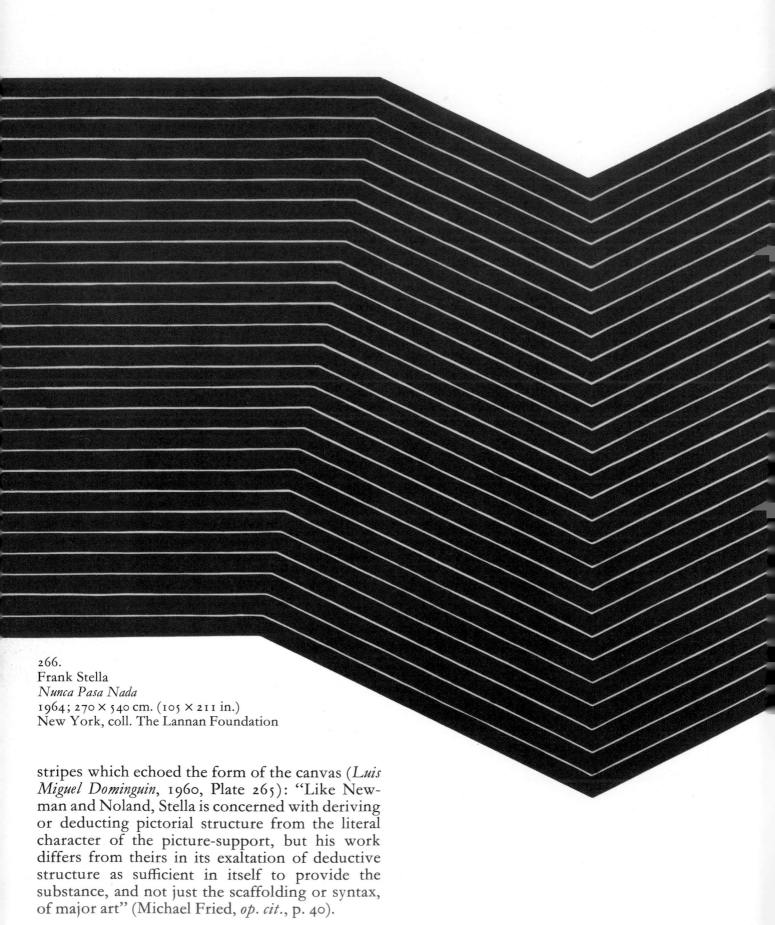

266.
Frank Stella
Nunca Pasa Nada
1964; 270 × 540 cm. (105 × 211 in.)
New York, coll. The Lannan Foundation

stripes which echoed the form of the canvas (*Luis Miguel Dominguin*, 1960, Plate 265): "Like Newman and Noland, Stella is concerned with deriving or deducting pictorial structure from the literal character of the picture-support, but his work differs from theirs in its exaltation of deductive structure as sufficient in itself to provide the substance, and not just the scaffolding or syntax, of major art" (Michael Fried, *op. cit.*, p. 40).

One characteristic of these stripe paintings was that they proceeded from the edge inwards (some of Stella's striped canvases had an actual void in the centre) rather than from the centre outwards, as for example with Rothko or Pollock. This seemed to lay additional emphasis on their quality as objects rather than as painted surfaces. Stella said in an interview given in 1966: "My painting is based on the fact that only what can be seen there is there. It really is an object. All I want anyone to get out of my paintings, and all I ever get out of them, is the fact that you can see the whole idea without any confusion. What you see is what you see" (Frank Stella in "Questions to Stella and Judd", by Bruce Glaser, edited by Lucy Lippard, *Art News*, Vol. 65, No. 5 [September, 1966], p. 58).

By the time this interview was given, he had already begun to develop the sculptural impli-

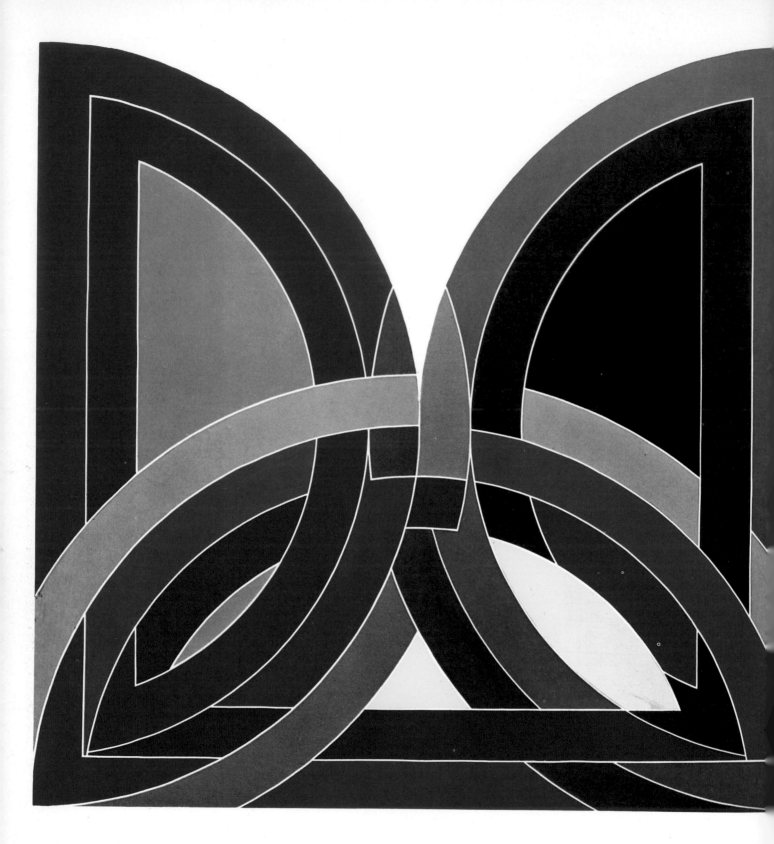

cations implicit in what he was doing in a series of paintings where the actual shape of the canvas was really much more important than anything that might be happening on its surface (*Nunca Pasa Nada*, 1964, Plate 266). He was in any case wholly opposed to any notion of inflection: "One could

267.
Frank Stella
Tahkt I-Sulayman I
1967; 305 × 610 cm. (119 × 238 in.)
California, Pasadena Art Museum

344

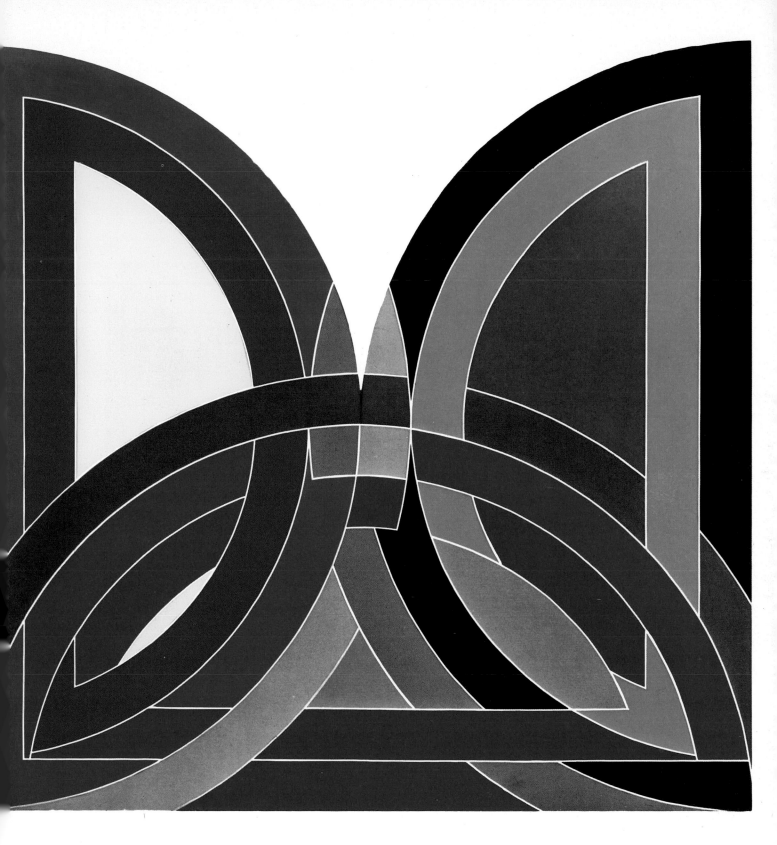

stand in front of any Abstract Expressionist's work for a long time, and walk back and forth, and inspect the depths of the pigment and the inflection and all the painterly brushwork for hours. . . . I feel that you should know after a while that you're just sort of mutilating the paint. . . . If you have some feeling about either color or direction of line or something, I think you can state it. You don't have to knead the material and grind it up. That seems destructive to me; it makes me very nervous" (Frank Stella, *op. cit.*, p. 59).

It is not too much to say that there is implicit, in

268.
Frank Stella
Ossippee I
1966; 242 × 350 cm. (94 × 137 in.)
New York, coll. Mr. and Mrs. Ernest Kafka

Stella's work during the earlier part of his career, a philosophy closely related to, though not precisely the same as, that of the group of sculptors who became known as the Minimalists.

Stella's change of direction, during the later part of the Sixties, was a shock to those who had hitherto supported his work, not so much because of its violence (violent changes of this type have, since Picasso, come to be expected of leading modern artists) but because of what it implied. Like Bridget Riley, who had also been devoted to monochrome, Stella took the plunge into colour, but with far more disconcerting results (*Tahkt I-Sulayman I*, 1976, Plate 267). It is worth recording the comment of a leading American reviewer when the series to which the illustrated work belongs was first shown: "The interdependence between literal and depicted shape fails to materialize. In its place I simply see circular armatures behind the arcs . . . rays of color recede in vertiginous traditional illusionism . . . it feels very strange to see a painting by Frank Stella in the light of Cubism . . ." (Rosalind R. Krauss, "On Frontality", *Artforum*, Vol. VI, No. 9, [May, 1968], pp. 40–5).

In fact, the move to colour brought the informed spectator face to face with the decorative element which had always lurked within the apparent austerity of Stella's work. Worse still, it was now decoration of a recognizable kind. Like Lichtenstein in some of his weaker paintings, and certainly with some of his sculptures, Stella had aligned himself not so much with Cubism in its pure form as with the Art Deco revival which was sweeping through fashionable circles in New York, Paris, and London. The new works, even when they *were* new, had all the false seduction of the period piece, and their weaknesses even imported this slightly tainted flavour into much of what Stella had produced before.

Even more than with most art movements, Post-Painterly Abstraction loses coherence when it is examined closely. There is a great difference between the works Morris Louis produced immediately following his breakthrough and the *Protractor* series of Frank Stella—a difference of intention as well as of quality. There is, and this is more important, a visible difference between the *Veils* and *Unfurleds* of Louis, and the works with which Stella made his reputation. Louis immediately after 1954, and indeed until the advent of the striped paintings, remains within the current of Abstract Expressionism. His is a more refined, more rarefied, less vital version of what had already been accomplished by artists such as Pollock and Rothko, and no amount of talk about the unity between colour and ground can alter that fact. It would be unjust not to concede that Louis was, for a brief period, a painter who made an original contribution to the development of abstract art in America. At the same time, it is necessary to admit that this contribution was of a special kind—he took an established tradition to the point where it could progress no further, rather as G. B. Tiepolo did with the baroque in Italy.

With Stella we see, as early as 1960, a groping towards the Minimal Art which was to exercise so powerful an influence a little later, but we also find, encapsulated in his earlier paintings, the nihilism which was to paralyze so many artists in the Sixties and Seventies. Michael Fried's assertion that a painter such as Stella is forced to live "in a state of continuous intellectual and moral alertness" now seems to state not the truth of the situation, but what is diametrically opposite to the truth. These are nerveless works, which suppress intellect, morality, and above all, alertness, as much as they are able. When Stella finds the dehumanized situation in which he has placed himself intolerable, and attempts to break out, the only escape he can find is to the kitsch which had already been exploited, with more intelligence and poise, by the adherents of Pop Art.

Like Warhol, Stella is an important figure, not because one can in conscience assert that his painting is good, but because one can locate in it the crisis which was to overtake Modernism as the Sixties progressed—a crisis which is still with us, in a yet acuter form, during the 1970's.

Sculpture in the Post-war Period: Towards Minimal Art

Concern with the status of the painted canvas as an object in a world of objects gradually brought painting and sculpture closer together during the 1960's, to the point where what had seemed to be very different realms of artistic activity became, at least in the minds of many artists and critics, almost interchangeable. The term "sculpture" acquired a prestige, and also a breadth of meaning, which it had not possessed during the earlier part of the twentieth century, when the modern movement first came into being.

The dominance of painting over sculpture was something that early Modernism inherited from the nineteenth century. Painting was the less expensive and therefore more independent medium. The artist who was prepared to starve, or at least to exist with the help of only a few private patrons, could still hope to produce important works of art. No such opportunity was open to the sculptor out of tune with his time.

The result of this situation was that Modernism itself developed through painters and through painting. When sculptural experiments were made, it was men who thought of themselves as being primarily painters who made them, with a few important exceptions. Thus we may list Matisse, Picasso, Modigliani, and Boccioni as being among the most important pioneers of modern sculpture.

It is true that, as the modern movement progressed, certain men emerged whose main activity was making sculpture. Among them were Julio Gonzalez, Raymond Duchamp-Villon, Alexander Archipenko, the Constructivists Gabo and Antoine Pevsner, and Constantin Brancusi. But the painters rather than the sculptors continued to be the experimental vanguard. The new styles that arose—Cubism and Surrealism—found their first and most convincing embodiment in two dimensions rather than in three. In fact, there were certain aspects of both these styles which tended to inhibit the sculptor rather than to inspire him.

In the case of Cubism, the overriding concern with the representation of what was three-dimensional upon a flat surface tended to make sculpture itself seem irrelevant. Attempts were indeed made to adapt the ideas of the Synthetic Cubists to sculpture in stone—the early work of Henri Laurens is a good example. But Laurens found himself in a curiously contradictory situation. For example, when he made stone reliefs in a Cubist style inspired by Braque, he found himself impelled to colour them. "I wanted", he later said, "to do away with the effects of variations of light on statues." Cubist sculpture tends to look both decorative and decorous when set beside the paintings that inspired it. Worse still, it tends to look illogical. Why, we ask ourselves, should the planes be flattened in this way, when a sculptor is fully at liberty to develop them in real space?

A more powerful and more important artist, Julio Gonzalez, also showed the mark of the struggle to escape from Cubist influences, and from that of Picasso in particular. But in Gonzalez's case the struggle was in the end beneficial, as he was forced to find new techniques in order to express himself. In particular, he experimented with the process of oxy-acetylene welding, which he had learned when he worked at the Renault car factory during the First World War. This led him to think of sculpture not so much as the creation of three-dimensional forms as of executing a drawing in space. It also led him to see that a sculpture need not be unitary, but could be an accumulation of parts, with a corresponding emphasis on the way in which these parts were joined together. "To project into space and draw with it", Gonzalez declared, "with the help of new mediums; to use this space and build with it, as if it were a newly discovered material—that is my whole endeavour."

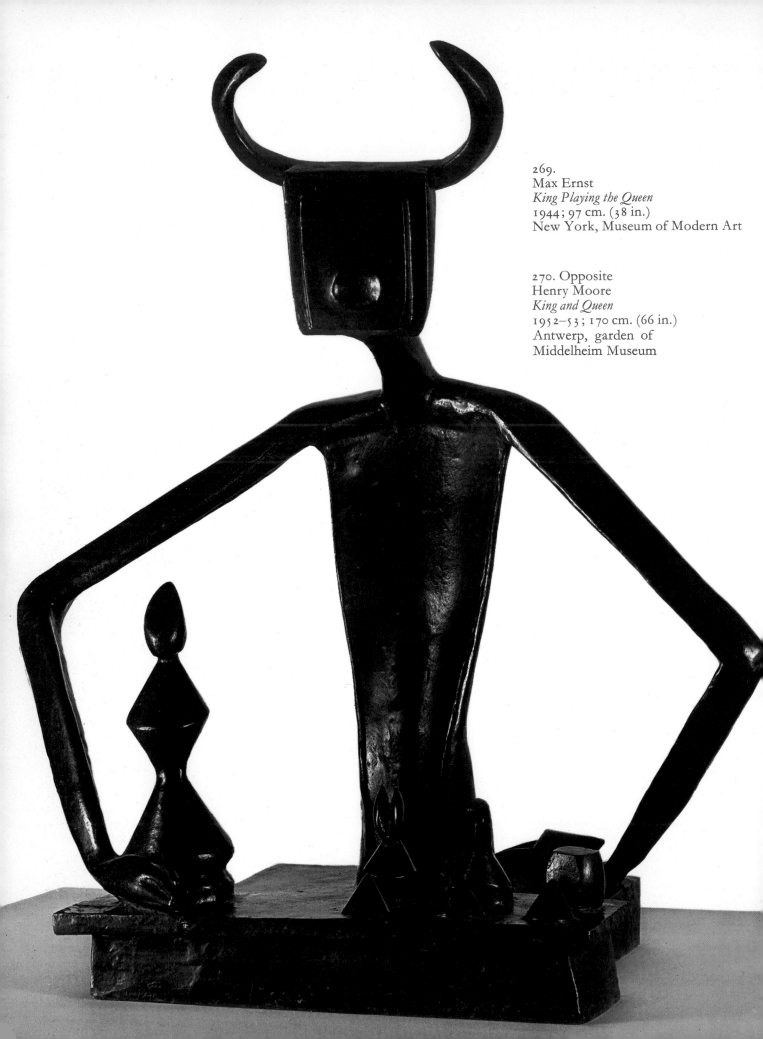

269.
Max Ernst
King Playing the Queen
1944; 97 cm. (38 in.)
New York, Museum of Modern Art

270. Opposite
Henry Moore
King and Queen
1952–53; 170 cm. (66 in.)
Antwerp, garden of
Middelheim Museum

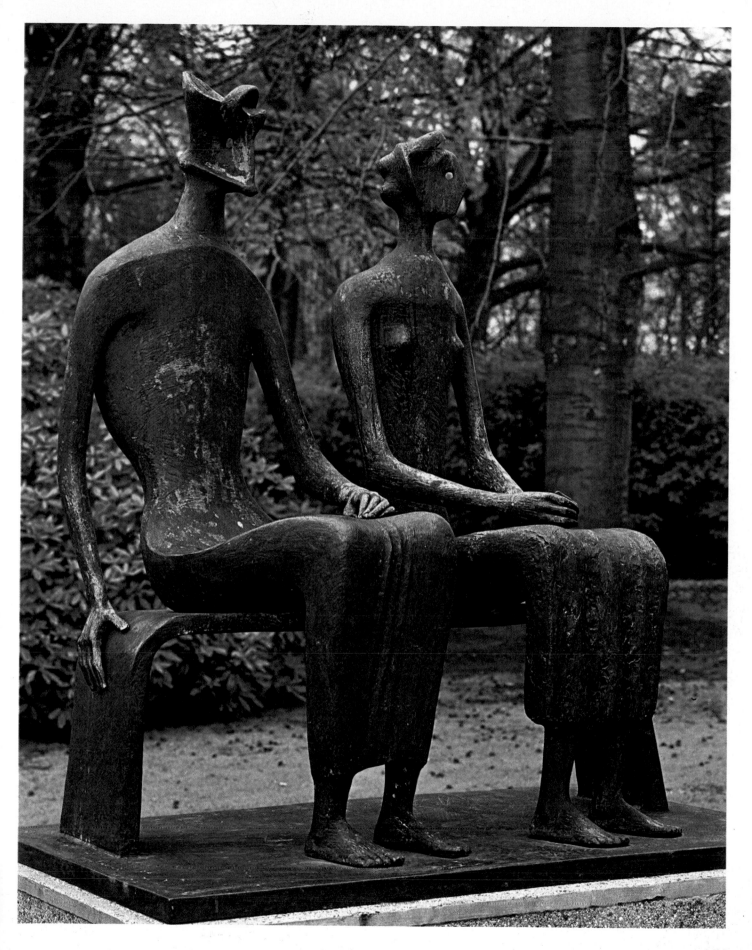

Surrealism hampered the development of modern sculpture in a subtler way than Cubism. Where Cubist painters seemed to question the necessity for sculpture, since painting itself could now be made to express what was previously the province of the three-dimensional work, the Surrealists gave sculpture a rival, in the form of the Surrealist object. The object, so typical of the production of many Surrealist artists, is something which exists in three dimensions, but which makes no claim to be thought of as sculpture, that is, as a statement concerning form and formal relationships. Where the object is concerned, all relationships are those of association, of memory, fantasy, and dream. As has appeared in some of the earlier chapters of this book, the object has known a long and prosperous career under Modernism, and has survived quite comfortably into the post-war world, as we can see from the work of artists such as Oldenburg and Rauschenberg.

The various disadvantages under which the sculptor laboured, during the period from 1905 to 1945, meant that three-dimensional work never acquired the coherence of aim which we discover in early Modernist painting. The sculptor tended to exist rather on the fringes of group activity, and the isolation in which he worked made it more difficult for him to exercise a real influence over the course of events.

The most distinguished sculptor of the early Modernist epoch was Constantin Brancusi, and in many ways Brancusi's career seems to sum up the essential isolation of the art he practised. Brancusi belonged to no movement, though the leading members of the Cubist and Surrealist fraternities knew and respected him. What he sought, almost throughout his life, was an alternative road to that taken by Auguste Rodin, who had exercised a powerful influence over Brancusi's early work. Where Rodin was theatrical, dramatic, full of sentiment, Brancusi sought impersonality and restraint. The search led him back to objects produced by archaic civilizations, though he never fell into the trap of archaistic imitation. His search for archetypes was to exercise an enormous influence over sculptors junior to himself.

Despite all the difficulties I have just outlined,

modern sculpture did, during the Thirties in particular, begin to establish a place for itself in the hierarchy of Modernism. In England, Henry Moore, after difficult beginnings, earned a reputation among those who were interested in modern art (a tiny band) for work which was influenced by Surrealism, but which also seemed to respond to Brancusi's search for archetypes. Barbara Hepworth also attracted attention, for work which went in much the same direction as Moore's, but which seemed, too, to owe a debt to Constructivism. In France, Alberto Giacometti emerged as a leading Surrealist. His work also demonstrated the irresistible attraction of the archaic—in this case, to the Cycladic artifacts which were just beginning to attract attention among collectors and archaeologists. In Italy, Marino Marini had begun to look for ways of reviving the Italian sculptural tradition through the study of Far Eastern art as well as that of Egyptian, Etruscan, and Roman Republican work.

Perhaps because they had already had so much to contend with, these sculptors survived the hiatus of the war years more successfully than some of the painters who were their contemporaries. We are conscious of a definite break in the development of painting during the 1940's, and of a transfer of power from Paris to New York. No such gap is visible in the history of modern sculpture. The break had yet to occur, and did not in fact happen until much later. Nor was there any sudden shift from Europe to America, perhaps because the development of the new American painting was not matched by any corresponding upsurge in sculpture, despite the activity of artists such as Ibram Lassaw and Reuben Nakian.

If we look at the condition of sculpture in the years immediately following 1945, we observe first of all the continuation of tendencies which had already established themselves before the war, though sometimes with a different emphasis to suit changed circumstances. Max Ernst, for example, though still primarily a painter, had been seriously interested in sculpture from the middle Thirties onwards. During his period of exile in

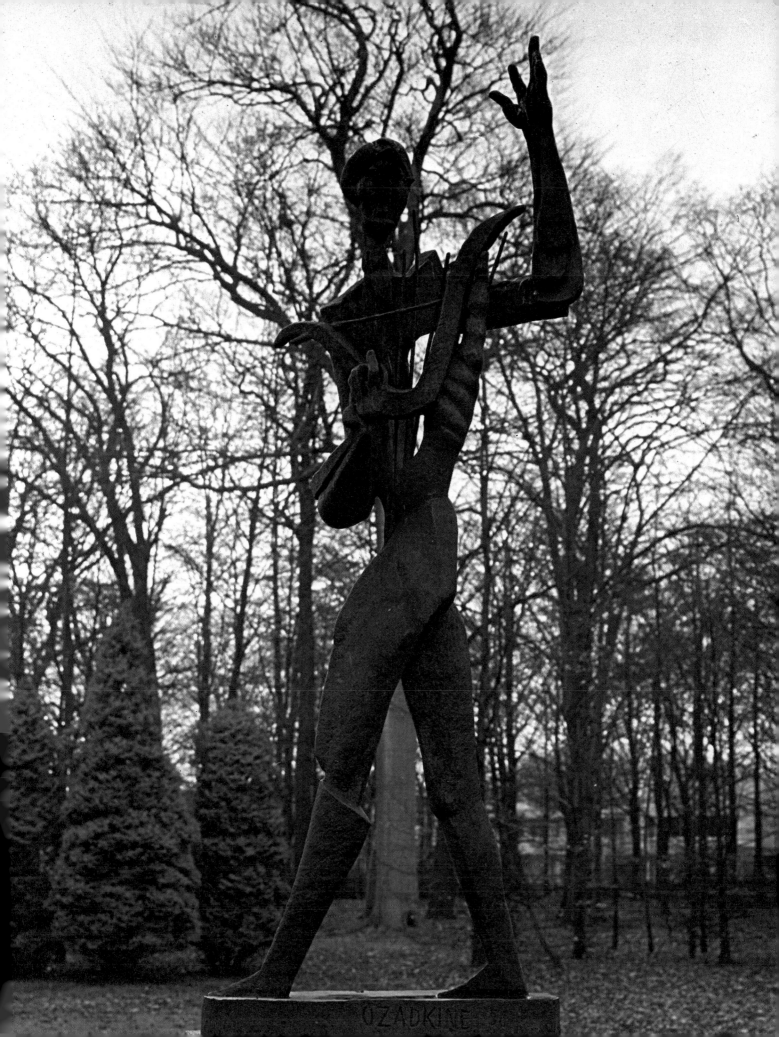

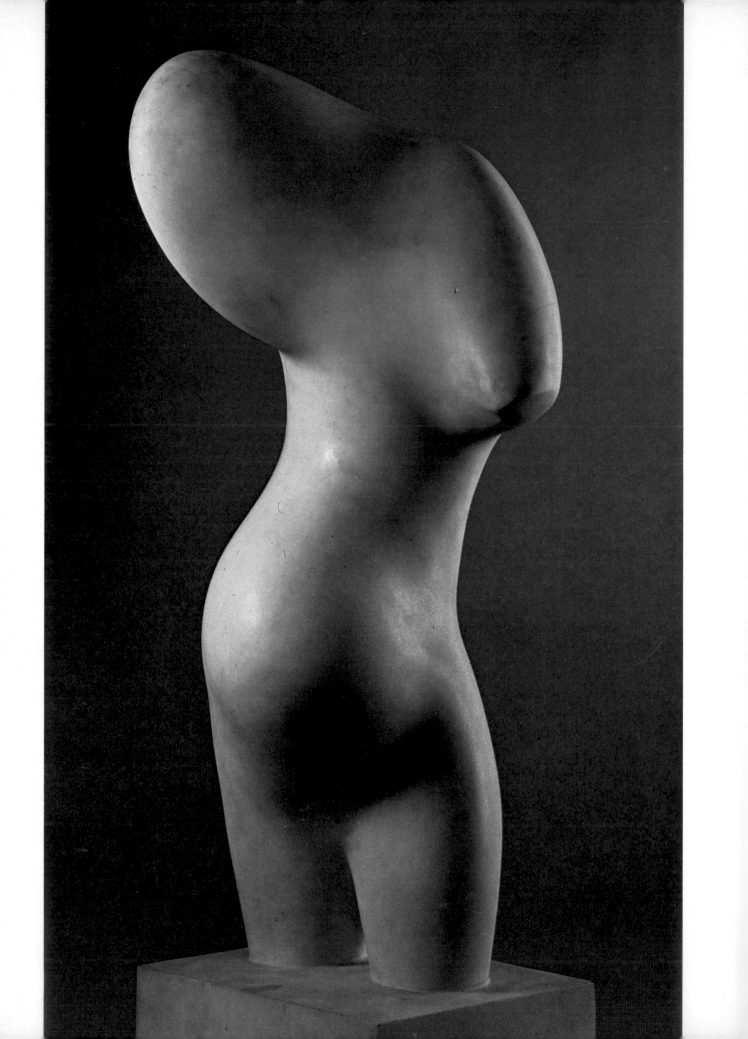

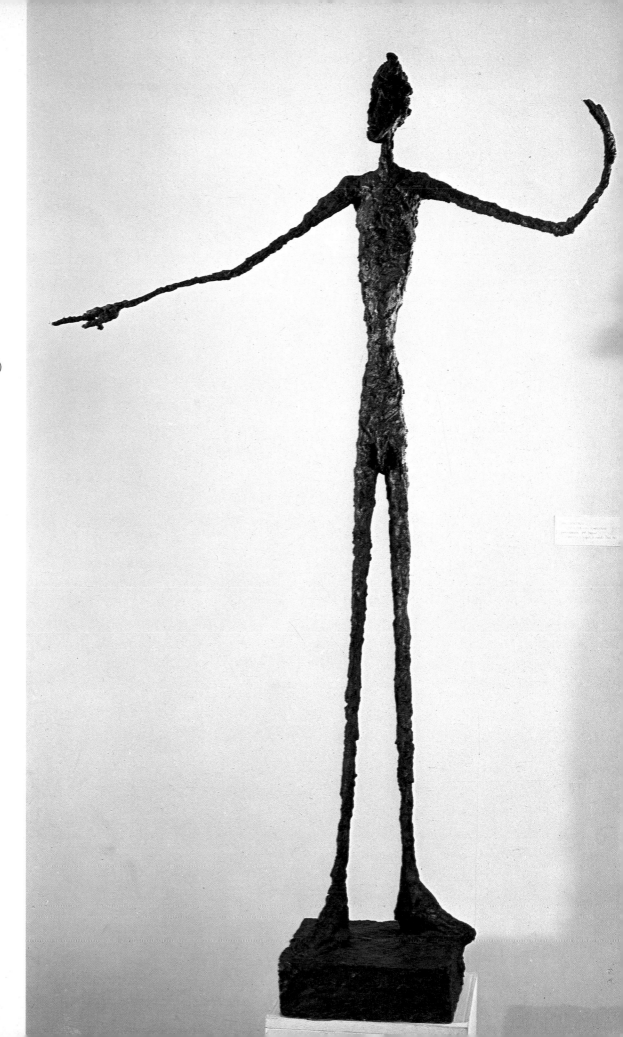

272. Opposite
Jean Arp
Torse de Femme
1953; 80 cm. (31 in.)
Cologne, Wallraf-
Richartz Museum

273.
Alberto Giacometti
Uomo che indica
1947; 178 cm. (69 in.)
New York, Museum
of Modern Art,
gift of Mrs. John D.
Rockefeller III

274.
Barbara Hepworth
Three Obliques (Walk-in)
1968–69; 290 cm. (113 in.)
London, Gimpel Fils

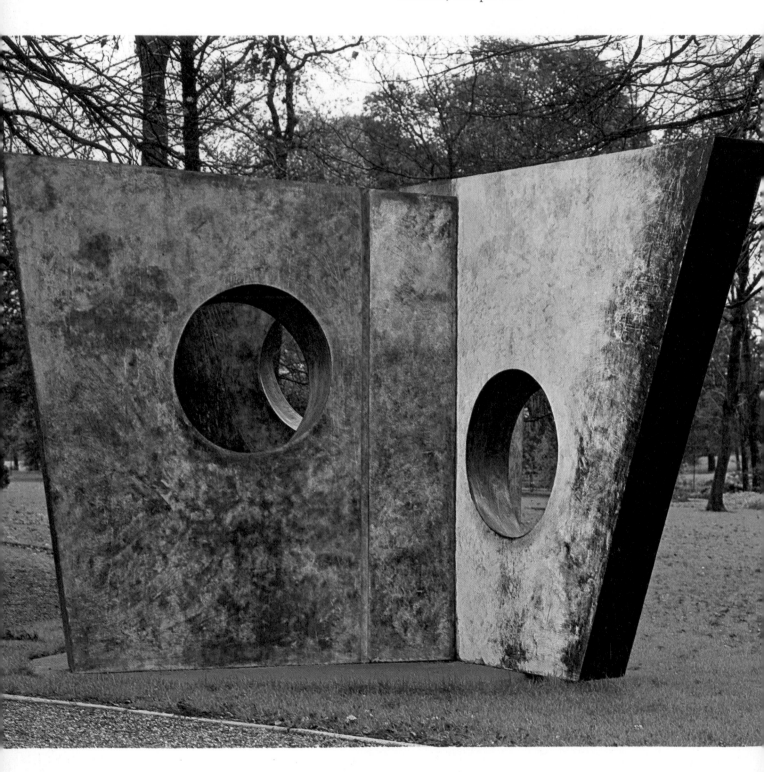

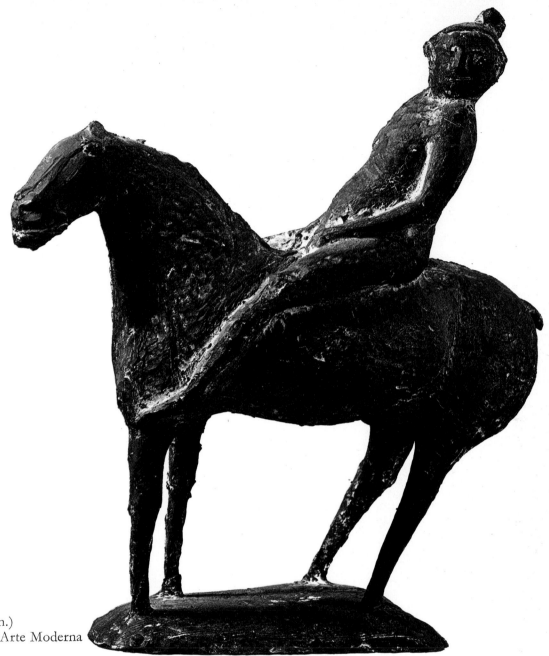

275.
Marino Marini
Cavaliere
Bronze
1946; 50 × 45 cm. (20 × 18 in.)
Rome, Galleria Nazionale d'Arte Moderna

America this interest continued, and indeed some of his most important sculptures, such as the *King Playing the Queen* (Plate 269) of 1944, were produced during his sojourn in the United States. Ernst's *King Playing the Queen* makes an instructive comparison with one of the best known of Henry Moore's post-war bronzes, the *King and Queen* of 1952–53 (Plate 270). Moore's sculpture has been accused of being in some respects formally incoherent. Commentators have pointed to the inconsistency of style between the stylized heads and the naturalistic hands and feet of the figures. Despite this, one notices that Moore's work has a density and fullness which is denied to the Ernst

piece. The longer one looks at the latter, the more it comes to seem a capricious *assemblage* of bits and pieces which in fact have very little relationship to one another.

The figure by Ossip Zadkine (Plate 271) is at any rate the work of an artist whose main activity is sculpture. It has a swaggering confidence and professionalism which reminds the spectator, not unjustly, of the work of the sculptors who showed in the various French Salons towards the end of the nineteenth century. Indeed, Zadkine's work does show a strange trajectory, from close association with the avant-garde to disguised academicism. Zadkine, a Russian Jew, was born in

276.
Lynn Chadwick
Two Guardians V
1960; 57.5 cm. (22 in.)
Cologne, Wallraf-Richartz Museum,
gift of Wilhelm Grosshenning

Smolensk, but by 1909 he had made his way to Paris, where he, like his colleague Jacques Lipchitz, was drawn into the circle of the Cubists. Between the wars he more or less abandoned Cubism, and by 1930 a baroque element had started to reveal itself in his work, closely allied to the decorative fashions of the time. Eventually, after emigrating to America in 1937, Zadkine began to experiment with ways of opening up the massive forms of his sculptures so as to give them greater lightness and energy. The idea of penetrating the form in this way had already occurred to Moore and Hepworth, who used it in a far more daring and inventive fashion. In itself the device can be regarded as a Cubist legacy, and as being something which sprang from the desire to show different aspects—front and back, inner and outer—from the same point of view and simultaneously.

The use of this device in a piece such as *Orphée* is, however, of much less importance than the bland classicism of the outline. Fluently and rather emptily decorative, Zadkine's late work seems to tell us that nothing has changed in sculpture since the late nineteenth century. The influence of genuine innovators, such as Gonzalez, is painlessly absorbed. The post-war Zadkine was at his most effective when faced with the kind of commission which any nineteenth-century academic sculptor would have found familiar. The efficiently rhetorical *Commemorative Monument to the Destruction of Rotterdam*, a shouting figure raising anguished arms to the sky, is in direct line of descent from works like the reliefs by François Rude which ornament the Arc de Triomphe in Paris.

Jean Arp came from a different background and developed in a different way. Arp, born in Alsace, was bilingual as well as multi-talented. He was first associated with the world of avant-garde art in Germany, exhibiting at the second show of the Blaue Reiter group in Munich in 1912. During the war years he was one of the originators of Dada in Zurich. At this period he wrote burlesque poems, made collages, and illustrated the poems of his friends, as well as producing the reliefs in painted wood by which his activity during those years is

277.
Germaine Richier
Chess Piece: Queen
1959
Hamburg, Kunsthalle

now best remembered. He did not return to sculpture in the round (he had had a brief flirtation with it before the war) until 1930, when he was living near Paris. Gradually his work moved into a more solemn and romantic phase, related on the one hand to the simplicity of Brancusi and on the other to the biomorphic forms that populate the compositions of Tanguy. A French critic asserts that it was Arp who "demonstrated that a sculptor could find the equivalent of the automatic writing of the poets" (Sarane Alexandrian, *Connaissance des Arts*, July, 1972, p. 55).

Having discovered what seemed to be a viable sculptural style, Arp stuck to it firmly, and the works produced after the war (Plate 272) are very little different from those created in the late Thirties. The American critic Harold Rosenberg has justly commented with reference to the later phases of Arp's career: "For the non-militant avant-gardist, maturity consists in passing from games in the garden of the imagination to the inventions of a professional in a world of institutionalized values" (Harold Rosenberg, *The Re-Definition of Art*, London, 1972, p. 80).

Artists like Arp and Zadkine seemed an integral part of the immediately post-war sculptural scene chiefly because the scene was so stagnant. Nevertheless, there were artists who seemed to be trying to bring new life to the Modernist tradition. These can be divided into those who had already made reputations before 1945 and those who were newcomers.

Giacometti possessed one of the most important of the established names, and the direction taken by his art was extremely important for sculpture in general. He had joined the Surrealist movement in 1929, and his return to working from the model in 1935, which led to his being denounced by his Surrealist colleagues, was in every way a significant decision. The years 1935–45 were those which Giacometti spent in forging the new style which was to have such an impact upon the post-war public. The most striking characteristic of this second phase of the sculptor's work was the extreme attenuation of the figures (Plate 273). Usually these very thin sculptures were provided with relatively massive

bases, which served to increase the impression of distance and alienation from the viewer.

In immediately post-war Paris the "un-graspability" of Giacometti's personages was immediately equated with the essential un-graspability of human experience, as preached by the newly prominent existentialist philosophers, such as Jean-Paul Sartre. If this was legitimate (Giacometti formed important friendships within the existentialist group), it was perhaps less legitimate to equate these skeletal figures with the general misery and depression of post-war existence, and in particular with the appearance of those who had survived imprisonment in German concentration camps. Nevertheless the comparison was made. Giacometti, who was the most private of artists, found that he had become the symbol of a new humanist concern among modern artists—a humanism which focused its attention upon social problems and evils.

The post-war Henry Moore did not seem as radically different from his former self as the post-war Giacometti. For Moore, unlike most other modern artists, the war years had been to some extent at least a period of opportunity. Working in the shelters during the Blitz, Moore produced a remarkable documentation of a nation's ordeal. Later, when he was able to resume work as a sculptor, Moore, like many of the artists working at that time in Britain, showed a move towards work with a broad popular appeal—the famous *Madonna* for St. Matthew's, Northampton, is perhaps the best-known case in point. And when the conflict at last came to an end, the sculptor had established himself as a figure whose importance was admitted by a broad spectrum of people. His international stature was meanwhile confirmed by an exhibition which the British Council sent to New York.

Presented with opportunities such as no modern sculptor had had before him, Moore was able to take advantage of them to the full, thanks to his outstanding creative energy. A technical change took place in his work, in that, from being primarily a carver of stone and wood, he now made bronze his chief medium of expression. Some critics saw in this a tendency on the part of

278. Opposite
Arnaldo Pomodoro
La colonna del viaggiatore
1961; 134 × 29 × 8.5 cm. (52 × 11 × 3 in.)
Cologne, coll. of Mr. and Mrs. Alfred Otto Müller

279.
Arnaldo Pomodoro
Cubo
1965–75; 130 × 130 × 130 cm. (51 × 51 × 51 in.)
Gedola (Saudi Arabia), sculpture Park

the artist to compromise the standards he had hitherto maintained. But there was no denying Moore's ability to create memorable images. This was accompanied by an astonishing flexibility of style. Moore never seemed to abandon an idea or a theme, but moved from works which were almost Rodinesque, such as the *Hand Relief No. 2* of 1952, to others as grandly abstract as the *Locking Piece* of ten years later.

The reputation of British sculpture was also sustained by the career of Barbara Hepworth. The direction taken by her work in the late Forties was influenced by the friendship which she and her then husband, the painter Ben Nicholson, formed with the veteran Russian Constructivist Naum Gabo during the preceding decade. Gabo arrived in England in 1935, and he was in close contact with Hepworth and her husband for the next ten years. Her work, however, could never be described as fully Constructivist, since it had a strongly surviving element of poetic irrationality, reinforced by the landscapes and seascapes which the artist saw about her in Cornwall, where she lived and worked from 1939 onwards. "From the sculptor's point of view," she later remarked, "one can either be the spectator of the object or the object itself. For a few years I became the object."

The intensity Hepworth achieved during the late Forties was not entirely sustained during the decade that followed, which brought, only a little behind Moore, a great expansion of her reputation and therefore of the opportunities open to her as an artist. Carving had been even more central to her original aesthetic than it had been to Moore, but now she too was tempted into using bronze, a material in which it was so much easier and quicker to attain monumental scale. These late monumental works (Plate 274) are not likely to enhance her reputation when a final assessment is made.

In Italy, Marino Marini's reputation grew in a way analogous to what happened to Moore and Hepworth after 1945. His equestrian groups (a theme he had attempted as early as the mid-Thirties) became one of the type-images of modern art (Plate 275), and many people cited his work as proof that contemporary sculpture could keep its integrity and yet convey a message to a broad public. Marini and his near-contemporary Giacomo Manzù became the standard-bearers in Italy of a new figurative and humanist sculpture, just as Giacometti had done in France.

The energy of artists such as Giacometti, Moore, and Marini, and the attention which naturally focused on their activities, made it hard for new sculptors to find a footing in the immediately post-war years. The group that emerged most prominently did so, surprisingly enough, in England. It included Lynn Chadwick (Plate 276) and Reg Butler, both of them major prize-winners in the Unknown Political Prisoner competition of 1953. This, with its emotionally charged subject matter, did much to attract attention to a new generation of artists. Butler and Chadwick, together with Kenneth Armitage and Bernard Meadows, were shown by the British Council at the Venice Biennale of 1952, and this exhibition, in a rather narrower sense, also seemed significant in showing what sculpture might become in the future. All the four artists I have mentioned were exponents of a romantic figurative style which owed something to Surrealism without being fully Surrealist. The human figure, in their hands, was transformed and distorted so that it became a metaphor for the emotions felt by the artist.

This strictly subjective realism appeared, though in more developed fashion, in the work of the French sculptor Germaine Richier, who spent four years as a private pupil of Émile-Antoine Bourdelle. Richier's sculptures are caught in the very midst of a process of transformation (Plate 277)—the figure here is always in the midst of turning into something not human at all, be it an insect or a hurricane, in a way that resembles the transformations of imagery we find in modern poetry, for example in the work of Richier's husband, the French poet René de Solier. In this rather specialized sense Richier was a literary artist. She is at any rate literary enough to seem incredibly remote from much of the sculpture that followed her death in 1959.

Humanistic sculpture of this type was not, however, the only option open to artists during

281. Opposite
David Smith
Cubi XIX
1964; 287 × 156 × 105 cm. (112 × 61 × 41 in.)
London, Tate Gallery

282.
David Smith
Primo Piano III
1962; 315 × 368 × 46 cm. (123 × 144 × 18 in.)
New York, Marlborough-Gerson Gallery

the 1950's. Some, for example, tried to evolve an idiom which would supply an equivalent for the abstract painting of the time. This is probably the best way of approaching the work of Arnaldo Pomodoro, who held his first exhibition in Venice in 1955. Like his brother, Giò Pomodoro, Arnaldo Pomodoro began as a designer, decorator, and metalsmith—that is, he began with the material, and with a keen awareness of its sensuous

qualities. It was through manipulation of metal that he became a sculptor, and his subtle contrasts of smoothly polished and apparently corroded surfaces (Plates 278 and 279) are an equivalent of what an artist such as Tàpies does with paint.

Another approach, different again, was through the impersonal logic of the old Constructivist tradition. Perhaps the most interesting exponent of this in the post-war world has been the Swiss

283.
Anthony Caro
Midday
1960; 148 × 366 × 97 cm. (58 × 143 × 38 in.)
London, by kind permission of Kasmin Ltd.

284. Opposite
Anthony Caro
Month of May
1963; 280 × 358 × 26 cm. (109 × 140 × 10 in.)
London, by kind permission of Kasmin Ltd.

sculptor-architect Max Bill (Plate 280). Bill was a pupil of the Dessau Bauhaus in 1927–29, and the rest of his career has been devoted to an elaboration of Bauhaus ideas. His sculptures approach the problems of three-dimensionality in a spirit of detached curiosity. How, for instance, can a frontal, static quality be avoided, so that the piece has no main aspect, but only an unfolding series of aspects, each of which seems "right" at the moment when it is looked at, but each of which

nevertheless urges the spectator onward to a new and different viewpoint, until the circuit is completed? Sculpture, for Bill, is a question of experiments with form. Emotion is irrelevant. In this he has much in common with younger men, yet it is difficult to trace any specific connection between his *oeuvre* and what was to succeed it.

The revolution in sculpture, when it came, took place in several stages. The first and most important stage is represented by the work of two

artists, an American and an Englishman: David Smith and Anthony Caro. Smith was a contemporary of the leading Abstract Expressionist painters, and his evolution has some resemblance to theirs. Born in 1906, he was attracted to art from his high school years, but did not actually succeed in making any reputation as an artist until the mid-Thirties, at which time he was associated with the Federal Art Project. This reputation was consolidated during the war, when Smith caught the attention of the influential critic Clement Greenberg; but it was not until the 1950's that his artistic identity was fully visible.

The technique that assumed great importance for David Smith was direct welding. He moved towards this from two different directions—from his experience on the assembly line of the Studebaker plant at South Bend, Indiana, in the middle Twenties, and from his admiration for the welded sculpture of Picasso and Julio Gonzalez.

285.
Eduardo Paolozzi
Last of the Idols
1963; 244 × 61 × 11 cm. (95 × 24 × 4 in.)
Cologne, Wallraf-Richartz Museum, coll. Ludwig

286. Opposite
Philip King
Through
1965; 213 × 335 × 274 cm. (83 × 131 × 107 in.)
Bedfordshire, collection of the artist

He first became aware of their work from reproductions of it in a copy of *Cahiers d'Art* which he saw in 1931. Later, during the Second World War, Smith again had a welding job at the American Locomotive Company plant in Schenectady.

Smith began his career as an artist uncertain of whether he wanted to be a painter or a sculptor, and long after he opted definitely for sculpture his work relied upon a kind of draftsmanship in metal. The effect is particularly pronounced in some beautiful sculptures of around 1950, which look like an attempt to rival Abstract Expressionist calligraphy in painted steel.

Soon after this, Smith's work became increasingly industrial in style and handling. In the *Agricola* and *Tanktotem* series of 1952 and 1953, he started to make use of ready-made industrial parts. This was not an entirely new venture. As early as 1933 Smith had made use of found objects. But now, in the early Fifties, Smith began to break away from the Surrealist attitude towards the found object. What it might evoke counted more for this than its inherent formal qualities: "I find many things [he said to an interviewer], but I only choose certain ones that fit a niche in my mind, fit into a relationship I need, and that relationship is somewhat of a geometric nature" (interview with Thomas B. Hess, 1964, reprinted in *David Smith*, edited by Garnett McCoy, London, 1973).

Smith found that by using industrial parts, some of them ordered from manufacturers' catalogues, he was able to make sculptures of substantial size both easily and rapidly. His tendency to work in series, from the 1950's onwards, was prompted by this. It led, in turn, to a rather different attitude towards sculpture itself than that taken up by his predecessors. The late sculptures of the *Cubi* series (Plate 281) have an improvised, almost provisional

287. Opposite
William Tucker
Nine Poles
1967; 224 × 91 cm. (87 × 35 in.)
London, Kasmin Ltd.

288.
Kenneth Snelson
Audrey I
1965
Colorado, coll. Kimiko and John Powers

quality. The gain in dynamism is balanced by a corresponding loss of the authority that sculpture is traditionally supposed to possess.

The majority of the *Cubi* series do, however, retain some vestiges of tradition. With most the sculpture starts from a base; and many can be interpreted as paraphrases, though distant ones, of the human figure. In other work of the Sixties Smith was even further from the conventional notion of sculpture (*Primo Piano III*, Plate 282), though it must be noted that sculptures of this type have a strong resemblance to some of the more ambitious "stabiles" as opposed to mobiles produced by Alexander Calder.

Smith's work, coupled with advice and encouragement from Clement Greenberg, was destined to have a decisive impact upon the work of the British sculptor Anthony Caro, who in 1959 paid a first visit to the United States. In the course of this he saw work by Noland and Louis, as well as sculpture by Smith. Before this, Caro had worked for a time as an assistant to Henry Moore, enlarging Moore's small-scale models to final

sculptures. He had also produced a number of figurative sculptures of his own in a boldly Expressionist style. Now, like Smith, Caro started making sculptures out of scrap steel, girders, and sheet metal.

The earliest of these, for example, *Midday*, which dates from 1960 (Plate 283), are more closed in form, and more massive, than subsequent work. But already there are marked differences between

289. Opposite
Tony Smith
Amaryllis
1965; 350 × 129 × 350 cm. (137 × 50 × 137 in.)
Connecticut, Wadsworth Atheneum

290.
Larry Bell
Ellipse
1965; 136 × 35.6 × 35.6 cm. (53 × 14 × 14 in.)
New York, Whitney Museum of American Art,
gift of Howard and Jean Lipman

291.
Donald Judd
Untitled
1966; 122 × 305 × 305 cm. (48 × 119 × 119 in.)
Connecticut, coll. Mr. and Mrs. Howard Lipman

292. Opposite
Donald Judd
Untitled, detail
1968; 23 × 102 × 79 cm. (9 × 40 × 31 in.)
Los Angeles, County Museum of Art

Caro and Smith. Caro abolishes the base altogether, and his sculptures tend to be horizontal in orientation. Many are entirely below eye level. The rambling quality of much of Caro's work (*Month of May*, Plate 284) prevents the spectator from anthropomorphizing it. But the free interplay of parts has a strong effect upon the whole of the surrounding space. A sculpture like *Month of May* is not environmental in the exact sense of the term. It does not surround the viewer, nor can he walk through it as well as around it. But its chief function is, nevertheless, to alter spatial perception.

An interesting comparison can be drawn between Caro's work of the early Sixties and that being done at the same moment by another British sculptor, Eduardo Paolozzi (Plate 285). Paolozzi, during the previous decade, had been closely involved with the beginnings of the Pop Art movement in Britain, but his own work had remained a compromise between nascent Pop

ideas and Surrealism. The two allegiances were neatly epitomized in Paolozzi's most characteristic technical device, which was to create an intricate surface pattern upon sheets of wax, using small cogwheels, wheels from toy motor cars and similar small objects, and then to form these sheets into slightly monstrous creatures which were afterwards cast in bronze, the traditional material of the sculptor. But now Paolozzi, too, started using ready-made industrial parts, which were welded together and brightly painted. The forms he made with them, however, were recognizably humanoid—witty fantasies based upon the robots and Martians in comic strips.

Caro exerted an important influence on younger British sculptors through his work as a teacher at the St. Martin's School of Art. This influence announced itself in an exhibition called "The New Generation: 1965", which was held at the Whitechapel Art Gallery in London. The majority of the exhibitors had studied at St. Martin's under

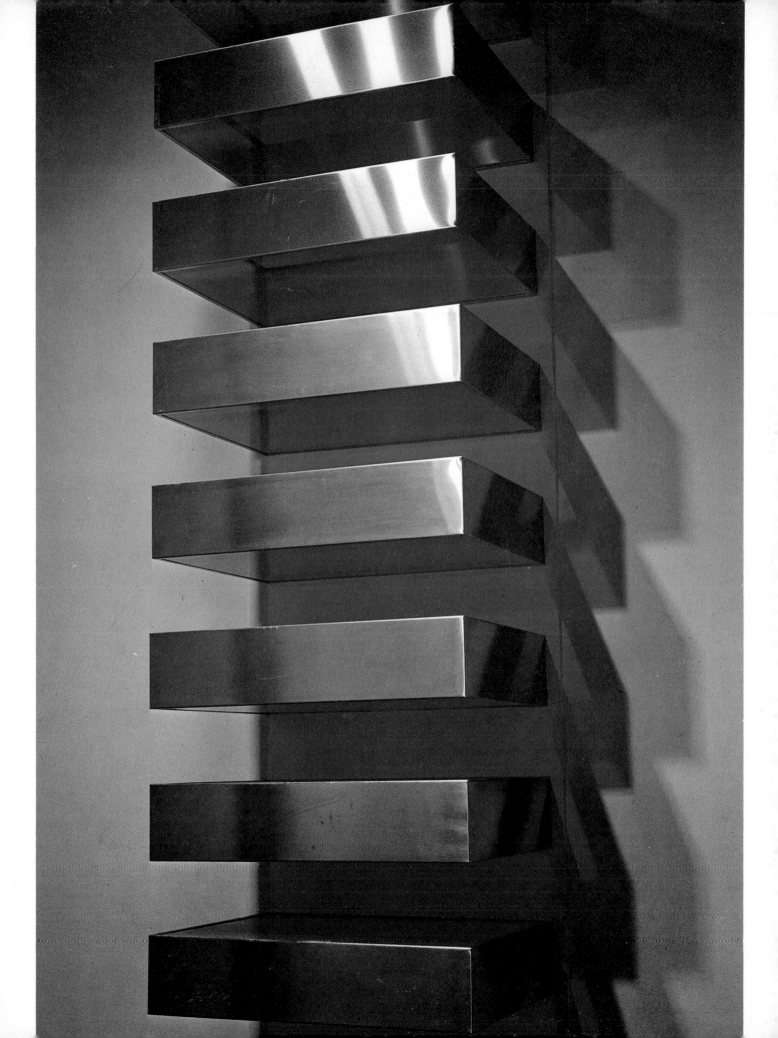

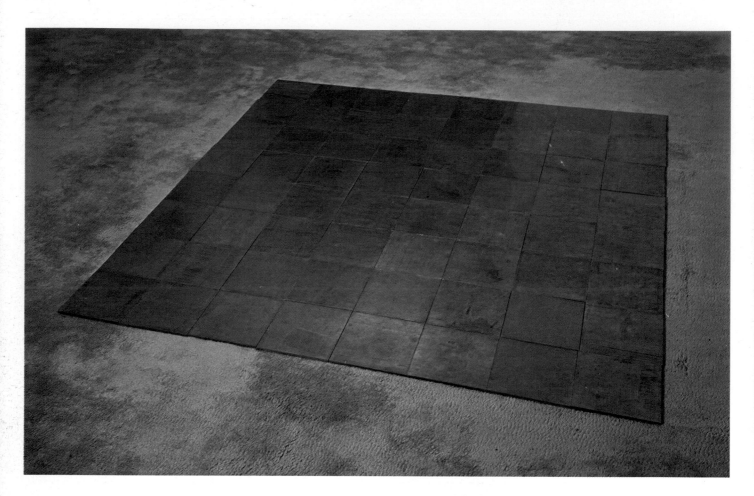

Caro. Among them were Philip King and William Tucker. King's *Through* (Plate 286) dates from the same year as the Whitechapel exhibition and exemplifies many of the qualities to be found in this new group of artists—a feeling for formal ambiguity, which is nevertheless closely controlled, combined with a determination to get away from any kind of external or nostalgic association, even the associations conjured up by Caro's girders. A neutral material—fibreglass—is given life with deliberately synthetic colour, and it is the play of colour, as much as the interaction of form, that gives life to the piece.

William Tucker (Plate 287) sticks much closer to Caro's example, but a comparison between *Month of May* and *Nine Poles* reveals that a tidying-up process has taken place. Tucker's sculpture has a rather arid logic which is quite different from

Caro's use of similar elements.

The feeling for logic and regularity which showed itself in King and Tucker was to reappear in far more drastic guise in the American sculpture of the same period. There were, of course, certain resemblances to what was being produced in Britain at the same time. One can see, for instance, a distinct kinship between *Nine Poles* and Kenneth Snelson's *Audrey I* (Plate 288). Both make logical use of linear units. But the more closely one examines the two pieces, the less alike they seem. Snelson takes up and exaggerates one aspect of David Smith's work: the feeling of instability. An American critic, discussing the sculpture illustrated, remarks: "*Audrey I* is a dynamic structure which achieves only a very tenuous and threatened balance. Poised lightly upon the apexes of triangular units, its insubstantiality is emphasized

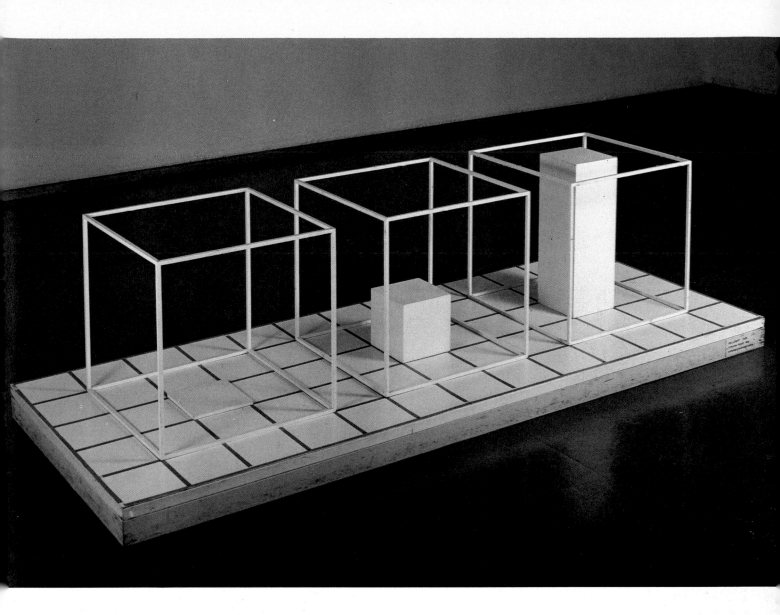

as well as its dependence upon the strength of the cable system" (Stephen A. Kurtz, "Kenneth Snelson: The Elegant Solution", *Arts Magazine*, New York, 1968).

Snelson takes the provisional quality of David Smith's work a stage further by introducing a means of construction which is genuinely precarious, instead of just seeming so.

Snelson's work is outside the mainstream of American sculpture of the Sixties because, despite the simplicity of the parts, they are used to create a complex structure. Even he, as it happened, was to simplify his work and make it more regular and stable in appearance in the course of the decade.

The term "Minimal Art" was coined by the British philosopher Richard Wollheim in 1965. He used it to describe the kind of contemporary art object that seems to rely, for its aesthetic impact,

on a paradoxical absence of art content. The readymades of Marcel Duchamp would be a case in point. Almost immediately, this term came to be used by art critics as a convenient label for a particular kind of extremely simplified sculpture then being produced in America. Such works were also dubbed "Primary Structures"—the title of an exhibition held at the Jewish Museum in New York in 1966—and the movement which gave birth to them was dubbed "Structuralism". Among the artists whose work was included in the show at the Jewish Museum were Larry Bell, Dan Flavin, Donald Judd, Sol LeWitt, John McCracken, and Robert Morris.

The artist who most clearly demonstrates the derivation of Structuralism from the late sculptures of David Smith is the latter's namesake Tony Smith. The way that Tony Smith's sculptures look

295.
Robert Morris
Untitled
1966; 61 × 244 cm. (24 × 95 in.)
Colorado, coll. Kimiko and John Powers

296. Opposite
Robert Morris
Untitled
1970; 183 × 244 cm. (71 × 95 in.)
New York, Leo Castelli Gallery

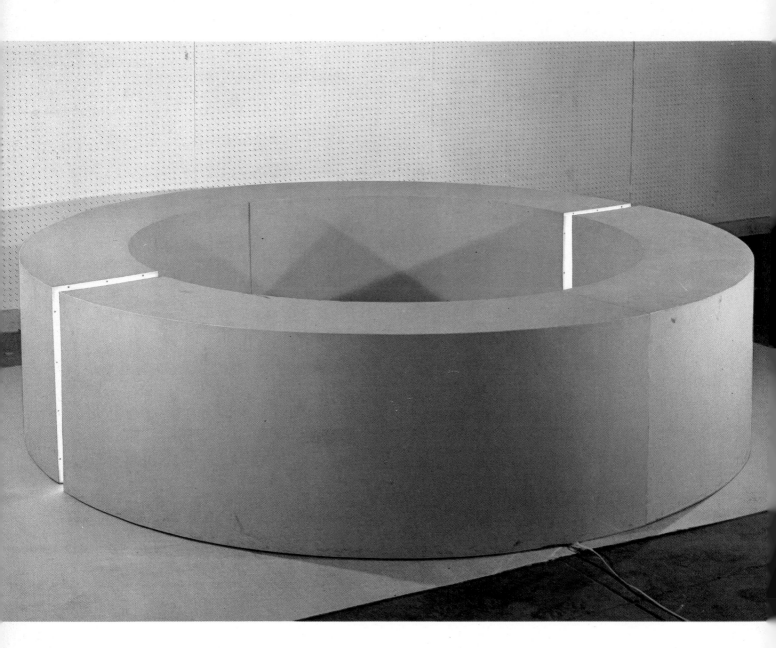

is in part at least the product of the circuitous route by which he came to making sculpture. Born in 1912, he had made a career in architecture, working as an assistant to Frank Lloyd Wright in the late Thirties, then during two decades independently designing numerous buildings. It was not until 1960 that he started his career as a sculptor, and the decision was in large part due to his impatience with the impurity of architecture—to the fact that the architect's intentions were always compromised and distorted by the pressures of human use and human need.

But there is also to be found in Tony Smith's work a version of the cult of inexpressiveness which we have already encountered in the paintings of Andy Warhol. Describing the genesis of his piece *Amaryllis* (Plate 289), the artist said: "I set out to make something like a cave. I wanted to make the space and light as tangible as possible and in other ways it was to be the architecture of an

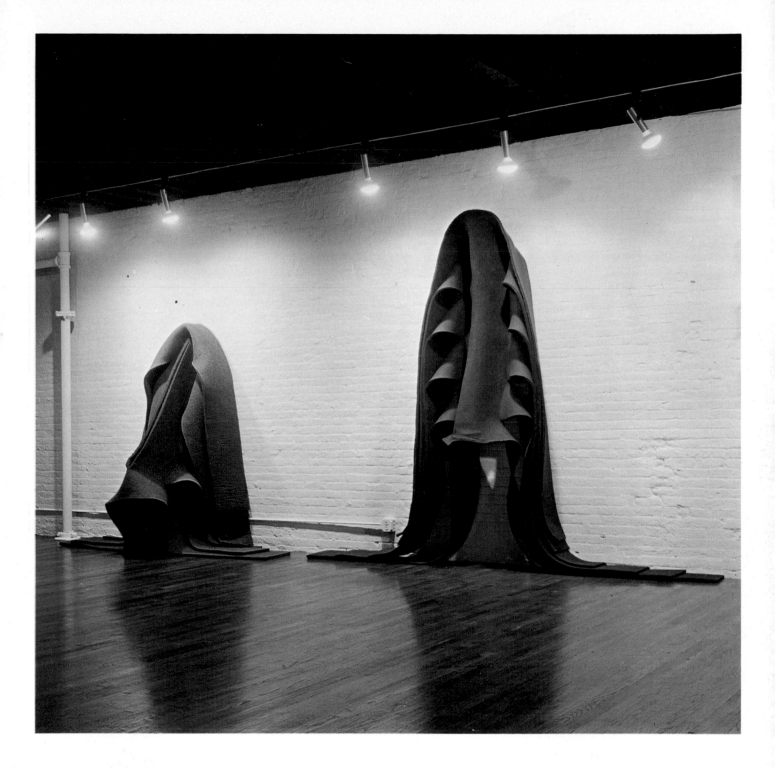

idiot" (Tony Smith in the catalogue of "Tony Smith—Two Exhibitions of Sculpture", shown at the Wadsworth Atheneum, Hartford, Connecticut, 1966, and at the ICA, Philadelphia, 1966–67).

This piece makes the connection with David Smith very clear. *Amaryllis* is a large box structure made of sheet metal, which looks like a flowing-together and enlargement of certain parts of the *Cubi* series. Its large scale seems to reflect Tony Smith's long experience as an architect. But this characteristic is not confined to his work alone. Very many Minimal sculptures are of monumental size, and this fact, like the bland banality of their forms, has been linked by commentators to the ideas of Gestalt psychology. The "good Gestalt" the spectator is unconsciously in search of resides, according to this theory, in the soothing uniformity of these vast shapes, and in the fact that they are big enough to block all other objects from our view.

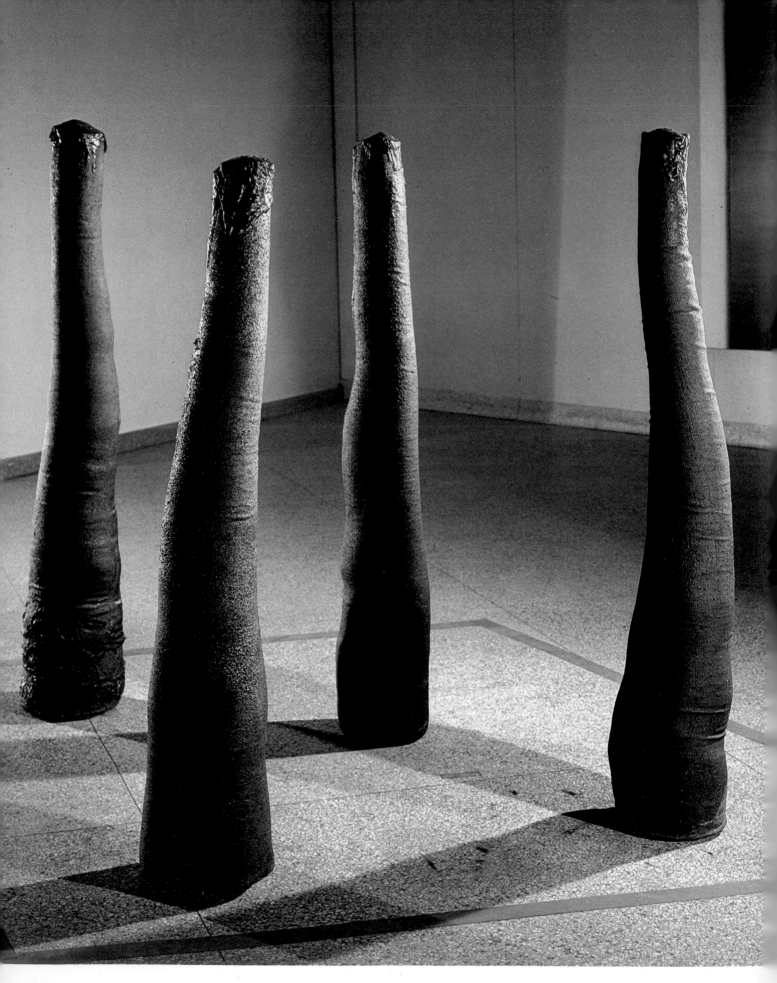

297. Opposite
Barry Flannagan
Four Rahsbs 4, 1967
1967, 127 × 152.4 × 152.4 cm. (50 × 59 × 59 in.)
New York, Solomon R. Guggenheim Museum

298.
Richard Serra
Untitled 1969
1969; 268 × 272 × 47.5 cm. (105 × 106 × 19 in.)
New York, coll. Jasper Johns

Not everything placed under the heading of Minimal Art was as inherently simple as the phrase itself suggested. There was a complex play of reflection in the coated glass cubes made by Larry Bell (Plate 290), even in those made when he had ceased to inscribe designs upon the surface. And when he stopped making cubes, and instead simply placed sheets of coated glass at right angles to one another, the play of imagery continued to be the main subject of the work.

At the heart of Minimal Art lay an austere puritanism which makes an artist like Bell seem slightly divorced from its real purposes. This puritanism is especially conspicuous in the work of a sculptor such as Donald Judd, with its passion for total visibility and the absence of any ambiguity (Plates 291 and 292). Judd asserts: "A shape, a volume, a color, a surface is something itself. It shouldn't be concealed as part of a fairly different whole. The shapes and materials should not be altered by the context. One or four boxes in a row, any single thing or such a series, is local

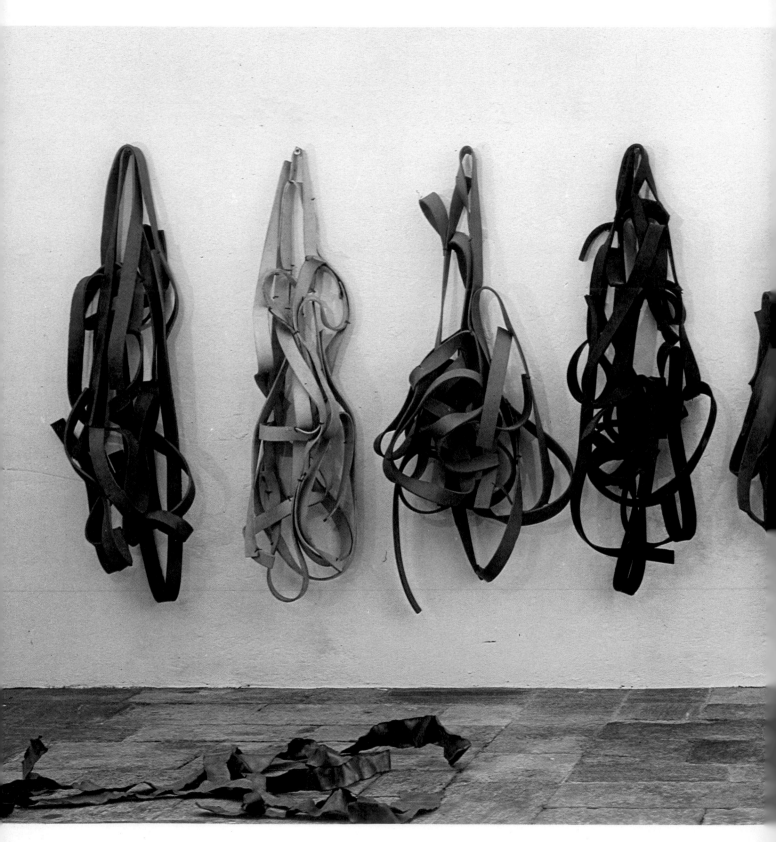

299.
Richard Serra
9 Rubber Belts and Neon
1968; 190 × 553 × 44 cm. (74 × 216 × 17 in.).
Varese, coll. Giuseppe Panza di Biumo

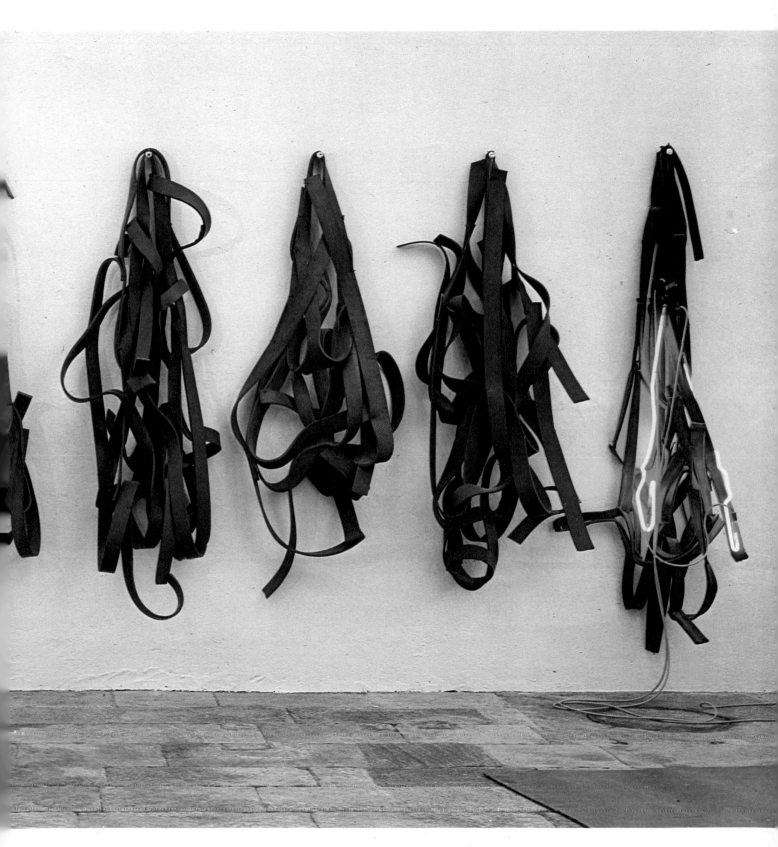

order, just an arrangement, barely order at all. The series is mine, someone's, and clearly not some larger order. It has nothing to do with either order or disorder in general. Both are matters of fact. The series of four or six doesn't change the galvanized iron or steel or whatever the boxes are made of" (Donald Judd, "Perspecta II, 1967", *Portfolio: 4 Sculptors*, New York, 1967).

The one concession Judd makes to ambiguity of any kind lies in the fact that his sculptures, like Kenneth Noland's stripe paintings or, before that, the *Endless Column* of Brancusi, give the impression that the sequence of identical shapes could be indefinitely prolonged.

We find another version of this idea in the floor pieces of Carl Andre (Plate 293), where the units (in this case copper plaques) have even less formal interest than Judd's boxes. Andre's work also demonstrates a number of other characteristics that tend to appear frequently in Minimal Art— the emphasis upon the plane of the floor, and the fact that the sculpture is what has come to be called an "installation piece", made to fit a particular physical situation, and without fixed identity, since all the components are movable.

There is an affinity between Andre's work and that of Sol LeWitt, but also a difference. LeWitt's structures, such as *3 Part Set 789 (B)* (Plate 294) are demonstrations of the conflict between "conceptual order and visual disorder". What LeWitt exploits is the contradiction between what we know to be there and what we actually see. The work *3 Part Set* presents a mathematical series in visual form, but our apprehension of this series is confused by matters extraneous to the real content of the work—perspective effects, the fact that one part may stand in front of another, cast shadows, and so forth. The conceptual content of LeWitt's sculptures links them directly to his wall drawings and prints. Here the marks are made according to rigid sets of rules, which are designed to eliminate the effects of either taste or accident.

One of the chief theoreticians of the Structuralist movement has been Robert Morris, and his personal evolution has, correspondingly, been among the most interesting. Earlier works, such as *Untitled* of 1966 (Plate 295), show the rigidity of post-David Smith sculpture. In this particular case the artist has even chosen to emphasize the nature of the structure by putting a light inside it, and by providing two slits at opposite sides through which the light can be seen. That is, he demonstrates to us that a ring-like form which we might in fact accept as solid and unitary is in fact hollow. Later works (Plate 296) are the opposite of rigid, and seem to owe a good deal to the soft sculptures of Claes Oldenburg. Morris explained his change of orientation thus, in an article in the influential art magazine *Artforum*: "In object-type art, process is not visible. Materials often are. When they are, their reasonableness is usually apparent. Rigid industrial materials go together at right angles with great ease. But it is the *a priori* evaluation of the well-built that dictates the materials. The well-built form of objects preceded any consideration of means."

The solution, according to Morris, is to follow the lead given by the material itself: "Sometimes a direct manipulation of a given material without the use of any tool is made. In these cases considerations of a given material begun as means result in forms which were not projected in advance. Considerations of ordering are necessarily casual and imprecise and unemphasized. Random piling, loose stacking, hanging, give passing form to the material. Chance is accepted and indeterminacy is implied since replacing will result in another configuration, since disengagement with preconceived enduring forms and orders for things is a positive assertion" (Robert Morris, "Anti-Form", *Artforum*, New York, April, 1968).

Morris's argument, which is, in effect, that to be truly Minimal sculpture must abandon fixed form altogether, has found an echo among quite a number of avant-garde artists. The English sculptor Barry Flannagan, with his *Four Rahsbs 4, 1967* (Plate 297), seems to be making at least a tentative protest against the kind of work that was simultaneously being turned out by members of the "New Generation", a group of sculptors who took their name from an exhibition at the Whitechapel Art Gallery, London, in 1965. The forms can be read as a kind of parody of what other

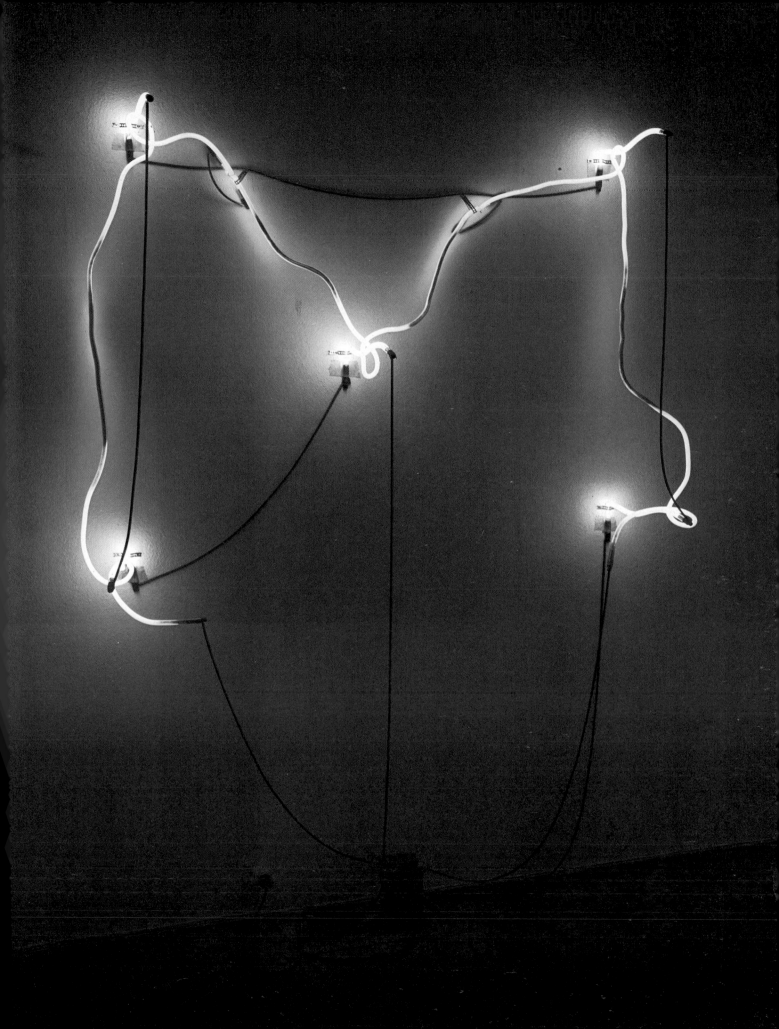

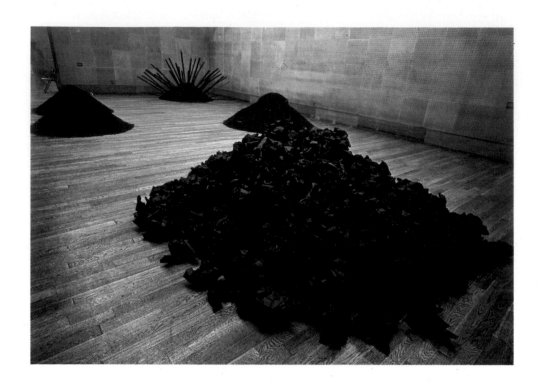

English artists were doing at the same moment. Flannagan's piece, for instance, dates from the same year as William Tucker's *Nine Poles*.

Richard Serra's *Untitled 1969* (Plate 298) looks like an attempt to achieve the same kind of "anti-form" as Morris's work, using more intractable materials; and, like Morris's felt pieces, it has a simple but hidden principle of order, since the metal shapes have been formed by pouring molten lead into the corners of the room where they are shown, and the results of what happened have been accepted as something "given". Serra's *9 Rubber Belts and Neon* (Plate 299) of 1968 is directly comparable to Judd's hanging felt pieces of the same year. The bent neon tube which forms part of one of the tangles of rubber belting could be read, indeed, as an ironic commentary on the claim made by Morris that the chosen material will dictate its own form. In Keith Sonnier's *Wrapped Neon Piece* (Plate 300) the calligraphy of the tubes seems to stand in the same relationship to some of Morris's work as Lichtenstein's *Brushstrokes* do to the techniques of Abstract Expressionism.

The extreme of Minimal anti-form is reached with the *Paper Heap* of the German artist Reiner Ruthenbeck (Plate 301). This, though done six years ago, seems to mark the extreme limit of post-war sculpture's trajectory. It is hard to think of anything at a further extreme from the immediately post-1945 work of Henry Moore.

The impulse towards the minimal was sufficiently strong to draw along with it a number of artists whose sensibility remained slightly at odds with the doctrines that men such as Judd and Morris were attempting to propagate. Dan Flavin's sculptures are formed out of ready-made fluorescent light fixtures. A piece like *Monument for V. Tatlin* (Plate 302) leads the spectator's mind in several different directions. The title and indeed the form suggest a parody or paraphrase of Tatlin's project for a *Monument to the Third International*. In this sense there is a dual connection—to Constructivism on the one hand and to Pop Art on the other. The chosen material, neon tubing, in any case has Pop associations because of its employment in advertising signs and shop fascias. On the other hand the putting together of ready-made industrial parts indicates that, in terms of his technical approach, Flavin can be considered yet another descendant of David

386

302.
Dan Flavin
Monument for V. Tatlin
1964–69
New York, Leo Castelli Gallery

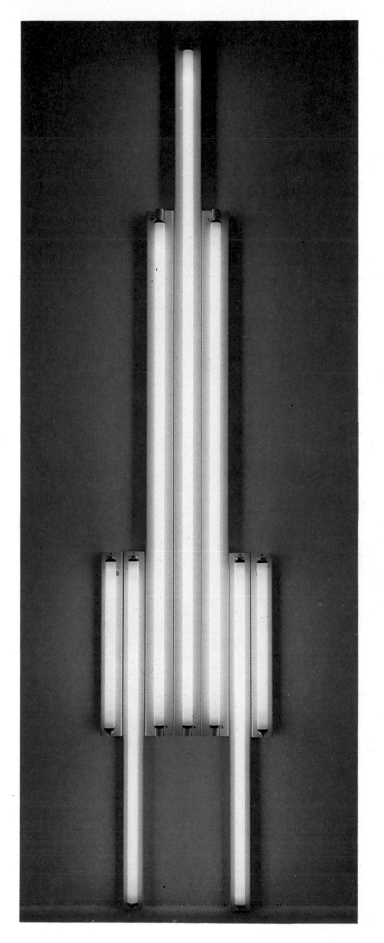

Smith. His work therefore, despite its apparent simplicity, brings together a whole complex of associations, at least for the informed spectator. Nevertheless, Flavin would not want any symbols we may find in his work to take precedence over what is actually seen: "As I have said for years, I believe that art is shedding its vaunted mystery for a common sense of keenly realized decoration. Symbolizing is dwindling—becoming slight. We are pressing downward toward no art—a mutual sense of psychologically indifferent decoration—a neutral pleasure of seeing known to everyone" (Dan Flavin, from the catalogue of the exhibition "A New Aesthetic", Washington Gallery of Modern Art, 1967, p. 35).

John McCracken and Craig Kauffman differ from the Structuralists with whom they are sometimes grouped because they both have a sense of the seductive and the decorative which relates them to other kinds of art produced during the Sixties in California (where they both come from), and especially to the ultra-refined Pop of Ed Ruscha. Kauffman began his career as an artist in the late Fifties, at which time he was a painter working in the standard Painterly Abstract style then prevalent in San Francisco. By 1963 he had made his first factory-produced plastic pictures based on organic forms, and in 1967 he made a series of vacuum-formed rectangles with rounded corners (Plate 303). These are still his best-known works. Though they are three-dimensional, it is an open question whether they should be classified as sculpture or painting, in view of the artist's own comments: "I began working in plastic with an idea of form, it is true, but my principal impetus was a passion for a kind of color, a kind of light, a sensual response to material . . ." (Craig Kauffman, ibid., p. 51).

McCracken's reputation rests on a series of brightly coloured slabs which lean against the wall (*Red Plant*, Plate 304). The artist himself seems to think of these as being definably sculptural: "I'm concerned with making things that exist and operate in real space in an integrated and non-static way. I want a sculpture to have a definite presence and individuality of its own, but at the same time to function interactively with things

303.
Craig Kauffman
Untitled, Wall Relief
1967; 128 × 196 cm. (50 × 76 in.)
Los Angeles, County Museum of Art, loaned by the
Kleiner Foundation, Beverly Hills

around it" (John McCracken, ibid., p. 37).

On the other hand, he does not deny the importance of colour itself: "I think of color as being the structural material I use to build the forms I am interested in. The fact that in another sense I use plywood, fiberglass and lacquer as structural materials is of less importance. I have found that a certain combination of color intensity and transparency and surface finish provide me with the expressive means I want, at least for the present" (John McCracken, from "New Talent

USA", *Art in America*, Vol. 54, New York [July, 1966]).

McCracken's work, more perhaps than that of any other artist, makes one aware of the degree to which the distinction between painting and sculpture has broken down.

The erection of Minimal Art into a successful, indeed a momentarily dominant, style, is a phenomenon which may require a good deal of explanation from the art historians of the future. Even at this distance of time it is possible to see

304.
John McCracken
Red Plant
1967; 259 × 45 × 7.5 cm. (101 × 18 × 3 in.)
Los Angeles, coll. L. M. Asher family

that the art of the late Sixties represented a serious crisis in the relationship of modern art and its public. Clement Greenberg, the major promotor, or perhaps the inventor, of Post-Painterly Abstraction, and the convinced admirer of David Smith and Anthony Caro, denounced the Minimalists as men who had turned what he called "the far out" into an end in itself. That is, he believed that a dynamic of extremism had developed, and that young artists were now competing with one another for the leadership of an avant-garde which had become institutionalized.

There are indeed indications that Minimalist developments were due in part to a struggle for dominance within a closed society of artists. If one reads the writings of a theoretician-artist like Robert Morris, one notes that the concepts which he puts forward are elaborated in direct proportion to the simplicity of the work. One also notes that not Morris only but nearly all Minimal artists presume that the spectator will bring to their work not only a high degree of aesthetic sophistication, but also a self-conscious awareness of his own sensibility and the pitfalls into which it may lead him. An art which eschews taste nevertheless demands, from those who come to look at it, a keen awareness of what taste is and how it operates. This amounts to saying that Minimal Art is a conspicuously mandarin style.

How does a mandarin style—rarefied and elitist—operate in a democratic society? The answer seems to be that Minimal Art owed a great deal to the increasing institutionalization of Modernism. The point at which it arose, in the mid-Sixties, was certainly also the point at which one began to notice, not indeed for the first time but more acutely, the fact that avant-garde art activity had become almost entirely dependent upon official or semi-official patronage. The more avant-garde he was (granted that stable criteria for vanguard activity could be found), the more confidently the artist looked to the public sector for support.

Happenings and Environments

If Minimal Art seems to represent post-war Modernism at its most elitist—or very nearly so (as we shall see, Conceptual Art has claims to be considered more elitist still)—then the Happenings and other events staged by avant-garde artists can be thought of as an attempt at populism.

One must be careful not to present the cult of the Happening as a movement or style, the equivalent of Pop or Op. Rather, it was a phenomenon connected with a number of art movements. A further and perhaps more serious error is to regard the Happening as the product of the artistic climate that grew up after 1945. Instead, it was a revival of some aspects of the earliest Modernism. Before the First World War, both the Italian and Russian Futurists had staged performances of various kinds. During the war, the Dadaist Cabaret Voltaire in Zurich had been one of the most important manifestations of the spirit of Dada. Later still, the Surrealists had been responsible for various collective demonstrations, which brought what they were trying to do to the attention of the public.

Italian Futurism was the first Modernist movement to abandon the studio and the art gallery for the lecture hall, the theatre, and the street. F. T. Marinetti, the founder of the movement, was a publicist of genius. As early as 1908, he had realized that "articles, poems and polemics were no longer adequate. It was necessary to change methods completely, to go out into the streets, to launch assaults from theatres and to introduce the fisticuff into the artistic battle."

Some amusing accounts survive of the "Futurist evenings" organized by Marinetti and his colleagues. Here, for example, is a glimpse of one such performance in Naples, as described by Marinetti's friend and collaborator Francesco Cangiullo: "Suddenly a storm broke in the orchestra seats, the room was beginning to divide in two: friends and enemies. The latter inveighing against the Futurists in gusts of insult and profanity, fists shaking, faces twisted into masks. The others clapped insanely. '*Viva* Marinetti! ... *Abbasso*! ... *Viva*! ... *Abbasso*! ... Idiots! Cretins! Sons of whores!' The whole was crowned by a rain of vegetables: potatoes, tomatoes, chestnuts ... an homage to Ceres. Finally, in a moment of calm (very relatively speaking), the chief of Futurism began..." (quoted by R. W. Flint, in his introduction to *Marinetti: Selected Writings*, London, 1969, p. 24).

The Russian Futurists, who almost from the beginning kept in close touch with what Marinetti was doing, followed his example by staging performances of their own. The poet V. V. Mayakovsky strolled through the streets of Moscow in a yellow shirt with a wooden spoon stuck in his buttonhole. Other members of the Futurist group had strange signs painted on their faces—one had a urinating dog on his cheek "to show that he had a sense of smell". In the years 1913–14, Mayakovsky, together with his friends the Burliuk brothers and Vassily Kamensky, made a tour of seventeen Russian cities to publicize their ideas. David Burliuk had the words "I—Burliuk" written on his forehead, in the hope of provoking the proper kind of stir.

Yet despite their determination to outrage their audience—one Russian Futurist manifesto, issued in 1912, is actually called "A Slap in the Face of Public Taste"—the Moscow avant-garde found their antics were disconcertingly popular with the local bourgeoisie who were also becoming collectors of their work.

The Zurich Dadaists were equally anxious to provoke and puzzle the public. Hugo Ball, the leader of the group, describes one performance in some detail in his diary. His legs, he tells us, were encased in a tight-fitting cylinder of blue card-

305. Opposite
Edward Kienholz
Roxy's, detail
1960–61; 240 × 540 × 670 cm. (94 × 211 × 261 in.)

306. Overleaf
Claes Oldenburg
Bedroom Ensemble I
1963; 304.8 × 318.2 × 609.6 cm. (119 × 124 × 238 in.)
Darmstadt, Hessiches Landesmuseum; coll. Karl Ströher

board which reached as high as his hips. Above this was a cardboard garment, at once collar and coat, scarlet outside and gold inside, which the performer could flap with his elbows. Ball also wore a tall, cylindrical witch-doctor's hat. Thus attired, he proceeded to recite an "abstract poem" made up of meaningless sounds. After a few moments of puzzlement the audience exploded: "In the midst of the storm Ball stood his ground (in his cardboard costume he could not move anyway) and faced the laughing, applauding crowd of pretty girls and solemn bourgeois, like Savonarola, motionless, fanatical and unmoved" (Hans Richter, *Dada*, London, 1965, p. 42).

When, in the years that immediately followed the war, Dada moved its headquarters to Paris and was eventually transformed into Surrealism, the tradition of performances and events continued. A hostile journalist described an early Max Ernst exhibition as follows: "With characteristic bad taste, the Dadas have now resorted to terrorism. The stage was in the cellar, and all the lights in the shop were out; groans rose from a trap-door. Another joker hidden behind a wardrobe insulted the persons present . . . the Dadas, without ties and wearing white gloves, passed back and forth André Breton chewed up matches, Ribemont-Dessaignes kept screaming 'It's raining on a skull,' Aragon caterwauled. Philippe Soupault played hide-and-seek with Tzara, while Bejamin Péret and Charchoune shook hands every other minute. On the doorstep, Jacques Rigaut counted the automobiles and the pearls of the lady visitors . . ." (Maurice Nadeau, *The History of Surrealism*, New York, 1967, pp. 62–3).

If one looks for common factors in all these early avant-garde manifestations, one finds, sure enough, the qualities that the Italian critic Renato Poggioli declares to be the true indices of avant-gardism—he summarizes them as "activism, antagonism, nihilism, and agonism". But one also finds something else which is perhaps more unexpected. From the very beginning, avant-garde demonstrations owed a great deal to the popular theatre.

To understand why this was so we must again look to Italian Futurism, and, in particular, to the manifesto on "The Variety Theatre" which appeared in 1913. This is one of the most significant of all the Futurist manifestoes. Among the reasons it gives for exalting the variety theatre we find the following: "The authors, actors and technicians of the Variety Theatre have only one reason for existing and triumphing: incessantly to invent new elements of astonishment. Hence the absolute impossibility of arresting or repeating oneself, hence an excited competition of brains and muscles to conquer the various records of agility, speed, force, complication, and elegance."

And we also find: "Today the Variety Theatre is the crucible in which the elements of an emergent new sensibility are seething. Here you find an ironic decomposition of all the worn-out prototypes of the Beautiful, the Grand, the Solemn, the Religious, the Ferocious, the Seductive, and the Terrifying, and also the abstract elaboration of the new prototypes that will succeed these" (*Marinetti: Selected Writings*, edited by F. W. Flint, London, 1969, pp. 116–7).

It is scarcely possible to give, even today, a better description of the aims of the Happening at its most ambitious. The obvious connection between the avant-garde performances of the Sixties and Seventies and the popular entertainments of the time when Modernism began is one of the paradoxes of the history of the avant-garde.

In the period that immediately followed the Second World War, there was, as we have seen, a mood of introversion in the arts that was scarcely propitious to the large-scale "performance" as the Futurists had understood it. Futurism itself, in any case, was in almost total eclipse because of Marinetti's worship of war and violence, and his close association with fascism during the later years of his career.

Nevertheless, the Modernist thirst for self-publicity and the need for direct confrontation with the public remained. In 1950, Georges Mathieu presented a "Night of Poetry" at the Théâtre Sarah Bernhardt in Paris, in the course of which he painted an enormous picture on stage. It took him twenty minutes. The next year the same artist organized a series of "Ceremonies to Commemorate the Second Condemnation of Siger

392

de Brabant". There were four cycles of change—
Cycle sacredotal, Cycle royal, Cycle bourgeois, with
Voltaire, Diderot, and others represented as
hanged men, and a portrait of Descartes to walk
on, and finally a contemporary cycle featuring
Frigidaires and juke-boxes.

Some of the more interesting events of the
period took place in relatively remote locations,
and were symptoms less of the need to attract
attention than of impatience with the condition of
things within the art world itself. In 1952 the
musician John Cage organized an evening at Black
Mountain College, where he then taught. The
audience, seated in four triangular, inward-facing
blocks, was treated to a lecture by Cage himself,
delivered from the top of a ladder, to poems by
Charles Olson, delivered from another ladder, and
to various kinds of music (Robert Rauschenberg
played a wind-up Gramophone). Meanwhile,
dancers moved through the seating spaces.

From the mid-Fifties onwards, the Gutai Group
was active in Japan. Many of the things done by its
members anticipated things which were only to be
done considerably later in Europe. As early as
1955, for example, Kazuo Shiraga was creating
outdoor performance pieces in which his own
body became the medium of expression. In the
Gutai Group we seem to see a fusion of the age-old
Japanese taste for elaborate rituals with the new
tenets of Modernism.

The real rise of the Happening, however, is
connected with the birth of the Pop Art movement
in America. Most of the major Pop Art names
created or took part in Happenings during the
early Sixties, and there were some specialists, such
as Allan Kaprow, who made reputations for this
kind of activity alone.

As has already been noted, there is a connection
between the Pop Happening and the Pop En-
vironment. Keinholz's elaborate *Roxy's* (Plate
305), a Surrealist re-creation of a 1940's brothel,
seems the kind of setting in which a Happening
might take place. The same is true of Oldenburg's
massive *Bedroom Ensemble I* (Plate 306). Environ-
ments did not precede Happenings—the two
developed hand in hand.

Oldenburg's "thematic" show, *The Store,* of

307.
Claes Oldenburg
*Claes paints the work on which he was working on in that period in
the Store*
1962, New York
© 1962 by Robert R. McElroy

308. Opposite above
Jim Dine
Vaudeville Act
1960, New York
© 1960 by Robert R. McElroy

309. Opposite below
Jim Dine
The Smiling Workman
1960, New York
© 1960 by Robert R. McElroy

1961 (Plate 307), provided the artist with a setting which could be used for further activity. The Happening itself, for Oldenburg, is simply a direct extension of the kind of work involved in the creation of *The Store*. It is, he says, "one or another method of using *objects in motion*, and this I take to include people, both in themselves and as agents of object motion". *The Store* therefore led to the creation of *Store Days I*. This took place in three adjacent rooms: *The Bedroom—Jail*; *The Living Room—Funeral Parlor—Whorehouse*; *The Kitchen— Butcher Shop*. There were also three "periods" of action: *A Customer Enters*, *A Bargain*, and *How the Founders Struggled*. Each room had several "stations" related to the various phases of what was taking place. These elaborate subdivisions of place and time were contrasted to the simplicity of the actions themselves.

Jim Dine, too, thought of the visual side of the Happenings he staged as an "extension" of his paintings, but added that "there were other things

310.
Allan Kaprow
Going to the Dump (part of the collective Happening *Gas*)
1966, Springs, Long Island, New York
© 1966 by Peter Moore

involved—since I think on two levels". The point was made again, and more graphically, in *The Smiling Workman*, a brief event staged at the Judson Church in New York in 1960 (Plate 309). Dine himself has described what took place: "I had a flat built. It was a three-panel flat with two sides and one flat. There was a table with three jars of paint and two brushes on it, and the canvas was painted white. I came around it with one light on me. I was all in red with a big, black mouth: all my head and face were red, and I had a red smock on, down to the floor. I painted 'I love what I'm doing' in orange and blue. When I got to 'what I'm doing', it was going very fast, and I picked up one of the jars and drank the paint, and then I poured the other two jars of paint over my head, quickly, and dove, physically, through the canvas. The light went off" (Jim Dine in *Happenings*, by Michael Kirby, New York, 1965, p. 185).

Vaudeville Act (Plate 308), which was the successor to *The Smiling Workman*, has also been described by Dine: "It was all kinds of crazy things: organ music, me talking—it was a collage on tape. I came out with a red suit on and cotton all over me, my face painted yellow. To the music that was going on, I pulled the cotton off and just let it fall to the floor until there was no cotton on me. Then I walked out" (ibid., p. 186). The performance did not conclude with the artist's disappearance. After he had gone, there was a dance of strung cabbages, carrots, lettuces, and celery. Red paint was poured down the flats, and then Dine himself reappeared in a red suit and a straw hat, carrying a cardboard puppet of a nude girl on each

311.
Allan Kaprow
Montauk Bluffs (part of the collective Happening *Gas*)
1966, Montauk, Long Island, New York
© 1966 by Peter Moore

arm, made in such a way that each of his arms became the inner arm of one of the puppets. With these puppets he then did a dance.

Anyone reading this description of *Vaudeville Act* may well be reminded, not only of the Futurist manifesto concerning the variety theatre, which has already been quoted above, but also of accounts of the two Eric Satie ballets *Parade* and *Relâche*. A recent London revival of *Parade*—an apparently faithful reconstitution of the original—showed it to be a startling anticipation of the Happenings of the 1960's, with its roots in the same soil of popular entertainment.

Among the other prominent makers of Happenings in the United States during the 1960's were Red Grooms, Robert Whitman, Allan Kaprow, and Carolee Schneeman. Grooms, whose

Burning Building dates from 1959, and was one of the earliest manifestations of the new interest in performance art in America, has spoken of the influence exercised over his childhood imagination by the big circuses—Ringling Brothers, Barnum & Bailey—which still flourished in those days. He has also declared that "the structure of my performances came from the idea of building a set like an acrobat's apparatus." Here yet again we meet the ideas and images we have encountered elsewhere.

Where Oldenburg, Dine, and Grooms have moved away from the creation of events, Robert Whitman and Allan Kaprow have continued their involvement with this form of visual activity. Whitman offers a contrast to Dine and Oldenburg because his work is a great deal more abstract than

theirs. The thing that interests him is not so much the manipulation of objects as the manipulation of time: "The thing about the theatre that most interests me is that it takes time. Time for me is something material. I like to use it that way. It can be used in the same way as paint or plaster or any other natural material. It can describe other natural events" (Robert Whitman, ibid., p. 134).

Though his Happenings seem more abstract than those of Dine and Oldenburg, they are still intended as "stories of physical experience and realistic, naturalistic descriptions of the physical world". Whitman has made extensive use of film in many of his performance pieces, exploiting the contrast between the action recorded on the celluloid (already one degree removed from the spectator) and the action taking place in his presence. *Cinema Piece* of 1968 makes a direct confrontation between what is real and what is a recording of reality. Here there is a shower with a film of a girl taking a shower projected on to the curtain.

Allan Kaprow has been described, by Adrian Henri in his authoritative book *Environments and Happenings*, as "the central figure in the rise of the happening, and the main authority on the way in which it evolved out of the environment". Kaprow has always had two aspects to his career: on one side an academic one, as a professor of art history; and on the other side involvement as a creative artist, beginning first as an Abstract Expressionist, then becoming, in the mid-Fifties, a maker of *assemblages*. The *assemblages* became increasingly environmental, and from this, in turn, there came a perception that "every visitor to the Environment was part of it".

Though his Happenings arose in such an informal way, they were at first elaborately scripted and conscientiously rehearsed. But Kaprow soon found that he was encountering various difficulties. Actors were useless because they wanted stellar roles, and were in any case self-conscious and awkward. Friends were unreliable. Kaprow decided that on each occasion he would have to make deliberate use of whatever was available, the people as well as the environment. But even this decision brought its own difficulties,

chiefly the lack of rehearsal time when doing a Happening outside New York, with a completely fresh group of amateur performers: "So the next thing was to find a method to do a performance without a rehearsal—to make use of the available people on the spot as quickly as possible. ... So I thought of the simplest situations, the simplest images—the ones having the least complicated mechanics or implications on the surface. Written down on a sheet of paper sent in advance, these actions could be learned by anyone. Those who wished to participate could decide for themselves. Then, when I arrived shortly before the scheduled event, I already had a committed group, and I could then discuss the deeper implications of the Happening with them as well as the details of the performance" (Allan Kaprow, ibid., p. 49).

It was thus purely practical considerations that led Kaprow to shift the emphasis in his performance pieces away from the value derived from them by the spectator, and towards those got from them by the actual participant. What we see in his work is a move towards the concept of the Happening as a therapeutic ritual. This is particularly visible in a piece like *Gas* (1966, Plates 310, 311, and 312), which was carried out at a number of different locations and which therefore, by its very nature, was fully apprensible only to those who took part in it.

Kaprow's work prompts a consideration of the true nature of the Happening, at least as it developed in America. Michael Kirby, author of one of the first textbooks on the subject, proposes the following definition. Happenings, he says, are "a form of theatre in which diverse elements, including non-matrixed performing, are organised in a compartmented structure". By "compartmented structure" he means that the Happening is made up of self-contained units of action, which may or may not take place simultaneously. He suggests a comparison here to the activities in a three-ring circus. "Non-matrixed performing", according to Kirby, means the absence of the matrix of time, place, and character which we get in almost any kind of play.

This definition was proposed in 1965 and seems to fit the work of the artists whom Kirby chooses

400

312.
Allan Kaprow
Southampton Parade (part of the collective Happening *Gas*)
1966, Southampton, Long Island, New York
© 1966 by Peter Moore

313.
Carolee Schneeman
Happening
1966, New York, St. Mark's Church

to discuss—Dine, Oldenburg, Kaprow, Grooms, and Whitman—more than adequately. The interesting thing is that it seems a good deal less adequate to performers whom Kirby has left outside his scope. Even in the work of Carolee Schneeman (Plate 313) there is an element of deliberate bravura, an acceptance and simultaneous defiance of moral as well as theatrical convention which supplies a very definite matrix for what is taking place.

Once Happenings had established themselves as a recognized part of the New York art scene (they rapidly attracted the attention of fashionable and would-be fashionable people, just as the Futurist cabarets had done in pre-Revolutionary Moscow), the performance medium began to develop in different directions. Many of these were inimical to the survival of the Happening itself as a definable art form. The legitimate theatre, against which the artists had staged this effective but anarchic revolt,

was quick to borrow from its critics. The Off-Broadway and especially the Off-Off-Broadway theatre owes an immense amount to the Happening. The stranglehold of narrative was broken, and it became possible for dramatists to communicate with their audiences by means of visual and verbal images which would have seemed impossibly irrational and outré only a few years previously. At the same time there was a renewal of interest in improvisation, and the actors learned to shed the self-consciousness which Allan Kaprow had once found so frustrating.

The Happening also had a marked impact on the dance in America. Avant-garde dance companies, that of Merce Cunningham, for example, had been involved with the movement from the very beginning, but the way of thinking initiated by men like Whitman and Kaprow set them free for bold experimentation. The barrier between the professional and the amateur dancer—far more

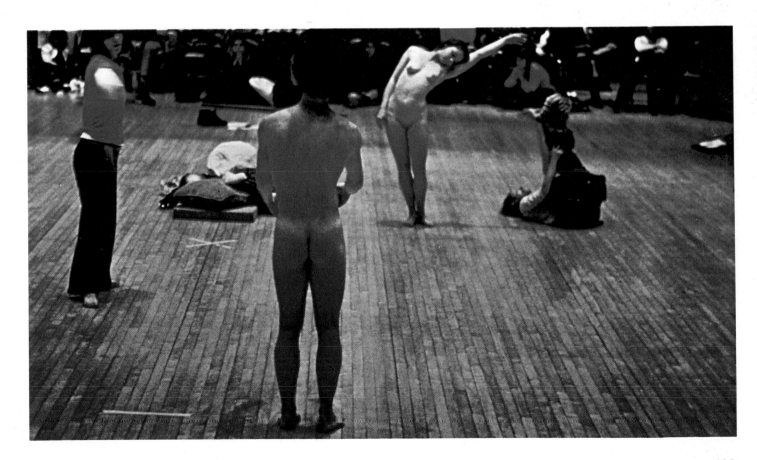

316.
Steve Paxton
Physical Things
1966, from 9 Evenings: Theater and Engineering
New York Armory

317.
Ann Halprin
Paper Dance, 1963
(Photo: Paul Fusco)

rigid than that between the professional and amateur actor—was to some extent at least broken down. Artists, notably Rauschenberg, who in any case had had a long association with Cunningham, could now appear in a dance context without seeming ridiculous (Plate 314). At the same time professional dancers, such as Yvonne Rainer, found themselves freed to do things onstage which they might not otherwise have dared to attempt (Plate 315).

The "Evenings in Art and Technology" which have already been mentioned (Chapter VII) represented a somewhat less reassuring development (Plate 316—Steve Paxton, *Physical Things*). Big business was now willing to put its resources, those of advanced technology and money, at the service of something that had originally represented a revolt against everything that big

business might be supposed to stand for. The main beneficiary was once again the protean Rauschenberg, who was able to absorb the technological experience and use it in works such as *Soundings* (Plate 318). Projects like Stan van der Beek's environmental *Movie Drome* (Plate 319) were also distantly related to the Happening, as indeed were the spectacular light shows favoured by leading rock groups such as the Pink Floyd in the late Sixties.

Missing from the American-bred Happening was the element of confrontation, which had played so large a role in the original Futurist and Dadaist events. When European artists such as Wolf Vostell, or even Japanese ones such as Ay-O, worked in America, their events and performances seemed to be distinguished from the native product by the undercurrent of political and social

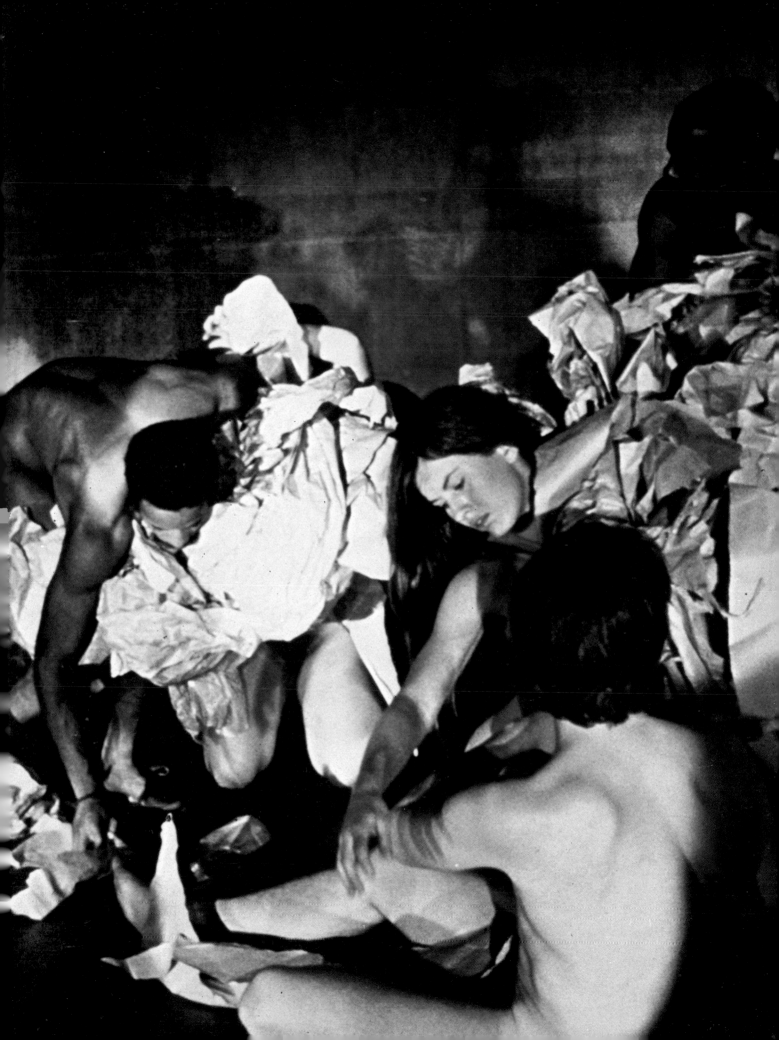

commentary. This made itself felt, for example, in Ay-O's *Kill Paper, Not People*, presented at the Fluxus Paper Concert in New York in 1967 (Plate 320). Vostell's use of what he called "decollage" as a creative principle (Plate 321) was also a symptom of this rather different orientation, though in a more general sense. Vostell has informally defined his way of thinking thus: "What fascinated me was the symptoms and the emanations of a constant metamorphosis in the environment and in artistic expression, in which destruction in general, together with dissolution and juxtaposition, is the strongest element. Dé-coll/age is a production principle which makes use of destruction and autodestruction, in contradistinction to collage, in which mostly undestroyed, although heterogenous, objects are assembled" (Wolf Vostell, from *vor der collage zur assemblage*, Institut für moderne Kunst, Nuremberg, 1968).

A natively American idea of confrontation in the arts had to await the bitter period of the Vietnam War. There was a certain amount of activity of this kind on the West Coast, in San Francisco and Los Angeles. The Los Angeles Provos (whose name was borrowed from a Dutch organization) on one occasion had the idea of collecting unwanted possessions from the Watts ghetto and then distributing them to the pros-

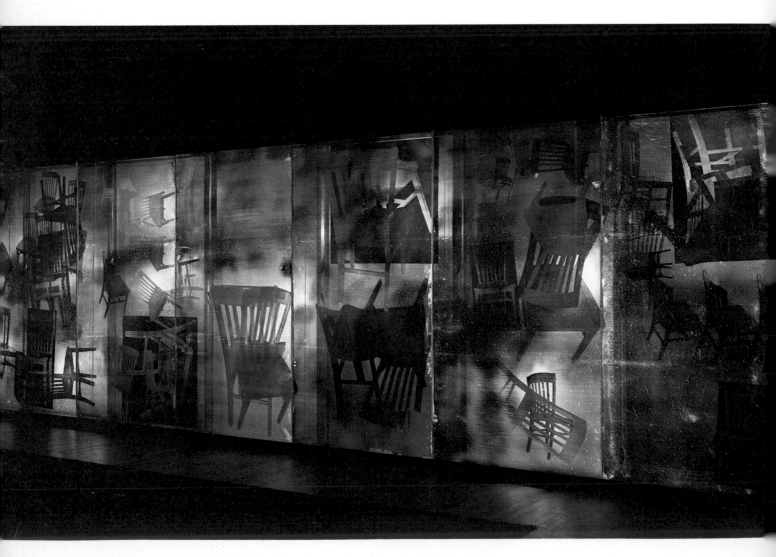

perous suburbs from a decorated truck. In New York, the Art Workers' Coalition was established at a meeting in April, 1969. The militant wing of this formed the Guerrilla Art Action Group. This was involved in a demonstration mounted in front of Picasso's *Guernica* to protest against the Song My massacre. In the course of the demonstration there were readings from the Bible and from reports of the massacre which had been printed in *Life* magazine. Members of GAAG also took part in mounting an exhibition called "The People's Flag Show", in which various artists showed works with the American flag as a common basis. Since the design of the flag is protected by American law, the exhibition was closed by the police, and some of the artists (no doubt to their secret delight) were prosecuted as a result of it.

Events such as this in America were tame compared to the activities of members of the Institute of Direct Art in Vienna. Post-war Austrian society was markedly more conservative than any other free society in Europe. In this sense it provided an equivalent to Marinetti's pre-1914 Italy, and it is fascinating to note how soon Neo-Dada activity made its appearance there. By the mid-Sixties a whole school of artists were making themselves notorious for their acting out of sadistic fantasies. Hermann Nitsch, announcing

his intention (in June, 1962) to "disembowel, tear, and pull to pieces a dead lamb", continued with the claim: "Through my artistic production (a form of the mysticism of being), I take upon myself the apparent negative, unsavoury, perverse, obscene, the passion and the hysteria of the act of sacrifice so that YOU are spared the sullying, shaming descent into the extreme" (Hermann Nitsch, *Orgien Mysterien Theater*, Frankfurt, 1969).

Another artist, Günter Brus, performed what he dubbed a *Scheiss-Aktion* in 1967—this involved an act of ritual public defecation and was filmed. In 1969, a third member of the Viennese group, Otto Mühl, was the principal performer in an event called *Libi*. In the course of this an egg was broken into the vagina of a menstruating girl, who then positioned herself so as to allow the egg to drip into the artist's mouth.

Actions such as these seem designed as a protest, not against any specific form of social evil, but against the humiliation of the human condition. They are the products of Poggioli's nihilism and agonism, rather than of his activism and antagonism.

The extremism of the Viennese group might seem to exclude it permanently from any kind of artistic establishment, but even here the social organism showed an astonishing capacity to absorb just those elements which had been designed to be totally unacceptable to it. The Kassel Documenta of 1972, the premier exhibition of modern art in Europe, contained a section devoted to the work of Günter Brus and another which documented that of Hermann Nitsch. Both

found themselves categorized under the anodyne heading "Individual Mythologies" and seemed to rouse no particular sense of excitement or wonder among the throngs of visitors who came to see the show.

Though the Happening attracted so much attention in America, the roots of the art "event" or "performance" were perhaps deeper in Europe, and one reason why the Viennese artists whom I have just mentioned won a certain degree of acceptance was that their work was perceived as only part of a wide spectrum. The buried moralism of Brus or Nitsch appeared quite openly in events staged by other, chiefly German artists, among them Klaus Rinke (*Masculine, Feminine*, Plates 322 and 323). In Holland, as might have been expected, this mode of expression formed a close link with the "ecological" art of a man like Ger van Elk (Plate 324).

But it was in England during the late Sixties and early Seventies that performance art seemed to enter into a new phase of expression. There were a number of reasons for this. The most important was lack of competition from media like experimental video and experimental film which increasingly occupied the attention of the American avant-garde. The British theatre, too, proved to be far more flexible than its American counterpart; and this meant that in Britain there was not the sharp contrast between Broadway and Off-Broadway which for a long time polarized theatrical energies in New York. By an ironic paradox, this meant that those individuals in Britain who saw themselves as truly "avant-garde" or experimental

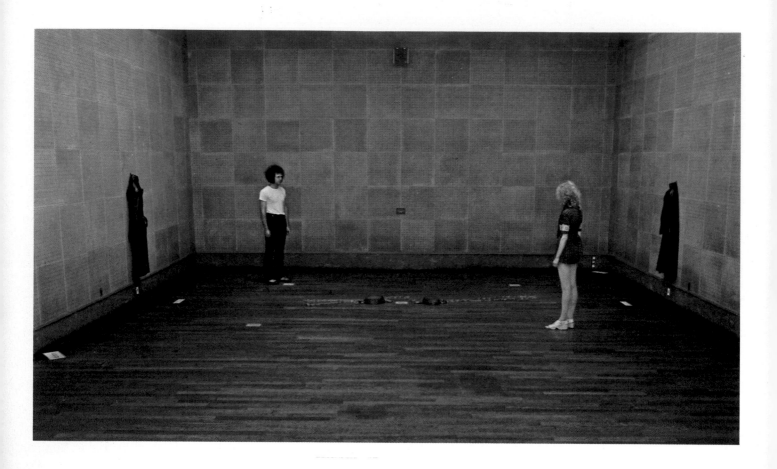

tended to turn their backs on any kind of recognizably theatrical format—at least for a time. I say "at least for a time" because it is clear that the British "event" or "performance" was usually essentially more theatrical than its American counterpart.

Another characteristic of British performance art was its tendency to be at its most flourishing and effective outside London, while the American Happening was, by contrast, a New York phenomenon which subsequently spread elsewhere, chiefly to places like universities and colleges where New York exercised its greatest influence.

The earliest performance events to be put on in England—or at any rate the earliest in the post-war period—were those staged in Liverpool as part of a Merseyside Arts Festival in 1962. The moving spirit was the poet-painter Adrian Henri, who describes them as being "a mixture of poetry,

rock'n'roll, and assemblage" (*Environments and Happenings* by Adrian Henri, New York, 1974). Liverpool is still a regular venue for environmental and mixed-media events, most of them based on the Great Georges Project, a large converted neo-classical church in a socially deprived area of central Liverpool.

Yorkshire, particularly the cities of Leeds and Bradford, was another place where performance art made rapid headway in the 1960's. In Bradford, the focus of energy was provided by Albert Hunt, and by the Complementary Studies Department run by Hunt at the Bradford College of Art. In 1967, for instance, Bradford became the stage for a Hunt-inspired re-creation of the October Revolution in Petrograd, whose fiftieth anniversary fell that year.

The most notable product of Yorkshire, however, was the Welfare State, the largest, most ambitious, and most successful of all British

410

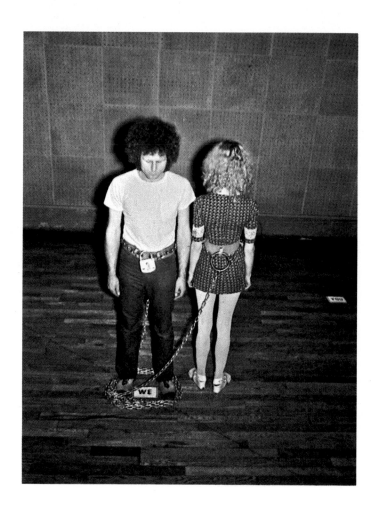

performance groups. This was founded and led by John Fox. There is some argument as to whether the Welfare State's activities can be described as performance art or not. Certainly, group members till recently insisted on describing themselves as "artists" rather than actors, though the Welfare State as an entity is now usually described as an experimental theatre company. Fox and those he gathered around him had a great gift for generating unexpected and memorable poetic images, through techniques which mingled ideas borrowed from traditional music hall with others taken from primitive ritual. A manifesto issued by the group reads in part: "We make art using the traditions of popular theatre such as mummers, circus, fairground, puppets, music-hall, so that as well as being entertaining and funny and apparently familiar in style to the popular audience our work also has a more profound implication. We will react to new stimulus and situations spontaneously and dramatically and continue to fake unbelievable art as a necessary way of offsetting cultural and organic death" (quoted by Adrian Henri, *op. cit.*, p. 119).

Still more in the "popular" or music-hall vein is the work done by the group variously called (according to caprice and circumstances) John Bull's Puncture Repair Kit and the Yorkshire Gnomes. Its activities also owe more than a little to anarchic British radio comedy of the Forties and Fifties, and especially "The Goon Show".

Not all British performance work was in this knockabout vein. Stuart Brisley turns the Happening into an endurance test for performance and audience alike—immersing himself, for example, in a bath in which float animal entrails, or enduring long periods of isolation in a room where nevertheless his every action could be observed. In fact, one of the most interesting aspects to the events done in Britain is their sheer variety, and

325.
Peter Kuttner
Coloured Food Event "Edible Rainbow"
1971; London, Chessington Zoo
By kind permission of the artist

the number of different techniques they have involved. Peter Kuttner (Plate 325) has made a specialty of food, tinted in garishly improbable colours but nevertheless perfectly edible; while Peter Dockley (Plate 326) makes use of wax figures, as well as, in the instance illustrated here, reverting to the science-fiction imagery which has proved so popular with all types of Pop artist.

The effort to disentangle the chief themes and purposes of performance art during the post-war period cannot be an easy one. There is no single simple explanation for the tremendous amount of energy that has been put into this medium of expression since the early Sixties. For some commentators, the art event is primarily a response to an oppressive political climate. It is the confrontation with the established order which is valuable. By this interpretation, the Paris "events" of 1968 were simply a Happening writ large. But

one only has to examine the argument to see how specious it is. As a form of political communication, Happenings, like most other manifestations of Modernism, are almost uniquely inefficient, since formal considerations invariably get in the way of the message to be delivered. The most ambitious Happening delivers less, in terms of effective political propaganda, than a moderately well-attended political rally.

Other commentators see art events and performances as being chiefly valuable as an attempt to democratize the avant-garde, and to make its ideas accessible to a broader spectrum of people, more especially to those who would never dream of setting foot in a museum. The participatory nature of many art events responds, according to this argument, to the desire that people themselves have to take a more active part in culture. An offshoot of the interest in Happenings has been, in

a number of European countries, the so-called community-art movement, which aims to bring the making of art, as well as its appreciation, down to local grass-roots level. It is sad to have to point out first that what makes the street performance popular is generally its most traditional and nostalgic elements—knockabout physical comedy, clowns, and circus tricks; and secondly that the community-art movement has involved, for better or worse, a concerted attack on the notion of artistic standards, on the grounds that they are both obstructive and undemocratic. Modernism has consistently sought not to abolish standards of judgment, but to change them, and if the community-art movement succeeded on a large scale, the avant-garde as we now recognize it would certainly be the first victim.

A third way of looking at Happenings is to see them as rituals—as having a therapeutic function for the performers and also, to a lesser extent, for the spectators. There is certainly a powerful argument for regarding much modern art as a

substitute for religion in a now-secularized society. Freud foresaw that art would have to fulfil this function, and discusses his insight in *Civilization and Its Discontents*.

But is the therapy as effective as the supporters of the avant-garde would like to assume? Udo Kultermann, in his recent book *Art-Events and Happenings*, compares the makers of events to the traditional shaman: "The shaman does not produce objects, although he is usually an artist in primitive communities, and he acts like an artist by renouncing the self and by bringing a sacrifice for society. In that he is himself engaged, he activates healing forms of behaviour in others. Seen in this light, the Happening is the consequence and expression of modern shamanism" (Udo Kultermann, *Art-Events and Happenings*, London, 1971, p. 12).

The objection to this is that it takes the will for the deed. There is no evidence that the rituals devised by modern artists have elicited any deep sense of commitment from the mass. Indeed, when mass audiences occasionally come in contact with activities of this sort, they greet them with the detached, mildly ironic curiosity evoked by the more trivial kind of news event.

The Happening is at its most effective when it fulfils the traditional function of the Renaissance "triumph" or the baroque pageant. Not surprisingly, it is Japanese groups and artists who have shown the acutest sense of this, often in works which show the traditional Oriental impulse towards unity with nature. Yukihisa Isobe's hot-air balloon (Plate 327), shown at the seventh annual New York Avant-Garde Festival, was no more avant-garde than the brothers Montgolfier—indeed, a good deal less so, given the strides made by technology in the course of two hundred years. But it still had the power to delight. The *Event for the Image-Change of Snow* (Plate 328), put on by the GUN group in Japan, provided a pictorial image worthy of a Hiroshige or a Hokusai.

Earth Art and Concept Art

Since the rise of Minimal Art there has been no absolutely dominant art style or movement—nothing which, as Pop Art did, seemed to bring everything into relationship with itself, whether through the influence that it exercised or by the opposition it aroused. On the other hand, it is possible to trace a line of development, with the attitudes embodied in Minimalism as its source. Art manifestations which seem superficially very different from one another turn out to have hidden intellectual links.

In the case of what came to be called Earth Art, the connections with Minimal sculpture are not hidden but obvious, and often the same artists were involved with both forms of expression. The cult of anti-form, initiated by Robert Morris, led to experimentation with all kinds of materials. Rafael Ferrer's *Hay, Grease, Steel* (Plate 330), shown at the Whitney Museum in 1969, is only a brief step away from Morris's soft sculptures on the one hand, and one or two of Christo's more ambitious environmental pieces upon the other (*Wrapped Floor*, 1970, Plate 329). But even anti-form, for some artists, was not enough. They wanted a direct confrontation with "outside" reality. One way of achieving this was to bring the outside, as literal earth and stones, into the art gallery. This was what Robert Smithson did with his *Sandstone with Mirror* (1969, Plate 331).

It was more logical, however, to remove the art work from the gallery altogether, and to create it through intervention in the natural environment. Smithson's *Spiral Jetty*, in Great Salt Lake, Utah (Plate 332), has become, in the handful of years since its creation, perhaps the best-known single example of Earth Art.

Like many apparently simplistic recent art works, *Spiral Jetty* has been the focus for complex explanations: "The very form of the work, a spiral, is an open one, which, in terms of Gestalt, is impossible to grasp without accepting the notion of the infinite. Contrary to all the Minimal artists who have been preoccupied with cubic volumes, which have a 'closed' Gestalt, Smithson has always preferred volumes that imply a geometric progression" (Grégoire Müller, *The New Avant-Garde*, London, 1972, p. 17).

But an approach through Gestalt psychology was not the only possible one, according to Smithson's commentators and critics. For example, there were the physical properties of the Great Salt Lake itself—the high density of salt which gives the water a reddish colour and which promotes crystallization on the edges of the work. There were also legendary associations—one legend claims that the lake was once connected with the ocean, another that it contained a dangerous whirlpool (of which the *Spiral Jetty* became the symbol). Created at a time when "underground" culture was taking a passionate interest in the possible esoteric meanings of prehistoric monuments, most notably barrows, earthworks, and turf figures, Smithson's piece could also be regarded as an effort to re-create and rival prehistory.

One of the most important things about *Spiral Jetty*, however, was its inaccessibility. Sited in a sparsely inhabited tract of country, it could only be fully apprehended from the air. For most of the people who theorized about it, it could only be known through photographic and other documentation. The "reality" of the piece thus, by a paradox, existed chiefly at one remove from the spectator.

Michael Heizer, who at one stage collaborated with Smithson, takes the process of abstraction even further. His *Displaced, Replaced Mass* at Silver Springs, Nevada (Plates 334 and 333), is in fact one of the more conventional of his works, because it seems at least to propose a formal equation. *Double

Negative, another example, is notable not so much for its form as for the enormous mass of material that had to be removed in order to make it—no less than 240,000 tons of earth and rock. Its form was determined by the nature and conformation of the ground, at least as much as it was by the artist's intentions. *Double Negative* was nevertheless the subject of a massive documentary effort on the part of its creator. He took over a thousand photographs of the piece, at right angles and from an equal distance, in order to overcome the effects of perspective distortion. These images, when brought together, preserved the "true" form of the piece.

Neither Smithson nor Heizer is as indifferent to the final embodiment of their ideas as Douglas Huebler (Plate 335). A catalogue statement issued by this artist reads as follows: "The existence of each sculpture is documented by its documentation.

329. Below
Christo (Christo Jaracheff)
Wrapped Floor
1970; 1240 sq. m. (1476 sq. yd.)

330. Right
Rafael Ferrer
Hay, Grease, Steel
1969
New York, Whitney Museum of American Art

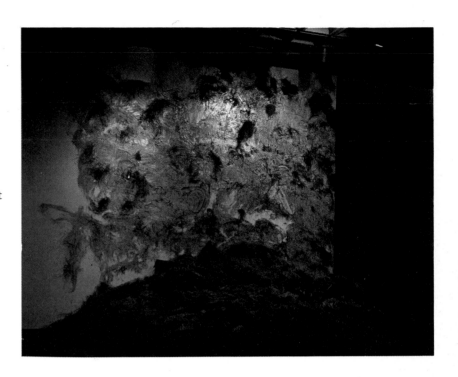

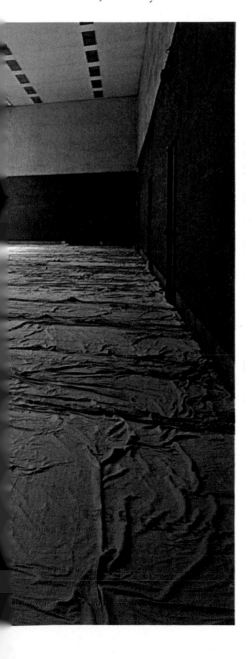

"The documentation takes the form of photographs, maps, drawings and descriptive language.

"The marker 'material' and the shape described by the location of the markers have no special significance, other than to demark the limits of the piece.

"The permanence and destiny of the markers have no special significance.

"The duration pieces exist only in the documentation of the marker's destiny within a selected period of time.

"The proposed projects do not differ from the other pieces as idea, but do differ to the extent of their material substance" (catalogue of the exhibition "Douglas Huebler", at the Seth Siegelaub Gallery, New York, November, 1968).

Here the importance of the original concept, as well as that of the documentation in support of the concept, seems to be far more important than the actual physical embodiment of the work. Huebler says that none of his works can be experienced as physical presence, and that he attaches no significance to the sites of his pieces: "When I go to the site to document it—to 'mark' it—I think 'here it is' and that's all. As a matter of fact I

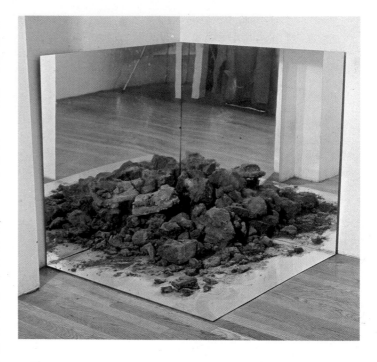

consider it important that it is no different from the next ten feet or next block or whatever. Both the sites selected and the shape that they describe are 'neutral' and only function to form 'that' work" (Douglas Huebler, interviewed by Arthur Rose, in *Idea Art*, a critical anthology edited by Gregory Battcock, New York, 1973, pp. 143–4).

Huebler's work is a reminder of the fact that Earth Art does not necessarily involve the transportation from one place to another of many tons of earth and rock. To mark the site in one way or another may be enough to create the piece.

Other artists working with variants of Huebler's ideas tend to be more romantic than he is. In fact, it is surprising to discover in them what looks like a survival of early nineteenth-century attitudes towards nature. Walter de Maria's *Las Vegas Piece* (Plate 337) is a mile-long line drawn in the Nevada desert. De Maria's original idea with pieces of this kind was that any photographic reproduction of them would be forbidden, so that the spectator, in order to experience them, would actually have to go out into the wastelands where they were situated. Dennis Oppenheim's *Branded Mountain* (Plate 338) evokes the world of cattle kings and cattle rustlers, in fact the whole of the American cowboy myth—since the brand is an enlargement of the kind of brand used to indicate the ownership of cattle. Oppenheim has also created examples of Earth Art by interfering with the pattern of growth in crops (Plate 339) and by cutting curving channels in the ice of a frozen lake.

Earth Art occasionally made its appearance in an urban context, for instance with Serra's *To Encircle: Base Plate (Hexagram)* (Plate 340), with its fashionable reference to the *I Ching*, but here the idea is not so much to identify with the context as to contrast simple elements of order or disorder— the circle is an "area of order", the *I Ching*'s symbols are arrived at by the random tossing of yarrow stalks or coins.

Essentially, however, Earth artists seem to have intended a reaffirmation of oneness with nature and natural forces. This impulse makes itself especially conspicuous in the work of two English practitioners of the genre, Richard Long and Hamish Fulton. Richard Long has clearly been influenced by Bronze Age earthworks, such as the impressive mound of unknown origin and purpose at Silbury Hill in Wiltshire, and both he and Fulton document their work with conspicuously romantic photographs. On the other hand there is also an element (which we also recognize in men like J. M. W. Turner and Lord Byron) of the desire to pit oneself against one's surroundings. The artist, for example, sets himself to accomplish a trek of a given distance in a given number of days or hours. Earth Art thus becomes linked to performance art, and to the widespread notion that ritualized behaviour, rather than the actual production of objects, now forms the most important part of the avant-garde artist's activity.

Earth Art can involve co-operation with natural processes as well as the wilful alteration or even contradiction of nature. One sees this contradiction in simple guise in Wolf Kahlen's *Baum-Raumsegment* (Plate 341), where a tree is partially sprayed with paint. Earth Art seems to move into another category, however, when the emphasis shifts to documentation and process. At this point we seem to cross a frontier and to be exploring a different category: the phenomenon that critics have called Conceptual or Concept Art.

332.
Robert Smithson
Spiral Jetty
1970, Great Salt Lake, Utah
By kind permission of the artist

One artist who often seems to exist on the borderline between the two is the Dutchman Jan Dibbets (Plate 342). He uses a wide range of different media—maps, the mail, photography, tape recordings, and videotape—but is perhaps best known for his "perspective corrections". These are photographs of landscape in which the camera has been manipulated to produce an alternative image to the true one. For example, Dibbets uses the camera to build mountains out of the flat lands of his native Holland.

Dibbets clearly regards the way of thinking, the method of approach, as being far more important than the actual subject-matter: "I really believe [he says] in having projects which in fact can't be carried out, or which are so simple that anyone could work them out. I once made four spots on the map of Holland, without knowing where they were. Then I found out how to get there and went to the place and took a snapshot. Quite stupid. Anyone can do that" (quoted in Ursula Meyer, *Conceptual Art*, New York, 1972, p. 121).

One of the paradoxes of Concept Art is that it can embody itself in almost any form the artist chooses to adopt. Thus there is a strongly conceptual element in the work of Tom Phillips,

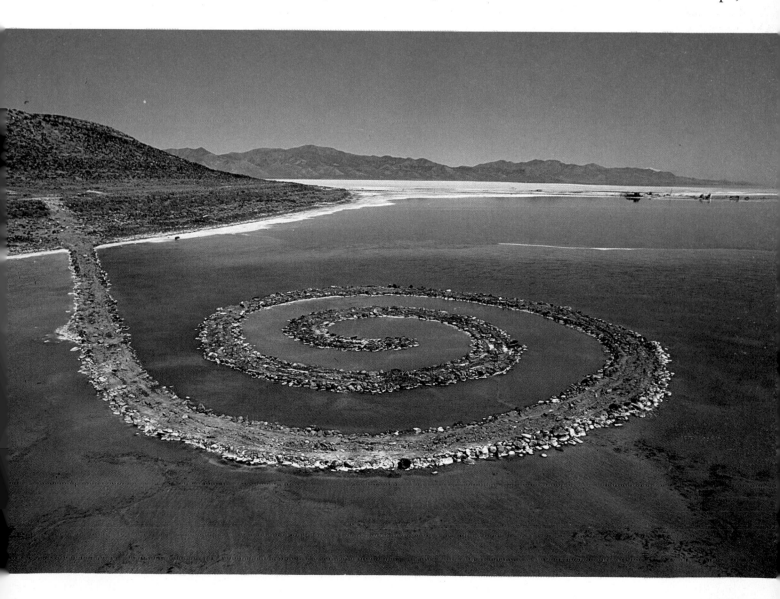

333 and 334.
Michael Heizer
Displaced, Replaced Mass
1969, Silver Springs, Nevada
New York, coll. Robert C. Scull
By kind permission of the artist

335. Overleaf
Michael Heizer
Double Negative
1969–70; 9 × 15 × 450 m. (30 × 49 × 1478 ft.)
Nevada, Mormon Mesa, coll. Virginia Dawn
By kind permission of the artist

even though it is embodied in a relatively conventional format, in paint on canvas. The painting *Benches* (Plate 344) is a good example of his method of work.

It began with the chance purchase of a postcard at a railway station. The image, which showed people sitting on a bench, had a strong connection with mortality in the artist's mind because of a childhood recollection. This connection gave the

main "subject" of the work. There are also connections with T. S. Eliot's *The Waste Land*, Dante's *Inferno*, and the Brahms *Requiem*—the artist and his wife sang in the choir when a recording of this work was made by Otto Klemperer. In addition to this, the vertical intervals in the work were determined by means of random coin-tossing procedures, and the conspicuous striped areas form a "colour-catalogue"

336. Above
Douglas Huebler
Location Piece No. 13
1969, in the desert twenty miles from Mojave, California
(Photo: Frederic Tuten)

337. Below
Walter de Maria
Las Vegas Piece
1969, in the desert of southern Nevada
By kind permission of the artist

338.
Dennis Oppenheim
Branded Mountain
1969; 9.2 m. (30 ft.); San Pablo, California
By kind permission of the Sonnabend Gallery,
New York, Paris

of all the hues employed. The artist remarks: "A curious chicken/egg state of affairs subsisted in this picture and others with regard to the relation of stripes to image. The image generates the colours to fill the stripes; the stripes condition the procedure of painting the image" (Tom Phillips, *Works. Texts. To 1974*, Stuttgart, London, Reykjavik, 1975, p. 145).

Phillips perhaps differs from other artists in the conceptual field not so much because he sticks to a traditional means of expression—paint on canvas—but because he still clings to a humanist view of the artist's function: "What I most want the picture to do is what art has always done, to help people see the world; art continues as its main function (perhaps even more emphatically in the 20th century or with justified urgency) to lead people to see more of the world, more in the world; the natural and the man made; the spaces even that lie between things in the world, 'the

339.
Dennis Oppenheim
Surface Indentation
1968; 15.3 m. (50 ft.); Hamburg
By kind permission of the Sonnabend Gallery,
New York, Paris

atomic facts' (Wittgenstein) one by one.

"From this picture people may look at post-cards (and back to things), may look at benches, may examine the actions they perform and the ritual places of these actions and come to view them as metaphors" (ibid.).

One thing, nevertheless, that makes it appropriate to include *Benches* in a discussion of Concept Art is the heavy reliance upon inscriptions in addition to the images.

Though Concept Art stems very largely, as we have seen, from ideas that first took shape with the rise of Minimal sculpture, it also has an important link with Pop, since Pop was the first art movement to give such prominence to the inscription or incorporated caption. This habit derived in part from the advertisements and comic strips which Pop artists used as their raw material, and in part from the employment of letters and numerals by Jasper Johns.

With Pop Art, however, the word was still relatively subordinate—at any rate, it was not the whole of the work. With Shusaku Arakawa's *Look at It* (Plate 345) we reach a rather different situation. Here the verbal content of the painted diagram dominates the rest. Moreover, the work itself is about the correspondence, or lack of it, between what we see, how we see it, and how we verbalize our experience of what we have seen. The point is more brutally and less ambiguously put in Mel Bochner's *Language Is Not Transparent* (Plate 346), though here the hand-drawn lettering and the dripping of the background paint still keep us within touching distance of the physical world inhabited by Abstract Expressionist painting.

When we arrive at a work such as Joseph Kosuth's *Neon Electrical Light English Glass Letters* (Plate 347), it is reasonable to say that we have come to a point where the intellectual input is more important than any message the senses may happen to receive. Kosuth's piece is a tautology: it announces what it is, it is what it announces. The same is just as true, and perhaps truer, of Pier Paolo Calzolari's *Zero* (Plate 348), Stephen Kaltenbach's *Art Works* (Plate 268) and Alighiero Boetti's *Oro Longchamp 2 234 2288* (Plate 350). In varying degrees, and with a variable tone of irony,

they are all three of them statements of the self-evident.

Kosuth is one of the best informed, philosophically, of the artists working in his field, and his views may be regarded as authoritative. For him Conceptual Art is "An enquiry by artists that understand that artistic activity is not solely limited to the framing of art propositions, but further, the investigation of the function, meaning and use of any, and all (art) propositions, and their consideration within the concept of the general term 'art', and as well, that an artist's dependence on the critic or writer on art to cultivate the conceptual implications of his art propositions and argue their explication, is either intellectual irresponsibility or the naivest kind of mysticism" (Joseph Kosuth, in the catalogue of the "Information" exhibition, Museum of Modern Art, New York, 1970).

This amounts to saying that the critic, even in the role of auxiliary moralist (which is that claimed for him by Michael Fried), is now entirely superfluous. In another context, Kosuth has claimed that "The validity of artistic propositions

429

340.
Richard Serra
To Encircle: Base Plate (Hexagram)
1970; 7.9 m. (26 ft.)
Bronx, Webster Avenue and 183rd Street, New York

is not dependent on any empirical, much less any aesthetic, presupposition about the nature of things. For the artist, as an analyst, is not directly concerned with the physical properties of things. He is concerned only with the way (1) in which art is capable of conceptual growth and (2) how his propositions are capable of logically following that growth. In other words, the propositions of art are not factual, but linguistic in *character*—that is, they do not describe the behaviour of physical, or even mental objects; they express definitions of art, or the formal consequences of definitions of art" (Joseph Kosuth, "Art After Philosophy", in Ursula Meyer, *Conceptual Art*, p. 165).

A comment made by the veteran critic Harold Rosenberg arguably provides an appropriate marginal note to this particular declaration: "To qualify as a member of the art public, an individual must be tuned to the appropriate verbal reverberation of objects in art galleries, and his

341.
Wolf Kahlen
Baum-Raumsegment
1970, Monschau
By kind permission of the artist

receptive mechanism must be constantly adjusted to oscillate to new vocabularies" (Harold Rosenberg, "Art and Words", in *Idea Art*, edited by Gregory Battcock, New York, 1973, pp. 153–4).

As it happens, the examples of Concept Art that have already been mentioned are by no means the "purest" available. For Mario Merz, various mathematical demonstrations and propositions can be art—for example, *610 Functions of 15* (Plate 351). Merz has spent a number of years exploring the possibilities of the Fibonacci series, discovered by a monk of the same name during the Middle Ages. This series is a progression obtained by adding 1 to 2, 2 to 3, 3 to 5, 5 to 8, and so on. Reduced to geometrical terms, the series defines a perfect spiral—precisely defined and yet open.

Hans Haacke, a German artist who lives in the United States, has interested himself in systems both inorganic and organic (Plate 352, *Chickens Hatching*), and he has also interested himself in social and political phenomena. In 1970, he conducted a poll of visitors to the Museum of Modern Art in New York, concerning the attitude taken by the then governor of New York, Nelson Rockefeller, towards the war in Vietnam (Plate 353).

More neutral presentations of research as art are the projects undertaken by the husband-and-wife team Bernhard and Hilde Becher, who make photographic documentations of items of anonymous industrial architecture, such as watertowers (Plates 354 and 355).

Finally, there are Concept Art "pieces" which consist of statements only, in which the movements of the mind alone constitute the "art" experience. The following, by Donald Burgy, may serve as an example:

"*Name Idea No. 1*

"Observe something as it changes in time. Record its names.

"Observe something as it changes in scale. Record its names.

"Observe something as it changes in hierarchy. Record its names.

342.
Jan Dibbets
The Perspective Correction: Horizontal, Vertical, Cross
1968; 120 × 120 cm. (47 × 47 in.)

343. Opposite
Jan Dibbets
Panorama with Mountain, Sea II A
London, Tate Gallery

BENCHES.1.BATTERSEA PK
FOR ALL FLESH IS AS GRASS. THE GRASS WITHERETH

II.MEANWHILE ON THE
ENS. HARROGATE. THE
GARDENS. BOURNEMO
E REST GARDENS. 'FIS
UPNET PT. 3005. IN CE
OUTH. PGC.CO.C24.3.S.2
BRIGHTON. LANSDOWN
IN THE PARC. CEFN O

434

344.
Tom Phillips
Benches
London, Tate Gallery (Photo: John Webb)

345.
Shusaku Arakawa
Look at It
1968; 91 × 122 cm. (35 × 48 in.)
Tokyo, Minami Gallery

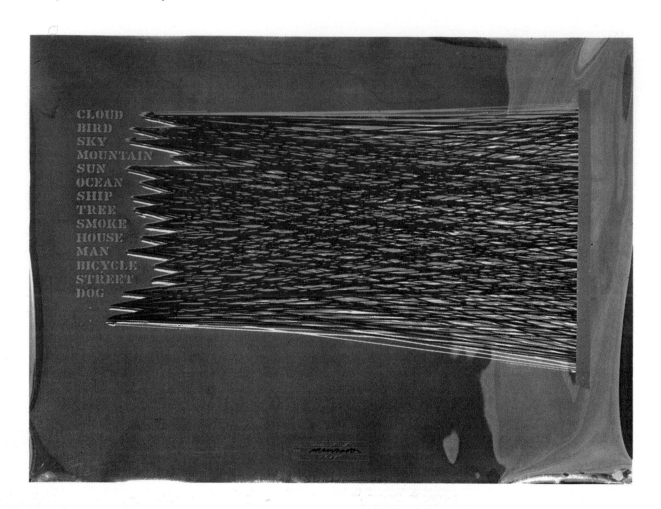

"Observe something as it changes in differentiation. Record its names.

"Observe something as it changes under different emotions. Record its names.

"Observe something as it changes in different languages. Record its names.

"Observe something which never changes. Record its names.

"September, 1969" (from Ursula Meyer, *Conceptual Art*, New York, 1972, p. 90).

The apparent impersonality of Concept Art does, nevertheless, conceal a paradox which is not as apparent as it might be from the instances which have so far been given. This paradox is related to the way in which Concept focuses upon the person and personality of the artist. If the art work as such is abolished, then attention turns to the person who, despite this, claims to possess or embody the notion of art.

In one way this is an intensification of something that has already been going on for a long time. Abstract Expressionism asked the spectator to focus his intention upon the psyche of the artist, which was reflected in the turbulent swirls of paint. The act of painting the picture—the processes whereby it came about—was thus of equal interest to the finished result, or perhaps even more interesting. Increasingly, during the years that followed, art came to be thought of as being essentially a record of its own making. The work of Tom Phillips, discussed in this chapter, is an excellent example of so-called process art, in which one of the main aims of the artist is to supply, actually within what has been done, a full history of the work from its inception to its completion.

When the artist enacts rituals rather than creating objects, logically the process of making

436

346.
Mel Bochner
Language Is Not Transparent
1970; 195.6 × 127 cm. (76 × 50 in.)
New York, by kind permission of the Dwan Gallery

347. Below
Joseph Kosuth
Neon Electrical Light English Glass Letters
1966
Varese, coll. G. Panza di Biumo

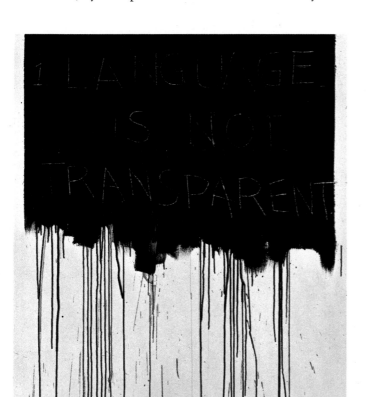

art manifests itself directly in, as well as through, him. An almost ludicrously simple example of what I mean can be found in some of the activities of Dennis Oppenheim. Oppenheim's *Reading Position for a Second Degree Burn* demonstrates how the artist deliberately inflicted a bad sunburn upon himself (Plate 356). The open book used to protect the unburnt area of skin is significantly entitled *Tactics.* Oppenheim says that, for him, what is now labelled Body Art arose directly from his involvement with Earth Art: "My concern for the Body came from constant physical contact with large bodies of land. This demands an echo from the artist's body. Now I'm doing microscopic slides of skin tissue: the focus is becoming more and more intimate. It fascinates me how the body changes under different stimuli and pressures" (Dennis Oppenheim, quoted by Douglas Davis in *Newsweek*, May 25, 1970).

Another artist associated with Body Art is Bruce Nauman. His *Bound To Fail* (Plate 357) is an exemplification of a statement of intent made in a leading art magazine: "Examination of physical or psychological response to simple or even oversimplified situations which can yield clearly experienceable phenomena" (Bruce Nauman,

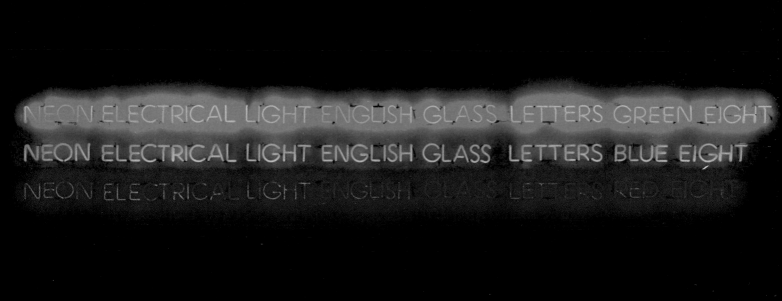

348.
Pier Paolo Calzolari
Zero
1970
Paris, by kind permission of the Sonnabend Gallery
New York, Paris

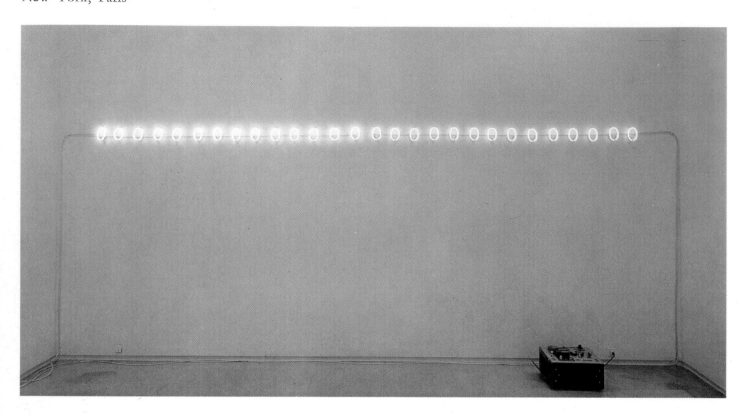

349. Below left
Stephen James Kaltenbach
Art Works
1968; by kind permission of the artist

350. Right
Alighiero Boetti
Oro Longchamp 2 234 2288
1967–70; 72 × 72 cm. (28 × 28 in.)
Rome, by kind permission of the Galleria Sperone

Mario Merz
610 functions of 15
1971; 345 × 157 × 57 cm. (135 × 61 × 22 in.)
New York, John Weber Gallery

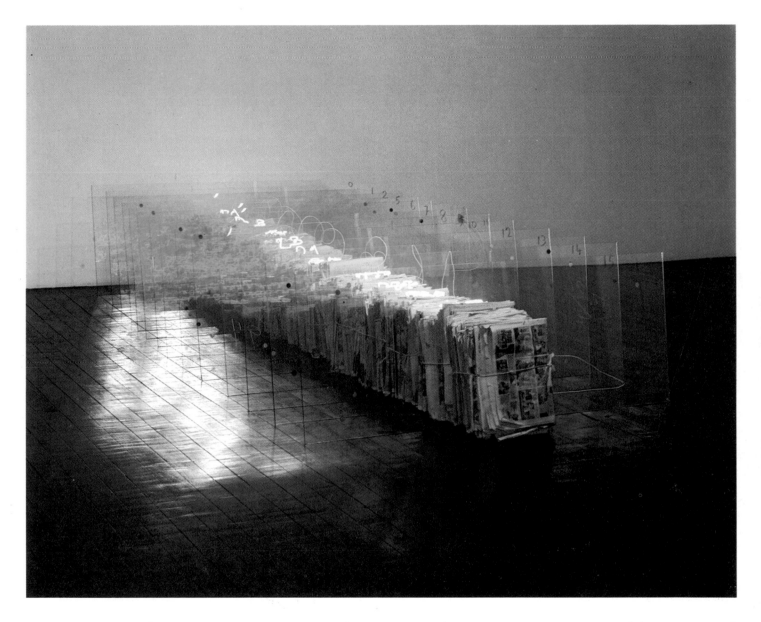

"Notes and Projects", *Artforum*, December, 1970).

It has been said of Nauman that his true originality lies not in the invention of one language but of various languages, that he is interested in all the different and overlapping ways in which a given thing can be expressed: "Being 'invented', these forms of language are the result of an 'unconscious choice'. They are exclusive of other forms of language and might be adequate only in one kind of environment. By slightly altering this environment, Nauman makes evident the inadequacies of our forms of language and forces us to find new systems of relationships with a changing reality" (Grégoire Müller, *The New Avant-Garde*, London, 1972, p. 22).

In the light of this interpretation, *Bound to Fail* might be said to be "about" the gap between the three words which form the title and what is shown in the picture.

There is obviously a close connection between Body Art and the Happening. Some of Stuart Brisley's "actions" might be interpreted as belonging simultaneously to both categories. But

other questions also arise. One of the most interesting of these is "What happens when the artist insists on being continuously not only an artist, but actually art?" Some members of the avant-garde wish us to think of every detail of their existence as being part of a continuously evolving work. Perhaps the best instances of this are the two Englishmen Gilbert & George.

Gilbert & George operate through an organization called Art for All. Much of their material goes out through the mail. A typical specimen of one of their cards is *A Sculpture Sample Entitled Sculptors' Samples* (Plate 358). The artists send physical mementos of themselves—hair, clothing, food—and give us to understand that this is "sculpture" and also a series of excerpts from a larger and more complex work: Gilbert & George themselves, continuing their quotidian existence. The boundary between art and life has been summarily abolished.

For this reason one cannot speak of Gilbert & George as artists who fit into any particular category—all categories have been rendered

nonexistent by their basic aesthetic premise. At one moment they are performers, miming to a record of the music-hall song "Underneath the Arches". At another they are painters in the most thoroughly conventional and Victorian way, with a series of self-portraits of themselves in sylvan settings, entitled *Ourselves in the Nature*. At yet another they are making videotapes, or are happy to allow some aspect of their daily existence to be recorded by a camera. As far as the artists are concerned, all of these, however diverse they may seem, are still "sculpture" (Plates 359 and 360). It shows how far the meaning of the word has now been stretched.

If Gilbert & George have attained not only considerable reputations within the avant-garde but even a certain celebrity outside it, it is probably because they inject an element of sly humour into almost everything they do. This makes them acceptable as the successors of the Pop artists who flourished in the Sixties. In particular, they seem to have inherited Hockney's mantle of glamour, his ability to associate with the fashionable world

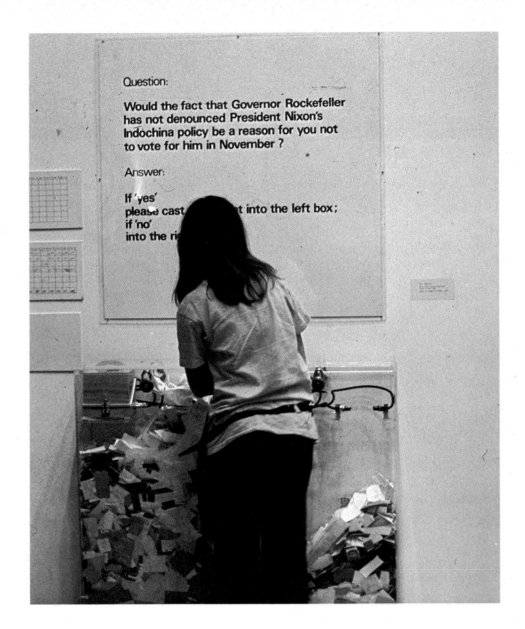

without being contaminated by it.

Joseph Beuys, who has built up an even more powerful legend than that of Gilbert & George, is an artist in deadly earnest. Beuys has been around for a considerable time. His first exhibition was held in 1953 in Wuppertal, Germany, at the Museum von der Heydt. But it was not until the middle Sixties that he began to excite widespread curiosity. At this time he was making *assemblages* (Plate 361, *Chair with Fat*, 1964) and creating environments (Plates 362 and 363, *Room Sculpture*, 1968), which seemed more "radical" than anything being done by other artists. One element which fascinated spectators was the use of apparently inappropriate materials for symbolic purposes. *Chair with Fat* belongs to a series which Beuys dubbed *Fat Corners*, which combined, in his own interpretation, the energy of fat with the

regularity and order of the right-angled corner.

Beuys's reputation was really cemented, however, by the effect he made in performance pieces. One of the most celebrated of these was his *How To Explain Paintings to a Dead Hare* (Düsseldorf, 1965). Another "action", which exists on film, was *Eurasienstab*. In this we see Beuys apparently alone in a room, in which there are a number of boards covered with felt, a metal pole, and some margarine. The artist dons a pair of metal shoes, which seem to anchor him to the ground, and which make his subsequent tasks more difficult, then proceeds to take one board after another and build with them a kind of enclosure. Within this "sacred" space Beuys performs a kind of foundation rite, transforming chaos into cosmos, which he completes by pointing the curved end of the metal pole—the *Eurasienstab* itself—from left

354.
Bernhard and Hilde Becher
Pitheads
1971
Property of the artists

355. Opposite
Bernhard and Hilde Becher
Pitheads
1972–73
London, Nigel Greenwood Inc.

to right, west to east, that is, towards the direction from which the experience of initiation comes. Meanwhile, the margarine, which first appears in an unformed state, gradually becomes a triangular block.

Beuys has a powerful personality and has impressed nearly all those with whom he has come in contact. It has been said of him that he is "an actor with a mask which reminds us of the faces of certain actors in the silent movies, above all the impassioned, secretly pathetic mask of Buster Keaton". But it was not until he began to close the distance between the performer and the everyday persona that he achieved a fame which no other post-war German artist had enjoyed. What happened was that he became a teacher and a politician who asserted that teaching and politics were now to be considered his means of artistic expression.

443

Gradually he abandoned the idea of performing at all, in favour of appearances in which he explained his ideas directly to the public and answered any questions that those who were present might care to put to him. The connection with art was usually that these confrontations took place in art galleries—Beuys conducted a daylong seminar at the Tate, and was given an office at the Kassel Documenta. However, he also opened a shop-front office in Düsseldorf, the city where he was employed as a professor at the Düsseldorf Kunstakademie, in an effort to reach the kind of public that would not normally visit an art exhibition or a museum.

The message that Beuys preaches on these occasions can be summed up in the following quotation from an interview: "Even though sociology is a science of man, even though it cannot come into existence without the help of what is schematically called science, nonetheless, because of a series of positivistic hestitations, it assumes a polemical attitude with respect to art: art has no value, has no social purpose, is useless, is in no way a means of revolution, only science can

444

356. Opposite
Dennis Oppenheim
Reading Position for a Second Degree Burn
1970; by kind permission of the Sonnabend Gallery,
New York; Paris

357.
Bruce Nauman
Bound To Fail
1967–70
New York, Leo Castelli Gallery

A SCULPTURE SAMPLE
ENTITLED
SCULPTORS' SAMPLES

1. *G & G's make-up.*

2. *G & G's tobacco and ash.*

3. *G & G's hair.*

4. *G & G's coat and shirt.*

5. *G & G's breakfast.*

*Gilbert and George have a wide range
of sculptures for you—singing sculpture,
interview sculpture, dancing sculpture,
meal sculpture, walking sculpture,
nerve sculpture, cafe sculpture, and
philosophy sculpture.*

So do contact us

George and Gilbert

'ART FOR ALL'
12 FOURNIER STREET
LONDON, E.1

Telephone 01 - 247 0161

be revolutionary. But from where I stand, I affirm that only art can be revolutionary, and especially so when one manages to liberate the concept of art from its traditional technical meanings by passing from the zone of art to anti-art, to the gesture and to the action, in order to put it at man's complete disposition. Which is to say ART = LIFE, ART = MAN. The only revolutionary means is a global concept of art that also gives birth to a new concept of science" (*A Score by Joseph Beuys: We Are the Revolution*, Naples, 1971).

It can be seen from this that Beuys makes very large claims for art—provided that we are prepared to accept his definition of what art is. In fact, the extra dimension added to Beuys's utterances by his own extraordinary personality makes it difficult to decide if his remarks have any general validity.

Beuys is especially interesting because he seems to symbolize, and to sum up in his own person, the role of the artist in the society of the 1970's. Or, rather, he gives us a vivid sense of what artists would like their role to be. To a somewhat lesser extent, we see the same thing in the *modus operandi* adopted by Gilbert & George, and by a Body artist such as Dennis Oppenheim. The artist sees himself as a shaman, and he also sees himself as a "chosen" being, whose claims to be recognized as an artist are dependent not upon anything he has produced or may produce, but upon some inherent quality which the rest of us, audience rather than artists, are bound to recognize and equally bound to acknowledge with enthusiasm. Art having become sufficient unto itself, like the Deity, artists themselves are sacred beings who can claim special consideration without violating our sense of democracy. One point that supports this contention is the way in which art—Richard Long's and Hamish Fulton's timed walks, Oppenheim's sunburn, the self-amputations of the Viennese artist Rudolf Schwarzkogler—has taken on the character of a test or ordeal. One is reminded of the way in which the shaman discovers his vocation through suffering; and, still more, of the way in which the Indian fakir achieves merit by staring fixedly at the sun or lying on a bed of nails.

BAD THOUGHTS

The question we have to ask ourselves is whether conduct of this kind has any validity in the context of the industrial and technological society we know. It can be argued that the *faux naïf* behaviour and apparent frivolity of the Zen philosopher have age-old roots in the culture of China and Japan. Zen is at once a refinement and an exaggeration of something which has always existed. But the modern artist cannot make his gestures meaningful simply by claiming that they are so. What he does has to mesh with the world around him.

Some artists have tried to achieve this through a passionate engagement with the things which seem to them to typify the times. In the Seventies one of the most active fields of avant-garde experimentation has been video. Video Art, as it has come to be called, already covers a very broad spectrum. The best definition of what artists have tried to do with the medium is supplied by Ernest Gusella's list of negatives. In reply to a questionnaire from the magazine *Art-Rite* he said: "My video is not:

"—Accompanied by a 'pink sludge' rock and roll soundtrack.

"—Documentation of a conceptual perfor-

361.
Joseph Beuys
Stuhl mit Fett (Chair with Fat)
1964; 47 × 42 × 100 cm. (18 × 16 × 39 in.)
Darmstadt, Hessisches Landesmuseum, coll. Karl Ströher

mance in which I jump out of a 13th story window to test the laws of chance.

"—Synthetic images created with rebuilt surplus World War I airplane parts.

"—Shot with two cameras attached under each armpit and one between my legs.

"—A group therapy encounter between the Neo-Nazi Anarchists and the Bowery Satanists.

"—An underground sex-opera starring all my beautiful friends.

"—A presentation about the 3rd coming of the Punjab of Mysore to bless his freebies in America.

"—Product with future marketing potential" (*Art-Rite*, No. 7, p. 11).

This baleful catalogue at least gives a good notion of all the things video has tried to be. They range from "alternative" politics masquerading as art to a prettier and more complex version of the old-fashioned kaleidoscope. The perils and pleasures of technically experimental video can best be

362 and 363. Below and opposite
Joseph Beuys
Raumplastik (Room Sculpture)
1968; 10 × 12 m. (33 × 39 ft.)
Darmstadt, Hessisches Landesmuseum, coll. Karl Ströher

sampled in the work of the Korean artist Nam June Paik. The *Paik-Abe Synthesizer* (Plate 364) delivers a flood of astonishing images which eventually become boring because they have no stability and therefore no point of rest for eye or mind. Further adventures, such as Paik's collaboration with the cellist Charlotte Moorman, who sometimes plays her adapted instrument bare-breasted (Plate 365), suggest a desperate search for novelty at any price.

But even technological top-dressing of the kind supplied by video cannot disguise the fact that the artist, or one kind of contemporary artist, has come very close to the total abolition of art. On the one hand, as Kosuth does, he calls for an activity which is totally self-sufficient and immune from criticism and even description (since the only true account of the work is given by itself). On the other hand, as Beuys does, he claims that art is a totality so vast, so powerful, and so all-embracing

451

that it needs no embodiment other than the person of the artist.

Art's struggle to escape from itself presents a far from reassuring spectacle—that is, if one continues to believe in the shibboleths of the avant-garde. If the Seventies seem a significant decade in the history of Modernism, it is because they supply an increasing quantity of evidence that the accepted theory of the avant-garde is breaking down. Since 1905, the development of art has been interpreted in terms of a frontier which was always being pushed forward, and the assumption was that this process could be continued indefinitely. A secondary theme, apparently contradictory but in fact very closely related to the first, was the development of nihilism, so that the progress of art was measured by its tendency to turn itself into some new variety of anti-art. The one thing which was never invoked was the law of diminishing returns.

Superrealism

However great their success with critics and museum curators, the various Minimal and Conceptual styles did not completely sweep the field. They faced serious competition from a way of painting pictures and making sculpture which seemed the polar opposite of such abstract and cerebral modes. The name given to this artistic phenomenon was Hyper Realism or Superrealism. Superrealism, like its predecessor Pop Art, enjoyed a tremendous success with collectors and dealers, but attracted less than unanimous critical support. Indeed, even those critics who had finally accepted Pop tended to feel dubious about this new manifestation. This was understandable—on the face of it, Superrealist artists were trying to return art to the condition which it had been in not only before Modernism, but before the triumph of Impressionism. It seemed as if, by a final cynical paradox, the advocates of Superrealism were trying to assert that the only style worthy of a truly avant-garde artist was the academic Salon painting of the late nineteenth century. The wheel had come full circle.

In fact, in the years since 1945, realism had never quite ceased to assert itself. There was even a handful of artists who escaped the label "academic" while practising what was recognizably a kind of realism. In Italy, for example, there was the intensely prolific Renato Guttuso, whose realist works, tinged with Expressionism, were the product of his Marxist political convictions. In France there was Balthus, whose strangely erotic paintings of pubescent girls distilled a Surrealist atmosphere without being overtly Surrealist in any detail. In England there was Lucien Freud, who, beginning as a neo-romantic, proceeded to evolve a plain, direct style which owed something to Walter Sickert and a great deal to the camera.

British Pop Art always remained close to straightforward realism, particularly in the work of Peter Blake. Blake himself refused to accept the Pop label and always insisted that he was most accurately described as being simply a "realistic" painter. As his work matured, it seemed as if Blake's deepest ambition was to be recognized as a belated colleague of the Pre-Raphaelites (who in the 1960's and 1970's continued to enjoy an immense popularity with the gallery-going public).

Another British painter with increasingly close links to traditional realism was the boy wonder of Pop Art, David Hockney. Hockney has often asserted that one of the things which fascinates him about painting is the contrast between the different conventions of representation an artist can use. Now the conventions he chose were those which the masters of the Renaissance would have recognized as familiar. Hockney's *Double Portrait of Ossie and Celia* (Plate 366) is, from the point of view of the committed Modernist, a brilliant but disturbing work. It is undoubtedly intensely contemporary, in that it distills the essence of the fashionable London world of the late Sixties. In this respect it resembles works such as John Singer Sargent's portrait of the Wertheimer sisters, which performs the same service for the Edwardian age. But the contemporaneity of Hockney's painting goes further than this. We find in it a way of arranging the forms, a response to certain colours, even to a certain kind of light, which makes it intensely evocative of the moment at which it was created. Now that the Sixties are already fading one can see that it evokes the spirit of the time as no other work could do. Yet it is exactly this quality—and the painter's keen eye for social nuances—which makes it seem anachronistic compared to the art since the Second World War.

There is, however, a difference between Hockney's painting, even in this phase, and the kind of painting that was being done by the American artist Philip Pearlstein (Plate 367).

Pearlstein's obsessive concentration upon the nude—usually but not always the female nude—has been thought to make him one of the sources of Superrealism. This is not true, except in the general sense that Pearlstein preserved, and made available to other American artists, the tradition of American realism which had had a strong revival during the 1930's, and which is well represented in the work of Edward Hopper.

Pearlstein differs from the painters of the Superrealist group and from Hockney, too, because he will have nothing to do with the camera. His nudes are painted from life, usually by artificial light. One quality which might lead us to think that they are not life studies is the arbitrary way in which they are cropped, just as an unskilled amateur photographer will often succeed in framing his subject in a way that he doesn't intend. In Pearlstein's case the cropping seems rooted in the method of work. The artist does not deliberately "compose" the picture, but starts with a single detail and moves outward from that, stopping when he reaches the edge of the canvas. This, in turn, makes him seem very different from those who painted the figure during the nineteenth century or, for that matter, earlier. Pearlstein's method announces to us that it is the whole process of perceiving something and then of rendering it into paint that counts. The arbitary cropping of the image does not matter so long as the process itself is fully demonstrated.

The idea of process also enters very strongly into the work of Malcolm Morley, an English artist now domiciled in America, who may be regarded as the true founder of Superrealism. Morley invented a variation of the Pop Art approach to the "given" image. What Lichtenstein does, in his paintings derived from comic strips, is first to take something which seems to have been irremediably coarsened by the processes of cheap colour reproduction, and then to refine and formalize this before using it as the basis for a picture. The fact that the painting shows a series of mannerisms and conventions that derive from the original printed source serves in a way to distance it from that source. We know, from the scale alone, but also from other aspects as well, that this is not simply a frame from a comic strip, but the transformation of such a frame.

Morley, following the dialectical pattern of so much art after 1945, set out to criticize Lichtenstein's method. In the middle Sixties he produced a series of paintings which, instead of being based upon crude comic-strip images, derived from high-quality four-colour reproductions of photographs, pictures of the kind one finds used to decorate the offices of shipping lines and to illustrate the brochures of travel agents (Plate 368). Morley has since said that he did not find the pictures themselves particularly interesting. What did interest him was the process of making a painted equivalent—of doing by hand what the machine already did so efficiently. For this reason he adopted an arbitrary method of copying. The printed original was divided into a number of squares, and all but one of these squares was covered while the artist was working on his copy. He only saw how near he had managed to come to what he was trying to imitate when the whole job was finished. To add to the arbitrariness of the procedure, the original was often copied upside down.

One finds similar attitudes at work in the painting of John Clem Clarke, another painter who can be regarded as forming part of the transition between Pop and Superrealism. Clarke is an extremely prolific and uneven artist, whose work shows many changes of direction. Among his most significant pictures are his versions of the Old Masters. He does not seem to undertake these in quite the same spirit as that which animates Martial Raysse, in the latter's versions of Ingres and Pierre Paul Prud'hon. Clarke has no quality of sarcasm. As far as he is concerned, these "translations" are simply a method of making the works he chooses available to his own time. If the translation also involves a degree of cheapening, the artist is prepared to accept this, as a comment on the society which he himself inhabits.

Clarke's *Three Graces* series has unusual complexity, because here he is parodying not an "established" kind of art, but one which in 1970, when the pictures were painted, was still in some disfavour. The obvious source is A.

367.
Philip Pearlstein
Female Model Reclining on Bentwood Love Seat
1974; 120 × 150 cm. (47 × 59 in.)
New York, Allan Frumkin Gallery

W. Bouguereau, whose paintings of nudes were star items in the Paris Salons of the late nineteenth century, and who was admired particularly by the rich American collectors of that time. Even in 1970, Bouguereau was beinning to attract renewed interest, but there was certainly still something perverse or anti-art about professing an admiration for him. Clarke does not make a direct transcription of his work. Instead, he suggests a contemporary equivalent. These are Bouguereau's nudes seen through the eyes of the camera. But it is important to make the point that they are not pin-ups. None of these girls would ever make the centrefold of *Playboy*. The artist therefore manages to pack quite a lot of comment into a single canvas—about changes in erotic tastes, changes in artistic style, about the difference between the camera's true vision and the apparently "photographic" vision of popular Salon painting.

Indeed, Clarke seems to be divided from the

368.
Malcolm Morley
SS "Amsterdam" in Front of Rotterdam
1966
Courtesy of the artist

mainstream of Superrealist painting by the amount of comment embodied in his activity. The true Superrealist aspires to be strictly neutral. This at least is the theoretical defence put up for it by the handful of critics who have bothered to investigate it. They see these canvases, with their deliberate lack of an imposed style and their apparently slavish dependence upon the camera, as a new variation upon the theme of the found object. They find in Superrealism a nihilistic streak which goes even beyond Minimalism.

Of course the painters now classified as Superrealists are as keenly aware of the Modernist heritage as artists who work in other styles. Gerhard Richter, a German artist who is an occasional adherent of the movement, has even produced a parody version of Duchamp's *Nude Descending a Staircase* (Plate 370). He bases it upon the fact that Duchamp's nude takes as its own original source the experiments with simultaneous photography made by men such as Marey, and retranslates the action of the figure into present-day photographic terms.

Another item that preoccupies Superrealist painters is the modern reflex camera—both its powers and its limitations. The artist in whose work we can most easily examine its influence is Charles Close, who specializes in large-scale paintings of heads (Plates 371 and 372). These paintings, which are often of fantastic technical refinement, raise a number of important questions. The first of these is that of scale. The effect of enormously enlarging the heads is to make them seem, not less real in a general sense, but less, rather than more, like the person they are supposed to represent. At the same time this enlargement serves as a reminder that the camera, too, has no inbuilt sense of scale. This lack manifests itself in several ways. In the first place, it is possible to enlarge the image on a modern negative to almost any dimension—the tiniest object can be blown up to monumental size. The dynamic range of enlargement is increased by the fact that the camera is a sophisticated optical instrument, which can be fitted with lenses that make it possible to record aspects that the naked eye cannot perceive. Secondly, when we look at

461

369.
John Clem Clarke
Small Bacchanal
1970
New York, O. K. Harris Gallery

photographs, we are often uncertain of the relative proportions of the objects *within the frame*, especially if the picture has been unskilfully composed. We are often able to judge the height of a building, or the size of a statue, only because the photographer has been careful to include a human figure. Close's portraits destroy scale, and are in this sense disorienting.

Another problem in photography is that of the "all over" quality of the camera's vision. When photography was born, in the nineteenth century,

the men of that time were astonished by the sheer quantity of details which the lens recorded on the sensitized plate or paper. There were far more of these details, they realized, than even the most industrious artist could hope to include in his painting or drawing. (This made them feel, naively, that photography was inherently superior to painting. Superrealism often seems to concede this superiority, which other art disputes.) Close grapples with this problem in two ways. The first is by reducing the content of the work—a single

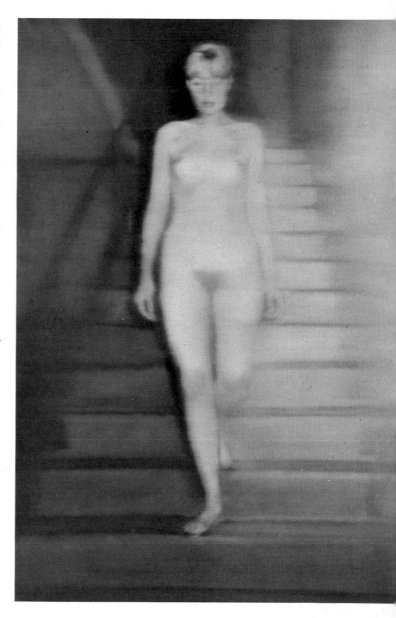

head is all he is willing to paint. The second is by a laborious effort to reproduce precisely what the camera has seen. He can at any rate examine this vision minutely and at leisure on the print, which permits a scrutiny closer and more intimate than that which could be given to the living sitter.

In many of his paintings, especially the more recent ones, Close also tries to echo the camera's faults as well as its virtues. He seems anxious to reproduce the aberrations of vision that are peculiar to the camera lens. Sophisticated as lenses may now have become, they are in most respects less sensitive and flexible than the human eye. The principle of the variable aperture, which allows the photographer to adjust his instrument to different lighting conditions, brings with it certain penalties. In particular, the wider the aperture the photographer uses, the shallower the zone in which the image is in sharp focus. This can create difficulties in close-up work. In taking a picture of a head, the photographer may find that if he gets the tip of the nose in focus, the eyes, in a directly frontal view, are already not quite sharp. He juggles with the problem as best he can, usually choosing to have the plane of focus resting on the eyes and cheekbones, rather than on the tip of the nose. Close reproduces these defects without editing them. In some of his portraits the tip of the nose is slightly blurred, and the blurring begins again behind the focal zone—with the ears, for instance, and the hair as it springs away from the forehead.

Another characteristic of his paintings is that, like photographs, they are the product of monocular rather than binocular vision. This gives the portraits an intensity, as does the rigidity imposed by a mechanical way of seeing. The eye collates impressions through a scanning process, focusing on different areas in turn in a way that we are usually unaware of. The camera has no such facility of adjustment.

Close's work also directs our attention towards another characteristic of Superrealist painting as a whole, which is that it is impossible to reproduce it satisfactorily. The image borrowed from a photograph, when reduced in size and turned into another photograph, re-assumes the qualities it had at first, before the artist began work on the image.

It may perhaps be asked why these looming heads should be of any more interest to the spectator than the photographic originals upon which they are based. The easiest answer to this question is to say that they exercise the fascination that has always been attributed to *trompe l'oeil*—the kind of painting which reproduces reality in such a way that we mistake what is painted for the real thing. Since Close bases his work so closely upon a photographic original, it might even be said that he is not in fact a portraitist, but a still-life painter

371.
Chuck Close
Susan
1972; 252 × 226.5 cm. (98 × 88 in.)

372. Opposite
Chuck Close
Richard
1969
Aachen, Neue Galerie, coll. Ludwig
(Photo: Ann Munchow)

465

whose chosen subject happens to be the photographic print. It is really only the change in scale which militates against this argument, and even that is not conclusive, since, as I have already noted, the photographic print itself can be made upon almost any scale.

In fact, it is not merely the technical skill of the performance which makes Close interesting as an artist, but the inevitable gap between the simulacrum and the reality—even if this "reality" is itself a simulacrum. Close, unlike Roy Lichtenstein, does not admit that he makes adjustments in the original image. Rather he asserts the opposite— that he wants to reproduce the original as closely as he can. But, nevertheless, in making this statement he is forced to admit that there will be an area of difference, however slight, between what he sets out to do and what he actually accomplishes. This tiny discrepancy is enough to animate his paintings, to give them life as works of art.

Another artist who works in this severely restricted yet interesting area is Richard McClean. As nearly all the Superrealist painters do, he confines himself to a very narrow range of subject-matter. In his case, he limits himself almost entirely to paintings of horses and riders. Usually these are based either on publicity photographs or on the kind of picture that is taken of a winning racehorse, with its jockey up and its owner or trainer proudly holding the bridle (Plate 373). In fact, McClean has turned himself into a kind of contemporary George Stubbs, but with this proviso—he does not seem to work for the owners of the prize-winning beasts but rather to examine this equine world with an ironic fascination, a tendency to stress its philistinism and bad taste. Yet to say this is probably to read something into the paintings which is not present in the artist's mind. What probably interests him most is the exercise of making a "hand-made" version of a mechanical original.

If one is inclined to deny McClean's work any significant sociological content, this is not the case with other leading Superrealist artists. Four men who in various ways seem to typify the style, and to explain the very direct reaction it arouses, are Robert Cottingham, Richard Estes, John Salt, and Ralph Goings. In each of these we find an unmistakable, and obviously intentional, reflection of salient features of contemporary American life.

Cottingham is a painter whose work once again underlines the close connection between Superrealism and Pop Art. His specialty is the sign. He portrays the words and letters which adorn the movie-house marquees and department-store facades of his native New York. He thus presents us with a version of Pop's fascination with the written word and with advertising. The signs that Cottingham choose to paint (Plate 374) are inevitably viewed through the lens of the camera, and it is the camera which is used to impose the arbitrary croppings which sometimes rob the letters of meaning, and at other times supply meanings different from those they possess in reality—as, for instance, when the word MART is transformed, by a piece of symbolic legerdemain, into ART. Cottingham's clean style of painting gives his work a slightly simplified look, which also tends to suggest a relationship to the somewhat more drastic simplifications typical of Pop.

A striking thing about Cottingham's work is that it is so thoroughly urban. The same is true of the work of Richard Estes. Of all the Superrealist painters whose work is illustrated here, Estes is formally the most complex, and this fact alone brings him closest to painting of a traditional kind. As his colleagues do, Estes uses colour transparencies as his prime materials. These transparencies, however, are not only rigorously winnowed but most selectively employed. Estes is the poet of the modern city and, in particular, the poet of New York. The glittering glass facades of New York buildings, with their multiple reflections, and reflections within reflections, exercise an obsessional fascination over him, only rivalled by the equivalent effects to be discovered in the glittering metallic maze of the subway system. If the figure makes an appearance in his paintings, it generally does so in a completely subordinate role—dimly seen within a store or cafeteria, or reflected, ghostlike, in a shop-window. Estes's subject is architecture, not people (Plate 375).

374.
Robert Cottingham
F.W.
1975 ; 200 × 200 cm. (78 × 78 in.)
Collection of the artist

375.
Richard Estes
Façade
1974
Courtesy, Allan Stone Gallery

376.
Ralph Goings
Paul's Corner
1970; 120 × 189.4 cm. (47 × 74 in.)
New York, O. K. Harris Gallery

It soon becomes apparent, if one examines Estes's work at all closely, that he, as Roy Lichtenstein does, makes innumerable small adjustments in the selected image. These adjustments, as are those made by Lichtenstein, are aimed at imposing order upon chaos. Estes makes virtuosic use of a complex geometry of planes and angles. Within each of his compositions is concealed an abstract organization almost as complex as that to be discovered in a Kandinsky. In fact, there is a close resemblance in method to the work of some of the leading architectural painters of the past, in particular to the best of all the Dutch seventeenth-century painters of church architecture, Pieter Saenredam. The latter, like Estes, is an artist who

extracted a very wide variety of effects from apparently limited subject-matter.

Ralph Goings is a Californian, and his paintings do for the urban landscape of California what those of Estes do for New York (Plate 376). Automobiles occupy the forefront of his paintings; and the flimsy drive-in stores and eateries lining the great Californian superhighways usually form the background. To some extent, Goings therefore tends to parallel the work of the Californian Pop artist Ed Ruscha, who has been attracted by the architecture of American filling stations. Goings, with the majority of Superrealist artists, makes use of the airbrush, a technique which originated in advertising design studios,

and which gives a smooth, meticulously impersonal finish to the work. He is perhaps the best known of a whole group of artists now resident in California who treat similar subject-matter in a more or less identical way.

The fact that Goings, even more than Estes, chooses to paint a landscape with no apparent redeeming features has been used to support the argument that he, too, is a nihilist, in search, like so many avant-garde artists before him, of acceptably "unacceptable" subjects. This seems to me to beg the question. It was not until the time of the Romantic movement that people began to think that the painter, and the landscape painter in particular, must make beauty only from what was already agreed to be beautiful. And even during the Romantic period the rule was as much honoured in the breach as in the observance. Philippe de Loutherbourg painted *Coalbrookdale by Night* in 1801, thus making art out of the worst horrors of the Industrial Revolution. Turner performed much the same feat a little later with his *Keelmen Hauling Coals by Moonlight*, that hymn to the beauty of industrial Tyneside. The fact is that artists traditionally tend to look for subjects that are "original"—that is, unsullied by the attempts of previous artists. They do this at least as often as they choose a subject that is already guaranteed to be "artistic". At the same time there is an understandable tendency on the part of the more

471

original and adventurous painters to seek out subjects that seem to them to be typical of their own time, as a means of saying something about the society they live in. Goings and the other Californian Superrealists have been able to prove, in however unambitious a fashion, that art is still capable of fulfilling some of the functions which used to be attributed to it—if this is the direction in which the artist himself chooses to go.

One Superrealist whose pictures seem to have a marked symbolic content is the émigré Englishman John Salt. His chosen subject-matter is automobiles, and in this he resembles not only Ralph Goings but also numerous other artists of the same school, among them Robert Bechtle and Don Eddy. But Salt's cars are not roadworthy—they are the battered wrecks on American automobile dumps. Even when he chooses to paint one of the great trailers which so aptly symbolize American mobility and American leisure, he shows it apparently abandoned and surrounded by debris—old refrigerators and non-functional washing machines (Plate 377). It is hard not to see his paintings as deliberate reflections of affluence and waste, and indeed I can think of no reason why the spectator should resist this interpretation.

Not all the art classified under the rubric Superrealist is interpretable in this way. As we have already seen, the explanation would not apply to Charles Close. Nor would it serve as a means of approaching the curious work of Stephen Posen (Plate 378). Posen takes banal objects, in this case some streamers and an elaborate birdcage, and subjects them to an unwavering scrutiny. This scrutiny seems designed to bring out the sense of alienation the artist feels. Another device favoured by Posen is a kind of still-life painting based on a group of cardboard boxes covered with a cloth. Here, too, but more obviously, we are informed of the way the mysterious and the ordinary intermingle with one another. Posen shows virtuoso power in depicting his chosen subject-matter, but the world he inhabits is peculiarly narrow and claustrophobic.

Another, and a much more various and engaging, virtuoso is Howard Kanovitz. Kan-ovitz, indeed, is too various to be easily classifiable. Some of his paintings, like the deadpan *The Opening* (Plate 379), are best thought of as offshoots of Pop. Others, such as *The Painting Wall, The Water-bucket Stool* (Plate 380), have a metaphysical quality which seems to owe a good deal to Magritte. This direction—a movement towards the surprising and the magical—is that taken by his more recent work. Kanovitz demonstrates that irrational elements can survive successfully within an idiom that is apparently totally realistic. Indeed, the sudden leap into irrationality which occurs in many of Kanovitz's most successful paintings is fuelled by the virtuosity of his technique, which includes a marked ability to manipulate *trompe l'oeil* effects without allowing *trompe l'oeil* (as it so often does) to dominate the composition into which it has been introduced.

One of the curious things about the fully developed Superrealist style is that it is so firmly rooted in the United States. Those Englishmen, such as Malcolm Morley and John Salt, who have made a name for themselves by practising this kind of realism have actually been domiciled in America. There seem to be two reasons for this. One is the tradition of American realism, deep-rooted and stubborn even in the early twentieth century, at a time when realist styles were in retreat almost everywhere else except in Soviet Russia. The second reason is not historical but economic. Superrealism is a style which has depended for its support, unlike other recent Modernist styles, upon the enthusiasm of private patrons. The United States was the place where the greatest remaining reservoir of private patronage was to be found.

It has also been said by some critics that the curiously "closed" quality of Superrealist art is a reflection of the numb conservatism of Nixon's America. Art responds to the stagnation of politics by developing a kind of carapace, an insulating brilliance of technique. A somewhat similar development took place in Spain during Franco's last years, though the best known of the so-called Spanish realists, Claudio Bravo, is actually a Chilean, domiciled first in Tangiers and more

379.
Howard Kanovitz
The Opening
1967; 49 × 69.5 cm. (19 × 27 in.)
Cologne, Wallraf-Richartz Museum, coll. Ludwig

recently in New York. His dazzling still-life compositions (Plate 381) do, however, allude to the tradition of Zurbaran.

This tendency to use the art of the past as a point of reference is most characteristic of a new kind of European realism which differs from American Superrealism in many important respects, not least in its willingness to embrace the personal and the expressive. In Britain, for example, the Pop realism of Hockney and Peter Blake has been succeeded in the second half of the Seventies by the more classically realist art of Michael Leonard. *Up on the Roof* (Plate 382) is one of a series of recent paintings showing scaffolders at work. Though the artist makes use of photographs for reference, the composition is both more complex and more

deliberately formal than it would be in American art of the same type. There are deliberate allusions to the art of the past—the reclining figure in the foreground, for instance, seems to be based on the back view of the Theseus of the Parthenon pediment. In a broader sense, too, Leonard looks to the established tradition of European art. From the seventeenth century onwards, European artists have produced pictures which endowed ordinary occupations with a kind of heroic dignity. Leonard glances backwards at the French *peintres de la réalité*, and particularly at the Brothers Le Nain.

In German art, and especially among artists based in Berlin, there has also been a strong revival of realism during the 1970s. This has earned for

474

380. Opposite
Howard Kanovitz
The Painting Wall, The Water-bucket Stool
1968; 240 × 295 cm.; 97 × 45 cm. (94 × 115 in.; 39 × 18 in.)
Aachen, Neue Galerie, coll. Ludwig

381. Overleaf
Claudio Bravo
Il pacchetto blu
1971; 111 × 140 cm. (43 × 55 in.)
London, Marlborough Fine Art

itself the labels of "Ugly Realism" or "Critical Realism". Hermann Albert's *The Four Seasons* (Plate 383) is typical of the work done by members of the group as a whole. His art, writes the German critic Christian von Holst, takes as its subject-matter "the affluent bourgeois ... seen either in homely surroundings, at leisure, or on holiday ...

Albert succeeds in characterizing different types, without giving details of situations or actions. A few symbolic attributes are enough—a certain bikini, sunglasses or holiday sandals—and together they make the 'man'. Attitude, hair style, and accessories are one. These people are merely the sum of their attributes—collages of consumer

goods that indicate the identity of the bearer" (from the catalogue "Prinzip Realismus", Berlin, 1971).

Albert, like many of the other artists involved in "Ugly Realism", refers the spectator to the Neue Sachlichkeit, or New Objectivity of the Weimar Republic—that is, to the work of artists such as Georg Grosz, Max Beckmann and Otto Dix. Like the Neue Sachlichkeit, "Ugly Realism" is not, strictly speaking, realistic—it owes more to the long-established tradition of European Expressionism and makes no pretense at detachment from either personal or political passions. The political element is in fact one of the most interesting things about it, as the return of politics to the visual arts has been a significant aspect of the art of the Seventies. Hardly less significant is the fact that "Ugly Realism" is a national rather than an international style, something very distinctively German in flavour.

382.
Michael Leonard
Up on the Roof
1979; 96.5 × 99.5 cm. (38 × 39 in.) with the frame;
86.2 × 81.3 cm. (34 × 32 in.) image without frame
London, by kind permission of Fischer Fine Art

383.
Hermann Albert
Vier Jahreszeiten (The Four Seasons)
1974; 150 × 150 cm. (59 × 59 in.)
Berlin, Galerie Poll

384.
John De Andrea
Woman on Bed
1974–75
New York, O. K. Harris Gallery

Despite its roots in the German past and in German culture, "Ugly Realism" does, however, suffer from one inescapable weakness, especially when one compares it to the art of Weimar. Artists such as Grosz and Dix attacked real social evils, which were very apparent to everyone. Albert and his colleagues—they include the painters Johannes Grützke, Mathias Koeppel, and Wolfgang Petrick—often seem inspired by a more generalized discontent about society and the way in which it is developing. Social commitment becomes something the artist owes to himself, to his own self-image, not something he owes to the people who surround him.

Up to this point I have said nothing about realist sculptors. Indeed, even though it exists, American Superrealist sculpture may still seem uncomfortably paradoxical, especially if we consider the fact that Superrealist painting is so largely concerned with the illusionistic rendering of objects on a flat surface. Even at those times in the past when art was most concerned with realism—the seventeenth century, for example—sculpture tended to maintain a distance between itself and the moving flux of life. However illusionistic Gianlorenzo Bernini's sculptures became, the spectator was in no danger of mistaking them for living people. One of the few exceptions to this rule is supplied by Spanish art. Here, indeed, some seventeenth-century religious images, with their painted faces, glass eyes, jewels, and real clothes made of silk and satin, have an astonishing resemblance to living beings. To those who came to worship, they were in fact as close to living people as made no difference.

American Superrealist sculpture, as exemplified by the work of John De Andrea and Duane Hanson, does indeed tend to strike the spectator as disturbing, almost indecorous. The same spectator would be most unlikely to have a reaction of an identical kind to the work of Superrealist painters, however pronounced the *trompe l'oeil* element. Speaking of realist art in the 1920s, when it was in retreat almost everywhere except in Germany, the Spanish philosopher-critic Ortega y Gasset touched upon the subject of the waxwork. Waxworks, he said, had a peculiar effect upon us

480

385.
Duane Hanson
Woman with a Shopping Cart
1969; 166 cm. (65 in.)
Aachen, Neue Galerie, coll. Ludwig

because they were neither one thing nor the other, neither art nor life.

Are Superrealist sculptures no more than waxworks brought up to date and promoted to the art galleries? It is tempting to say that they are. In many ways they are more realistic, less illusionistic, than the wax figures in Mme. Tussaud's. Contrary to popular belief, for example, waxworks are not cast from the living body, whereas Superrealist sculpture is often put together from casts made in this way. Technically, the work of De Andrea and Hanson derives directly from that of George Segal. What these two artists have done is to take Segal's method of casting from life and perfect it. Now the figure emerges, not as a white and slightly clumsy version of the original model, but as a simulacrum which is exact in every detail—smoothed over, coloured to resemble life, provided with real hair and eyelashes and a pair of glass eyes; with clothing, too, where this is appropriate.

De Andrea does not clothe his figures. His nudes (Plate 384) are bland duplications of the American middle-class kids who are their originals—handsome and well built for the most part, but not hardened by any real effort of endurance. They somehow give away both their class and their national origin through details of posture, hair style, and expression. The fact that one can feel a mild dislike for De Andrea's sculptures, thought of simply as people, says something for their quality of lifelikeness, but it is still difficult to argue that they in any way transcend the waxworks which they so closely resemble. It has been argued that one of the things that makes modern art "modern" is its desire to break down the barrier that separates art from life. Thus Duchamp's bicycle wheel is simultaneously a work of art *and* a bicycle wheel, Warhol's Brillo box remains a Brillo box, and so forth. De Andrea's work lends continuing support to this theory, which is perhaps the best that can be said for it.

Duane Hanson is a different matter. What he does for the most part is to present us with a gallery of American types, brilliantly if somewhat cruelly observed. Occasionally he attempts a more elaborate tableau—there is one of a race riot—but these are usually less successful. Hanson's claim to be an artist is founded upon traditional talents for observation and synthesis. No American housewife could ever be as perfectly representative of the whole race of American housewives as his bulging *Woman with a Shopping Cart* (Plate 385). Hanson is, in fact, that extreme rarity, an artist who uses sculpture, rather than painting or drawing, as a vehicle for social criticism.

European artists (in which category I also include artists from the other side of the Atlantic who have made their careers in Europe) have approached the problem of veristic sculpture in a rather different way. One indication of the difference in attitudes is given by the work of the young British sculptor John Davies (Plate 386). Like De Andrea and Hanson, Davies sometimes makes use of the technique of casting from life. He also uses real cloth to make garments for his figures, though stiffening the material to make it more plastic and sculptural. But his figures are not coloured to resemble life. Instead, they are a greyish, blanched echo of life. Also these figures are often provided with strange additions—false noses, contraptions of board and wire. These give Davies an obvious affinity to the pre-war Surrealists—the labels Surrealist and Superrealist have, in any case, a linguistic connection. But his figures still have an extraordinary veracity which is far from typical of classic Surrealism. This is not the world of dream or fantasy but an alternative universe.

A further step in this kind of sculptural development is represented by the work of a British sculptor even younger than John Davies. Mandy Havers makes figures and fragments of figures from suede and leather, sewn and stuffed. There is nothing crude or clumsy about these creations. *Mother* (Plate 387) is extraordinarily skillfully made. It is also quite extraordinarily disturbing. The pregnant figure is made of flesh-coloured leather. Its basic form recalls that of Epstein's *Genesis*, itself once the subject of an artistic scandal. From the mother's swollen belly protrudes the head of her child and also parts of its limbs. Realism is here mixed with metaphor—

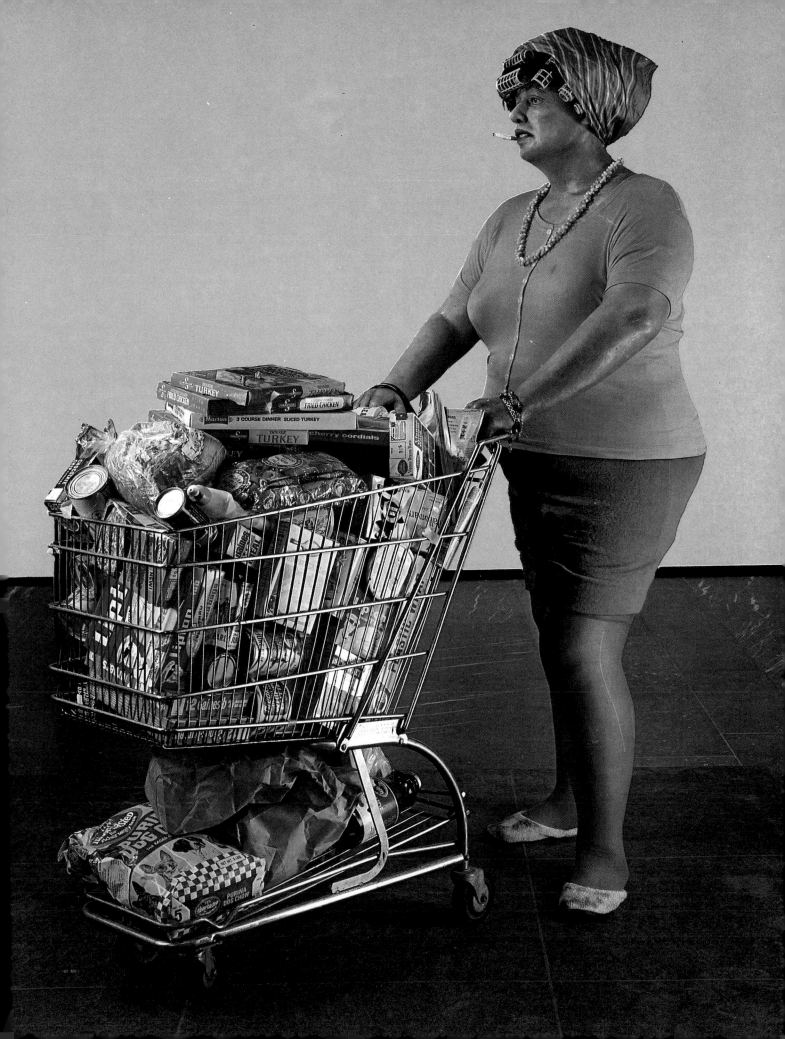

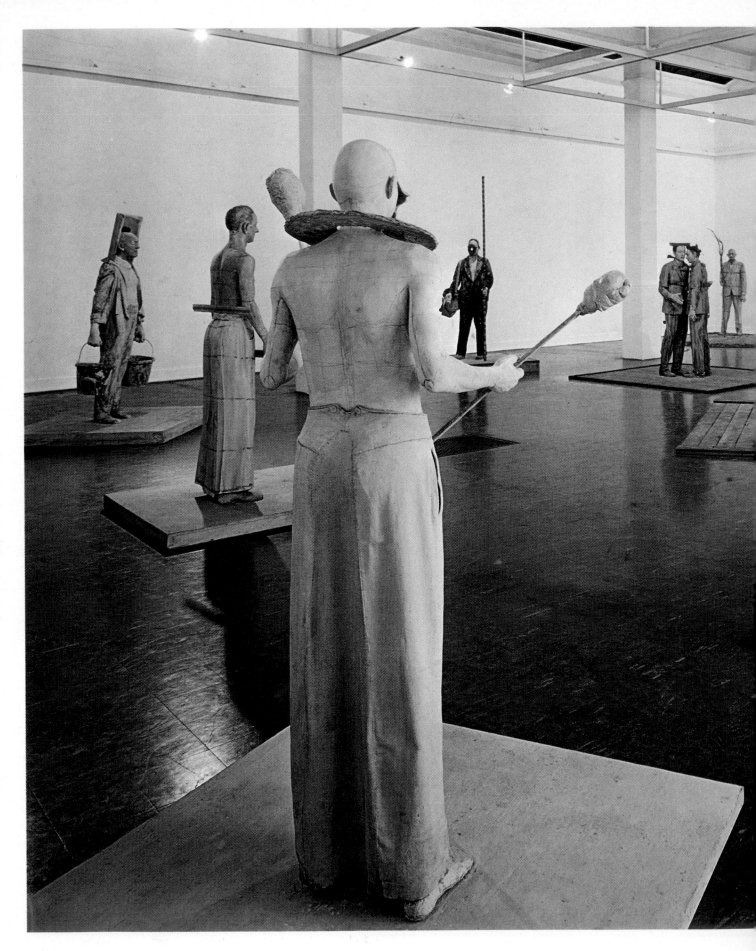

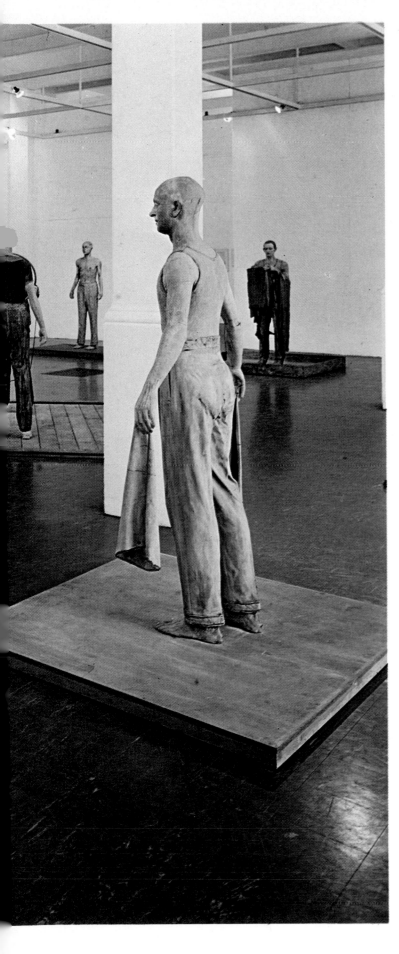

386.
John Davies
View of the Show
1975
London, Whitechapel Art Gallery
(Photo: Annely Judah Fine Art)

leather and skin are treated as equivalents; the child which is about to be born is already bursting from its mother's womb.

Another disturbing image, marking a further stage of development towards the metaphorical and theatrical, is the mixed-media environmental piece *Yard (Canes lupi)* by the American artist Denis Masi, currently domiciled in England (Plate 388). Here the chief "actors" are a pair of stuffed Alsatians, prepared by an expert taxidermist according to the artist's instructions. It is only certain details, such as the neat nest of silver wires in the middle of the area enclosed by the wooden stockade, which assure the spectator that this is not the reproduction of a situation which might be met in real life. All the details, and even the accompanying tape of dogs whining, snuffling and barking, are meant to evoke a profound sense of unease. Even more than the piece by Mandy Havers, this is an expert evocation of indefinable fears which most of us do not usually care to acknowledge.

Mortal Issues (Plate 389), by the Argentinian artist Leopoldo Maler, is another complex visual metaphor. Here a nurse sits beside a bed on which there tosses and turns the figure of an emaciated old woman. Various levels of reality are involved. The nurse is a live figure, an actress playing a role. The old woman is a film, skillfully projected onto a surface whose dimensions exactly correspond with those of the image. The framework of the hospital bed is made of thin neon tubing. The contrast between the seated woman, who lives and breathes, and the impalpability of the image on film powerfully suggests a process of fading away, a metaphor for death due to old age.

As I have already half suggested at the beginning of this chapter, Superrealism seems to represent a point of rest in the development of modern art. In general, the second half of the Seventies, insofar as one can judge a period so recently over, has been characterized by an important reconsideration about the role of the modern movement seen as a whole.

Irving Howe, in his *The Idea of the Modern in Literature and the Arts*, published in 1967, remarked that "Modernism must always struggle

485

and never quite triumph, and then, after a time, must struggle in order not to triumph." To this perception Daniel Bell has more recently added the following comment: "Modernism, seen as a whole, exhibits a striking parallel to the social science of the late nineteenth century. For Marx, beneath the exchange process was the anarchy of the market; for Freud, beneath the tight reins of the ego was the limitless unconscious, driven by instinct; for Pareto, under the forms of logic were the residues of irrational sentiment and emotion. Modernism, too, insists on the meaninglessness of appearance and seeks to uncover the substructure of the imagination. This expresses itself in two ways. One, stylistically, is an attempt to eclipse 'distance'—psychic distance, social distance, and aesthetic distance—and insist on the absolute presentness, the simultaneity and immediacy, of experience. The other, thematically, is the insistence on the absolute imperiousness of the self, of man as the 'self-infinitizing' creature who is impelled to search for the beyond" (Daniel Bell, *The Cultural Contradictions of Capitalism*, London, 1976, p. 47).

Modernism, as Professor Bell points out, is basically a response to major social changes which took place during the nineteenth century. Its extraordinary power of endurance, in the very midst of its own insistence on change, is not the least extraordinary thing about it.

During the Seventies, there began to be signs— and the Minimalism which lapped over from the end of the Sixties into the early part of the decade was not the least among them—that Modernism had become institutionalized to a point where it had begun to contradict its own nature.

There have been two reactions to this among artists themselves. One, largely confined to the United States, is exemplified by what has been happening to abstract painting. With the Minimalism of the successors of Rothko, Barnett Newman, and Kenneth Noland, it seemed as if art had reached a kind of ultimate—the surface of the canvas became totally undifferentiated and inert, the painting itself aspired to be a totally neutral and de-energized object. It was not surprising that American artists could not endure this condition

of stasis for long. One reaction, exemplified by the work of artists such as James Havard and Jack Lembeck, was to take a hint from the parodies of Abstract Expressionist brushstrokes once produced by the Pop artist Roy Lichtenstein, and to do work in which typically Abstract Expressionist calligraphy seemed to float in space in a kind of *trompe l'oeil*, casting shadows on a neutral ground. This approach simultaneously paid homage to an established mode and at the same time deliberately contradicted its most fundamental quality of spontaneity.

More radical in its approach was the school dubbed Pattern Painting. Pattern Painting drew ideas from a number of different sources. As with the painting by Katherine Porter illustrated here (Plate 390), it looked back to Matisse, and to the designs produced by Bakst and others for the Ballets Russes of Serge Diaghilev. Porter's *Myth to Phyllis* can easily be thought of as an enormously enlarged rough sketch for a theatrical decor. Pattern Painting, as its name implies, also puts heavy reliance on the idea of pattern itself—this feature can be seen in the borders to Porter's composition, and it appears even more conspicuously in the work of artists such as Joyce Kozloff and Robert Zakanitch. Zakanitch's *Late Bloomer* (Plate 391) looks, not like a sketch for a theatrical decor, but like a design for a piece of fabric.

Pattern Painting makes statements which contradict many aspects of orthodox modernism. It is, for example, deliberately hedonistic and lightweight. It devalues the self by its use of repetitive units. It also seems to break down the barrier between fine art and craft—a frontier which the modern artist has always been particularly insistent on keeping in place. Finally, it is revolutionary in stressing its own lack of revolutionary intention. The movement, however, can still be read, though with more difficulty than usual, as part of the general dialectic of styles which has characterized the development of modern art since 1945.

By contrast, there are artists who have tried to free themselves altogether from this pattern of aesthetic action and reaction, putting art at the service of some outside cause. In my chapter on

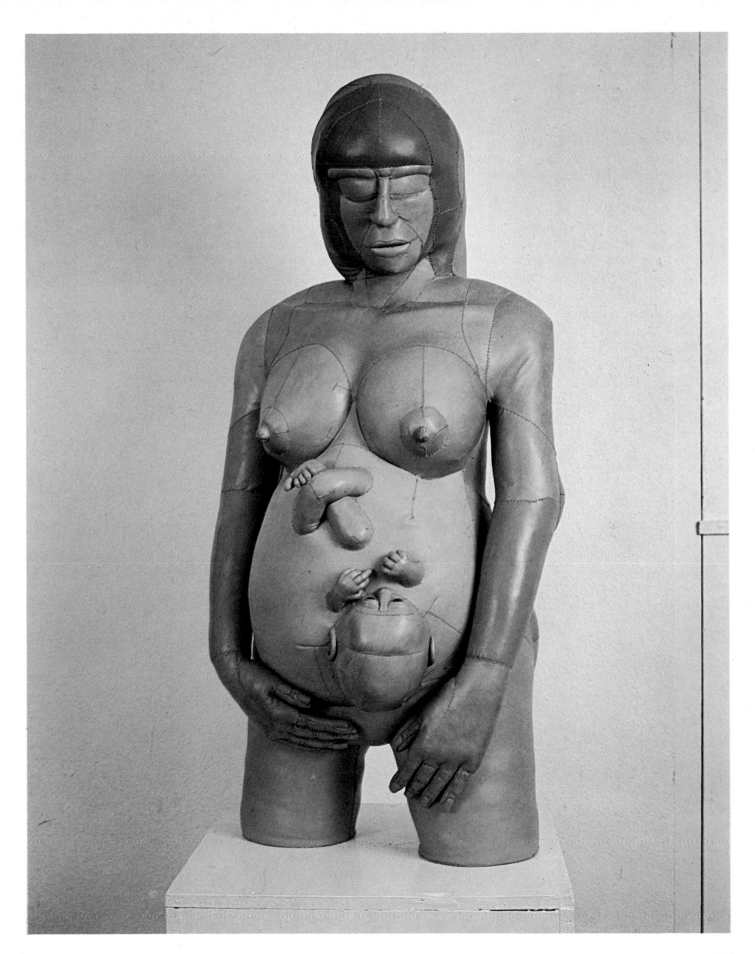

388.
Denis Masi
Yard (Canes lupi)
1978–79
By kind permission of the artist

389.
Leopoldo Maler
Mortal Issues
1976
By kind permission of the artist

"Happenings and Environments," I have already noted the element of political confrontation to be found in many art works of this type. During the late Seventies the number of political works of art produced continued to increase, especially in Europe, though these were generally in well-established Conceptual modes. In the United States perhaps the most notable tendency during the second half of the decade was the increasing strength and assertiveness of the Women's Movement. A notable collection of critical essays was published on the subject (Lucy R. Lippard, *From the Center*, New York, 1976), and artists such as Judy Chicago and Miriam Shapiro, who were prominent organizers of feminist art programs, came to occupy a special place in the American art world.

The art they produced, for example Shapiro's

390.
Katherine Porter
Myth to Phyllis
1977; 215 × 195 cm. (85 × 77 in.)
New York, David McKee Gallery

391.
Robert Zakanitch
Late Bloomer
1975; 244 × 442 cm. (96 × 174 in.)
New York, Robert Miller Gallery, Inc.

The First Theater (Plate 392), was often not directly an art of political statement. But it did try to seek out fundamentally "female" images, and to use typically feminine materials and techniques. In the work illustrated, Shapiro makes use of fabric collage in patterns which seem to derive from traditional American designs for patchwork quilts. Judy Chicago has devoted a good deal of time to exploring the intricacies of china-painting, traditionally considered a women's hobby in the United States.

Though feminist activity in Europe remains at a somewhat lower level, the movement has already begun to take root, with recent exhibitions of feminist art in Amsterdam and other cities, and more attention is being given to the work of women artists everywhere.

The development is significant because the Women's Movement seems to have an independent foundation, something quite outside the usual preoccupations of Modernism. One of these pre-occupations has of course been the idea

that revolution in the arts was in some way to be equated with revolution in politics – a myth often scotched by events themselves, but never completely extirpated. Much nearer to the fact of the matter is Thomas Mann's notion that Modernism cultivates "a sympathy for the abyss": "Whatever the political stripe, the modern movement has been united by rage against the social order as the first cause, and a belief in the apocalypse as the final cause. It is this trajectory which provides the permanent appeal and the permanent radicalism of the movement" (Daniel Bell, ibid., p. 15).

What the Women's Movement has done is not to remove anger against injustice, but to substitute female pragmatism for the desire for some kind of *Götterdämmerung*. It is the first sign that rage against the social order is beginning to break out of the institutional role which has so long been assigned to it, and that this rage is no longer wholly dependent for its audience and livelihood upon the very framework it condemns.

If one sees art taking a new direction, and

491

Modernism coming to the end, this does not mean that certain basic achievements must be discarded. The Renaissance and the Baroque both triumphantly survive the destruction of the framework of ideas which provided them with intellectual scaffolding. What it does mean, on the other hand, is that Modernism can no longer be seen as something present and immediate, but instead as something which, to be fully understood, must be set in a historical context which is no longer the one that we ourselves inhabit.

Perhaps the most important point to make at the present moment is that the promised "destruction of art"—the apparent motivation force of each new Modernist style—is never in fact the destruction of art, though it may indeed involve the supersession of whatever artistic idiom happens to be dominant at the moment. The impulse to make art is so deep-rooted that it seems likely to continue as long as human society exists. The only way to destroy art is to destroy society, and this is one reason why avant-garde artists have so often seemed to campaign not merely against the existing social order, but also against the continuing existence of the social organism.

Yet despite this, it is society which teaches us to interpret art – this is at least as true as the contrary proposition, which is that art teaches us to interpret and understand society. The gallery of illustrations in this book supplies us with a mirror of the fears and contradictions which have existed in Europe during the period which it covers. The aesthetic truth we may find in them is at least rivalled by the social truth.

It is impossible to predict what the art of the next two decades will be like, and even more impossible to prophesy what artists will be doing in the first decades of the new millenium. It will surely be quite unlike the work that is illustrated here, which will then have taken its proper place as historical and sociological as well as aesthetic evidence of the strengths and weaknesses of the twentieth century. The one prediction which I will venture, with whatever becoming degree of hesitation, is that the concept of Modernism will by that time have been replaced by something else, whose essential nature we are not as yet able to perceive.

Brief Biographies

Adami, Valerio
(Bologna, 1935). Italian painter. Studied in Milan at the Brera Academy from '53 to '57; worked in London from '61 to '62 and in Paris from '62 to '64. Lives in Milan. Makes use of the images of consumer design, of mass communications, using also their flat tonal colour, breaking it down apparently according to a methodology originally Cubist, actually in a dynamic disordering of the habitual context of the image as it is offered by the mass media.

Agam, Yaacov
(Richon Lezion, Israel, 1928). French painter and sculptor. Interested in literature, music, theatre, and photography. Studied in Jerusalem up to '48. In Zurich from '50–'51; living since '51 in Paris. Began as a painter with "polymorphic" works, creating surfaces on corrugated steel panels arranged so as to change shape with the spectator's change of viewpoint; he has also produced "transformable" and tactile paintings, and mobiles. In '67 he developed a series of transformable sculptures made up of free modular elements, which allow the composition to be varied.

Albers, Josef
(Bottrop, 1888). Naturalized American painter, born in Germany. At Weimar between '20 and '23, student at the Bauhaus; stayed on at Weimar from '24–'33 as a teacher. In '33, when the Bauhaus school was closed by the Nazi government, he emigrated to America and taught at Black Mountain College, in North Carolina ('33 and '49). Later taught at Harvard University, in the Graduate School of Design, and in many other American universities up to '60 (Princeton University). A member of the international Abstraction-Creation group. Albers is a representative of one of the main European artistic tendencies transported to America. With Mondrian he is alone in the United States in remaining faithful to the geometric-concrete vision in an organized way. He uses colour-light in geometrical relationships as a means of plastic organization. His predominant theme, "the square within the square", offers him inexhaustible opportunities for luminous-chromatic variations, within a closed formula, absolutely dependent on internal relationships.

Albert, Hermann
(Ansbach, 1937). German painter. Associated with the "Ugly Realism" or "Critical Realism" movement in German painting, which mostly centers upon Berlin. Currently teaches in Braunschweig. Has exhibited in Berlin, Düsseldorf, Baden-Baden, Florence, and Milan.

Alechinsky, Pierre
(Brussels, 1927). Belgian painter. Studied up to '47 at the College of Architecture and Decorative Arts in Brussels, then made a number of study trips (Morocco, Yugoslavia). In '48 he joined the group *Jeune Peinture Belge*. Made a first stay in Paris and in '49, once again in Brussels, with Appel, Corneille, Jorn, Pedersen, and the writer Christian Dotremont, he was among the founders of the CoBrA group, and remained a member until its break-up in '51, after which he moved to Paris. In '53 he became technical director of the first number of the magazine *Phases* and also became a member of the "October Committee". In '55 he visited the Far East, afterwards making the film *Calligraphies Japonaises* (which won the '57 Bergamo Festival prize and a certificate of honour at the Tokyo Festival, '61).

Andre, Carl
(Quincy, Massachusetts, 1935). American art worker. Studied at the Phillips Academy in Andover (Massachusetts) from '51 to '53. From '53 he worked in Patrick Morgan's studio and from '58 with Frank Stella. From '60 to '64 was stoker and ticket collector on the Pennsylvania Railway. Lives in New York. Works in the field of Minimal Art (primary structures), using elementary geometrical constituents, also of "poor" materials, as a means of spatial denotation.

Anuszkiewicz, Richard
(Erie, Pennsylvania, 1930). American artist. His works are strictly in the field of optical art, of a perceptual and optical-dynamic type. He was one of the participants in "The Responsive Eye" review begun by the Museum of Modern Art in New York in '65.

Appel, Karel
(Amsterdam, 1921). Dutch painter. Studied in Amsterdam from '40 to '43. In '48 was one of the founders of the Reflex Group, which in '49 combined with the international CoBrA group. Has lived in Paris since '50. Won the UNESCO prize in the Venice Biennale of '54. Trained as an Expressionist, he has made a long study of the modern tradition in painting, from the Impressionists to Picasso. He has also followed the development of the School of Paris. Later devoted himself to the study of primitives and naïfs. His gestural, abstract interpretation of colour as an emotive, vitalistic fact expresses itself in a vivid, violent rendering of the image, interpreted in an Expressionist manner, with a personal vision of great feeling and irrational violence.

Arakawa, Shusaku
(Nagoya, 1936). Japanese painter. In '63 initiated a schematic type of pictorial technique in which the images, reduced to graphic silhouettes, relate to design objects in the field of technology. Slowly images gave way to a calligraphy composed of different texts in a sort of pregnant vacuum, out of which he created new possibilities for organizing images as if to illustrate the workings of the imagination through the systematic analysis of language. He is also the author of extremely interesting art films.

Archipenko, Alexander
(Kiev, 1887–New York, 1944). Russian sculptor, naturalized French and then American. In Paris in 1908 he studied ancient Egyptian and Central American sculpture. In '10 he made contact with the Analytic Cubism group. In '12 he experimented in his sculpture with holes and cavities which bring out the relationship with space. A member of the Sturm group from '13. In '14 he developed his sculpto-paintings, which were syntheses of painting and sculpture. In '21 he moved to Berlin and in '23 to the United States. With his "Archipentura" he later attempted a synthesis between painting, space, and time, introducing movement into his works. In his later years arrived at a type of sculpture ever more involved with spatial dynamics, including light and movement within the work by means of a Plexiglas filter. As Moholy-Nagy did, he calls these "light modulators".

Arman, Fernandez A.
(Nice, 1928). French art worker. Studied at the National School of Decorative Arts in Nice and at the Louvre School in Paris. From '67 to '68 he taught at UCLA. In '60 was one of the founders of the New Realism group, whose theorist was Pierre Restany. From informal poetics he moved to New Dada, by an accumulative process which he applied both to the *assemblage* of objects of the same kind, as well as parallel sections of the same object (mandolins, commemorative statuettes), and to a kind of frozen immersion in Perspex of coloured paint from different tubes, to show, as Restany wrote, "the pure and simple taking possession (accumulation) or pure and simple destruction (anger ... conservation, the discharge of hostility) in relation to the world's impenetrability".

Armitage, Kenneth
(Leeds, Yorkshire, 1916). English sculptor. Studied at Leeds Art College and became head of the Department of Sculpture at Bath Academy of Art. Figurative. Bases his dynamic-vitalistic research on a highly suggestive, geometrically structured framework, in a dialectical opposition that makes a lively visual impact.

Arp, Jean
(Strasbourg, 1887–Basel, 1960). German painter and sculptor, naturalized French. Began his artistic studies in Strasbourg and later went to the city's Art School until 1907. First went to Paris in 1904 (the year in which he published his first poems in *Das Neue Magazin*). In 1908 he went to the Académie Julian in Paris. In 1909, at Weggis in Switzerland, he first made contact with many artists with whom later, in '11, he founded the *Moderne Bund*. In '11 he also made

the acquaintance of Klee and Wiggs, and in '12, in Munich, of Kandinsky and Delaunay, taking part in the second exhibition of the Blaue Reiter. In '13 in Cologne he met Max Ernst; in '14, in Paris, Picasso, Jacob, and Apollinaire; and in '15 Sophie Tauber, whom he later married. After this he withdrew to Zurich, where he took part in the Dadaist meetings at the Cabaret Voltaire in '16. In '19, with Janco, he founded the *Association des Artistes Revolutionnaires* and took part in various Dadaist initiatives in Cologne, with Max Ernst, and in Berlin; in '23 he contributed to Schwitters' Dadaist review *Merz*. From '20 to '30 he was a member of the Surrealist group and took part in their first exhibition ('25). After '30 he joined the *Cercle et Carré* group and in '31 joined the group called Abstraction-Creation. He was one of the most vital and interesting figures of the contemporary artistic movement and was in the forefront of the principal avant-garde movements, constantly maintaining within each his own unmistakable personal expression, always aiming at an extreme formal purity within the freedom of an organic structure inspired by the spontaneous growth of nature.

Atlan, Jean
(Constantine, Algeria, 1913–Paris, 1960). French painter. Orthodox Jew. Moved to Paris in '30 and devoted himself to the study of philosophy and the formulation of a type of experimental poetry. From '41 he devoted himself to painting. Was interned in a psychiatric hospital during the German occupation. In '44 he published his first volume of poetry (*Le Sang profond*). Was a member of the group of artists from the School of Paris. His painting develops themes of signs which are of a symbolic and almost totemistic character and are vividly reminiscent of pre-Columbian and Negro art.

Ay-O
Japanese art worker. Was a member of the international Fluxus group. Works in the field of environments and happenings in an interdisciplinary form of expression, integrating music as well in his funk and "poor art" works in which he actively involves the onlooker.

Bacon, Francis
(Dublin, 1910). Irish painter of English origin. In '26 he began to make study trips to London, Berlin, and Paris. Having moved to London, he established contact with Sutherland, with whom he worked for a time. His works show a pitiless analysis of the atrocity of the existential condition of modern man, shown through the monstrous deformation of his image. For this purpose he has often chosen to rework famous portraits (Velásquez's *Innocent III*), which he transforms, with a violently expressive energy, into figures fixed in distraught expressions emerging from a gelatinous, organic, oppressive background, so as to symbolize the destruction of man. Bacon, with Giacometti, is considered the leader of the "New Figuration" which is existentialist in character.

Baj, Enrico
(Milan, 1924). Italian painter. After studying law in Italy and making a number of study trips to Paris and Brussels, he founded the *Movimento Nucleare* ('51) with Crippa, Dova, and others,

and he published its manifesto in Brussels. In '53, with Asger Jorn, he promoted the *Mouvement International pour un Bauhaus imaginiste* against the New Bauhaus at Ulm, founded by Max Bill. He developed his own ironic and demystifying language of a Neo-Dadaist type. He used collages of different materials (medals, broken mirrors, trimmings, etc.) with which he created his robot figures (the *Generals*, the *Ubu*), symbolizing the degeneration of the middle-class world. He branded this with his acute, satirical style, also denouncing the "appropriation" of all kinds of contemporary artistic expression (from the informal to Picasso) and the deforming manipulation that the self-interested consumerism of mass communication exerts on artistic activity.

Balla, Giacomo
(Turin, 1874–Rome, 1958). Italian painter. Lived in Rome from 1895; in 1900 he made a study trip to Paris, where he met Pissarro and joined the Pointillist movement. Later met Marinetti and in '10 joined the Futurists and signed the first Futurist Manifesto with Boccioni, Carrà, Luigi Russolo, and Severini. His experience of Divisionism helped in his explorations of Futurist dynamics, interpreted as a rapid fanlike shifting of the image, as in the photodynamics of Bragaglia and as in Duchamp's *Nu descendant l'escalier* (his *Cagnolino al guinzaglio* [*Dog on a Leash*] belongs, like Duchamp's work, to '12). He searched for the same dynamics in colours in his *Compenetrazioni iridescenti* (*Iridescent Interpenetrations*), which remain, almost prophetically, among the first outstanding examples of optical-dynamic research and of the interaction of colours as light. In '14 he published, with Despero, the manifesto entitled *Ricostruzione futurista dell'universo* (*Futurist Reconstruction of the Universe*).

Baumeister, Willi
(Stuttgart, 1889–1955). German painter. First visited Paris in '12; in '14 he again went to Paris, with Oskar Schlemmer, and their association is reflected in his first non-figurative works, which were highly disciplined in composition. He later met Kokoschka and Loos. Following this, he came closer to the purism of Le Corbusier and Ozenfant. In '33 he left the School of Fine Arts in Frankfurt because of Nazi persecution of what was defined as "degenerate art". In '37 he began to insert biomorphic motifs into his paintings, transforming them into great symbolic ideograms, and in his later years accentuated their ties with matter by making reliefs in sand. He had contact with Miró, Ernst, and Klee.

Bazaine, Jean
(Paris, 1904). French painter. Among the main representatives of the School of Paris, in '41 he organized, in Paris, the exhibition of the group called *Jeunes Peintres de Tradition Française*; he was also the group's theorist. Reasserting the chromatic values expressed first in Cubism and by the Fauves, he sought the essence of form expressed through colour and elementary structuring. After the war he moved from a figuration developed on these theories to an essential abstractionism developed from the dynamic structure of the sign. He is also the author of *Notes sur la peinture d'aujourd'hui* (*Notes on Contemporary Painting*).

Baziotes, William
(Pittsburgh, 1912–1963). American painter. Studied at the National Academy of Design in New York. During the war he remained in contact with American artists. In '48, with Motherwell, Newman, and Rothko, he was one of the founders of the "Subject of the Artist" school, forerunner of what was later termed the Pacific School. He interpreted the language of Abstract Expressionism in emblematic terms, with references to Oriental theories, and this gives life at times to symbolic and mysterious images.

Becher, Bernhard and Hilde
(Bernhard, Siegen, 1931; Hilde, Berlin). German art workers. Live in Düsseldorf. Work in the field of conceptual research, with anthroposociological implications. They use photographic means to document a fast disappearing industrial typology, with the intention of offering documentary material for archaeology in the future.

Bell, Larry
(Chicago, 1939). American art worker and sculptor. Lives at Ranchos de Taos New Mexico. Develops his plastic works in a form of Minimal Art, using neon light as a structural element and Plexiglas as a dynamic element, to enliven the structure of the image.

Beuys, Joseph
(Kleve, 1921). German art worker. Lives in Düsseldorf. Uses all kinds of media from photographs to felt, margarine, copper, even his own body, in an attempt to free the individual from the restrictions of an authoritarian society, anticipating certain themes of "behavioural" and Body Art, to show the present exploitation of man's capabilities.

Bill, Max
(Winterthur, 1908). Swiss architect, painter, sculptor, and designer. Studied in Zurich until '29; from '29 to '32 was a student at the Bauhaus in Dessau. From '31 he was a member of the Abstraction-Creation group. From '44 to '45 he taught in Zurich and from '51 to '56 he was director of the Hochschule fur Gestaltung (the New Bauhaus) at Ulm, which he had founded on the model of Gropius' Bauhaus. He has developed a pictorial and plastic language based on a rigorous structuring of form. His didactic interests developed according to a lucidly rational projectuality.

Blake, Peter
(Dartford, 1932). English painter. Studied at the Royal College of Art in London. One of the exponents of English Pop Art, he analyzes the world of advertising and television images, those of a depersonalized society, using photographic material which combines with his pictorial technique.

Boccioni, Umberto
(Reggio Calabria, 1882–Sorte, Verona, 1916). Italian painter and sculptor. Moved to Rome in 1901, and with Severini, Sironi, and Cambellotti he frequented Balla's studio. He began with Divisionism, which after 1907, in Milan, he interpreted, together with Previati, according to a psychological interest of the image, from which he later developed his theory of "states of mind". Meanwhile, he had stayed for

long periods in Paris, Russia, Padua, and Venice. He was interested in the symbolist culture of the Secession, in Munch, and in German culture, and after a careful reading of Bergson's philosophical works he came to define his concepts of "dynamism" and "simultaneity", which later formed the basis of Futurist poetics, as a synthesis of plastic and chromatic elements. On February 11, 1910, after a series of meetings with Carrà, Russolo, and Marinetti, Boccioni signed the Manifesto of Futurist Painters and shortly afterwards, with Carrà, Russolo, Severini, and Balla, he also signed the Technical Manifesto of Futurist Painting, in which he put forward the theories of plastic dynamism and of states of mind. In '13 he wrote the essay *Pittura e Scultura futurista* (*Futurist Painting and Sculpture*). In '13 he also wrote the *Manifesto tecnico della scultura futurista*. In the same period he painted *La città che sale* (*The City Rises*), 1910; *Visioni simultanee* (*Simultaneous Visions*), 1911; *Gli addii* (*The Farewells*), 1911. In the meantime he was an active proselytizer, making frequent trips abroad. In '15, gradually detaching himself from Futurist poetics, Boccioni became increasingly interested in plastic images through Cézanne's influence. However, having volunteered, he was killed in the war.

Bochner, Mel
(Pittsburgh, 1940). American painter and art worker. Lives in New York. In the field of conceptual art he uses mathematical and geometric "measurements" as instruments for the analysis of space.

Boetti, Alighiero
(Turin, 1940). Studied in Turin and later moved to Rome. He analyzed the creative process by which completed experiences of different kinds are transposed into art. From this he also developed the analysis of the creative process of the image.

Brancusi, Constantin
(Pestisani Gory, Roumania, 1876–Paris, 1957). Roumanian sculptor, naturalized French. Lived in Paris from 1904 and worked for Rodin from 1906–07. From 1908, after a post-Cubist and neo-Cézanne period, he turned to a search for a closer adherence to the essence of his materials (*The Kiss*, 1908), also maintaining his concentration on the motifs of Negro art. But his purist structural vision soon brought him to elaborate an individual language in defining a compact ovoid shape of a rare and extraordinary formal, as well as symbolic, intensity.

Braque, Georges
(Argenteuil, 1882–Paris, 1963). French painter. Lived in Le Havre from 1890 until his move to Paris in 1900 and there, through Othon Friesz's influence, he joined the Fauves. In 1907 he was at L'Estaque; there, through the study of Cézanne and inspired by a visit to Picasso at the Bateau Lavoir in Paris, where he saw *Les Demoiselles d'Avignon*, he developed the principles of Cubism, which linked him to Picasso in a union that lasted until '14. His initial themes, during the first (Analytic) and the second (Synthetic) Cubist periods, are still lifes. In these he introduced the use of techniques different from those of traditional painting, to assert the artist's freedom in the use of means of expression (the inclusion in his paintings of

letters and numbers, *papier collé* and collage). The breaking up of the plastic form in space, reproduced on the surface, and the reduction of temporal "duration" in a space-time synthesis are dominant themes of the Cubism which Braque developed with Picasso. The First World War separated the two artists, and afterwards Braque's work proceeded entirely independently. After '40 the themes of interiors and the flight of birds predominate in a new, dynamic conception of form in space, developing an extraordinarily coherent vision, even through the variations of themes and formulas which make Braque's language among the most effective.

Bravo, Claudio
(Valparaiso, Chile, 1936). Chilean painter. Lives in Madrid. He belongs to the Hyper Realist movement and is known for his nudes, such as his *Adam and Eve*, of which he has produced two versions with the images seen alternatively from the front and from behind, and for his portraits, characterized by a cold, analytic realism.

Brüning, Peter
(Düsseldorf, 1929). German painter and sculptor. Studied at the Stuttgart Academy of Art under the guidance of Baumeister from '50 to '52. In his early days as a painter he came under the gestural influence of Twombly. Since '64 he has elaborated his own kind of pictorial language in which the sign becomes a symbol, based on cartographic elements, with a clear reference to the modern urban and industrial environment.

Buffet, Bernard
(Paris, 1928). French painter. Began painting in '43. With Rebeyrolle, Minaux, Mottet, Venard, and other young members of the group called *L'homme témoin*, which he joined in '49, he rejected abstract tendencies for a spare and concise figuration, which resolves itself in the use of black in clean lines, in a sectional development according to the contours of the images, reduced to outlines in cold and livid tones.

Burri, Alberto
(Città di Castello, 1915). Italian painter. He began to paint in '44, when he was a prisoner of war in Texas. Has lived in Rome since '45. He was a member of the *Origine* group from '50 to '52, with Ballocco, Capogrossi, and Colla. Already non-figurative in '47, he concentrated from '48 to '49 on studies of materials. His first *Sacks* belong to '52 and the first *Cinders* to '56; they are followed by *Plastic*, *Wood*, *Paper*, in a crescendo of denunciation of the waste and the spoilt, burnt, shattered, filthy remains that man leaves behind, evidence of his condition in the modern world. Between '57 and '60 he worked on the *Iron* series; later came the backgrounds of burnt cellophane and the *Cellotex*.

Bury, Pol
(Haine-Saint-Pierre, Belgium, 1922). Belgian art worker. Studied at the Mons Academy of Art until '38; in '39 he met Chavet and Laurent, two poets of the *Rupture* group; in '48, influenced by Magritte and Tanguy, he took part in the international Surrealist exhibition at Brussels. In '47 he was one of the group *Jeune Peinture Belge*; after '49 he took part in the

activity of the international CoBrA group with Alechinsky. In '54 he gave up painting to present his "mobile planes" for the first time. Since then he has been occupied with kinetic art.

Calder, Alexander
(Philadelphia, 1898–New York, 1976). American sculptor. After graduating in engineering he studied design at evening classes. In '26 he moved to Paris, where in '27 he exhibited his first sculptures in steel wire, in which he had already tackled the possibilities of movement. In '28 he held his first personal exhibition in New York and, on his return to Paris, became the friend of Arp, Miró, Mondrian, and Léger. In '31 he joined the Abstraction-Creation group and created the first abstract sculptures, which Arp called "stabiles". He followed them with his first sculptures driven by a working motor, and from these moved on to "mobiles", structures whose movement depends on that of the air.

Calzolari, Pier Paolo
(Bologna, 1943). Italian art worker. Lives in Bologna and works in the area of "Process" art, with connections in "poor art" and Conceptual Art, according to a fairy-tale vision of the world and of existence which permits him to capture the poetic quality of everyday things transposed into a strange setting.

Camargo, Sergio de
(Rio de Janeiro, 1930). Brazilian sculptor. Worked first at Buenos Aires with Emilio Pettoruti and Lucio Fontana. In '48 he went to Paris for the first time and concentrated on the study of Brancusi and Arp. He was again in Paris from '51 to '53, and in '54 he visited China. Since '61 he has lived in Paris. He has developed an optical-dynamic language, creating monochromatic surfaces made up of modular cylindrical sections arranged in a close series at different angles, producing an interesting and lively chiaroscuro effect.

Capogrossi, Giuseppe
(Rome, 1900–1972). Italian painter. After attending the Carena studio he was in Paris until '32, producing works in a Post-Cubist style. In Rome after '32, with Cagli, Cavalli, Mafai, and Pirandello, he formed the group later known as the Roman School. After a series of journeys to Austria and Sardinia he moved in '49 to abstract art, becoming with Burri a member of the *Origine* group. In '53 he signed the Sixth Spatialist Manifesto with Fontana, Crippa, and Dova. Since '46 he has developed an emblematic synthesis of form, consisting in the identification of a kind of elementary graphic lettering, echoing the archaic symbols of remote civilizations and characterized by a lively emotive force and great formal dignity.

Caro, Anthony
(London, 1924). British sculptor. From '51 to '53 he was Henry Moore's assistant. In '59 he made his first visit to America, where he taught from '63 to '64. In this period he met Albers, Noland, and David Smith. From his American experience he derived a new idea of sculptural language, in which the plastic element, reduced to its essence in accumulations of material in direct relation to the surrounding space, rejects any implications of formalism.

Carrà, Carlo
(Quargnento, 1881–Milan, 1966). Italian painter. Trained at the Brera, after a visit to Paris in 1900, and in London, with Tallone. He was active in anarchist circles in Milan and London; as a painter he moved from Divisionism to Futurism, signing in '10 the Painters' Manifesto with Balla, Boccioni, Russolo, and Severini. In '13 he contributed to *Lacerba*, and in '15 he published *War Painting*. His love for the Old Masters and his meeting with De Chirico and Savinio in the Ferrara military hospital in '16 impelled him towards a metaphysical vision of reality and thence to the "magical realism" which was the basis of the Italian *Novecento* movement. Carrà was among the founders of this movement and was one of the advocates of a new conception of sculptural representation, of fifteenth-century inspiration.

Castellani, Enrico
(Castellamare, Rovigo, 1930). Italian painter. After moving to Brussels at the age of twenty-two, he studied painting and sculpture at the Academy there. In '53 he graduated in architecture. In '59 he founded the magazine *Azimut* with Piero Manzoni and Vincenzo Agnetti. He developed a rigorous and precious formal language from an optical-plastic source created by the incidence of light on the canvas, using negative and positive reliefs obtained by fixing the canvas in the frame or raising it out.

Caulfield, Patrick
(London, 1936). British painter. From '57 to '60 he studied at the Chelsea School of Art and from '60 to '63 at the Royal College of Art. He teaches at the Chelsea School of Art. He works in the manner of Lichtenstein, basing his own paintings on the images of the mass media, using them for their visual implications rather than for their literary significance.

César (César Baldaccini)
(Marseille, 1921). French sculptor. After studying at the School of Fine Arts in Marseille and having worked in the studio of the sculptor Cornu, he was in Paris in '43, attending Gaumont's studio. In the field of New Realism, he works violently on industrial waste material from which, by "compression", he draws disturbing images that symbolize the destructive stress man suffers daily in the consumer society. He is well known for his "compressions" of car bodies.

Cézanne, Paul
(Aix-en-Provence, 1839–1906). French painter. In Paris from 1861 he identified himself with Camille Pissarro and the future Impressionists. During the Franco-Prussian War in 1870 he withdrew to L'Estaque. He later returned to Paris, and in '73–'74 he stayed with the well-known Dr. Gachet. Through his contact with Pissarro he came closer to the Impressionists and exhibited with them at Nadar's studio in '74. In '78 he settled permanently in Provence, except for a brief stay in Paris in '88, when he discovered Gauguin, Van Gogh, and Bernard. In '95 he held his great Paris exhibition, organized by Vollard, but it was his great retrospective in 1907 that revealed the innovatory force of Cézanne's painting, the significance of his "modelling through colour", of his *"refaire Poussin sur nature"*. His well-known decision "to treat nature by means of the cylinder, the sphere, and the cone" later came to be an article of faith for the Cubists, who took from him the structural and plastic significance of volume in space.

Chadwick, Lynn
(London, 1914). British sculptor. Studied architecture and turned to sculpture in '45, under the influence of Calder. Later developed a sculptural representation of a symbolic kind (insects, monstrous animals), in a dynamic and rigorous synthesis which the critic Herbert Read called the "geometry of fear".

Chamberlain, John
(Rochester, Indiana, 1927). American sculptor. From '41 to '44 he served in the American Navy; from '50 to '54 he attended classes at the professional school of the Art Institute of Chicago. He taught from '55 to '56 at Black Mountain College in North Carolina with Charles Olson. He lives in New York and Los Angeles. Worked in Abstract Expressionism and later developed a Neo-Dadaist type of plastic expression, based on the *assemblage* of technological materials rendered visually aggressive by the use of vivid industrial colour.

Christo (Jaracheff)
(Gabrovo, 1935). Bulgarian sculptor. Lives in New York. Works in the area of New Realism and of performance art. His *empaquetages* of objects began about '58 and suggest the increasing anonymity to which consumer culture is leading us. Carried onto an environmental scale, they relate to the poetic of land art, resulting in visual effectiveness.

Clarke, John Clem
American art worker. Works along the lines of American Hyper Realism in the new objective manner, creating pictures from photographic materials, where the reality of the image is crystallized and frozen by the technique.

Close, Charles
(Monroe, Washington, 1910). American painter. Lives in New York. Works in Post-Pop pictorial activity, intent on re-creating the realistic image as it is given us by means of actual reproduction (from photography to rotogravure); in this the image takes on a stereotyped character, "more real than real", crystallized by a vision which is not that of realistic optics. He belongs to the Hyper Realist group.

Corneille (Cornelis van Beverloo)
(Liège, 1922). Belgian painter. Studied in Amsterdam from '40 to '43. In '48, with Appel and Constant, he was one of the founders of the "Experimental Group" of the magazine *Reflex* and later, with Appel, Alechinsky, and Jorn, of the CoBrA group. He has lived permanently in Paris since '49 but makes frequent trips to Denmark, Sweden, Tunisia ('48), South America, the Antilles, and New York ('58).

Cornell, Joseph
(Nyack, New York, 1903). American sculptor. After beginning in painting he soon abandoned it to develop *assemblages* of heterogeneous objects, which he arranged in a painted case, with symbolic suggestions of a kind of memory-objects. His repertory later grew more complex with the inclusion of constantly different elements (glass, mirrors, photographs, stuffed birds), to increase the sense of narrative profundity and multiplicity.

Cottingham, Robert
(Brooklyn, New York, 1935). American painter, living in Los Angeles. Studied at the Pratt Institute in New York and belongs to the Hyper Realist movement.

Cruz-Diez, Carlos
(Caracas, 1923). Venezuelan painter and sculptor, living in Paris. Works in the optical-perceptual area and belongs to the international group *Nouvelles Tendances*. He draws on perceptions based on effects of anamorphosis and of false perspective.

Dado (Miodrag Djuric)
(Cettigne, Montenegro, 1923). Yugoslavian painter. After studying in Montenegro he moved in '56 to Paris, where he worked as a lithographer until he was discovered by Dubuffet and began to exhibit ('58). Dado's language, stimulated by a Surrealistic symbolism and expressed in almost naïve forms, reveals itself in a proliferation of images which all appear as if drawn from excrescences of nature, vegetable or mineral.

Dali, Salvador
(Figueras, 1904). Catalan painter. Trained in Madrid, friend of Federico Garcia Lorca and Luis Buñuel. After a first period of varying experiences, Futurist, metaphysical, and Cubist, he met Picasso, Miró, Breton, and Eluard in Paris in '27 and became a Surrealist; he developed, however, his own haunted and extravagant vision, which he described as his "paranoiac-critical method", based on psychoanalysis and automatism. He has written various books (*La Femme visible*, '30; *The Secret Life of Salvador Dali*, '42), contributed to *Minotaure* and *Cahiers d'art*, and worked, with Buñuel, on the screenplay of the Surrealist films *Le Chien andalou* ('29) and *L'Age d'or* ('20). He abandoned Surrealism in '34 after being repudiated by Breton. His language thereafter became one of almost academic realism, increasingly elaborate and artificial. In '39 he settled in the United States. The extravagance of his behaviour has always echoed his eccentric and exhibitionistic pictorial vision.

D'Arcangelo, Allan
(Buffalo, 1930). American painter. Lives in New York. In Pop Art, D'Arcangelo analyzes the new visual reality of the landscape expressed in the road, whose linguistic dimension is reflected in the sharp partition of lines and stripes, and in the incidence of traffic signs or of the "signs" and "traces" of events (such as the assassination of John Kennedy seen in the car's broken driving mirror), all of which replace direct contact with a nature unconditioned by urban man, with a new technological nature.

Davies, John
(Cheshire, 1946). British sculptor. Studied painting at the Manchester College of Art and sculpture at the Slade School in London. In '70 he won the Sainsbury Prize. He has exhibited in various European cities and recently at Edinburgh in an exhibition organized by Annely Juda Fine Art. His sculptures, similar to those of the Surrealists, are created by casting from life and aim at mirroring the greyness of daily life.

Davis, Stuart
(Philadelphia, 1894–New York, 1964). American painter. Studied in New York from '10 to '13 and was present at the famous Armory Show ('13). On that occasion he abandoned the academic education of Robert Henri and became a follower of Synthetic Cubism in large works, imitating collages and pasted papers ('17–'21). He then moved on to Constructivism and later, after journeys to New Mexico ('23) and Paris ('28–'29), he developed his brilliant vision of the modern city.

De Andrea, John
(Denver, Colorado, 1941). American art worker, living in Denver. Studied at the University of Colorado. A Hyper Realist, he creates sculptures in coloured polyester that seem perfect casts of the persons he represents, caught in the actions of ordinary life; as in the example of the couple (*Arden Anderson and Nora Murphy*, '72) exhibited at Kassel in '72.

De Chirico, Giorgio
(Volos, 1888 – Rome, 1978). Italian painter, born in Greece. Studied in Athens and Munich from 1906. At the height of the Secession he came under the Symbolist influence of Boecklin and became interested in the philosophical theories of Nietzsche, Schopenhauer, and Weiniger; Weiniger's ideas were later essential to the formation of his own metaphysical aesthetic. In 1908 he was in Milan and in '11, after a short stay in Turin, a city that for him evoked magical images, he was in Paris, where he stayed until '15, together with Apollinaire and Picasso. In '15, while in Ferrara for his military service, he met Carrà and from this friendship and his acquaintance with Morandi, De Chirico developed the "metaphysical painting" which he pursued until '18. During this period he produced *Le Piazze d'Italia (Italian Piazzas), Le Muse Inquietanti (The Disquieting Muses), Ettore e Andromaca (Hector and Andromache)*. At the same time, with Carrà, Savinio, Morandi, and Broglio, he contributed to the magazine *Valori plastici (Plastic Values)*, which aimed to lead Italian painting back to its original values. He was in Paris once again in '24 and the next year he took part in the first Surrealist exhibition, his pictures having aroused great interest in those circles. But already since '18 he had begun a period of cultural revision of the past, which after '24 led him to return to a monumental classicism in the Italian climate of "a return to order". In Paris, in dispute with André Breton, De Chirico produced, together with his classical-realist works, a number of fantastic paintings in which he rendered his own individual Surrealist vision. In the meantime he attempted new techniques elaborating a kind of painting with a thick impasto, giving a bright, enamelled, pearly surface. This is the period of the *Mannequins*, the *Gladiators*, and the *Horses*. About '40, after a series of visits to America and Europe, De Chirico settled permanently in Rome.

De Kooning, Willem
(Rotterdam, 1904). Dutch painter, naturalized American. After studying in Holland, in '26 he was in New York. In '34 he was already painting abstract as well as figurative works. In '46 his language defined itself in the automatic use of the gesture, Surrealist in origin but in its psycho-dynamic function foreshadowing action painting.

Delaunay, Robert
(Paris, 1885–Montpellier, 1941). French painter. After a Fauvist period he turned through the study of Cézanne to Cubism and initiated its third phase, that of "Orphic" Cubism (according to Apollinaire's definition). This was seen as a study of colour-light, of the interpenetration, the simultaneity, and the dynamism of the planes of colour (the series of *The City of Paris* and *Windows* and, later, *Circular Rhythms* and *Simultaneous Discs*), in which the planes of light are broken down into facets, creating dynamic whirling syntheses, along the lines of Seurat's and Chevreuil's theories of colour. After returning, around '25, to figurative painting, he redeveloped the abstract style in about '30, seeking, with his wife, an architectonic integration of his work in murals.

De Maria, Walter
(Albany, California, 1935). American art worker. Works in the field of land art and "actions", with Conceptual implications.

Dibbets, Jan
(Veert, 1941). Dutch art worker. In his Conceptual works he uses photography as an instrument for the analysis of visual perception in its temporal aspect. In this he uses images in sequence to form a kind of diagram of the temporal and spatial development of the event being perceptually investigated.

Dine, Jim
(Cincinnati, 1935). American painter. After training in Boston he moved to New York in '58 and, with Chamberlain, Oldenburg, and Stella, joined the Pop Art movement. This, however, he elaborated in an expressive development of action painting in a Neo-Dadaist manner, following a special technique of *assemblage* of objects positioned in the painting in a kind of collection which does not aim to assume a plastic or symbolic significance but to present the object as a real, contingent presence.

Dockley, Peter
American art worker. He has been one of the exponents of the tendency which, following Allan Kaprow, has produced spectacular Happenings and "Action-Environments", representing man's life in present-day society.

Donaldson, Antony
(Godalming, Surrey, 1939). British painter. Studied at the Slade School and from '58 took part in the Young Contemporaries exhibitions. A representative of Pop Art in England, he uses a figuration developed through backgrounds of flat colour by rotogravure, combining painted images with photographs.

Dorazio, Piero
(Rome, 1927). Italian painter. Studied architecture in Rome, exhibiting while very young with the Roman group *Arte sociale*. After the war he worked with Perilli, Guerrini, and Buratti; and in '47, with Accardi, Attardi, Consagra, Guerrini, Perilli, Sanfilippo, and Turcato, he signed the *Forma Uno* manifesto, the expression of Italian abstract painting at that period. His work, constantly renewing itself, focuses on values of "sign-colour-light", realized through textures of fine colour signs with intense effects of light or in intersecting bands of colour, or expanses of colour in which variously arranged blotches spread over the canvas.

Dubuffet, Jean
(Le Havre, 1901). French painter. After classical studies he devoted himself to music, literature, and commerce. From '33 he concentrated on painting, only to abandon it in '37 for a business career and take it up once again for good in '47. Starting from the use of the informal technique in the manner of Fautrier, Dubuffet elaborated a style derived from the noncultural manifestations of figurative art (drawings by children, the insane, or primitives) which he calls *art brut*. In varied, complex works aimed at investigating the possibilities of the materials and of spontaneous expression can be recognized the dreamlike element and the automatism typical of Surrealist themes. His three trips to the Sahara ('49) greatly influenced his work. His painting developed in great cycles: the series *Peinture de la vie moderne (Paintings of Modern Life)*, '39–'43; the series of *Grotesque Landscapes*, of the *Corps des dames* and *Sols et terrains* ('46–'52), developing his studies of materials; *Assemblages* and *Texturologies* ('53–'59), using collages of different materials; *Phénomènes* ('58–'62); *Matériologies* ('59–'60), *L'Hourloupe* ('61–'62), with Neo-Dadaist and Expressionistic echoes; *Cabinet Logologique* ('67); *Découpés peints* ('71). Particularly interesting is his relationship with Jorn, with whom he composed music in '60.

Duchamp, Marcel
(Blainville, 1887–Neuilly, 1968). French painter. After beginning as a caricaturist he went through phases of Fauvism and Cubism. In '11 he joined the *Section d'or*. In '12 he painted his first *Nu descendant l'escalier*, which created a great scandal when exhibited in '13 at the Armory Show. With this work Duchamp related the demands of Cubism to those of Futurist photodynamics. In '14 Duchamp invented the ready-made, the common object, taken from its usual context and re-employed as the artist's "work", with the purpose of demystifying and profaning the traditional concept of art. On his first trip to New York, Duchamp met Man Ray, the photographer Stieglitz, and Picabia, and with them he initiated the Dadaist movement in America; as in Europe this proposed the nihilistic and ironic overthrow of all established academic institutions in the world of art and consequently in society as well. His great work on glass, *La Mariée mise à nu par ses célibataires, même* (the *Large Glass*), on which he worked incessantly from '15 to '23 and which he left unfinished, is the synthesis of all his alchemic-magic theories and of his idea of art as a "mental" fact. During the 1920's he worked on kinetic objects and produced the Dadaist-Surrealist film *Anémic Cinéma*. He stopped painting in '23, although he continued his busy activity of demystifying art and liberating it from outmoded, traditional dogma. In his last years he produced a series of multiples from his most famous ready-mades and a work for the Philadelphia Art Museum, *Etant donnés* (a sculptural-erotic environment), which was closed to the public, except for a peephole, according to his wishes.

Duchamp-Villon, Raymond
(Danville, 1876–Cannes, 1918). French sculp-

tor, brother of Jacques Villon, Marcel, and Suzanne Duchamp. Abandoned medicine for sculpture. Studied in Paris. Applied to sculpture the Cubist principles of shifting planes and simultaneity.

Ensor, James
(Ostend, 1860–1949). Belgian painter and engraver. Was one of the major contributors to the Symbolist movement between 1880 and '90, and one of the most important exponents of Surrealism, which he interpreted with an inexhaustible vein of invention and magical, fantastic imagination. He lived for most of his life in Ostend except for a brief period in Brussels. After an unhappy childhood under the influence of a dominating mother and a sensitive and weak father who died an alcoholic in '87, Ensor studied at the Brussels Academy. In '83 he joined the group called *Les XX* and later joined *La Libre Esthétique* ('94). After a naturalistic-realist period he passed to a so-called dark period ('79–'83), during which he used a special chiaroscuro technique. He later achieved the fantastic vision of a symbolic-grotesque kind which became typical of his work and which anticipated many later tendencies such as Expressionism and Fauvism.

Ernst, Max
(Brühl, 1891–Paris, 1976). German painter and sculptor. Studied philosophy at Bonn (1909–11); later met Macke and became associated with the Blaue Reiter movement ('13). He moved from the climate of Abstract Expressionism to that of Dadaism and took part, with Arp and Baargeld, in the formation of the Cologne Dadaist group ('19). In Paris in '21 he was among the founders of Surrealism. In '25 he discovered the technique of *frottage*, obtained by rubbing with black lead on a sheet of paper placed over rough surfaces (wood, bark, cloth). In contrast to the automatist theory of Breton he developed a conception of Surrealism based on the symbolic significance of the image, about which he wrote his *Traité de la peinture surréaliste*. From '25 to '39 he worked on several series of well-known works from *Histoire naturelle* ('25), to *Une semaine de bonté*, a series of graphic works with a marked fantastic emphasis, to the organic series of *Forests* ('27) and *Cities* ('35–'36). After '39 he moved to the United States, where he greatly influenced young artists. Since the war he accentuated the narrative element in his works, while an historical-anthropological dimension enriched his vein of lyrical fantasy. He also invented the technique of "dripping" (the dripping of colour directly onto the canvas), which became characteristic of Pollock's action painting.

Errò, Gudmundur Gudmundson
(Olafsvik, Iceland, 1932). Icelandic painter, naturalized French. Studied in Reykjavik and Oslo; has lived in Paris since '58. In the field of realistic representation Errò has developed a kind of narrative *assemblage* of images drawn from every period of history in a proliferation at once naïve and also linked partly to the realist vision of Mexican murals.

Estes, Richard
(Evanston, 1936). American painter. A member of the Hyper Realist movement, which aims to reproduce the raw objectivity of the image, mixed and stereotyped by the methods of actual reproduction, from photography to roto-gravure, which crystallize and finally denature an immobilized moment of reality.

Fahlström, Öyvind
(São Paulo, 1928). Brazilian painter, naturalized Swede. Lived in Sweden from '39 to '61, when he settled in New York. He began by studying archaeology and the history of art, writing poetry and dramatic pieces and working in journalism. In '52, while working with the Fries Opera, he began to paint, with narrative and dynamic intentions. In '62 he produced the first examples of variable paintings, composed of two or three basic elements which have a dominant colour. His work presupposes the presence of the spectator who actively participates in the artistic process, arranging the parts of the composition according to his own idea of form. Often the individual parts of a Fahlström work are magnetized, for ease of movement. His subjects relate to the political, social, and scientific events of today.

Fautrier, Jean
(Paris, 1898–1964). French painter. Studied in London and moved back to Paris at the outbreak of the First World War. From '20 to '30 he produced works of a realistic type. In '34 he ran a hotel in the mountains of Upper Savoy and worked as a ski instructor. He was back in Paris in '40 and in '43, with his *Otages*, he initiated European informal art, creating material-gestural systems of great expressive force.

Ferrer, Rafael
(San Juan, Puerto Rico, 1933). Puerto Rican art worker. Lives in Philadelphia. Studied at the University in Puerto Rico and at Syracuse University; he has taught at the Philadelphia College of Art. He works in "poor art" with connections in land art.

Flannagan, John Bernard
(Fargo, North Dakota, 1895–New York, 1942). American sculptor. After studying painting from '14 to '17 at the Minnesota Institute of Arts and with Arthur Davies, he turned to sculpture. He preferred to use stone, revealing its rough, natural surface. His favourite subjects were animals, which he rendered in his own formal synthesis, and birth, the origin of life and of form, with results that were always very much his own and vitalized by his personal touch.

Flavin, Dan
(New York, 1933). American art worker. His works seek a perceptible realization of space, against which he sets elementary structures (in the manner of the exponents of Minimal Art), employing neon tubes as instruments of his expressive technique.

Fontana, Lucio
(Rosario de Santa Fé, Argentina, 1899–Milan, 1964). Italian painter and sculptor. From childhood he lived in Milan, and he studied at the Brera with Wildt. In '34 he was a member of the Parisian Abstraction-Creation group and in '35 exhibited in Turin and Milan with the first Italian abstract artists. Meanwhile, he worked in ceramics. From '39 to '46 he was in Argentina, where he published the *Manifesto Blanco* with his pupils; back in Milan in '47, he founded Spatialism and, at the Naviglio Gallery, created the first "spatial environment" with black light. In '49 came the first "holes" in his *Spatial Concepts* and in '58 the first "slashes". In '61 his *Spatial Concepts* were dedicated to the American city. Fontana's importance in contemporary Italian art has been fundamental because of his revolutionary role, the clarity with which he established his language, the richness of his creative fantasy, and the human feeling conveyed in his work. He was the first to identify in Secessionist art the possibility of its transformation into the language of the avant-garde. The school of Wildt and the influence of baroque culture (which remained the indispensable principles of his expression) provided the range and the richness of content of his spatial abstraction, permitting him, in cases such as the sketches for the doors of Saint Peter's, to achieve a very vital and articulate figurative language. The focal point of his work is in the *Spatial Concepts* (the "holes" and later the "slashes") where the artistic process is revealed in the dynamic gesture, the onslaught on the material that dominates and at the same time liberates it, which some ten years later developed into the violent "slashes" of the canvas.

Francis, Sam
(San Mateo, California, 1923). American painter. He was the pupil of Clyfford Still at San Francisco after the war, during which he was wounded while serving in the Air Force. In '50 he was in Paris, where he joined the group of American painters, with Riopelle. Later he journeyed to the Far East. He belongs with Abstract Expressionism and action painting but has developed within them his own symbolic-gestural style.

Frankenthaler, Helen
(New York, 1928). American painter. Studied with Rufino Tamayo at the Dalton School in New York. After a period of redeveloping the language of Cubism she moved to Abstract Expressionism through the study of Gorky and Kandinsky. In '50 she was working with Hans Hofmann and knew the work of Pollock and De Kooning. In '58 she married Robert Motherwell. Her style shows itself in a sensitive and lyrical treatment of colour, which she uses in broad thick strokes, strictly controlled even with the freedom of the movement. She uses predominantly acrylic colours.

Fuchs, Ernst
(Vienna, 1930). Austrian painter. Studied at the Vienna Academy with Gütersloh from '46 to '50. He lives in Vienna and Paris. He is one of the members of the new Viennese school which develops figurative themes, "Fantastic Realism". Inspired by mystical symbolism and by German graphics of the sixteenth century, their works are distinguished by their special magical, Surrealist character, with many psychological implications.

Gabo, Naum (Naum Neemia Pevsner)
(Bryanks, Russia, 1890). Russian-American sculptor. The brother of Antoine Pevsner, he began by studying medicine and natural sciences at the University of Munich, where he also followed Wölfflin's seminars on the history of art. He visited Italy in '12 and '13, and in '14 visited his brother, who was living in Paris; the latter introduced him to Cubism and Orphism. At the outbreak of the First World War he went

to Oslo, where his brother joined him. In '17, after returning to Russia, the two brothers published the "Realist Manifesto", in which they put forward the Constructivist programme ('20). In '22, when it was clear that Russia was not supporting the avant-garde, Gabo moved to Berlin and stayed there for ten years, maintaining contact with the Bauhaus and the Dutch De Stijl group. In '30 he held his first personal exhibition, entitled *Konstruktive Plastik*, in Hanover. Two years later he moved to Paris, where he became one of the organizers of the Abstraction-Creation group. In '35 he was in London, where with other contributors he directed the magazine *Circle*. In '38 he made his first visit to the United States, where he has lived since '46.

Gauguin, Paul
(Paris, 1848–Marquesas, 1903). French painter. As a child (1851) he lived in Lima with his family. On returning to France he studied in Orléans, and after a spell as a trainee pilot in the merchant navy he worked as a stockbroker in Paris and began a comfortable, middle-class existence. His friendship with the painter Schuffenecker encouraged him to take up painting. He later met Pissarro, who introduced him to the Impressionist group ('80). In '83 he gave up his job and followed his wife to Copenhagen. In '85 he was back in Paris and in '86 was at Pont-Aven, in Brittany, leaving immediately afterwards for Martinique, with his friend Laval. In '88 he was once again at Pont-Aven, and with Emile Bernard he initiated the Pont-Aven School, based on "Synthetist" theories and the antinaturalist technique of *cloisonnisme*, which was related to the technique used in medieval stained-glass windows in which the colours are enclosed within a metal framework. The idea of a new spirituality inspired all the new painting, giving its character to the image, colour, composition, and subject of the painting. At Pont-Aven, Gauguin met Sérusier, who was to transmit the Symbolist inspiration to Paris through the *Talisman* painting. Meanwhile, Gauguin met Van Gogh at Arles, but their relationship was broken up tragically by Van Gogh's aggression and the flight of Gauguin. In '91 he went to Tahiti for the first time, returning in '93 and again in '95 (the second Tahiti period). In 1901 he moved to the Marquesas Islands, no longer able to separate himself from the subjects essential to his painting, which sought in the savage or primitive world the origins of the symbolic spirituality that the civilized world had forgotten.

Genovés, Juan
(Valencia, Spain, 1930). Spanish painter. Studied at the Valencia Academy until '50. Lives in Madrid. His subjects relate to the progressive standardization of the human being, which he represents in dense groupings seen from the air, that form almost solid conglomerations, with collective expressions of fear or of obsessive and irrational will.

Gentils, Vic
(Ilfracombe, England, 1919). British sculptor, living at Antwerp. He interprets the New Realist style in an individual manner, creating *assemblages* of objects from ordinary life with a nineteenth-century flavour, in a sort of memory-totem of a gently familiar, poetic, and intimate world.

Giacometti, Alberto
(Stampa, Grigioni, 1901–Paris, 1966). Swiss painter and sculptor. After studying at Geneva he was in Italy from '20 to '21 and he settled in Paris in '22, studying with Bourdelle at the Académie de la Grande Chaumière. He developed from plastic work of a Cubist type to Surrealism ('29–'35) and after the Second World War achieved a definition of his own figurative language, emphasizing an existential relation between the image and space, as a symbol of the extreme impoverishment and alienation man suffers in society.

Gilardi, Piero
(Turin, 1942). Italian art worker, living in Turin. Working in the artistic activities that have developed from Pop Art, Gilardi has elaborated an artificial re-creation of nature, demonstrating with an acute and cold irony the ever-more-obvious impossibility for urban man of being able to establish a direct contact with nature.

Gilbert & George
(Gilbert, Italy, 1943; George, Orven, England, 1942). British art workers, working in London. They work in performance art, offering their own bodies as "living sculpture". In this they appear together, often with their faces painted silver, stick in hand, and making banal, minimal gestures.

Gnoli, Domenico
(Rome, 1933–New York, 1970). Italian painter. After receiving a classical education from his father, which led him to a traditional style of painting, he concentrated from about '50 on set designing. Moving to the United States, he developed his own interpretation of the expanded image characteristic of Pop Art, examining details of commonly used objects on a distortingly exaggerated scale and representing the object with a pictorial technique close to fresco.

Goings, Ralph
(Corning, California, 1928). American painter. Studied at the California College of Arts and Crafts up to '53 and at Sacramento State College ('66). Belongs to the Hyper Realist group of painters, also known as the Sharp-Focus Realism group.

Gonzales, Julio
(Barcelona, 1876–Paris, 1942). Spanish sculptor and painter. Born into a family of goldsmiths, he exhibited at the International Exhibition of Barcelona in 1892, at the height of the Art Nouveau period. He was in Paris in 1900, in Picasso's circle. After '27 he concentrated on metal sculpture, being the first to use the techniques of relief and of welding which Picasso later used, techniques Gonzales had experimented with during the war in the Renault car-welding section. After '27 he also took part in *Cercle et Carré*, formed in Paris by Torres Garcia.

Gorky, Arshile
(Tiflis, Armenia, 1904–Sherman, Texas, 1948). Armenian painter and naturalized American. He emigrated with his family to Transcaucasia during the First World War and worked as a typographer at Erivan. In '20 he moved to the United States. From '26 he attended the Central School of Art in New York, where he later taught, and became the friend of De Kooning, Stuart Davis, and later Max Ernst and Tanguy, through whom he came permanently under Surrealist influence. He later joined the group of American Abstract Artists ('30–'40). From '36 he worked for the WPA (Federal Art Project), creating frescoes, now destroyed, for the Newark Airport in '36 and for the aviation building at the New York World's Fair ('38). After meeting Matta and Breton ('44) he turned towards lucidly tense and dramatic painting, reflecting visionary influences, in which the Surrealist elements combine with a violent and dynamic gesturality of great expressive force. In '46 a fire in his studio destroyed forty-seven works. In '47 he became gravely ill; and in June, '48, in an accident he was seriously disabled. That July he took his own life.

Gottlieb, Adolph
(New York, 1903). American painter. A student of Jung's psychology, he developed a version of Abstract Expressionism which began from the meditative and contemplative assumptions of the Pacific School and resulted in a kind of action painting.

Guttuso, Renato
(Bagheria, 1912). Italian painter. After studying at Palermo he came to Rome as a young man and established contact with the artists of the Roman School. In '32 he formed the "Corrente" group in Milan and there developed the political-social beliefs that later led him to fight in the Resistance. After the war he belonged to the "New Front for the Arts". He is the most authoritative representative of Italian social realism, which takes its starting point from Picasso's post-Cubism and from the realist Expressionism of Mexican painting.

Haacke, Hans
(Cologne, 1936). German art worker, living in New York. He develops his work in Conceptual Art in an ideological fashion, in an analysis by means of photographs relating to urban life and the economy.

Haese, Günter
(Kiel, 1924). German sculptor. Studied with Bruno Goller at the Düsseldorf Academy and later worked as an assistant to Ewald Mataré until '48. His fragile, vibrant constructions in thin metal wire, combined with pieces of watch mechanism and mobile elements, achieve a delicate poetic lyricism recalling the lightness and lucid freshness of some of Klee's images.

Hamilton, Richard
(London, 1922). British painter. He is one of the major representatives of Pop Art and one of the first, even including the Americans. His first Pop collage (*Interior I*), of '56, shows a caustic intelligence in its use of photography as one of the means of expression closest to the iconography of the mass media.

Hanson, Duane
(Alexandria, Minnesota, 1945). American painter, living in New York. His work in Hyper Realism uses outlines of plastic and reproduces figures from different social levels in banal attitudes, ironically attacking the standardization of contemporary life.

Hartigan, Grace
(Newark, New Jersey, 1922). American painter. After graduating from Millburn High School in '40 she worked at first in New York. In '49 she was in San Miguel de Allende, in Mexico. Back in New York she became a member of the Abstract Expressionist group but abandoned it for a time to return to a figuration in which her Mexican experiences were reflected.

Hartung, Hans
(Leipzig, 1904). French painter of German origin. From his German education he absorbed the cultural influences which developed after '21-'22 in studies of the expressive value of the sign that were already abstract in intention. To escape Nazi persecution he left Dresden in '35 for Paris. During the Second World War he enrolled in the Foreign Legion. Wounded in Alsace, he had a leg amputated. He returned to painting in '45, resuming his studies of the sign.

Havers, Mandy
(Portsmouth, 1953). British sculptor. Studied at the Slade School of Fine Art. Has exhibited in group shows at the Nicholas Treadwell Gallery, London, and in Cologne, Bologna, Basel, Düsseldorf, and Vienna.

Heizer, Michael
(Berkeley, California, 1944). American art worker. With the need felt by the artist after the objectualization of Pop and Op Art, Heizer attempts a recovery of the natural. His land art works make a visible impression on the natural environment, using rollers and various other instruments to score, for instance, a frozen river and preserving the results by photography, which provides their only record. His work, like all land art or Earth Art, has many Conceptual elements.

Hepworth, Barbara
(Wakefield, 1903–1975). British sculptor. From a type of traditional sculpture, belonging to Post-Impressionist figurativism, she moved to the development of forms in dialectic interpenetration with space. In '33, with Moore, Nash, and Nicholson, she became a member of the Unit One group, the basis of which was the organic nature of form. The vitality Hepworth infused into geometric form reveals itself in the dynamic relation between the external and the internal and between space and light. She often used linear elements (wires, string) which link different parts of the sculpture in a rhythmical scansion. She died in a fire at her studio.

Hockney, David
(Bradford, 1937). British painter. A representative of English Pop Art. He attacks with vivid irony, in works of an emblematic type, the false and hypocritical complacency expressed in the images of well-being projected by advertising onto bourgeois society.

Hofmann, Hans
(Weissenburg, 1880–New York, 1966). American painter of German origin. From music and scientific research he moved on to painting. He was in Paris from 1903 until the outbreak of the First World War. He worked at the Académie de la Grande Chaumière with Matisse and later became the friend of Delaunay, meeting Picasso and Braque. After the war he opened an art school in Munich. In '30 he was invited to lecture in California at Los Angeles and Berkeley. In '52 he settled in the United States, where he continued his work, directed on one side towards geometric abstraction and on the other a freer, organic gesturalism.

Hopper, Edward
(Nyack, New York, 1882–1967). American painter. From 1900 to 1906 he studied in New York and from 1906 to '10 travelled in Europe. In Paris he got to know Cézanne, the Fauves, and Cubism. He returned to America in '25 and pursued a kind of painting later described as "American realism", full of volumetric solidity but pervaded by a set, almost metaphysical approach which was to have echoes in recent American Hyper Realism.

Huebler, Douglas
(Ann Arbor, Michigan, 1924). American art worker, living in Truro, Mass. He uses photography in a Conceptual manner to examine the temporal variations in everyday actions caused by voluntarily provoked rejections which in some way upset the temporal development.

Indiana, Robert (Robert Clark)
(New Castle, Indiana, 1928). American painter. He studied in Indianapolis, New York, and Chicago and, from '53 to '54, at the Edinburgh College of Art. He settled in New York in '56. Rather than on Abstract Expressionism, he has concentrated on the visual panorama represented by marks and sign systems, which he interprets with disturbing symbolic allusiveness in a kind of "poptical" art (Amaya), close to what in the 1920's and 1930's in North America was called Precisionism.

Isobe, Yukihisa
(Japan, 1932). Japanese painter and art worker, living in Japan. He produces Environments made with inflatable materials, using air pressure to define structure.

Jacquet, Alain George Frank
(Neuilly-sur-Seine, 1939). French painter. He studied architecture at Grenoble and Paris and was an actor for a time before turning to painting. Lives in Paris and is a representative of the movement associated with Pop Art.

Johns, Jasper
(Augusta, Georgia, 1930). American painter. Studied at Columbia and since '52 has lived in New York. He belongs to the American Neo-Dadaist movement. If Duchamp introduced the real object into art, transforming it into an "art object" by the disorientating change of context (the ready-made), Johns brought the object back to the painting, invading the area of painting with the object itself and trying to express the representational quality of everyday objects (the American flag, targets), an idea which Johns has since transferred to Pop Art.

Jones, Allen
(Southampton, 1937). British painter and graphic artist; belongs to the English Pop Art movement. His themes, developed with extremely free association of images, are those of erotic mass advertising.

Jorn, Asger
(Veirun, Denmark, 1914). Danish painter. Studied with Léger and Ozenfant in Paris from '36 but soon went beyond Purism to achieve a fluid and automatic calligraphy of Surrealist origin. In '48 with Appel, Constant, Corneille, Bille and Mortensen, he founded the CoBrA group, which reasserted the freedom of imagination and gesture against rational procedures. Later, with other artists, he also founded a movement for a *Bauhaus imaginiste*, in opposition to the New Bauhaus at Ulm, founded and directed at that time by Max Bill. In '53 Jorn published a plan for a *Methodology of the Arts*.

Judd, Donald
(Excelsior Springs, Missouri, 1928). American sculptor. In seeking to reduce artistic phenomenon to its essentials, he has worked in Minimal sculpture, reducing his works to essentials of a basic geometry, though worked out on a large scale.

Kahrlen, Wolf
German art worker. He works in the area of land art, creating architectural luminous structures arranged in the open, such as the *Baum Raumsegment* exhibited at Monschau in '70.

Kaltenbach, Stephen
Belongs to a new generation of American artists who try to overcome the distance between art and life, working in an ideological and socially conscious manner in opposition to the deforming influences of the system. He puts forward an identification of art and daily life.

Kandinsky, Wassily
(Moscow, 1866–Neuilly-sur-Seine, 1944) Russian painter. He studied law in Moscow but in 1896 he was already working as a painter in Munich at the height of the Secessionist period. In 1902 he initiated the *Die Phalanx* group; in 1909, with Jawlensky and Izdebsky, he founded the *Neue Kunstlervereinigung* (the New Artists' Association) in Munich. In '12, with Klee and Marc, he founded the Blaue Reiter (Blue Rider, a name taken from one of his paintings of 1903); in the same year he published *Concerning the Spiritual in Art*. Again in Moscow during the First World War and the October Revolution, he became director there of the Museum of Pictorial Culture ('19) and was one of the founders of the Academy of Arts and Sciences ('21). He returned to Germany in '22. He taught at the Bauhaus and was its president ('22-'23). In '26 he published his second essay, *Point and Line to Plane*, and with Klee, Feininger, and Jawlensky founded the group of the "Blue Four". Condemned by the Nazis as a degenerate artist, he emigrated to Paris. His pictorial development reflects that of a part of modern painting: from a naturalistic Impressionism he moved through work of a Jugendstil type, through Pointillism, Fauvism, and Expressionism, always moving further away from objective experience to adopt the manner and forms of an expressive gesturalism, close to musical expression, which increasingly resulted in abstraction. His first *Abstract Watercolour* dates from '10. The development of his later work is usually divided into the "dramatic" period ('10-'14), the "architectural" ('20-'24), the period "of circles" ('26-'28), the "concrete" or "romantic" ('28-'35), and the period of "the great syn-

thesis" (last period). He is usually considered to be the originator of Abstract Expressionism, based on the lyricism and spirituality of artistic expression, against (German) expressionism, based on immediate sensation.

Kanovitz, Howard
(Fall River, Massachusetts). American painter, living in New York. A forerunner of Hyper Realism, in the 1960's he represented the female body in a strongly realistic manner, very similar to photographic reproduction, setting it against elements with classical associations and so providing a contrast between the ideal formal transformation and reality.

Kaprow, Allan
(Atlantic City, 1927). American art worker of Russian origin. From '57 he began an artistic activity which excluded the use of traditional techniques and involved the physical presence of man and his environment. His Happenings and Environments, developed within Neo-Dadaist poetics, deal with men's relationships with each other and with the social reality in which they live.

Kauffman, Craig
(Los Angeles, 1932). American painter, living at Venice, California. He uses intense colours in such a way as to obtain volumetric depth in curved forms in relief, to be interpreted in a spatial-temporal manner.

Kelly, Ellsworth
(Philadelphia, 1913). American painter. He works in the area of reductive "radical painting", reductive, that is, in tending to reduce the painting to its primary essential elements (the pictorial means, colour, the surface of the canvas), without seeking any other thematic reference. He creates structural spreads of colour that are seen as two-dimensional space.

Kienholz, Edward
(Fairfield, Washington, 1927). American art worker, living in Los Angeles. He has developed from a type of post-Pop activity, producing *assemblages* of objects drawn from everyday life, to the creation of sculptures and Environments which tend to be presented as a mirror of the violence of present-day society. As a critical activity his work approaches in this aspect that of the New Realism.

King, Philip
(Tunisia, 1934). British sculptor. Living in Britain since '45, he studied languages at Cambridge University. From '57 to '58 he studied sculpture with Anthony Caro at St. Martin's School of Art in London and from '58 to '59 he was also Henry Moore's assistant. Since '59 he has lived in London, and he teaches at St. Martin's School. He was the first British sculptor to use polyester and glass fibre. His works are produced according to a system of "addition" by which they can be arranged repeatedly in varying ways.

Kirchner, Ernst Ludwig
(Aschafenburg, 1880–Davos, 1938). German painter. Studied at Dresden and came to painting through the study of Dürer and the German engravers. He was also interested in Japanese painting and in Negro sculpture. He

was an admirer of Van Gogh, Munch, Toulouse-Lautrec, and Vallotton. In 1905 with Heckel, Bleyl, and Schmidt Rottluff, he formed the group called *Die Brücke* (The Bridge) in Dresden, the first organized manifestation of German Expressionism. Later the group was joined by Emil Nolde and Pechstein. After he moved to Berlin together with the group ('11), his subjects changed from portrait and landscape to images of the city. Even with the break-up of *Die Brücke* ('13) Kirchner continued his work in Expressionist art, practising sculpture as well as painting and graphics, at which he worked from 1902. During the war in '14 he fell ill and went into a sanatorium, first in Germany and later in Switzerland. After his paintings had been included in the exhibition of "degenerate art" ordered by the Nazis in Berlin in '37, Kirchner committed suicide.

Kitaj, R. B.
(Cleveland, 1932). American painter, naturalized British. He has interpreted the Pop Art movement with sensitivity and with frequent references to literature and visual culture. In his paintings, rendered in a free and rapid style or with flat images, he refers especially to the themes of rotogravure advertising.

Klee, Paul
(Münchenbuchsee, Bern, 1879–Muralto, Locarno, 1940). Swiss painter and designer. Studied at Munich with Von Stuck. He was in Italy from 1901–02, in Paris in 1906, and in Munich from 1906 to 1920. The friend of Macke, Kandinsky, Marc, and Jawlensky, he was in '12 among the founders, with Marc and Kandinsky, of the Blaue Reiter (Blue Rider), an avant-garde group which anticipated Abstract Expressionism, and he took part in the group's second exhibition. In Paris in '12 he met and studied Delaunay and in '14 made a study trip to Tunisia. He taught at the Bauhaus in Weimar ('21–'24) and in Dessau ('26–'31). The results of his teaching are preserved in his *Theory of Form and Figuration*, published in '52, and his ideas on art in *The Artist's Confession*, written in '17–'18. Later he taught at the Düsseldorf Academy ('31–'33). In '25 he took part in the first Surrealist exhibition in Paris. Labelled by the Nazis as a "degenerate artist", he returned to Bern, Switzerland. Klee's style developed independently of contemporary artistic work, according to a vision which is among the most representative and "projective" of the period and among the most revolutionary; in it he reduces into vibrations of lines and colours the latent structural geometry of nature, which he investigated in complete freedom from conventional schemes in the inexhaustible and continual rhythm of growth and organic formation.

Klein, Yves
(Nice, 1928–Paris, 1962). French painter and sculptor. His discoveries of the symbolic value of monochrome belong to '46, when he painted a completely blue sky. In this period he also studied Oriental theories and the cosmogonal theories of the Rosicrucians. In '47 he created his *Monotone Symphony* (a continuous note followed by a prolonged silence). Later came his *Monochrome* developments. Between '48 and '53 he travelled in Europe and Asia and in '54 became technical director of the Spanish Judo Federation. In '55 he exhibited his *Mono-

chromes* in Paris. He then became leader of the Nice School, which in '60 gave way to the New Realism. Other members of the group were Arman, Raysse, Tingueley, and Hain as well as the theorist and critic Pierre Restany. Meanwhile, in '58, continuing his search for a kind of immaterial energy, he had organized the "Exhibition of the Void" in Paris and in collaboration with Walter Runhan, the "architect of the air", he worked on the project for the acclimatization of the atmosphere and the control of natural phenomena which was presented at the Sorbonne in '59 in two lectures on *The Evolution of Art and Architecture towards Immateriality*. In '59 he exhibited *Bas-reliefs in a Forest of Sponges* and, developing cosmogonal theories with the trilogy of fire, water, and rose-gold, he created other works using "living brushes" (the bodies of models covered with blue paint and made to move over paper, which constitute the *Anthropométries*), which were followed by *Cosmogonies*, painted with a rain of powdered paint. In '61 he produced his *Tableaux-feu*, exhibited at Krefeld, for which Klein used the gas jets from a blast furnace to create sculpture with sheets of asbestos. His last works were *Relief-portraits*, cast from life.

Kline, Franz
(Wilkes-Barre, 1910–New York, 1962). American painter. Studied in Philadelphia and in Boston until '35. From '37 to '38 he was in London and in '39 in New York. He developed from a post-Cubist figurativism to a violent orientalizing gesturalism; this fills the canvas with large gestures, giving it its structure, in an expanded, macroscopic interpretation of action painting, and so expresses the sensation of vast spaces and of the violent tensions provoked by the dynamic structures of great cities.

Kosuth, Joseph
(Toledo, Ohio, 1945). American art worker. He is one of the principal figures of Conceptual Art, which he presents as a linguistic analysis of the concept of art from the inside.

Kuttner, Peter
German art worker, belonging to the Düsseldorf group. His works belong with performance art and are intended to explore current myths.

Laing, Gerald
(Newcastle-on-Tyne, 1936). American painter and sculptor, living in New York and London. He is one of the artists who have worked in the area of Pop Art.

Latham, John
(Africa, 1921). African, naturalized British, sculptor. Studied at the Chelsea School of Art. Since '58 he has begun to use books as the materials for *assemblage*, creating works and panels of great force and symbolic significance.

Laurens, Henri
(Paris, 1885–1954). French sculptor. Studied in Paris, concentrating first on painting and then on sculpture, beginning by following the development of Post-Impressionism. In '11 he met Braque in Paris, who introduced him to other Cubist artists and to Apollinaire. He then joined the group and within it applied Cubist theories about the breaking up of planes to his own sculpture.

503

Léger, Fernand
(Argentan, Orne, 1881–Paris, 1955). French painter. He studied architecture in an architect's office in Caen and then moved to Paris, to the Académie Julien and to Gérôme's studio. In '10 he was already pursuing Cubist pictorial theories, reflecting their purist, mechanistic element. In '11 he exhibited in the Salon des Indépendants in Paris with Metzinger, Gleizes, and Delaunay. His *Still Lifes* of this period are already distinguished by a new structural vitality which Léger expresses through rounded forms with smooth spreading and through the use of primary, tonal colour. Later he became more interested in the symbols of industrial and mechanical civilization. He also discussed this subject in essays (*The Aesthetics of the Machine*, '23; *The New Realism Continues*, '36; *Colour in Architecture*, '46). In '24, with Ozenfant, he had founded a free school in which he gave one of the most advanced examples of collaboration between the arts. The period from '25 to '30 is described as "architectonic" because of the monumental character of the works he produced; the next period is called "dynamic" because of the new interests in the realization of Cubist themes. He produced murals, stage sets, tapestries, and mosaics, large ceramic pieces, and animated films (the *Ballet Mécanique*). From '39 to '45 he taught in America, at Yale and at Mills College.

Leonard, Michael
(Bangalore, India, 1933). British painter. Worked from '57–'72 as an illustrator. Held one-person exhibitions in '77 in New York and London. In '77–'78 there was a retrospective at the Gemeente Museum, Arnhem. Is represented in the Boymans-Van Beuningen Museum, Rotterdam. His work shows a new strain of classicism in British figurative painting.

LeWitt, Sol
(Hartford, 1928). American art worker, living in New York. He uses the surface or the third dimension as the scope for Conceptual work. On the surface he creates a network that unites points in different possible spatial dimensions; he produces geometrical, three-dimensional structures of a Minimal type as the means of a graduated and modular definition of the surrounding space.

Lichtenstein, Roy
(New York, 1923). American painter, living in New York. One of the most interesting innovators in American painting among the representatives of Pop Art. He uses enlarged comic-strips and blown-up images to express, through the same means as advertising images, the trivializing of everything real by the mass media, even of the artistic achievements of the past, which he often uses as the subjects of his works, enlarging them by means of a projector and reproducing them with the almost Pointillist technique of the printing screen.

Licini, Osvaldo
(Montevidoncorrado, 1894–1958). Italian painter. Studied in Bologna, where he met Morandi. He served in the First World War and from '20 to '30 developed his own line of tonal figurative work, one quite close to that of Morandi. In '31 he turned to abstract art as one of the group of Italian abstract artists formed around the

Milione Gallery in Milan (Bogliardi, Ghiringhelli, Magnelli, Reggiani, Soldati, and Fontana, as well as Meloni and the Como group, Radice, Rho, and Badiali).

Lindner, Richard
(Hamburg, 1901). German painter, naturalized American. He studied music in Bavaria and began a career as a concert performer. From '22 he devoted himself to painting. He studied painting at the Kunstegewerbeschule in Nuremberg and at the Munich Academy of Art. In '33, during the Nazi period, he left Germany for Paris, where he met Picasso and Gertrude Stein. He fought in the French and British armies during the war. In '41 he was in the United States, where he worked as an illustrator for magazines such as *Fortune*, *Vogue*, and *Harper's Bazaar* and for books (*Madame Bovary*, '44; *Tales of Hoffman*, '46). Since '51 he has concentrated entirely on painting and on teaching at the Pratt Institute in New York.

Lipchitz, Jacques
(Druskinikinkai, Lithuania, 1891–Paris, 1973). Lithuanian sculptor, naturalized French and later American. From 1909 he studied in Paris. He became involved with Cubism in '13, developing its themes of simultaneity and "space-time" in sculpture. After '25 in his plastic works the volumetric relations were brought out with greater clarity in the contrasts of substance and void, to the point of producing a kind of plastic arabesque, culminating in the "transparent sculptures" of '26–'28. He later returned to forms connected with figuration. From '41 he lived in the United States.

Louis, Morris
(Baltimore, 1912–Washington, 1962). American painter. He studied in Baltimore and later taught in Washington. In '39 he worked on the WPA (Federal Art Project). He lived in Washington. After a period of figurative work under the influence of Mexican murals, he developed a style which almost combines the New York gestural school with the Pacific School.

Lucebert (Lucebertus J. Swaanswijk)
(Amsterdam, 1924). Dutch painter, graphic artist, and poet. Studied at the Amsterdam School of Arts and Crafts from '38. In '48 he joined the international CoBrA group and showed a series of *Poèmes-Peintures* at the group's first exhibition. In '52 he visited Berlin at Bertolt Brecht's invitation. He now lives at Bergen, in Holland. Within the Expressionist gestural language of the CoBrA group he has developed an informal style in which emerge suggestions of phantom images, expressing terror or menace.

Mack, Heinz
(Lollar, Rhineland, 1931). German sculptor. Studied at the Düsseldorf Academy of Art from '50 to '53 and graduated in philosophy from Cologne University in '56. He creates luminous reliefs in mirror-like metal. In '58 he founded the Zero group with Otto Piene, and with the other members edited the three publications of the group. He then began to develop luminous vibrant columns and in '61–'62 created his "dynamic-luminous" objects, consisting of metallic surfaces which move irregularly by

means of plates of curved glass and electric motors.

Magritte, René
(Lessines, 1898-Brussels, 1967). Belgian painter. Studied at the Brussels Academy. After early work of a Cubist type he came to know the painting of De Chirico about '23 and, also through a personal acquaintance with Breton (during his stay in Paris between '27 and '30), he moved towards Surrealism, joining that movement and in fact becoming one of its most distinguished representatives.

Maler, Leopoldo
(Buenos Aires, 1937). Argentine film-maker and creator of art events and environments. Has been responsible for organizing numerous mixed-media events in Buenos Aires, London, Paris, Amsterdam, Barcelona, Mexico City, Venice, Rio de Janeiro etc. Grand Prizewinner at the 1977 São Paulo Biennale.

Malevich, Kasimir
(Kiev, 1878–Leningrad, 1935). Russian painter. From a Post-Impressionist style he moved to "Rayonism" (1908–10) and in '15 together with Larionov and avant-garde Russian poets he drew up the Suprematist Manifesto, becoming the leader of the Russian Cubo-Futurist movement. In '12 he took part in the second exhibition of the Blaue Reiter with all the Russian avant-garde. In '13 he produced his famous *Black Square on a White Ground*, the first example of Suprematist art. In '12 he organized the "Donkey's Tail" exhibition and did some stage sets. In '17 he produced his famous *White Square on a White Ground*. In '19, after actively participating in the Russian revolutionary struggle, promoting a new advanced cultural policy, he was nominated professor at the Moscow National School. Later he lost favour with the government and was transferred to Leningrad. In '15 he had published *The World of Representation*, which was brought out in '17 as a Bauhaus edition. He visited the Bauhaus in '26 and met Kandinsky.

Manessier, Alfred
(St. Ouen, 1911). French painter. Studied at Amiens. In '31 he moved to Paris, where he attended the École des Beaux Arts and the Académie Ranson, under the direction of Bissière, whom he met in '35. In '41, at the height of the war, with Bertholl, Marchand, Bazaine, Estève, Lapicque, Singier, and Le Moal, he organized an exhibition in Paris of the group *Jeunes Peintres de Tradition Française*, which aimed to combine Cubism with a new realist vision. In '44 his pictorial form became more geometrical without renouncing its emotional intensity and its character of offering a record of experience and a profoundly religious inspiration. In '58 Manessier made a journey to the South of France, which proved a revelation to him. His style became more flexible and more relaxed, his colour more vibrant. He also worked in the decoration of glass windows.

Manzù, Giacomo
(Bergamo, 1908). Italian sculptor. Studied at the Accademia Cicognini in Verona and moved to Milan in '30. He was in Paris in '33 and in '36. In '41 he joined the Albertina Academy group in Turin and from '43 to '54 taught at the Brera

in Milan. After a period of redeveloping the styles of Renaissance sculpture, making a special study of Donatello, he came under the influence of the Post-Impressionists and in particular Rodin and Medardo Rosso. About '40 he returned to the classical style and developed a type of figurative sculpture related to the canons of classical beauty.

Marini, Marino
(Pistoia, 1901). Italian sculptor, graphic artist, and painter. Studied at Florence as the pupil of Trentacoste. From '29 to '40 he taught at the Scuola d'Arte di Villa Reale in Monza, succeeding Arturo Martini. In '40 he was professor at the Accademia di Brera. He has spent long periods in other countries. Lives in Milan. He has close relations with major European artists and his reputation quickly became international. Having begun in sculpture and in design, developed with a sensitive naturalism inspired by Medardo Rosso, he later achieved an individual symbolism characterized by a sophisticated historical-cultural synthesis (in which an historical awareness of the Etruscans and the Egyptians is fused with twentieth-century culture) and culminating in the recurring themes of his work (the *Pomone*, the *Horses*, the *Riders*). In his *Portraits*, which are of particular importance, he transcribes in a careful psychological analysis a refined historical perception that is informed by a profound sense of personal experience and of artistic vitality, and ranges from a mannered archaism to nineteenth-century realism, from Rodin to the historic avant-garde movements. After '43 his sculpture moved away from the use of the rounded block, with its firmly architectonic foundation, and towards developments in which form was stripped down, in a concern with existential problems. Besides his sculpture Marini has produced many graphic works and a considerable pictorial achievement, which has been nourished by an historically informed artifice and enriched by a limpid chromatic density.

Marisol (Marisol Escobar)
(Paris, 1930). French sculptor, living since '50 in New York. In her *assemblages* she has developed a series of outline images which she colours according to a vision that has links with folklore, and in which she includes real objects, producing a wittily ambiguous and ironic but also often haunted activity of the memory.

Masi, Denis
(West Virginia, 1942). American photographer and creator of environments, currently resident in London. Has held one-person exhibitions in London, Milan, Paris, Bradford, and Bristol. His work is included in the collections of the Victoria & Albert Museum; the Kupferstichkabinett, Berlin; the Museum of Modern Art, New York; the Metropolitan Museum, New York; the Kunsthalle, Hamburg, and the Tate Gallery.

Masson, André
(Balagny, 1896). French painter and engraver. Studied in Brussels and Paris. At first influenced by the Cubism of Juan Gris ('22–'24), he turned later to work of a visionary and irrational character. His work was noticed by Breton, and as one of the Surrealists he developed automatic and almost gestural

techniques, still, however, maintaining direct contact with the natural world. From '34 to '36 he lived in Catalonia. Returning to Paris in '37, he took part in the '38 Surrealist international exhibition. At the outbreak of war he took refuge in the United States ('41–'45), where he had a marked influence on the American painters later associated with action painting and where he found stimulus in Indian and primitive art. He returned to Paris in '46 and later settled in Aix-en-Provence.

Mathieu, Georges
(Boulogne-sur-Mer, 1921). French painter. After studying law and philosophy he devoted himself to painting from '42. In Paris he exhibited from '47 at the Salon des Réalités Nouvelles and with the poet and painter Camille Bryen founded "Psychic Non-figuration", which was oriented towards a kind of automatic *tachisme*. Meanwhile, with Bryen, he organized the exhibition called "The Imaginary". In '48 he organized another exhibition of all those painters who were to be the masters of informal art in Europe and America (from De Kooning to Gorky, Pollock, Rothko, Tobey, Hartung, and Wols). In '56, on the occasion of the International Festival of Dramatic Art, he painted a work in oils, of 39 × 13 feet, on the stage of the Sarah Bernhardt Theatre in Paris. In Tokyo he produced twenty-one paintings in three days, among them one 26 feet and another 49 feet long. In New York he painted fifteen canvases in a day.

Matisse, Henri
(Le Cateau, 1869–Cimiez, Nice, 1954). French painter. Studied law in Paris and turned to painting in 1890 after reading a treatise on art. He joined Moreau's studio, where he met Marquet, Manguin, and Camoin. He also attended the Académie Julien, the École des Beaux Arts, and finally the Académie Carrière and the École de la Rue Étienne Marcel. He moved from a naturalistic style developed through chiaroscuro and relationships of colour and light to an almost tonal use of pure colour. In '98 in Carrière's studio he met Derain and quickly became one of the creators of Fauvism. After a visit to Brittany ('95–'97) his colour became clearer and continued to develop with the image, becoming a direct means of creation. In *Luxe, Calme, et Volupté* and in *Joie de Vivre*, both of 1905, his idea of art is defined in an entirely autonomous fashion, as an intimate vocation, a spiritualized contemplation, in contrast with the rationalism expressed, for example, by Cubism. Oriental art, Negro sculpture, and Persian ceramics contributed something to Matisse's style. After a journey to Africa, returning with some Negro statuettes that he showed to Picasso, he visited Russia, Spain, and Morocco. He took part in the exhibition of the Secession in Berlin and the Armory Show in New York ('13). He also engaged in stage designs and in graphics. In his last years, while living between Cimiez and Vence, he designed and frescoed the chapel at Vence. Towards the Fifties he discovered the use of *découpage* in graphics, by which he cut out the images in paper painted in pure watercolours.

Matta, Echaurren Sebastian
(Santiago, Chile, 1912). Chilean painter. Studied at the College of the Sacred Heart in Santiago and at the Catholic University, where

he graduated in architecture in '31. In Europe from '36, he worked as a draftsman ('36–'37) in Paris with Le Corbusier. In Spain in '36 he met Garcia Lorca, Neruda, and Rafael Alberti, and in '38 he joined the Surrealist group. At the outbreak of war he moved to New York. In '48 he was again in Europe and from '50 to '54 in Rome, then again in Paris. He has tended to enlarge Surrealist themes from the individual to the collective subconscious. He uses mechanistic and symbolic techniques to create a kind of allegorical representation of the alienating evils of our time.

McCracken, John
(Berkeley, California, 1934). American painter, living at Costa Mesa, California. He has been an exponent of Pop Art and has developed a pictorial language connected with Hyper Realism.

McLean, Richard
(Hoquiam, Washington 1934). American painter. He studied in various institutions and universities, such as New Meadows High School, Idaho, '53, Boise Junior College, Idaho, '53–'55, California College of Arts and Crafts, '55–'58 and Mills College, Oakland, '60–'62. He lives in Oakland, California, and has been a member of San Francisco State College since '63. He belongs to the Hyper Realist movement, which is also known as New Realism, Cool Realism, Radical Realism, and Sharp-Focus Realism.

Merz, Mario
(Milan, 1925). Italian art worker, living in Turin. Works in Conceptual Art, applying Fibonacci's theory of progressive numerical series to artistic activity and demonstrating how the progressive growth of those things closest to nature (such as the igloo) happens by natural rather than strictly mathematical laws.

Messagier, Jean
(Paris, 1920). French painter. Studied in Paris. Since '46 he has made a number of study trips to Algeria and Italy, where he has studied and copied Piero della Francesca and Fra Angelico. In '61, with the architect Jean Louis Veret, he designed the new mill at Colombier Fontaine, where he had settled. He has developed a gestural style which is, however, contained within an almost symmetrical organization of signs. At times he has used *assemblages* and collages of various objects, and he has also produced designs for tapestries.

Michaux, Henri
(Namur, 1899). Belgian poet and painter, naturalized French. He was in Paris in '23 and immediately afterwards made long journeys to India, China, Japan, Egypt, Uruguay, and Argentina. He began to paint about '25, translating his Surrealist poetic language into painting. Since '48 his pictorial and graphic output has constituted an independent activity, parallel to his literary output. He has developed the poetics of Surrealist automatic writing informally, giving it the mystical-symbolic significance of Oriental calligraphy, and has arrived at an analysis of the subconscious and the irrational, also by means of drugs.

Miki, Tomio
Japanese painter. He belongs to the international movement that has developed the

language of American Pop Art, which he interprets with lucid and detached irony.

Miró, Joan
(Montroig, 1893). Spanish painter. Studied at Barcelona. In Paris in '19 he came under the influence of Cubism, but after '23 he turned to Dadaism and Surrealism ('24). He interpreted Surrealism, whose manifesto he signed, in emblematic and fabulous terms, in a concentration of cultural experiences that are filtered through a transcription suggesting a kind of "rediscovered childhood". In '28 Miró was in Holland, and in '40 he returned to Spain, to Palma de Mallorca. He also worked in graphics, ceramics and sculpture, maintaining in these too his fairy-tale language and his delight in the fantastic.

Modigliani, Amedeo
(Leghorn, 1884–Paris, 1920). Italian painter and sculptor. He studied with Micheli, the pupil of Fattori, at Leghorn. His first journey, to Capri for the sake of his health, took him to Florence, Rome, and Naples. On his return (1902) he enrolled at the Academy in Florence and later moved to Venice, where he came to know the work of Klimt and the Viennese Secession. He was in Paris in 1906, installed at the Bateau Lavoir. The discovery of Negro sculpture and his familiarity with Brancusi and Picasso led him to that volumetric and linear synthesis which characterized his sculpture and his painting, the latter being sustained by an individual and profound chromatic density. In '14 he met the British poetess Beatrice Hastings, Paul Guillaume, and Leopold Zhorowsky, great friends and collectors of his work. His health was undermined by tuberculosis, and he died in the Charité Hospital in Paris.

Moholy-Nagy, László
(Bàcs-Borsod, 1895–Chicago, 1946). Hungarian painter, sculptor, and designer. Between '19 and '21 he was inspired by the theories of Suprematism and of Russian Constructivism, sharing the conception of the social function of art. From '23 to '28 he taught at the Bauhaus, where he developed a type of teaching based especially on experiment. As well as his kinetic and luminous works his experiments led him to the use of photography (in which at the same time as Man Ray he explored new techniques and methods, such as the "rayograph") and of abstract film. He was also responsible for the publication of fourteen *Bauhausbücher*. After leaving the Bauhaus he went to Paris, where he took part in the Abstraction-Creation exhibitions ('32–'36) and to Chicago, where he was among the founders of the New Bauhaus. His transparent sculptures in Perspex and his *Space Modulators* belong to this period. In '47 his *Vision in Motion* was published posthumously in which he set out his theories and teaching.

Mondrian, Piet
(Amersfoort, 1872–New York, 1944). Dutch painter. Studied at the Amsterdam Academy from 1892 to 1897. He reflects the influence of his Calvinist upbringing and his theosophical initiation. Until 1907 he worked according to the principles of Post-Impressionist figurativism; from 1907 to 1910 he went through a Fauve period, with Expressionist features. He moved to Paris in '11 and remained there until '14. In this period, under Cubist influence, he

pursued an abstract synthesis of form (on the theme of *The Tree*). On returning to Holland because of his father's illness, he was overtaken by the war and could not return to Paris until '19. However, in Holland in '17, with Theo van Doesburg he founded the neoplastic De Stijl movement and the review of the same title, the organ of the movement, which proposed "a common need for clarity and order" against subjective individualism, according to a structural language of organic spatiality. In '20 Mondrian published in French, in Paris, his essay on De Stijl, which was later issued in '25 as one of the Bauhausbücher with the title *Neue Gestaltung*. He was in London in '38, and when the Second World War broke out he took refuge in New York, where he further developed in a rhythmic-dynamic direction his themes of the breaking up of the surface of the painting (*New York City*, '42, *Broadway Boogie Woogie*, '43).

Monory, Jacques
(Paris, 1934). French painter. His painting can be seen as belonging to narrative realism; he deals with subjects ideological in intention. He combines photographic techniques with painting.

Moore, Henry
(Castleford, 1898). British sculptor. He studied in Leeds and London until '25. He then travelled in France and Italy with a study grant. In '36 he took part in the International Surrealist Exhibition in London. He took up the themes of the avant-garde revival in sculpture, accentuating the process of formal abstraction and developing the relation between the work and space, in terms of architectural structure and integration. After a short phase of post-Picasso Surrealism ('22–'23), he reached his period of greatest abstraction about '38 (*String Figures*). After '40 he returned to an essential figuration in sculpture. During the war he produced the celebrated drawings of life in the air-raid shelters (*Shelter Book*). Since the war his sculpture has been characterized by mythical images, set in landscape or framed by a building, in monumental, hollowed-out forms which also recall inorganic shapes.

Morandi, Giorgio
(Bologna, 1890–1964). Italian painter and engraver. Studied at Bologna, which during the rest of his life he left only for brief journeys. He was able, however, to grasp the significance of the modern movement and, although isolated and very reserved, succeeded in forming his critical judgment. Starting from the study of Cézanne, his ideal guide, he progressed through a revised Cubism from which he turned to a scholarly rediscovery of Renaissance structure, from Giotto to Piero della Francesca and Paolo Uccello. Between '18 and '20 he belonged to the metaphysical movement with Carrà and De Chirico. After '20, in a total revision of formal purism and of tonal values in painting, from Corot to Chardin, he turned to a style of painting in which objects (still lifes, bottles) are immersed in colour-light, achieving an essential completeness which, not formally but for the rigour of technique and ascetic aspiration, brings him close to Mondrian.

Morley, Malcolm
(London, 1931). British painter, living in New York. He uses the photographic image as the starting point for his painting, on themes

relating to mass tourism (often representing life on board ship) and to the traditional American sagas, such as the cowboy rodeos, which have now become a commercialized tourist spectacle.

Morris, Robert
(Kansas City, 1931). American sculptor and art worker. The author of essays on art published in *Art News*, *Art in America*, and *Aujourd'hui*, he moved from a Minimal phase (producing great Primary Structures with elementary geometric form and works in scraps of felt to be hung on the wall or spread on the floor) to a performance art, with Happenings of various kinds. Later he progressed to land-art activities, worked out in the open ('70–'71).

Motherwell, Robert
(Aberdeen, Washington, 1915). American painter. He graduated from Stanford and studied engraving with Seligman and Hayter before concentrating on painting. He took part in the activities of the New York School, tempering the symbolic gestural violence of action painting with a rigorous, rational organization of the pictorial work. With Baziotes, Newman, and Rothko, he founded the "Subject of the Artist" school in '48 which then became The Club, almost a forerunner of the Pacific School.

Nauman, Bruce
(Fort Wayne, Indiana, 1941). American art worker. Works in performance art, substituting operations of a Conceptual type for the artistic object and using the neon tube in a kind of gestural writing, with an environmental setting.

Nay, Ernst Wilhelm
(Berlin, 1902). German painter. He studied in Berlin with Karl Hofer, who helped him to an understanding of Expressionism. He was in Norway from '36 to '37, and he also visited Italy. In '44 he served in the army in France but succeeded in working at Le Mans, in the studio of a French friend. After a post-Cubist phase of an Orphist tendency, he developed towards a formal synthetism.

Nevelson, Louise
(Kiev, 1900). Russian sculptor, naturalized American. She has lived in America from early childhood and studied in New York. In '31 she was in Europe and painted under the guidance of Hans Hofmann. In '32 she collaborated with Diego Rivera on murals of New York. A journey to Mexico encouraged her interest in archaeology. Her *assemblages* of *objets trouvés* (waste, fragments of wood, and, later, serial elements), organized as the structures of the memory, appear totem-like symbols, archaeological discoveries of the present-day world.

Newman, Barnett
(New York, 1905). American painter. From '22 to '26 he studied in New York. In '48, with Baziotes, Motherwell, and Rothko, he formed the school which was later called the Pacific and which is distinguished from action painting by its orientalizing and contemplative interests, expressed in great expanses of pure colour. He took part in the exhibition of "The New American Painting" ('58–'59) and in the 1960 Lewerkusen exhibition "Monochrome Mal-

erei", together with the Italians Manzoni, Fontana, and Castellani.

Noland, Kenneth
(Asheville, North Carolina, 1924). American painter. He studied at Black Mountain College with Albers and in Paris with Zadkine. He lived in Washington until '63 and then moved to South Shaftsbury, Vermont. He belongs to the movement called New Abstraction. He works on large surfaces with uniform spreading and pure tonal colours, developing powerfully emotive structures of basic geometry or of large concentric circles (the Targets), which almost magically capture the onlooker's imagination.

Oldenburg, Claes
(Stockholm, 1929). Swedish sculptor, naturalized American. He studied in Chicago and at Yale University. In '53–'54 he attended the Art Institute of Chicago. In '56 he was in New York, and in '60 he organized the first Happenings. As one of the exponents of American Pop Art, he represents the objects of everyday life in a grotesque form, as soft and unnatural, new horrors of contemporary life (the soft typewriter, the soft handbasin), and a repertory of foods and objects of the consumer society blown up in an aggressively monstrous fashion.

Olitski, Jules
(Gomel, Russia, 1922). Russian painter, naturalized American. He studied at the Academy of Design in New York, then at the Académie de la Grande Chaumière in Paris until '50 and later at Ossip Zadkine's school. He has taught at C. W. Post College, New York University, and Bennington College. From '52 to '59 he worked on informal themes but later abandoned them for a wider vision of the pictorial surface. Since '63 he has treated the canvas as a lyrical mental space, with a direct vision in which contrasts of differently painted zones appear to develop, while a greater thickness of colour marks the borders of the picture.

Oppenheim, Dennis
(Mason City, Iowa, 1938). American art worker, living in New York. Works in land art, using macroscopic signs (tracks, furrows, and gigantic lines on snowy ground), visible also from above, to symbolize the repossession of nature by man and the modification of the environment. He also works in the area of performance art.

Ossorio, Alfonso
(Manila, Philippines, 1916). American painter, living in the United States since '29. He studied at Harvard University and afterwards, for a year, at the Rhode Island School of Design. From '43 to '46 he served in the Army. He belongs to the Abstract Expressionist movement; he made use of the dripping technique up to '55 and afterwards developed fantastic images in the informal medium of his painting. After '60 with the spreading of colour he combined a collage of various objects—shells, beads, and twine—which embellish and enrich the surface of his works.

Paik, Nam June
(Seoul, 1932). American art worker. He uses various techniques in his Body Art works, including the body (often of a naked woman with a violoncello), which he records on videotape, manipulating the image from a distance with the monitor, to repossess the technological means for creative purposes.

Paolozzi, Eduardo
(Edinburgh, 1924). English sculptor of Italian origin. He studied in Edinburgh and London. From '47 to '50 he worked in Paris, where he exhibited with the group Les Mains Éblouies in the Maeght Gallery. He taught fabric design in Paris from '49 to '55, and sculpture from '55 to '58. He has also worked on architectural projects. After a period influenced by Dadaism and by Dubuffet's Primitivism he moved to the creation of assemblages (which he had already used in '47). His assemblages are developed in a "brutalist" fashion, creating totemistic images of the machine society and anticipating some of the characteristic devices of Pop Art.

Paxton, Steve
In Conceptual Art he has produced films intended to contrast anonymity (to which city life daily submits the individual) with the recovery of personality and of individual attitudes outside the urban environment.

Pearlstein, Philip
(United States, 1924). American painter, belonging to the Hyper Realist movement. He often uses photography to make clear the reference to a reality fixed by a mechanical technique.

Pevsner, Antoine
(Orel, 1886–Paris, 1962). French painter and sculptor of Russian origin, brother of Naum Gabo. From 1902 to 1909 he studied at the Kiev School of Art, later entering the St. Petersburg Academy of Art, which he had to leave after a few months of training. At that time he was interested in medieval Russian ikons and in the modern French painting he saw in Moscow collections. In '11 he was in Paris, where he saw the Cubists. Again in Paris in '13, he entered Cubist circles, introduced by Archipenko and Modigliani. He added to this an awareness of Italian Futurism. In '14 he joined his brother, Naum Gabo, in Oslo and with him pursued Constructivist work in painting. In '17 the two brothers, returning to Russia, published the Realist Manifesto, in which they put forward the bases of Constructivist theories. In '23 Pevsner abandoned painting for sculpture and, leaving Russia, stayed for a short time in Berlin before moving to Paris ('24), where he met Marcel Duchamp and Katherine Dreier. In '30 he became a French citizen and in '31 joined the Abstraction-Creation group with Gabo, Herbin, Kupka, and Mondrian. The characteristic of his sculpture is the development of a dynamic surface through linear elements.

Phillips, Tom
(London, 1937). British painter, musician, and art worker, living in London. From '56 to '59 he was a student at Oxford and in '61 at the Camberwell School of Art, becoming afterwards a teacher at the Wolverhampton College of Art and at the Bath Academy in Corham ('62–'70). He presented his musical works in '68, and his opera Irma was performed for the first time in '73. He works on the photographic medium, transcribing the photographic image distorted by the screen, by being out of context, by fabricated colours, so as to re-create mentally the real image.

Picasso, Pablo
(Malaga, 1881–Mougins, 1973). Spanish painter, sculptor, engraver, and ceramist. He trained in Barcelona, where in 1901 he founded the magazine Arte Joven. He was in Paris for the first time in 1900, and he settled after 1904 in the famous Bateau Lavoir, inhabited by artists whose leader he soon became. From the naturalistic figuration that he had concentrated on from his youth, he moved to a vivid and intense version of French Fauvism, which was also reminiscent of medieval Catalan sculpture and had connections with Post-Impressionist and Symbolist painting up to the point of treating the realistic social subject matter of the time (the Blue Period, 1901–04), which brought him close in some respects to the sharp impact of Expressionist art. Afterwards he developed a more direct formal structure (the Pink Period, 1905–06) and then, following Cézanne and the new discovery of Negro sculpture and of primitive arts, he achieved a new pictorial form, Cubism (1907). This was anticipated in the painting Les Demoiselles d'Avignon, which Georges Braque saw in his studio, and developed by Picasso with Braque and Juan Gris. The bases of Cubism consist in the breaking down of the image into its various facets and in its treatment of volumes, all brought into the same plane, in a dynamic which introduces the temporal dimension into the painting, bringing it back to the simultaneity of vision. From Analytical Cubism (resulting in the breaking down of plastic form in the surface, 1907–11), Picasso moved to a Synthetic Cubism ('12–'14), in which the form is recomposed in a volumetric synthesis. Later, in the general atmosphere of the "return to order", came the Neo-Classical Period ('17–'24) and a phase of revised Neo-Cubism ('24–'26). In '25 Picasso approached Surrealist poetics (the Neo-Romantic Period, '25–'32), acquiring impulses of lively social commitment, of a fascinating expressive force, which culminated in the famous Guernica of '37, dedicated to the Spanish Civil War. This phase of Picasso's work was to have an extraordinary influence, and it had consequences for the entire neorealist tradition, from the Mexican murals up to post-Cubist developments, with their strong Expressionist elements, in the post-war period. Picasso's later work continued in this area of critical classical-Expressionist revision. The originator of many techniques and styles, Picasso used collage and assemblage, created sculptures of heterogeneous materials, and inaugurated the reconsideration of the nineteenth-century tradition, becoming through the force of his temperament the model and guide of generations of artists.

Pistoletto, Michelangelo
(Biella, 1933). Italian painter and art worker. He began with figurative painting and moved in '62 to the use of mirror glass as a "different" response to nature and as an ironic reflection of the current image of life and its socially accepted organization. The image in the mirror obtained by photographic means and by transfer becomes involved with the environment in which it is set, and the mirror involves both the onlooker and the setting in an ambiguous play of fiction and reality. From work of this type Pistoletto progressed to

collective and spectacular "actions" and to environment operations of a Conceptual kind, still playing on interpretative ambiguity.

Poliakoff, Serge
(Moscow, 1906). Russian painter, naturalized French. After a luxurious youth (his father owned large stud farms) he fled from Russia at the outbreak of the Revolution and joined an aunt in Constantinople. She was a well-known variety singer, and Poliakoff accompanied her for a time on the guitar. He wandered through Europe, playing the guitar, until he settled in Paris in '23 and concentrated on painting. He was in London from '35 to '37, attending the Slade School, and on his return to Paris associated with the Delaunays and Kandinsky. This led to his development towards geometric abstraction, which he interpreted in a personal fashion, creating a suggestive field of chromatic and luminous relations out of elementary forms and pure tonal scansions. These relations suggest meditative contemplation and an evocation of space reminiscent of ikon tradition. He belongs to the *Réalité Nouvelle* group.

Pollock, Jackson
(Cody, Wyoming, 1912–Springs, Long Island, 1956). American painter. He studied in Los Angeles and from '29 to '31 in New York with Thomas Benton, one of the representatives of the American scene. At first he also felt the influence of Albert Pinkham Ryder, the Mexican muralists, and Indian folklore. Then followed the post-Cubist example of Picasso and that of the Surrealist automatism of Masson, Matta, and Miró. He later resolved Expressionist and Surrealist influences in an identification of his own self with the painting, reflected in action painting and in the technique of "dripping" (that is, making the colour drip directly from the tube onto the canvas). Pollock arranged the painting on the ground and violently attacked it in a kind of excited ballet, almost becoming himself the immediate and direct gesture of the painting. Around '51 he painted in black and white. From '53 to '56 his paintings present images disguised in the tangle of the sign and the expanded dimensions of the painting, which is no longer an "object" but the expression of action. In this Pollock is the first contemporary painter to work on a large scale, abandoning easel painting.

Pomodoro, Arnaldo
(Marciano di Romagna, 1926). Italian sculptor. He came to sculpture after doing sophisticated work as a goldsmith and designer of modern jewelry in Florence with his brother Giò and Giorgio Perfetti in the "3 P" group, with whom he also worked on stage and interior designs. In '61–'62 he organized the exhibitions of the *Continuità* group, with Perilli, Novelli, Dorazio, Bemporad, and Fontana. In '56 he visited Paris for the first time, in '57 Brussels, and the United States in '59, where he organized the review *New York from Italy*. In '61 he was again in the United States and in Mexico, and in '63 he visited Brazil. He applies the poetics of the informal and of the sign to sculpture welded in metal, a poetics which he puts in continual dialectic with the lucid, mirror-like surface of the metal (often brass or gilded bronze). This contrast with the gestural tensions of the sculpture reveals an organic microstructural design, suggestive at times of an archaic script from the tables of some primeval law.

Poons, Larry
(Tokyo, 1937). American painter. He studied first at the New England Conservatory of Music and later at the Boston Museum School of Fine Arts ('55–'57). His relationship with the avant-garde musician John Cage has had a great influence on his work, introducing him to the methods of casual composition, which he has applied to painting. His first work was based on rhythmic progressions of musical origin and on graduated relations of broken geometric forms, as in the last American works of Mondrian. His later acquaintance with Pollock's work and the colour-field painting of Barnett Newman encouraged him to include in his paintings a visually effective combination of colours in dynamic relation.

Porter, Katherine
(Iowa, 1941). American painter. Has held one-person exhibitions in Boston, Washington and New York. Her work is included in the collections of the California Palace of the Legion of Honor; the Fogg Art Museum; the Carnegie Institute, Pittsburgh; the Whitney Museum, and the Worcester Art Museum. She is usually associated by American critics with the Pattern Painting movement.

Posen, Stephen
(St. Louis, 1939). Studied at Washington University, St. Louis ('58–'62) and at the Yale University School of Music and Art in '61. From '62 to '64 he went to Yale University and now lives in New York. He has also visited Italy, where he exhibited in '65 and '66. He is a member of the Hyper Realist group and interprets the realistic image in a provocatory and iconoclastic manner.

Rainer, Yvonne
She worked in the area of post-Pop Environments before coming to express herself through performance and action art.

Ramos, Mel
(Sacramento, 1935). American painter, living in Sacramento. He is one of the exponents of American Pop Art; his themes are drawn from erotic, sensual mass communications.

Ray, Man
(Philadelphia, 1890–1976). American painter, photographer, and film artist. He studied architecture, engineering, and painting in New York from 1897 to 1908. He then worked in advertising design. His meeting with Joseph Stella in '14 and his friendship with Duchamp and Picabia in New York from '15 were crucial for the development of American Dadaism. From '18 he painted with the air-brush, which until then had only been used in advertising. From '20 he began the use of the ready-made, that is, the transformation into works of art objects from everyday life, which the artist modified very little or not at all; their definition as "works of art" was due exclusively to their being used by an artist and put into a different context. The aim was an ironic debunking of the sacred concept of art and, as in the case of Duchamp, there was the shifting of the "artistic" from the work to the artist. In the same period he produced the "rayographs" (photographic images obtained without the use of a camera with the imprinting of objects on sensitive paper) and the solarizations (obtained by exposing the photographic plate to light while it was being developed). In '22 he produced his "writings with light". In '21 after having published *New York Dada* with Duchamp, he moved to Paris, where he also worked in the cinema, applying to it the iconoclastic techniques of Dadaism. He was in the United States from '40 to '51 and then returned to Paris, continuing to work in a Dadaist way.

Raysse, Martial
(Nice, 1936). French painter. He started painting in Nice in '57. He worked in the field of Neo-Dadaism and later in New Realism, using the techniques of the new technological panorama which has now replaced the natural panorama (fluorescent colours, neon, photography), aiming to liberate his works from the myths developed and imposed by advertising in a mechanized society.

Rauschenberg, Robert
(Port Arthur, Texas, 1925). American painter. In '50 he studied in Paris, and in '55 he worked for the Merce Cunningham Dance Company, producing stage designs and costumes. He is a representative of the Neo-Dadaist movement, emerging from the various strands of informal art, and has produced "combine paintings", using collage technique and the *assemblage* of non-art objects, which reflect a satiric intention in an ironic celebration of the consumer myths and figures of our time.

Reinhardt, Ad
(Buffalo, 1913–New York, 1967). American painter. He was the initiator of the "reductive" tendency in painting, directed towards analysis of the activity itself, without other content. With this radical intention he developed uniform black spreads of colour containing geometrical shapes, also in black, to create a kind of "event" which reflects in itself a concept of art defined by the artist, "art as art".

Richier, Germaine
(Grans, Provence, 1904–Montpellier, 1959). French sculptor. She studied at Montpellier under Guignes, the pupil of Rodin. From '25 she lived in Paris, first as a pupil of Bourdelle and after '29 in her own studio. She developed from a renewed classicism to an existential interpretation of the human figure, withered by the instruments of destruction in contemporary civilization (atomic wars, institutionalized genocide). From the period of the *Insect Women* ('45) she went on to the *Orages*, in which the luminous sensitivity of Rodin was transformed into a violent, almost animalistic portrayal of terror. Germaine Richier later produced *La Feuille*, *L'Ouragane*, and the *Tauromachia*, in which she attempted a more direct abstraction while retaining an animal vitality in her forms.

Richter, Gerhard
(Waltersdorf, 1932). German painter. He started with the alienating photographic record, adding in a "different" medium a progressive blurring by means of superimposed brushstrokes, in a rediscovery of informal gesturality, and arrived at the complete obliteration of the image in almost uniform strokes of colour.

Rickey, George
(South Bend, Indiana, 1907). American sculptor and painter. He has studied at New York, Paris, and Oxford. He began as a painter, working on numerous murals. In '65 he completed his first mobile, and he continued in kinetic plastic work, using stainless steel and various other metals in an abstract style characterized by lightness and clarity of form.

Riley, Bridget
(London, 1931). English painter. Studied in London. She is among those whose experiments in perceptual and optical-kinetic art have given the initiative to Op art. She has contributed to international exhibitions and to the review "The Responsive Eye", organized by the Museum of Modern Art in New York.

Rinke, Klaus
(Wattenskied, 1939). German art worker, living in Düsseldorf. He is an exponent of Body Art and uses the body as a system of elementary signs, excluding any subjective and intentional implications.

Riopelle, Jean-Paul
(Montreal, 1923). Canadian painter. He was a pupil, at the Montreal École du Meuble, of Paul Emile Borduas ('43–'44), through whom Canadian artistic culture achieved international recognition. He moved at once to abstract art and belonged, with Borduas, Mousseau, Leduc, and Gauvreau, to the *Automatisme* group, whose aim was the renewal of spontaneity in creative activity. In '48 he signed Borduas' *Refus Global* manifesto. Since '48 he has lived in Paris. Since then his language has developed towards a lyrical and dramatic Abstract Expressionism based on a striking fragmented calligraphy.

Rivers, Larry
(New York, 1923). American painter and sculptor. He at first studied music and also wrote poetry. He began painting with Hans Hofmann in a dynamic abstract style. In Europe in '50 he moved to a figurative style, which he has developed, however, with methods of combination and montage characteristic of Abstract Expressionism.

Rosenquist, James
(North Dakota, 1933). American painter, living in New York since '58. He works in advertising. He progressed from Abstract Expressionism to Pop Art, whose language is drawn from advertising graphics, taking from them the dilated scale of the image, the wall-poster style of design, and the typographical technique, which Rosenquist applies to large panels in flat, commercial colours, as in printing, so as to overturn by a change of context the contemporary world conditioned by the destructive machinery of consumerism. His best-known work is *F-111*, a panel 85 feet long.

Rotella, Mimmo
(Catanzaro, 1918). Italian painter. Studied in Naples and immediately afterwards moved to Rome. In '52 he went to the University of Kansas City in the United States. His work was already tending towards the use of photographic material, to decollage, photomontage, and phonetic poetry. Since '57 he has used "double decollage": he glues posters torn from city walls onto the canvas only to tear them off again.

Rothko, Mark
(Dvinsk, 1903–New York, 1970). Russian painter, naturalized American. He emigrated to Oregon in '13 and studied there until '21, when he went to Yale University. From '25 he attended Max Webern's courses at the Art Students League in New York. In '35, with Adolph Gottlieb, he was one of the founders of the Expressionist group The Ten. In '36–'37 he worked on the WPA (Federal Art Project). In '45 he became a Surrealist. But from '46 his work tended towards the definition of an individual language based on the elaboration of vast expanses of luminous colour. In '48 he founded the "Subject of the Artist" school with Gottlieb, Motherwell, and Newman. In '58, after a period of travel in Europe, he began the series of large murals for the Seagram Building in New York, designed by Mies van der Rohe (he later decided not to place them there). He committed suicide in '70 at the height of his fame. He is considered one of the principal figures of the abstract-concrete Pacific School. His murals establish themselves as real space, as space-quantity, light-quantity, and colour-quantity; the space of the image is interpreted as a concrete plane of perception, in terms of perspective and light. At the same time as Pollock was identifying space with life, as a convulsive restless drama in its development, Rothko through light interpreted the space of man, perceived space, as an achieved equilibrium, as contemplation. He arranged colour in successive and parallel planes, according to an architectural vision of relative space, determined in a regular, articulated manner in a simple, extremely pure structure; in this every superfluous movement is replaced by an emotive concentration, expressed in a luminous uniformity reminiscent of the contemplative theories of Oriental philosophy.

Ruscha, Ed
(Omaha, 1937). American art worker, living in Los Angeles. He has developed from his own, almost naturalistic, version of Pop Art to work of a Conceptual type which makes deliberately modest use of photography and is collected in series of a typological character with qualities of ironic and at times macabre banality.

Ruthenbeck, Reiner
(Velbert, 1937). German painter, living in Düsseldorf. He uses "poor" techniques and materials to demonstrate the need for a new "naturalness" in seeking a different image of the world.

Saint-Phalle, Niki de
(Paris, 1930). French sculptor. After living in New York as a child she returned to Paris in '51 and began to paint in '52. She lives at Soisy-sur-École (Essonne) and belongs to the international New Realist group. Since her "surprise pictures" of '61 (plaster panels of uneven surface from which tubes of liquid colour emerged as if out of sacks; the spectator was invited to shoot at the painting, which disgorged colour, so colouring the surface in different ways) she has developed to the creation of abnormally inflated three-dimensional images, a kind of monstrous, enormous caricatures of explosive, erupting vitality. In these works, some monumental in scale, with a variety of "events" inside, she approached Pop Art and anticipated the Environment but from a Neo-Dadaist angle.

Salt, John
(Birmingham, 1937). British painter. Studied at the Birmingham College and at the Slade School of Fine Arts in London. He lives and teaches in New York. He has followed the American Hyper Realists, working on enlarged, coldly objective, photographic representations of the detail of technological objects.

Samaras, Lucas
(Kastoria, Greece, 1936). Greek art worker, living in New York. His works analyze the environment and objects in common use (bed, chair), which are seen in a manner that shatters the myth of comfort. He creates disorienting settings, playing on ambiguities of perspective through the use of light.

Saura, Antonio
(Huesca, 1930). Spanish painter. A representative of European "informal" art, he makes use of an impetuous gesturalism, attacking the rich material of his paintings. He reflects the influence of De Kooning.

Schneeman, Carolee
German art worker. She works in the area of event art, in "actions" and "performances", using her body as instrument, as in the performance she staged in Berlin in '70 in which she presented herself in a series of transformations, clothed in different materials and objects.

Schöffer, Nicolas
(Calocsa, Hungary, 1912). Hungarian architect, sculptor, and painter, naturalized French. He studied in Budapest and later settled in Paris. In '50 he turned to abstract spatial sculpture characterized by a dynamic illusion, founding "spatiodynamism" in '48 and "luminodynamism" in '57. More recently he has realized his spatio-dynamic intentions through the use of electronic instruments that produce moving coloured images.

Schwitters, Kurt
(Hanover, 1887–Ambleside, 1948). German painter, sculptor, poet, and writer. He studied at Dresden and was in Hanover from '17 until he left Germany in '37. He began with post-Cubist and Expressionist work and from '19 took part in the European Dadaist movement. About '23 he was in contact with the Constructivists Moholy-Nagy and El Lissitzky, and with Van Doesburg, who was his guide on a visit to Holland. Hence his temporary adherence to the Concrete art movement and to the *Cercle et Carré* and the Abstraction-Creation groups ('23–'26). In the Neo-Dadaist movement Schwitters collected all his pictorial and literary work under the name *Merz* (from *Commerz*). In '19 he published a volume of poetry, *Anna Blume*, and produced the first *Merz* by the *assemblage* technique. Between '23 and '32 he published twenty numbers of the *Merz* review. Meanwhile, in his house in Hanover, he constructed the *Merzbau*, an architectural *assemblage* made up of the most disparate objects, which soon rose so high as to

509

force him to demolish two floors of his house (it was destroyed by a bomb in the Second World War). In '40 Schwitters, in Norway, withdrew to England. While almost all the Dadaists turned to Surrealism, Schwitters chose a line of his own, anticipating a kind of New Realism.

Sedgley, Peter
(Britain, 1930). British painter. Began with optical perceptual work associated with Pop Art to create new possibilities in optical dynamics.

Segal, George
(New York, 1924). American sculptor. Associated with Pop Art, he created human figures from life, using plaster casts, capturing them in familiar activities and settings, and accentuating the anonymity of the actions imposed by society. His first environmental sculptures date from '61. In '64 the Sidney Janis Gallery in New York held an exhibition of works by Dine, Oldenburg, Rosenquist, and Segal entitled "Environments by 4 New Realists".

Serra, Richard
(San Francisco, 1939). American art worker, living in New York. He works in a variety of basic materials with the intention of demonstrating in a conceptual way their ability to express energy, developing latent tensions and autonomous structural relations.

Severini, Gino
(Cortona, 1883–Paris, 1966). Italian painter. In 1899 Severini left Tuscany for Rome, where he met Boccioni in Balla's studio. Devoting himself to painting, from 1904–05 he studied and copied the Old Masters and the Florentine Renaissance. In 1906 he was in Paris, where he met Modigliani, Max Jacob, Suzanne Valadon, Utrillo, Dufy, and the artists of Picasso and Braque's circle. In '10 with Balla, Boccioni, and Carrà he signed the manifestoes of Futurism, which he introduced in that year to Paris. He contributed to *Lacerba* and in '30 became the friend of Juan Gris, who introduced him to Léonce Rosenberg. In '21 he published *Du Cubisme au Classicisme* and in the meantime, after a very advanced abstract phase, he returned to a classicist figuration with metaphysical overtones. Through different phases and different technical and formal experiments Severini developed his own abstract-geometric language, enriched by a classical, traditional basis.

Shapiro, Miriam
(Toronto, Canada, 1933). American painter. Has held numerous one-person and group exhibitions throughout the United States, many connected with the Women's Movement. Her work is included in the collections of the Museum of Modern Art, New York; the St. Louis City Art Museum; the Whitney Museum, New York; the Worcester Art Museum; the Hirschhorn Museum, Washington; and the Minneapolis Institute of Art.

Smith, Anthony
(South Orange, New Jersey, 1912). American architect and sculptor, closely associated with the New York School artists. He has worked with Frank Lloyd Wright. As a sculptor he has developed a lucid reduction of plastic language into basic geometric forms, in the manner of Minimal Art (Primary Structures).

Smith, David
(Decatur, Indiana, 1906–Bennington, 1965). American sculptor. He studied in Ohio and came to New York at the age of twenty, earning his living as a metal-worker while studying painting. In '30, influenced by Picasso and Gonzales, he began to include a variety of crude materials in his paintings, creating *assemblages*. In '32 he devoted himself to sculpture in wood and in '33 was the first in America to use welding in iron. He travelled in Europe in 1935, visiting Greece. Meanwhile, his sculpture was developing in Surrealist directions. In '40 he settled at Bolton Landing, near New York. From '48 to '50 he taught at Sarah Lawrence College and at the universities of Arkansas and Mississippi. In the 1950's his sculpture developed under Constructivist influences in unadorned monumental structures of spatial organization.

Smithson, Robert
(Passaic, 1938–Texas, 1973). American art worker. He worked along the lines of land art, using mechanical devices (rollers, carts) in various spaces and territorial zones with the object of modifying the landscape in accordance with geometric laws. His *Spirals* are to be understood in this way, being made of materials drawn from the same ground that they are created on.

Snelson, Kenneth
(Pendleton, Oregon, 1927). American sculptor. He works in Environmental art and the development of Minimal structures.

Sonnier, Keith
American art worker, living in New York. He works in activities which go beyond the specifically artistic, carrying the artistic "dimension" into life itself.

Soto, Jesus Rafael
(Ciudad Bolivar, Venezuela, 1923). Venezuelan aesthetic-visual worker. He has lived in Paris since '50, after being director of the Maracaibo Academy. Beginning from a neo-Concrete art, he has developed a study of optical dynamics on an enlarged scale with light filtered by means of thin linear diaphragms that move with the movement of the air or if touched by the spectator.

Soulages, Pierre
(Rodez, 1909). French painter. From an early interest in Celtic and Roman prehistory and archaeology, he moved to modern art in '39 in Paris. He was then in the war and on his return worked near Montpellier until '46. He returned to Paris in '46 and devoted himself to painting and scene painting. He is a representative of European Abstract Expressionism, which he expresses in large, symbolic movements structured in broad zones of colour (black, blue, brown), creating a plastic structuring of great expressive force.

Soutine, Chaim
(Smilivic, 1894–Paris, 1943). Russian painter, naturalized French. At thirteen he fled to Minsk, where he began to study design. In '10 he was at the Vilna Academy. In '13 he succeeded in reaching Paris, where he met Chagall, Léger, Delaunay, and Cendrars and was the friend of Modigliani. In '19, with the assistance of the merchant Zhorowsky, he was able to withdraw to Céret, in the Pyrenees. In '41, at the time of the German occupation, he took refuge at Champigny-sur-Vende. A visionary Expressionist, constantly engrossed in his private vision, he explored the extremes of colour as the means of representing a crude and painful psychic realism.

Spoerri, Daniel
(Galati, Roumania, 1930). Roumanian painter and art worker, belonging to the New Realism group. He creates *assemblages* of objects of daily use, preserved in the deteriorating squalor caused by use which turns them into the wreckage and revealing refuse of modern life.

Staël, Nicolas de
(St. Petersburg, 1914–Antibes, 1955). Russian painter, naturalized French. His family left Russia during the Revolution and settled in Belgium until '38. From '38 De Staël was in Paris. Coming to painting only after '40, he developed an intense, personal, and dramatically expressive style.

Stella, Frank
(Malden, Massachusetts, 1936). American painter. He creates basic geometric images, reducing the significance of the painting to objective expression without references of any kind. His "radical" pictorial work develops the same process which in sculpture is represented in the activities of Minimal Art (Primary Structures). His works, developed in terms of two-dimensional space, are composed of rhythmic bands and cruciform sections in moulded compositions on projecting canvases, along the lines of "shaped canvases".

Still, Clyfford
(Grandin, North Dakota, 1904). American painter. He studied at Spokane and in '41 moved to San Francisco, where he met Rothko and took part in the activity of what was to be called the Pacific School. An Abstract Expressionist from '40 to '50 (in '48 with Rothko, Motherwell, Baziotes, Hare, and others he belonged to the founding group of the "Subject of the Artist" school, and in '50 he worked in New York with Pollock and De Kooning). He later turned to structural work of a neo-Concrete type.

Takis (Vassilakis)
(Athens, 1925). Greek sculptor, naturalized French. His first sculptures date from '46, his "signal sculptures" from '54–'58, and his first "telemagnetic sculptures" from '58. In '57 he caused some spherical bronze sculptures to explode on a hill in Athens, and in the streets of Paris he presented "firework sculptures". Rather than the formal result, Takis has always sought to demonstrate in his sculptures the force of latent energy that nature expresses in its vital manifestations of explosive violence.

Tàpies, Antoni
(Barcelona, 1923). Spanish painter. He devoted himself to drawing from early childhood, having ample means of study in the extensive family library, and while still a boy he found himself in the midst of the Civil War ('36), which left indelible marks on him. In '43 he began to study law, as his father wished, but soon abandoned it for painting. He moved

510

from a variety of preliminary phases, the study of the Expressionists and of Picasso, towards a type of Surrealism inspired by Klee, Miró, and Ernst. In '46 he founded the *Dan al Set* group. Already at that time, in linguistically inspired works with Expressionist figuration, there appear the themes later dominant, the interest in matter-colour, the monochrome, and the subjects of "matter-mud". In Paris in '52 he met the critic Tapié, who became interested in his work. Later he approached a type of informal art which rejected painting as gesture, since existentially he rejects action, taking up a position of not acting, not being.

Tatlin, Vladimir (Avgrafovic)
(Karlow, Russia, 1885–Moscow, 1953). Russian sculptor, architect, and painter. He ran away from home at eighteen and became a sailor. In 1904 he studied at Pensa and in '10 at Moscow, where he became the friend of Vesnin and took part in the exhibitions of the "Donkey's Tail" ('12). In '13 he visited Berlin and Paris, where the work of Picasso made a strong impression on him. Returning to Moscow, he began the *Reliefs* that led the way to Russian Constructivism, which in contrast with Malevich's Suprematism favoured contact between art and technology and later brought about the birth of industrial design. His *Project for the Monument to the Third International*, one of the first examples of contemporary kinetic art, dates from '19–'20. In '22 he was summoned to teach at St. Petersburg. In '27 he returned to Moscow, where he taught at the advanced technical art institute.

Thiebaud, Wayne
(Mesa, Arizona, 1920). American painter, director, and graphic artist. He worked in New York as cartoonist, designer, and publicity artist. He occupies a special place among the representatives of Pop Art for his violently distorted rendering of images (especially convenience food) which a bright, advertising use of colour makes still more emphatically false and synthetic.

Tilson, Joe
(London, 1928). British painter and sculptor. He studied at the Royal College of Art in London and also in Italy. With Phillips, Kitaj, Blake, Jones, and Caulfield, he is one of the representatives of British Pop Art, which is more allusive and ambitious than American Pop Art. He produces compositions in relief in painted wood, using collage and presenting in a rigorous, emblematic manner what he himself calls "the ambiguous images of the great city".

Tinguely, Jean
(Fribourg, 1925). Swiss painter and sculptor. He studied at the Fribourg Academy of Fine Arts from '41 to '45, and he has constructed watermills supplied with sound tracks in a forest. Between '45 and '52 he developed his own interpretation of Dadaism, making abstract constructions in iron, other metals, wood, and paper. In Paris in '52 he developed "metal mechanism", creating *Speaking Metal Robots* and *Painting Machines*. Constantly poised between kinetic and New Realist work, he creates self propelling, edible, and musical machines (John Cage often supplies sound tracks).

Tobey, Mark
(Centerville, Wisconsin, 1890). American painter. He studied at the Chicago Art Institute and in '11 moved to New York. In '22 he moved to Seattle, where he taught painting. From his youth he has been interested in Oriental mystical and cosmogonal theories (especially in Bahai beliefs, which are based on the spiritual unity and equality of man and which spread in America after the First World War). About '23 he was initiated by the Chinese painter Teng Kwei into the technical processes of Oriental painting and calligraphy. He then travelled in Europe and in the East. He studied Chinese calligraphy at Shanghai and Zen painting at Kyoto. From '31 to '38 he lived in England. In '38, again in Seattle, he worked for the WPA (Federal Art Project). After '35 he introduced the sign element into his painting with a dynamic-luminous function (this is the period of the "white writing"). Developing his work on light as a "unifying idea", he later came to abandon any reference to a realistic image and to create dense, continuous surfaces, swarming with minute signs, through which he attempts to convey the sense of the frenetic rhythm of life and of the city.

Trova, Ernst
(St. Louis, 1927). American sculptor, living in St. Louis. Working in the area of Pop Art, he has developed a stereotyped image of man, reduced to a depersonalized metallic marionette, worked out in volumetric terms and often enclosed in containers, which accentuate the sense of any human object, and even its representation, as being "merchandise".

Tucker, William
(Cairo, 1935). British sculptor, living in Britain since '37. After studying languages at college he pursued sculpture at the St. Martin's School of Art with Anthony Caro and at the Central School of Art in London from '58 to '60. He teaches at the St. Martin's School and lives in London. His sculptures are abstract constructions in fibre glass, put together in painted modular parts produced industrially and capable of being assembled in different ways.

Uecker, Günther
(Wendorf, Mecklenburg, 1930). German sculptor. Studied in Berlin and Düsseldorf. He produces works with nails sticking out of the wood, almost like organic growths, which he elaborates by adding sources of light. In '61, with Piene and Mack, he joined the Zero group in Düsseldorf.

Van der Beek, Stan
(United States, 1928). American art worker. He has worked at the Massachusetts Institute of Technology in Boston, experimenting with electronic computers. He is well-known for his films, in which he uses a computer to subdivide the sections of microfilm in different planes, to create abstract, isolated, animated images.

Van Elk, Ger
(Amsterdam, 1941). Dutch art worker, living in Amsterdam and Los Angeles. Working in "poor" art, he has created some interesting films, one of a box projected onto the box and one of a pennant projected on itself. He also uses photographs to which he adds pictorial devices.

Van Gogh, Vincent
(Groot-Zundert, 1853–Auvers-sur-Oise, 1890). Dutch painter. After an initial period of exalted mysticism which led him, at about the age of twenty, to teach in a mining village in England and in '78 to be a preacher in Borinage, about '80 he turned to painting. In '86 in Paris, where he had gone at the invitation of his brother Theo, he developed from realism in Millet's manner to Neo-Impressionism, which he had discovered through Pissarro, Seurat, Toulouse-Lautrec, and Gauguin. In '88 he moved to Arles, where his frenetic pictorial activity began. Abandoning Neo-Impressionism, he turned to a tonal enkindling of colour, enhanced by the vibrant incisiveness of the sign. Gauguin joined him at Arles and there occurred his tragic attack on Gauguin and his self-punishing mutilation of his own ear. This led to the crises which in '89 caused him to enter the mental hospital in Saint-Rémy. In '90 Van Gogh moved to Auvers, near Dr. Gachet, the collector and friend of artists. In the same year he committed suicide.

Vasarely, Victor
(Pecs, 1908). Hungarian painter, naturalized French. At first he studied medicine in Budapest. He then went on to study art at the Mühely Academy of Alexander Bortnyik, the Budapest Bauhaus, where he was a pupil of Moholy-Nagy. In Paris in '30 he joined the Abstraction-Creation group, and in '44 he founded the Denise René Gallery. In '55 he published the *Jaune* manifesto and began the period of optical kinetic experiment which made him one of the pioneers of optical art. His studies of perception in its possibilities of creating virtual and ambiguous images, permutable "binary structures", still using exact geometric principles, represent one of the most extensive and fascinating investigations in the optical-perceptual field.

Vedova, Emilio
(Venice, 1919). Italian painter. Basically self-taught, in '37 he studied in Rome, and in '38 he was again in Venice. He was in the Resistance between '43 and '45 and was wounded during an ambush. In '46 he joined the New Secession and New Front for the Arts in Venice. In '52 he was in Venturi's "Group of Eight". From a kind of post-Cubism, filtered through a personal Expressionistic violence and through a fine revision of eighteenth-century Venetian graphics, he arrived at a dynamic, abstract-gestural language with political and existential content. Later, with the *Plurimi*, he moved to the acquisition of real space in his gesturality.

Vieira da Silva, Maria Elena
(Lisbon, 1908). French-Portuguese painter. She studied sculpture in Paris with Bourdelle and Despiau and later with Dufresne, Friesz, and Léger. She then turned to painting, elaborating linear surfaces in neutral tones. Later she accentuated the perspective relations of the surface structures, giving an ideal reference to urban structures with a dynamic perspective effect. She uses clear colours and a soft light which give the composition sensitivity and a mysterious emotiveness.

Vostell, Wolf
(Leverkusen, 1932). German art worker, living in Berlin. One of the international Fluxus

group, he produces Happenings of various kinds, with the purpose of demonstrating means of organized violence against the social system. He involves the public in his "actions" in order to identify them ideologically.

Warhol, Andy

(Philadelphia, 1930). American painter. He began as a commercial artist and studied at the Carnegie Institute. He became one of the leading figures of Pop Art and of the new Super Realism. He reproduces the objects of mass industrial consumerism in their obsessive multiplicability and uniformity, developing an inexorable and bitterly ironic criticism of mass society in which nevertheless he sees himself as an "integrated" consumer. In his pictures Warhol uses photographic materials and the industrial colours of offset printing with their crude violence. He has also made films which develop the same unrelenting themes.

Wesselman, Tom

(Cincinnati, Ohio, 1931). American painter. An exponent of Pop Art, he treats themes of mass communication in emphatic enlargement, rendering them with aggressive irony in clear, direct colours and with an explosive visual force.

Wols (Alfred Otto Wolfgang Schulze)

(Berlin, 1913–Paris, 1951). German painter and graphic artist. The son of a musician, he was a respected violinist from his youth. He studied in Dresden and Frankfurt, where he followed Frobenius' course at the Institute of African Studies. For a short time he then attended the Berlin Bauhaus, studying architecture with Mies van der Rohe and Moholy-Nagy. In '32 he was in Paris and was in contact with the Surrealists, working meanwhile as a photographer. At the beginning of the war, being German, he was interned in a concentration camp, where he began to make designs. In '45 he held his first personal exhibition. In '47 he began the series of illustrations for Sarte, Kafka, Artaud, and Paulhan. He belonged, with Fautrier and Dubuffet, to the founding triad of informal art in Europe (*tachisme*). The psychic impulse is transformed in Wols's works into a sign without the filters of memory. To see is to discover in oneself the complex reality of the spirit; this is interpreted in the delicate intricacy of signs and machines which makes up his painting, in a subterranean search for the process of organic growth in nature.

Yoko-o, Tadanori

Japanese art worker and painter. In the wake of the international diffusion of Pop Art he analyzes the erotic element in much of the mass media, from advertising to the commercial cinema, in an ironic and iconoclastic way.

Zadkine, Ossip

(Smolensk, 1890–Paris, 1967). Russian sculptor, naturalized French. He studied in Scotland and London; in 1909 he was in Paris, where after briefly attending the courses at the École des Beaux Arts he opened his own studio. The friend of Archipenko and Lipchitz and in close contact with Léger, Chagall, and Soutine, he was in the thick of avant-garde experiments. During the First World War he fought in the French army; and suffering from gas poisoning in '18, he returned to Paris, where, penniless and ill, he doggedly took up his work again. From a Cubist starting point he elaborated during the 1920's a plastic representation that united metaphysical elements reminiscent of De Chirico to Expressionist motifs, which often led him to a monumental heightening of the plastic image.

Zakanitch, Robert

(Elizabeth, New Jersey, 1935). American painter. First one-person exhibition '65, Alexandria, Virginia. Has since held a number of one-person exhibitions in New York and one in Basel. Collections include the Museum of Modern Art, Munich; the Museum of Fine Arts, Richmond, Virginia; the Philadelphia Museum of Art; the Phoenix Museum of Art; the Wadsworth Atheneum, and the Whitney Museum.

Bibliography

Abstract Art since 1945 (essays by various authors), London, 1971

Amaya, Mario, *Pop as Art*, London, 1965

Ashton, Dore, *The Life and Times of the New York School*, Bath, 1972

Bann, Stephen, with Reg Gadney, Frank Popper, and Philip Steadman, *Four Essays in Kinetic Art*, London, 1966

Barrett, Cyril, *Op Art*, London, 1970

Battcock, Gregory (ed.), *Minimal Art—a Critical Anthology*, London, 1968

———— (ed.), *Idea Art*, New York, 1973

Berger, John, *Selected Essays and Articles—The Look of Things*, London, 1972

Brett, Guy, *Kinetic Art*, London, 1968

British Painting and Sculpture 1960–1970, catalogue of the exhibition at the National Gallery of Art, Washington, D.C., November 12, 1970–January 3, 1971

Calas, Nicolas, *Art in the Age of Risk*, New York, 1968

Cobra 1948–51, catalogue of an exhibition at the Boymans-van Beuningen Museum, Rotterdam

Coutts-Smith, Kenneth, *The Dream of Icarus*, London, 1970

Creedy, Jean (ed.), *The Social Context of Art*, London, 1970

Davis, Douglas, *Art and the Future*, London, 1973

54–64, Painting and Sculpture of a Decade, catalogue of an exhibition organized by the Calouste Gulbenkian Foundation at the Tate Gallery, London, April 22–June 28, 1964

Figurative Art since 1945 (essays by various authors), London, 1971

Finch, Christopher, *Pop Art—Object and Image*, London and New York, 1968

Fried, Michael, *Three American Artists*, catalogue of an exhibition at the Fogg Art Museum, Harvard University, 1965

Geldzahler, Henry, *New York Painting and Sculpture 1940–1970*, catalogue of an exhibition at the Metropolitan Museum of Art, New York—London, 1969

Greenberg, Clement, *Art and Culture*, Boston, 1961

———— *Recentness of Sculpture*, "American Sculpture of the Sixties", catalogue of an exhibition at the Los Angeles County Museum of Art, April 28–June 25, 1967, and at the Philadelphia Museum of Art, September 19–October 29, 1967

Haftmann, Werner, *Painting in the Twentieth Century*, 2nd edition, London, 1965

Henri, Adrian, *Environments and Happenings*, London, 1974; published in the United States with the title *Total Art*, New York, 1974.

Kepes, Gyorgy (ed.), *The Nature and Art of Motion*, London and New York, 1965

Kirby, Michael, *Happenings*, New York, 1965

Kostelanetz, Richard (ed.), *The New American Arts*, New York, 1967

Kozloff, Max, *Renderings*, London, 1968

Kultermann, Udo, *The New Sculpture*, London and New York, 1968

———— *Art-Events and Happenings*. London, 1971

———— *New Realism*, New York, 1972

Lippard, Lucy R., *Pop Art*, London and New York, 1966

Lucie-Smith, Edward, *Movements in Art since 1945*, 2nd edition, London, 1976; published in the United States with the title *Late Modern*, 2nd edition, New York, 1976

———— *Thinking about Art*, London, 1968

Mailland, Robert (ed.), *A Dictionary of Modern Sculpture*, Paris, 1960; London, 1962

McMullen, Roy, *Art, Affluence and Alienation*, London, 1968

Meyer, Ursula, *Conceptual Art*, New York, 1972

Mueller, Robert E., *The Science of Art*, New York, 1967, London, 1968

Müller, Grégoire, *The New Avant-Garde*, Venice and London, 1972

O'Doherty, Brian, *Object and Idea*, New York, 1967

Pellegrini, Aldo, *New Tendencies in Art*, New York, 1966, London, 1967

Popper, Frank, *Naissance des arts cinétiques*, Paris, 1967

Reichardt, Jasia, *The Computer in Art*, London and New York, 1971

Restany, Pierre, catalogue of the "Superlund" exhibition, Lund (Sweden), 1967

Richardson, Tony, and Nikos Stangos (eds.), *Concepts of Modern Art*, London, 1974

Rodman, Selden, *Conversations with Artists*, New York, 1961

Rose, Barbara, *American Art since 1900*, London and New York, 1967

Rosenberg, Harold, *The Tradition of the New*, London and New York, 1962

———— *The Anxious Object*, London and New York, 1964

———— *The Re-Definition of Art*, London and New York, 1972

———— *Art on the Edge*, New York, 1975; London, 1976

Russell, John, and Suzi Gablik, *Pop Art Redefined*, London and New York, 1969

Sandler, Irving, *Abstract Expressionism: The Triumph of American Painting*, London and New York, 1970

Seitz, William C., *The Art of Assemblage*, catalogue of an exhibition at the Museum of Modern Art, New York, 1961

———— *The Responsive Eye*, catalogue of an exhibition at the Museum of Modern Art, New York, 1965

Tomkins, Calvin, *Ahead of the Game*, London, 1968

Tuchman, Maurice (ed.), *The New York School: Abstract Expressionism in the 40's and 50's*, London, 1970

Vergine, Lea, *Il Corpo come Linguaggio*, Milan, 1974

Walker, John A., *Art since Pop*, London, 1975

Weber, J., *Pop-Art: Happenings und neue Realisten*, Munich, 1970

Index of Illustrations

515